BASEBALL AS AMERICA

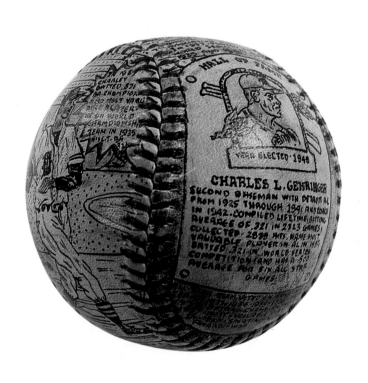

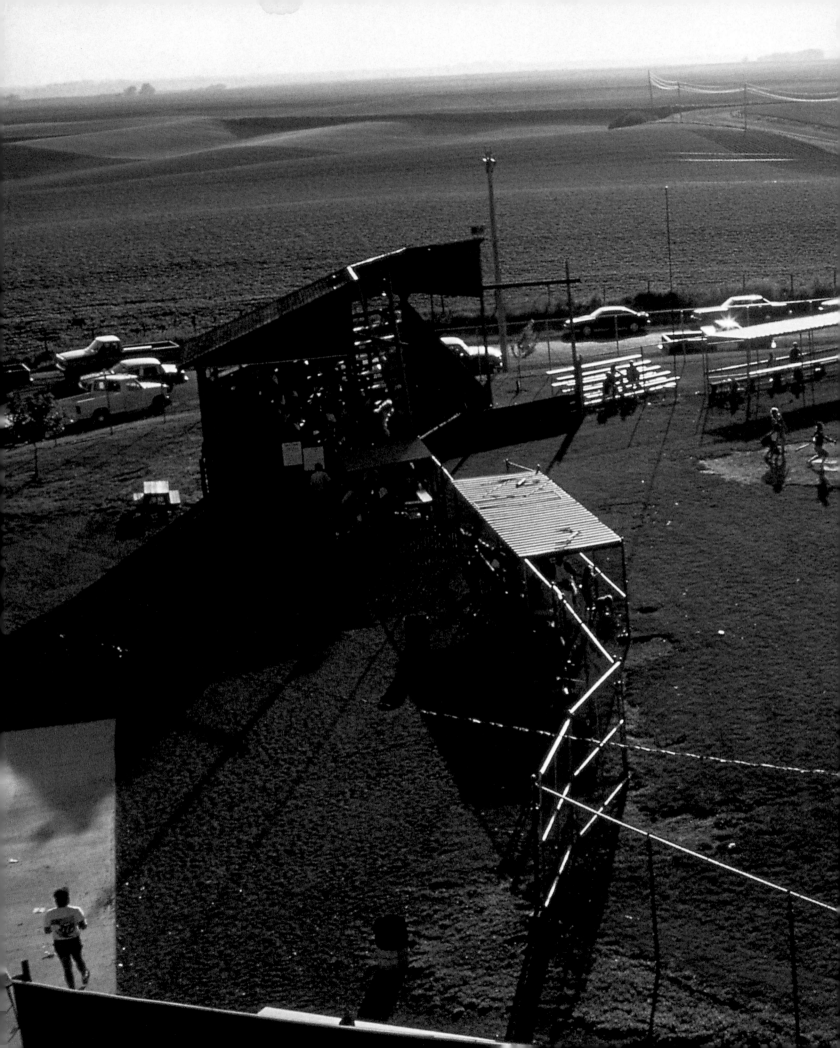

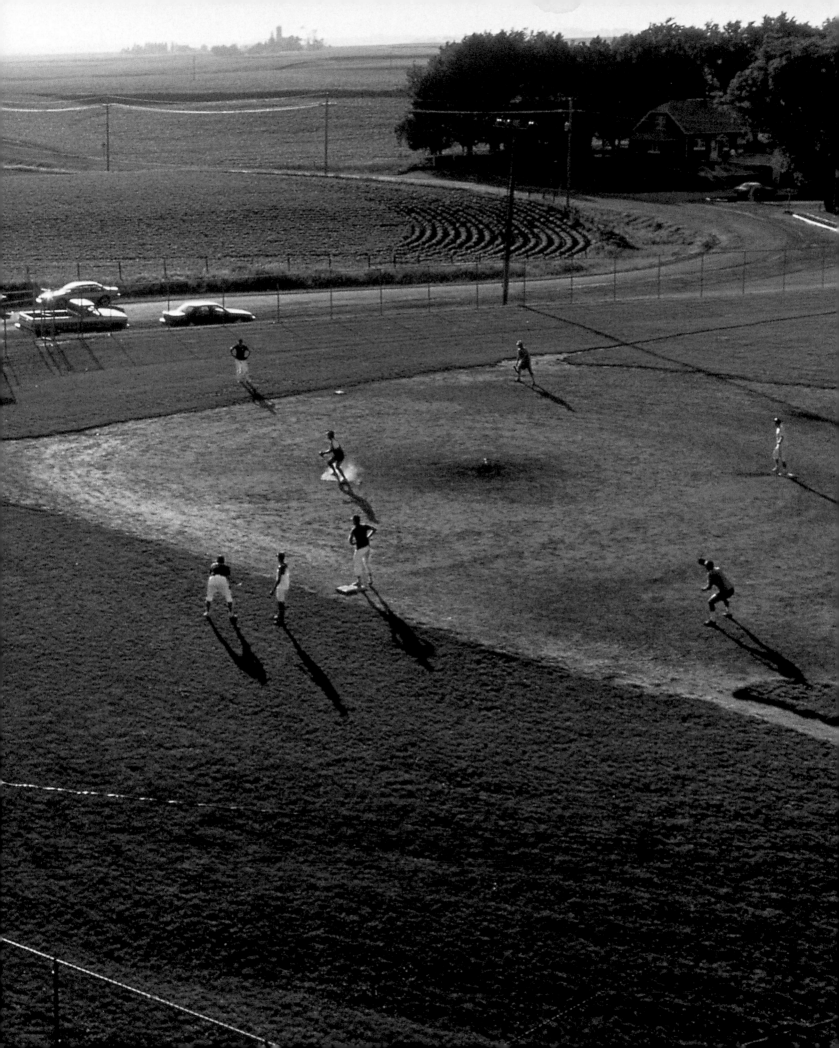

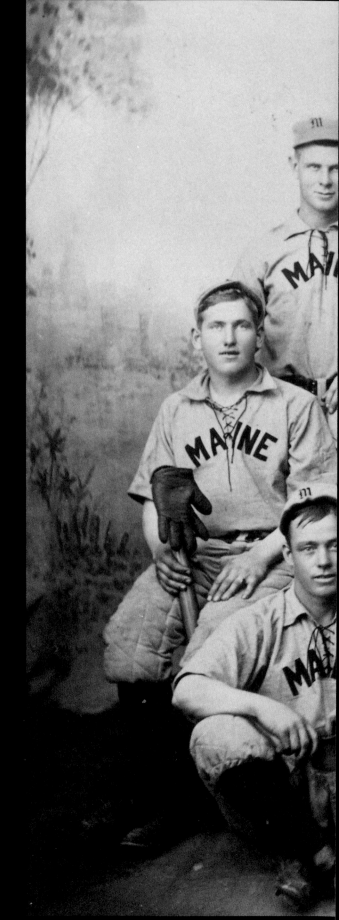

PAGE 1: Charlie Gehringer hand-painted baseball, ca 1956-1964 by folk artist and semipro umpire George Sosnak. The ball includes Gehringer's statistics and career·highlights, as well as an image of his Hall of Fame plaque. Sosnak also created balls for Casey Stengel, Ted Williams, Warren Spahn, and others.

PRECEDING PAGES: A timeless, rural American baseball scene. Though this photo was taken in Westphalia, Iowa, it could have been taken anywhere across America.

RIGHT: The USS *Maine* baseball team, which won the Navy's baseball championship in December 1897. All but one of the players, John Bloomer, top left, perished when the *Maine* exploded and sank in Havana Harbor two months later, touching off the Spanish-American war. Engine stoker and star pitcher William Lambert, top right, was described by a shipmate as "a master of speed, curves, and control."

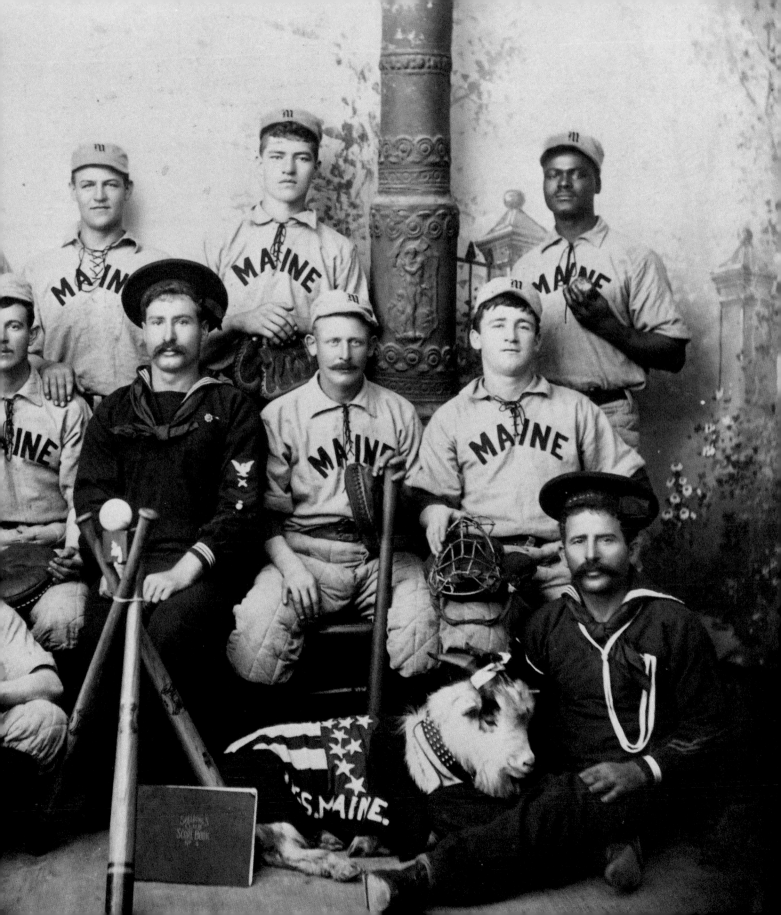

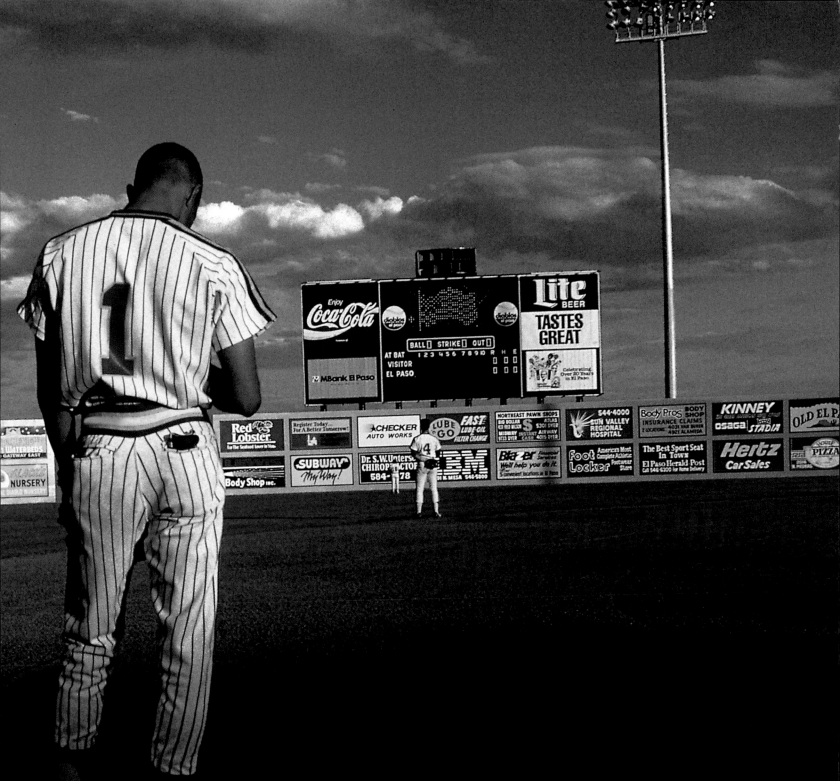

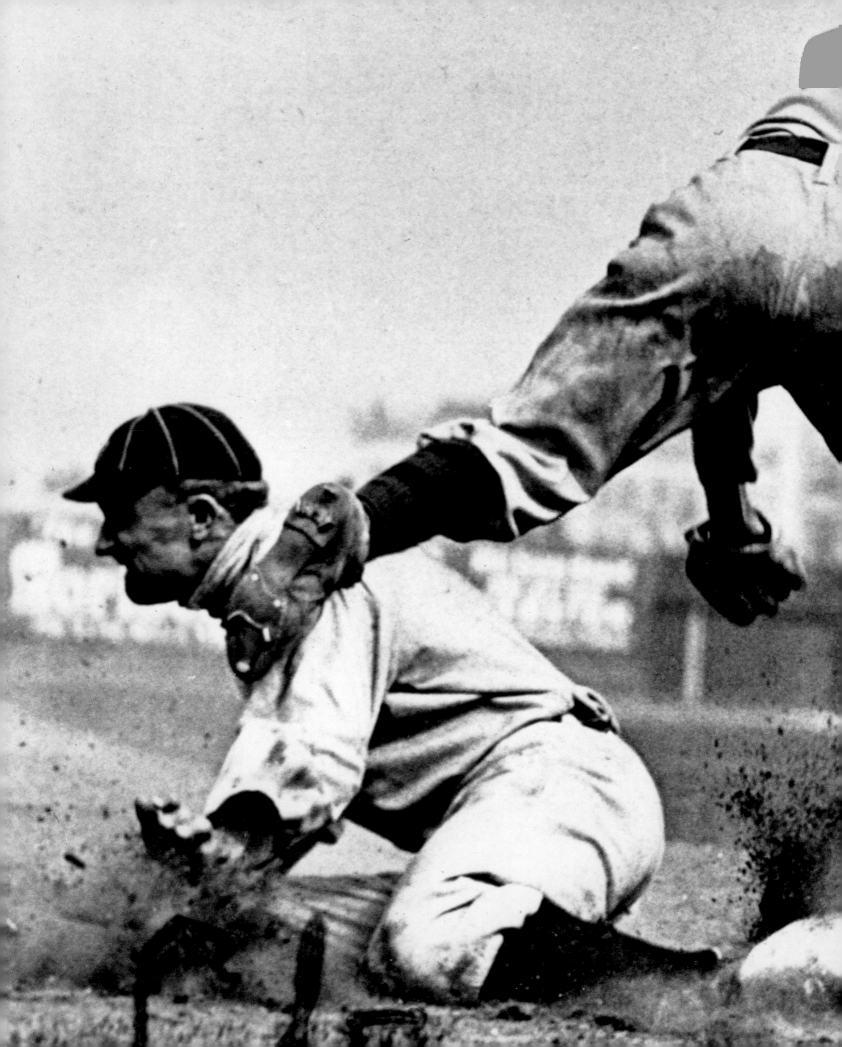

BASEBALL AS AMERICA

Seeing Ourselves Through Our National Game

NATIONAL GEOGRAPHIC

WASHINGTON, D.C.

Contents

OPPOSITE: The bat used by Babe Ruth to hit his record 60th home run in 1927. Ruth's total was more than that of any other team in the American League.

ABOVE RIGHT: Eastman, Georgia, Dodgers, minor league ticket for segregated colored seating section, 1953.

RIGHT: Button from Mickey Mantle brand jeans.

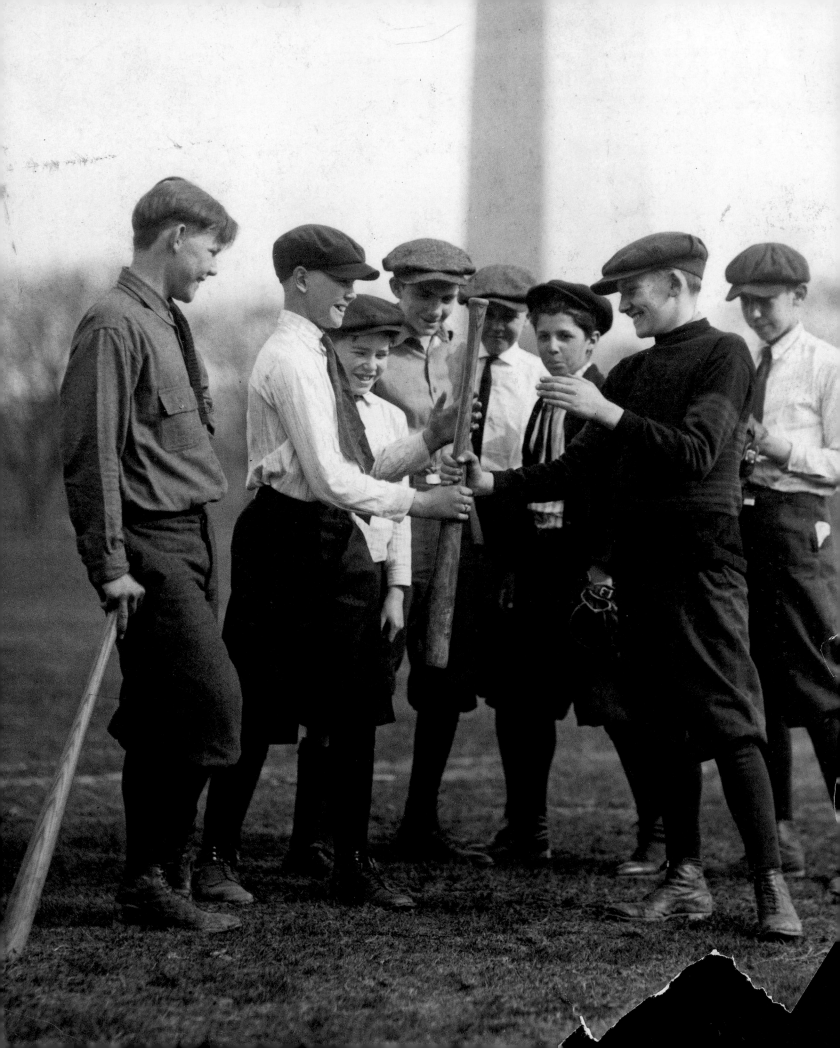

FOREWORD

 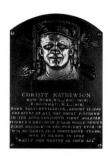 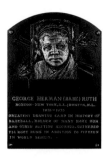 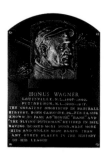

THE NATIONAL BASEBALL HALL OF FAME AND MUSEUM has the unique responsibility of preserving baseball's rich history and honoring its greatest heroes. As the institutional and spiritual home of The Game, we have an even greater responsibility to examine the deeper significance of baseball and reveal its enduring relevance to this great country and all Americans. The artifacts and the legacies that are in our safekeeping tell the story of a people brought together by a set of shared values and aspirations. This is baseball's story.

Baseball As America illuminates how baseball and America have grown up together. In exploring such social phenomena as immigration, integration, and industrialization, we see how baseball has both reflected and helped shape our development as a nation. Reaching across generations and bridging different heritages, baseball embodies fair play, ingenuity, and teamwork—core attributes of the American character. Baseball serves as a common legacy of a diverse people—it truly is our national game.

I would like to thank Ernst & Young, the sponsor of the national exhibition tour, "Baseball As America." They represent another great American tradition—that of patronage—providing support for the artistic and intellectual endeavors that better our society. Ernst & Young's generosity has helped us to bring this book and the exhibition it accompanies to the American people. They are great teammates.

This book and the exhibition also represent significant achievements for the Hall of Fame. *Baseball As America* would not have been possible without the talent and rigorous commitment of our entire museum staff in Cooperstown; I am tremendously grateful for their work on this project. I would also like to give a special thanks to the authors and to the artists who have shared their insightful perspectives on The Game. Above all, I salute the players and others who have donated priceless artifacts to the Hall of Fame. They serve the American people today and for generations to come by not only helping us better understand baseball history, but also ourselves.

—Jane Forbes Clark, *Chairman*
NATIONAL BASEBALL HALL OF FAME AND MUSEUM

◆ OPPOSITE: Congressional pages choosing up sides, sometimes known as "bucking up," in the shadow of the Washington Monument, 1922. ABOVE: Plaques of the first five inductees to the Baseball Hall of Fame: Ty Cobb, Walter Johnson, Christy Mathewson, Babe Ruth, and Honus Wagner.

JULES TYGIEL

Each baseball generation has its signature moment, an event that will be recalled, recounted, and relished in popular memory for decades to come. It might be a monumental blunder, like Fred Merkle's failure to touch second base in a New York Giants-Chicago Cubs game in 1908 that ultimately cost the Giants the pennant. Or it might be an instance of transcendent historical significance, as when Jackie Robinson first took the field for the

INTRODUCTION

Brooklyn Dodgers in 1947. ◆ For fans in the 1950s, Bobby Thomson's "shot heard 'round the world"—the pennant-winning home run that brought the Giants from behind to victory over the Dodgers in a 1951 playoff game—would echo throughout their lives. Few followers of baseball in the 1970s will ever forget where they were on April 8, 1974, when Hank Aaron hit his 715th career home run, surpassing Babe Ruth's long-standing record. ◆ For baseball fans in the 1990s, the signature moment came on Tuesday night, September 8, 1998, in St. Louis, where the Cardinals were playing the Chicago Cubs. All summer long, Cardinals first baseman Mark McGwire had relentlessly pursued the single-season record of 61 home runs, set 37 years earlier by the New York Yankees' Roger Maris. McGwire had been joined in this chase by Cubs slugger Sammy Sosa, who had doggedly shadowed McGwire with his own power displays. ◆ Sosa fittingly stood in right field, watching his friendly rival, when, in the fourth inning, McGwire drove a pitch from Steve Trachsel to left field. The blast was not one of McGwire's trademark, majestic, tape-measure home runs, but rather a laserlike line drive that cleared the fence almost before anyone could realize what had happened. McGwire trotted triumphantly around the bases, his right arm pointed heavenward as he approached home plate. In the outfield, Sosa offered a chivalric salute, tapping his hand on his heart.

In their epic quest, McGwire and Sosa had pursued not only Maris, but the larger specter of Babe Ruth, baseball's most mythic figure. When Maris had demonstrated the audacity to wrest the record from the legendary Ruth in 1961, many, including Commissioner Ford Frick, had viewed his campaign as sacrilege. In 1998, however, Americans embraced the assault on Maris's record by McGwire and Sosa with a near-religious fervor. The spectacle came to embody all that people loved about baseball, past and present, and the essence of America's enduring attachment to the game. The two men themselves epitomized eternal elements of America and its favored pastime. Because of the frequency and distance of his home runs, the red-headed McGwire, an overgrown Huck Finn, seemed to be the reincarnation of Ruth, while his good humor and grace under pressure evoked the more traditional all-American baseball hero envisioned in classic children's literature, a Frank Merriwell or Chip Hilton in the flesh. Sosa, on the other hand, conjured up the ghosts of Jackie Robinson, who shattered baseball's color line, and Roberto Clemente, the first great Latino superstar, and captured the spirit of the emerging international pastime. Little more than a half century earlier, Sosa, a dark-skinned native of the Dominican Republic, would not have been allowed to play in the major leagues.

Only 24 years earlier, some people had responded to Aaron's pursuit of Ruth's career record with racist hate mail. But in 1998, Sosa symbolized a more democratic game populated by African Americans, players from throughout the Caribbean basin, and a growing contingent from Japan, Korea, and Australia. Few questioned his legitimacy as a contender in the great home run race.

The ways that people tracked the McGwire-Sosa chase encompassed the myriad methods by which baseball had entered the consciousness of America, and increasingly the world, across the generations. Fans followed, as they had since the 1860s, the two players' progress in newspaper sports sections. They enjoyed, as they had since the 1920s, the instant access afforded by radio, not only listening to the play-by-play but also absorbing and participating in the commentary offered by sports talk shows. They watched, as they had since the late 1940s, on television, taking advantage of a modern cable and satellite network that allowed them a choice and variety undreamed of in earlier eras. Many followed the spectacle on the modern miracle of the Internet, availing themselves of instant updates, Web pages, and chat rooms. In each age, the emerging forms of media, reflections of our technological and communications progress, had immediately recognized and utilized baseball as an entry point into American life.

Through it all, a classic element of redemption underscored these events—redemption for McGwire, for Maris, and for baseball itself.

In his first full season in 1987, McGwire smashed 49 home runs, but he sacrificed his opportunity to become the first rookie to hit 50 when he chose to attend the birth of his son. In 1993 and 1994, he missed almost two complete seasons because of an injury that threatened to abort his career. As the resurrected McGwire crossed the plate after hitting his 62nd homer, he lifted his 12-year-old son, a bat-boy for the day, high into the air, capturing the bond between fathers and sons inherent in baseball folklore, fiction, and reality. Similarly, when Barry Bonds broke McGwire's record of 70 in 2001, he was greeted at the plate by his son, before his teammates piled on in jubilant celebration.

Ironically, the home run also brought redemption for the oft-maligned Maris, whose children sat in the Busch Stadium stands, an integral part of the unfolding drama. McGwire's accomplishment had given fans a greater appreciation for Maris's achievement. And for baseball, the popularity of which had momentarily dimmed four years earlier when a labor dispute had canceled the World Series, the enthusiasm for the McGwire-Sosa duel marked a reaffirmation of the game's status as the national pastime. The

◆ PAGE 16: American tableau: An outfielder warms up as Old Glory flaps in a strong breeze at Civic Stadium in Eugene, Oregon. There is often commerce in the temple, as the Dutch Girl advertising sign denotes.

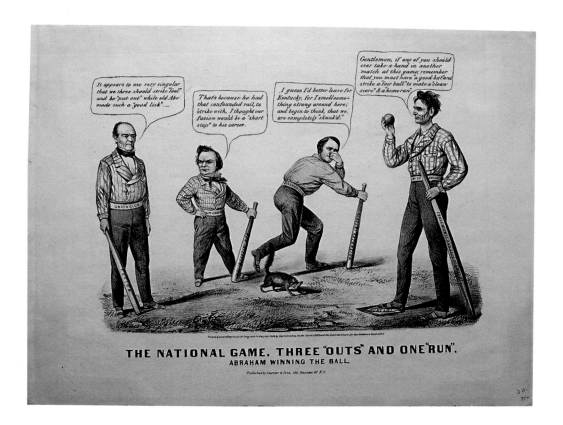

McGwire-Sosa home run extravaganza occurred a century and a half after baseball first arrived on the American scene. The game had few adherents prior to 1855, when it became a virtual overnight sensation, first in the New York metropolitan area, and then throughout the nation.

Simultaneously, baseball entered the American cultural mainstream. In 1858, J.R. Blodgett of Buffalo, New York, published "The Base Ball Polka," the first known baseball song. This ditty was followed within a decade by songs like "Home Run Quick Step," "The Base Ball Quadrille," "The Base Ball Fever," and "Catch It on the Fly."

Popular lithographers Currier and Ives demonstrated the extent to which baseball had penetrated the American consciousness in a remarkable print depicting the results of the 1860 presidential election. The illustration—entitled "The National Game. Three 'Outs' and One 'Run'" —featured Abraham Lincoln and his three defeated opponents dressed as baseball players and wielding bats. Each of the men discussed the outcome of the election using baseball terms. One wondered "why we should strike 'foul' and be 'put out.'" Another spoke of putting a "short stop" to Lincoln's career. Lincoln, himself, explains that to emerge victorious one must "have a good bat" and strike a "fair ball" to make a "clean score" and a "home run." Currier and Ives felt confident that its national clientele would understand the baseball imagery and be familiar with the language of the game. Within a few years, baseball terminology had already invaded and begun to transform the American vernacular.

During the 1860s, amidst Civil War and Reconstruction, baseball further cemented its hold on the nation. The first baseball book designed for fans, *Beadle's Dime Base-Ball Player,* appeared in 1860. Eight years later, William Everett wrote *Changing Base,* the first in a long line of fictional baseball works for children. In 1866, *Frank Leslie's Illustrated Newspaper* described the first baseball table game, Parlor Base-Ball, created by former pitcher Francis C. Sebring.

In the aftermath of the war, baseball, an increasingly

◆ A victorious Abraham Lincoln and his three opponents in the 1860 presidential election—John Bell, Stephen Douglas, and John Breckenridge—in a lithograph by Currier and Ives. By 1860, baseball was such a familiar game that the candidates' platforms could be depicted metaphorically, using baseball imagery and terms. Lincoln was a well-documented fan and player of baseball.

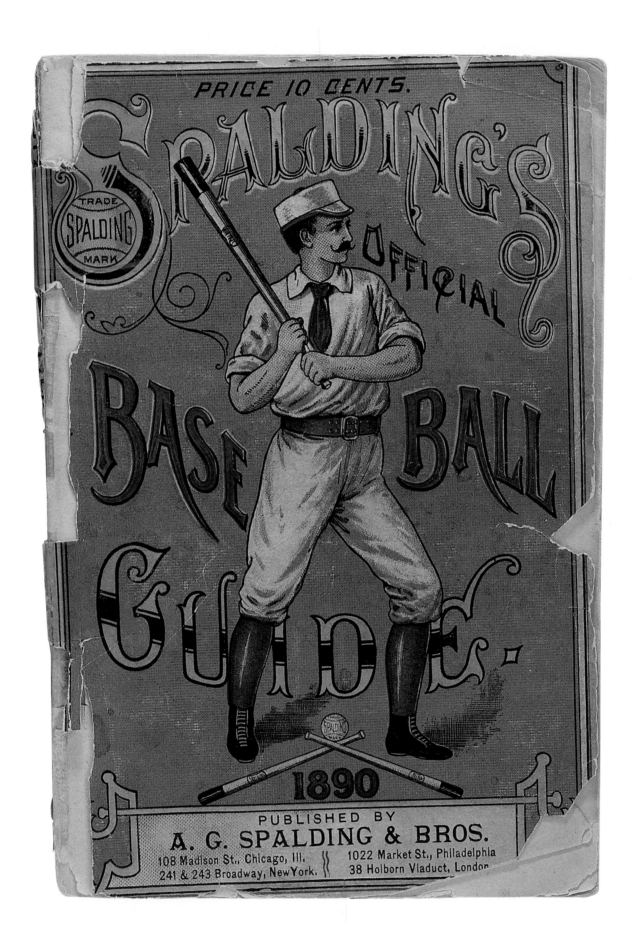

PRICE 10 CENTS.

SPALDING'S OFFICIAL
BASE BALL GUIDE

TRADE SPALDING MARK

1890

PUBLISHED BY
A. G. SPALDING & BROS.
108 Madison St., Chicago, Ill. 1022 Market St., Philadelphia
241 & 243 Broadway, New York. 38 Holborn Viaduct, London

popular spectator sport, became a symbol of reunification. In 1868, an estimated 200,000 people attended baseball games. The following year the Cincinnati Red Stockings, the first professional team, toured the nation, attracting 179,000 fans and capping their travels with a western excursion aboard the recently completed transcontinental railroad. The primary ambassadors of the national pastime traveling on the foremost symbol of a new America captured the essence of the modern era.

By the time the National League emerged in 1876, many of the rituals of the game had already become commonplace. Thanks to the pioneering efforts of sportswriter Henry Chadwick, fans could follow the daily progress of their favorite teams and players through intricate box scores concisely summarizing the previous day's play and ingenious statistics, like batting average, designed to measure each athlete's prowess and productivity. Fans could purchase scorecards that allowed them to keep a meticulous record of each player's performance as they watched the game.

As baseball expanded its influence in the late 19th century and became the nation's most popular participatory and spectator sport, the game also materialized in a wide variety of cultural venues. The Philadelphia Centennial Exposition of 1876 displayed artist Thomas Eakins's watercolor, "Baseball Players Practicing," in its celebratory exhibition. Cards depicting famous baseball players began to appear as premiums accompanying packs of cigarettes in the 1880s. Old Judge Cigarettes produced a set of large cabinet cards, with players posed in studio photographs for display in tobacco shops—a forerunner of the more widespread use of athletes in advertising. Table and card games brought baseball into the parlor. Lawton's Patent Base Ball Playing Cards, introduced in 1884, used a 36-card deck to simulate the play on the field. Four years later, J.H. Bowen created a mechanical bank, equipped with a pitcher who flipped a coin placed in his hand into the catcher's chest, where it would drop into a box, as an idle batter stood by. Bowen's

original model, dubbed "The Darktown Battery," featured African Americans as the athletes. Despite, or perhaps because of, its inherent racism, this version and its many successors became popular keepsakes.

Baseball often came to embody and encapsulate each new wave of American progress. Mark Twain called it "the very symbol, the outward and visible expression of the drive and push and rush and struggle of the raging, tearing, booming 19th century." One of the first demonstrations of the efficacy of Thomas Edison's electric lightbulb in 1880 involved a baseball game played at night at a seaside resort in Massachusetts. Electricity also allowed fans to experience games nearly instantaneously. Beginning in 1894, the Compton Electrical System appeared in many cities. The new system took play-by-play results from the telegraph and relayed them to a 10-by-10-foot display depicting a baseball diamond. The opposing lineups were listed on either side of the diamond, and lights indicated the batter, the count, and the base runners. During World Series contests in the early 20th century, these scoreboards attracted tens of thousands of spectators in arenas, central urban intersections, and town squares throughout the nation.

Edison, among the nation's foremost inventors, also turned to baseball as the focus of one of his first moving pictures, *The Ball Game*, in 1898. Indeed, as the movies matured, baseball, both on and off the field, often provided a prime subject. The adventures of fans sneaking off from work to see a ball game figured prominently in a pair of early two-reel films: *How the Office Boy Saw the Ball Game* (1906) and *How Jones Saw the Baseball Game* (1907). Efforts by gamblers to bribe an honest player provided the basis for *His Last Game* (1909).

Aspiring newsreel companies also quickly latched on to baseball action as a source for appealing footage. In 1908, the California-based Essanay Company filmed the World Series, editing the highlights into brief films and distributing them to local theaters. The first true newsreels

◆ *Spalding's Official Base Ball Guide*, 1890. Spalding's guide, and similar annuals, began to appear in the 1860s, and are still published today. Reflecting baseball's extraordinary interest in statistical data, the guides, several hundred pages in length, contain individual player statistics for hundreds of professional major and minor league teams.

surfaced in American theaters in 1911. By the end of the teens, sports events, especially baseball, accounted for as much as 25 percent of all newsreel footage.

In 1915, the same year that D. W. Griffith popularized the feature-length film with *Birth of a Nation,* the first full-fledged baseball movie, *Right Off the Bat,* made its debut. *Right Off the Bat* starred "Turkey" Mike Donlin, a former National League standout playing himself in a narrative loosely based on his career. Giants manager John McGraw had a cameo role. The success of the movie led other ballplayers to try acting. Ty Cobb headlined *Somewhere in Georgia* (1916), portraying a bank clerk with baseball skills who wins his way onto the Detroit Tigers. Babe Ruth portrayed a country bumpkin who whittled his own bats in *Headin' Home* (1920). "There is no reason for John Barrymore or any other thespian to become agitated about the matter," commented one critic about the Babe's acting skills.

In the 1920s, baseball became a major vehicle for introducing radio to the American public. Pittsburgh radio station KDKA went on the air in November 1920. In its first summer on the air, the station's innovative broadcaster, Harold Arlin, covered a Pirates game live from Forbes Field. That fall, WJZ in Newark, New Jersey, stationed a correspondent at the World Series in New York. The reporter telephoned play-by-play to an announcer in Newark, who recreated the game over the air, inaugurating a venerable radio tradition. In 1922, Westinghouse used the prospect of listening to the World Series as a lure for potential radio customers, advertising the opportunity for New York fans to hear sportswriter Grantland Rice broadcast the games from the Polo Grounds. Stores that sold radios erected loudspeakers for the occasion, attracting crowds of the devoted and the curious. The result was what the *New York Herald Tribune* called "the greatest audience ever assembled to listen to one man."

The following year, announcer Graham McNamee took over at the microphone. His dramatic renderings drove home the power and romance of radio. McNamee

became the voice of the World Series for the remainder of the decade, offering millions of people throughout the nation their first radio experience. McNamee brought "something vital into the living room," recalled future announcer Red Barber. McNamee would pause to let his listeners hear the cheers and jeers of the crowd, and, as one sportswriter noted, "these little inserts of realism transplanted the atmosphere of the diamond to every nook and corner of the United States."

As early as 1924, individual teams and local radio stations began to experiment with regular game programming. In the late 1920s, five Chicago stations carried the Cubs home games. Teams in St. Louis, Cleveland, Detroit, Cincinnati, and Boston also offered regular transmissions. A new type of celebrity, the baseball broadcaster, took hold in many cities. Fred Hoey in Boston became, in the words of a fan, "a regional giant. Fred was Boston baseball." In Detroit, Ty Tyson "made you feel like (Charlie) Gehringer, (Mickey) Cochrane and (Goose) Goslin were right next door."

Many feared that the availability of games in one's own home would keep fans from attending the games. More astute observers, however, recognized that radio would broaden the audience for baseball. The 1920s combination of regional radio, improved roads, and automobiles, noted John Sheridan, had expanded the radius of a team's market from five miles to 200 miles, bringing more fans to the ballpark. In midwestern towns, crowds would gather around loudspeakers to follow the progress of games played in nearby cities. In the 1930s and 1940s, national radio networks sprang up to carry games across the country. The Mutual Broadcasting System presented a *Game of the Day* every afternoon except Sundays. Gordon McClendon's Liberty Broadcasting Network flourished in the south and southwest, with a game of the day, game of the night, and Sunday games as well.

Baseball shared the same symbiotic relationship with early television. Television manufacturers offered "World

Series specials" to entice people to purchase sets. People who could not afford televisions could watch through the windows of appliance stores or in bars and restaurants. As early as 1947, an estimated 3,000 New York City bars had installed televisions, "the best thing to happen to the neighborhood bar since the free lunch." In 1951, live telecasts became available in most parts of the nation. Many people experienced their first glimpse of television watching the Yankees and Giants in the 1951 World Series, sending television sales soaring.

Once again, many feared that the new technology would decimate baseball attendance. "Radio stimulates interest. Television satisfies it," pronounced Brooklyn Dodger executive Branch Rickey. "TV Must Go Or Baseball Will," warned an article in *Baseball Magazine*. Television, by offering a broader variety of sporting events, did ultimately weaken the unique bond that had long existed between baseball and the American public. But, in the long run, it inevitably enhanced the baseball experience, giving people the opportunity to see more games, in more intimate detail, than ever before.

In more recent times, baseball helped to usher in the computer age. Few bodies of data offered the opportunities to demonstrate the capabilities of the computer as readily as did the universe of baseball statistics amassed since the age of Henry Chadwick. In 1959, researchers perfecting mammoth mainframe computers constructed models of play based on thousands of theoretical games. General Electric showed off a new computer model by having it analyze American League batting. In 1969, the *Macmillan Baseball Encyclopedia*, a landmark computer compilation of baseball history, also became the first book typeset entirely by computer.

In the 1980s and 1990s, millions of Americans took advantage of personal computers and the Internet to revolutionize the use of baseball statistics, manage Rotisserie leagues, and follow the progress of major and minor league teams in minute detail. Online gamecasts, instantaneously

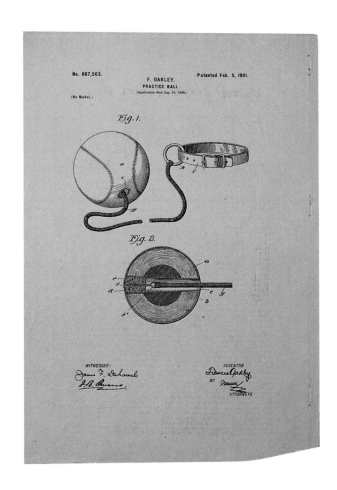

displaying a diamond and lineups, recreated the electronic scoreboards of an earlier age, though now the scoreboards materialized in one's home, rather than a public square, and offered a variety of statistics far beyond anything that Chadwick might have envisioned.

The technological innovations of each era influenced the manner in which Americans experienced baseball. Similarly, baseball mirrored the broader political, social, and economic changes of American history. The emerging professional game quickly became a beacon of opportunity for players and entrepreneurs alike. The formation of the National League and rival baseball alliances in the late 19th century reflected the rationalizing impulses of American businesses in the industrial era. Like other enterprises, baseball faced labor difficulties, resulting in the formation of a

◆ U.S. patent drawing for the "practice ball." Attached to the bat by means of a collar and elastic cord, the ball could be hit repeatedly without having to chase it.

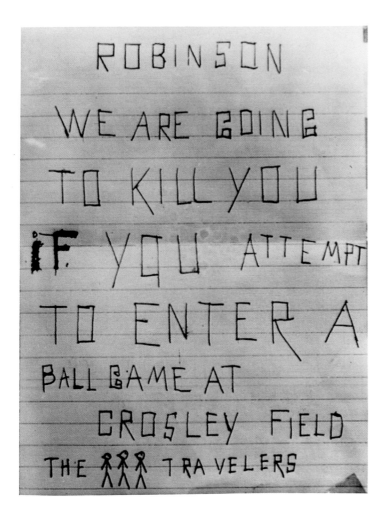

ROBINSON

WE ARE GOING

TO KILL YOU

IF YOU ATTEMPT

TO ENTER A

BALL GAME AT

CROSLEY FIELD

THE TRAVELERS

Americans, but from the earliest years of play, most leagues and associations excluded African Americans. By the late 19th century, parallel baseball worlds, separate but unequal, had crystallized. Jim Crow in baseball, however, more than in any other endeavor, visibly challenged the tenets of segregation and discrimination. Negro league superstars like Satchel Paige and Josh Gibson clearly did not lack the talent to compete against whites. Nor did interracial contests regularly played on the boundaries of organized baseball—on the barnstorming circuit, in the winter leagues, in semi-professional tournaments—support the notion that interracial play meant interracial conflict.

When the turmoil of the Depression and World War II began to challenge the prevailing racial consensus, baseball stepped to the forefront as a vehicle of change. In 1945, Brooklyn Dodgers president Branch Rickey recruited Jackie Robinson to defy the color line. Robinson's dramatic and convincing triumph produced a modern American legend and a blueprint for social revolution. The success of African Americans in baseball offered one of the nation's most compelling arguments for integration, making it a significant precursor of the civil rights triumphs to follow.

Robinson's achievement had such a profound impact precisely because baseball had such an intense hold on the American psyche. As Thomas Wolfe has written, baseball is "not merely 'the great national game,' but really the part of the whole weather of our lives, of the thing that is our own, of the whole fabric, the million memories of America."

No other common activity resonated so regularly and intensely in American life as the national pastime. Played virtually every day over a six-month span and tracked religiously in the mass media, baseball offered its partisans a steady diet of entertainment, drama, and controversy. Americans routinely interspersed their language with baseball metaphors. Unexpected occurrences came from "out of left field." People confounded others by "throwing them a curve." Prodigious feats were described as "Ruthian."

National Brotherhood of Base Ball Players and a short-lived Players' League in 1890. Baseball developed its own peculiar forms of exploitation—the reserve clause and, later, the farm system—to regulate its labor supply. For many years a relatively limited regional cartel based in the northeast and midwest, Major League Baseball in the post-World War II era followed the nation's population and business trends. Transplanting existing franchises and creating new ones in California and the west, the south and southwest, and expanding into Canada, this produced a truly national and international pastime.

Baseball also replicated the nation's racial practices. The game held a broad appeal for both white and black

◆ An example of the hate mail and death threats received by Jackie Robinson throughout his career. This letter was received on May 22, 1951, as the Dodgers traveled to Cincinnati for a doubleheader. Robinson played anyway, responding to the letter with a home run in the first game.

In a "fireside chat" broadcast on the radio in May 1933, President Franklin D. Roosevelt presented his hopes for his new administration to the American people in a language they would readily understand. "I have no expectation of making a hit every time I come to bat," explained Roosevelt. "What I seek is the highest possible batting average, not only for myself, but for my team." In the last days of his life, Roosevelt confessed: "I feel like a baseball team going into the ninth inning with only eight men left to play."

A host of rituals that tied baseball to the American way also accumulated over the decades. Annual Opening Day festivities were celebrated as rites of spring in major and minor league cities across the land, laden with pomp, circumstance, and panache. Season openers brought forth brass bands, parades, and aerial displays. Public officials threw out the first pitch. Some cities declared holidays for municipal employees and schoolchildren. The national anthem, sung before each game, became ineradicably entwined with the national pastime. The All-Star Game and World Series became engrained American spectacles, with red, white, and blue bunting draped along the field boxes in prominent view.

The development of a rich mythology also linked baseball to American patriotism. A blue-ribbon panel of statesmen, baseball leaders, and military veterans, determined to demonstrate the powers of American ingenuity, decreed in 1908 that baseball had not evolved from earlier games like rounders, but that it had sprung, Athena-like, from the fertile mind of Gen. Abner Doubleday, in Cooperstown, New York, in 1839. The pairing of baseball and Doubleday, a Civil War hero, tied America's national game to its most sacrosanct conflict, making baseball's version of the immaculate conception a part of the nation's folklore. That Doubleday had not been present in Cooperstown at the time and had never mentioned his inspiration did not deter the mythmakers from their appointed round. Nor did it prevent the location of a shrine to the game, the National Baseball Hall of Fame and Museum in Cooperstown, the site of Doubleday's alleged invention.

Though its origins were shrouded in the mists of myth, the National Baseball Hall of Fame and Museum has aspired to serve two central purposes: To honor those who best played the game and contributed to its development and to accurately record the history of baseball through the collection and display of artifacts, documents, and memorabilia. Based on the Hall of Fame of Great Americans at New York University (which has long since lost its luster), the baseball Valhalla became the model for Halls of Fame commemorating not just sports figures, but a wide variety of American endeavors. Yet, it is indicative of baseball's enduring hold on the American imagination that no other national honor inspires the debate and controversy that adhere to enshrinement in Cooperstown. Committees form to advance the cause of long-dead players and Negro league veterans, and debates rage over the results of each election. Thousands of people make an annual odyssey to upstate New York to celebrate the induction of new members.

For many, a journey to remote Cooperstown has become a treasured, ardently anticipated pilgrimage. The plaques honoring the game's greatest athletes; the bats, gloves, and balls used at fabled moments in baseball history; and the variegated assortment of odd relics and mementos that mark the intersection of the sport with American life and culture hold an overpowering allure for those who cherish the game. The National Baseball Hall of Fame and Museum encompasses America's intense relationship with baseball—the patriotism, freedom, rituals, opportunities, popular culture, innovations, and mythology. It reminds us at every turn of why, across the broad historic sweep of American experience, baseball maintains its hold on our imagination and reality and remains, above all other activities and institutions, our enduring national pastime.

GIANTS VS. WHITE SOX

WORLDS SERIES 1917

NEW YORK CHICAGO

Brush Stadium
Polo Grounds

© UNDERWOOD & UNDERWOOD

PRESIDENT WILSON THROWING OUT BALL AT THE OPENING OF THE
AMERICAN LEAGUE SEASON AT WASHINGTON.

A BIG ENOUGH BOY TO ENJOY THE NATIONAL
GAME —AND— A MAN BIG ENOUGH TO GUIDE
OUR COUNTRY THROUGH ITS GREATEST CRISIS.

Ironically, baseball became our "national pastime" before the game was played nationally and at the moment in history when Americans, on the eve of the Civil War, struggled to define themselves as a nation. In 1856, when the *Spirit of the Times* and *New York Clipper* began to refer to baseball as the "national game" and the *New York Mercury* coined the phrase, "The National Pastime," the Knickerbocker version of the

OUR NATIONAL SPIRIT

game, soon to seize the country's imagination, was played primarily in New York City and Brooklyn. In 1857, the new National Association of Base Ball Players consisted entirely of teams from those two cities. ◆ As late as 1859, a writer in *Harper's Weekly* commented, "We see no evidence that [baseball] is so generally practiced by our people as to be fairly called a popular American game." Yet, even at this time, baseball was making inroads into the New England, mid-Atlantic, and midwestern states and had spread as far as New Orleans and San Francisco. Sportswriters like Henry Chadwick advocated the creation of a national sport with uniform rules and standards that would distinguish American pastimes from those of England and Europe. By 1869, when the Cincinnati Red Stockings toured the United States, the prophecy of a "national pastime" had largely been fulfilled. ◆ Baseball's position as an American game above all others had already achieved a presidential stamp. In August 1865, just months after the Civil War had ended, Andrew Johnson welcomed the Brooklyn Atlantics and sportswriter Chadwick to the White House. Chadwick urged President Johnson to attend a baseball match, "as such countenance of the game would give a national stamp to it." One year later Johnson complied, watching the New York Mutuals defeat the Washington Nationals. This began a long history of presidential involvement with baseball.

Among those who greeted the Red Stockings in 1869 was President Ulysses S. Grant, who complimented the team on its play. Chester A. Arthur welcomed a group of athletes to the White House at the start of the 1883 season, noting, "Good ballplayers make good citizens." Grover Cleveland entertained Cap Anson and other players in 1886 and met with Albert Spalding and his Chicago White Sox to offer his support before they embarked on their world tour in 1888. Theodore Roosevelt, according to his daughter Alice, saw baseball as a game for "mollycoddles," preferring more violent sports like football, lacrosse, and boxing. As president, however, Roosevelt nonetheless accepted a lifetime gold pass to all professional baseball games in 1907, symbolically linking the Presidency to the national game.

William Howard Taft, a former semiprofessional pitcher who followed Roosevelt into office, was far more of a baseball enthusiast. In 1910, Taft authored a "blessing" for the game, calling it a "clean, straight game" and a "healthy amusement" that he himself enjoyed. Taft often attended Washington Senators games. On Opening Day in 1910, new Senators owner Clark Griffith unexpectedly handed Taft the ball and asked him to throw out the first pitch. The presidential first pitch became an annual tradition, a ritual that, as Harold Seymour explains, "in effect made [the president] the promoter of Organized Baseball and gives the appearance of conferring upon it the government stamp of approval." No other American sport can claim this distinction.

Baseball also has a special relationship with "The Star-Spangled Banner." The popularity and familiarity of the hard-to-sing song derives in no small part from the tradition of singing it at baseball games, a ritual that began even before the piece was named the national anthem in 1931. Although reports exist of "The Star-Spangled Banner" being played on earlier occasions, the modern practice dates from the patriotic fervor of World War I. During the first game of the 1918 World Series in Chicago, the band unexpectedly struck up the tune during the seventh-inning stretch. People spontaneously began singing. Cubs management ordered the song played again for the next two games. Not to be outdone, when the Series moved to Boston, the Red Sox offered a rendition before the game started.

During the 1920s and 1930s the singing of "The Star-Spangled Banner" was usually reserved for special events like Opening Days, holidays, All-Star games, and the World Series, when a live band would be present for the festivities. With the introduction of public address systems and the outbreak of World War II, however, the singing of the national anthem became the rule before each game, firmly tying baseball to the American spirit, and infusing it with an inherent sense of patriotism.

Attempts to inspire American fervor for baseball in other venues have met with a mixed response. In 1874, British-born George Wright, a former cricket player, took his Boston Red Stockings to England to "exhibit to the old nation the new nation's adopted game." After watching the American sport, The *London Observer* predicted "few of the youth of Great Britain will desert cricket with its dignity, manliness, and system for a rushing, helter-skelter game." Albert Spalding and his Chicago White Stockings embarked on a more ambitious tour in 1888-1889. The National League club and a rival team of all-stars traveled to Australia, Ceylon, Egypt, Italy, France, and the British Isles. Only in Australia did the game evoke any enthusiasm. In England, George Bernard Shaw would dismiss it as an "American tragedy."

Closer to home, however, baseball had greater success in planting its roots in foreign soil. Canadians began playing the "New York game" in 1860. Teams from Ontario appeared in the minor league International Association in

◆ PAGE 26: World Series program, 1917. With the nation embroiled in World War I, its "greatest crisis," the image of President Woodrow Wilson attending a ball game reassured the nation that our way of life and our national game would continue.

1877, and the Toronto franchise soon became a fixture in the International League. James "Tip" O'Neill, one of the great American Association stars of the 1880s, was born in Ontario. By the early 20th century, several Canadian leagues had sprung up, and several teams played in transnational leagues with teams in both Canada and the United States.

Cubans, who began playing the game in the 1860s, were introduced to it first by American sailors and then, more significantly, by native-born Cubans who attended college in the United States and brought the game back to the island. Cuban nationalists, seeking to win independence from Spain, seized on baseball as a symbol of democracy and freedom, and baseball became part of the national identity that distinguished Cubans from Spaniards. Spanish officials, fearing the liberalizing effects of the game, banned baseball on some parts of the island, but the game's popularity continued to grow exponentially.

Cubans became the apostles who spread the gospel of baseball to other parts of the Caribbean. Nationalist refugees from the Ten Years War (1868-1878) against Spain brought the game to the Dominican Republic, where it would become a national obsession. Cubans also helped spread baseball to Puerto Rico, Venezuela, and Mexico. When American troops occupied Caribbean countries, beginning in 1898, they often found well-established baseball leagues and highly talented players. The often prolonged presence of the Marines encouraged further development of the game.

In the early 20th century, players from Cuba had begun to appear on major league and Negro league teams. U.S.-born players, both black and white, began to appear in Caribbean winter leagues and on major league squads touring the region. The color line barred all but the lightest-skinned Latinos from the major leagues, but its demise in the 1940s created a more permeable border,

COMMUNICATION.

I was last Saturday much pleased in witnessing a company of active young men playing the manly and athletic game of "base ball" at the Retreat in Broadway (Jones') I am informed they are an organized association, and that a very interesting game will be played on Saturday next at the above place, to commence at half past 3 o'clock, P. M. Any person fond of witnessing this game may avail himself of seeing it played with consummate skill and wonderful dexterity. It is surprising, and to be regretted that the young men of our city do not engage more in this manual sport; it is innocent amusement, and healthy exercise, attended with but little expense, and has no demoralizing tendency.

A SPECTATOR.

◆ The earliest known American reference to a game of "base ball," this letter appeared in *National Advocate*, a New York newspaper, in 1823, sixteen years before the game was reportedly invented by Abner Doubleday at Cooperstown, New York.

Opening Day at Weeghman Park (later to be known as Wrigley Field), Chicago, 1914. The tradition of watching for free from the rooftops across the street apparently dates from day one.

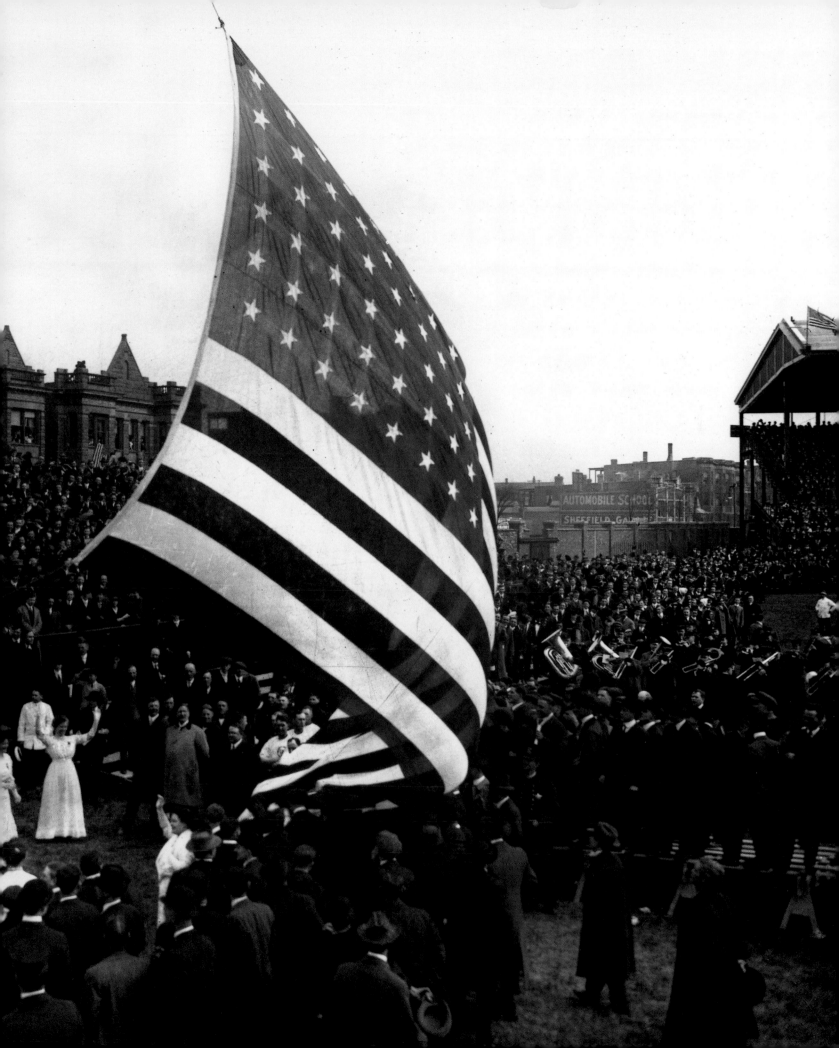

allowing the best players in the region to compete against each other at the highest levels of the game. Baseball began to take on elements of national pride, though Fidel Castro's 1959 revolution stanched the tide of Cuban players to the United States. Not until the 1990s, when several players defected from the island, did Cubans again reassert their presence in the major leagues. By this time players from the Dominican Republic, Puerto Rico, Mexico, Venezuela, and a host of small Caribbean islands constituted a substantial proportion of major league players.

More unexpectedly, baseball also reigns supreme in Japan, thousands of miles from its American homeland. Most credit Horace Wilson, an American professor at the Kansei School (later the University of Tokyo), with introducing the sport in 1873. Four years later, a Japanese nobleman, Baron Hiroshi Hiraoka, brought a translation of baseball rules back from the United States, and in 1878 American college teams began to tour the nation. Japanese college students flocked to the game, which received a great boost when a Japanese nine beat a team composed of American residents in 1896. The game began to take on elements of national pride for the Japanese, as their teams began to compete more evenly with American collegiate squads.

Professional All-Star teams from the United States began to arrive in Japan in 1908. A Negro league team toured in 1927. The most famous and fateful visit occurred in 1934, when Babe Ruth led a group of All-Stars to Japan. The major leaguers easily defeated the native ballplayers in most games, but 18-year-old high school pitcher Eliji Sawamura struck out Charlie Gehringer, Ruth, Lou Gehrig, and Jimmie Foxx in succession and held the Americans to only one run, only to lose 1-0. Two years later, in 1936, the Japanese formed a professional league, with Sawamura, a national hero, starring for the Tokyo Giants.

Japanese imperial aspirations spread baseball to other parts of Asia. Taiwan became a Japanese colony in 1895, bringing thousands of Japanese to the island. Initially, the sport was confined to the Japanese community, but in the 1920s the Nengkao Team, a squad from Taiwan's indigenous Ami tribe caused a sensation when they advanced to the finals of a tournament on mainland Japan.

Ethnic Chinese on Taiwan also took up the game in the 1920s; several played in the Japanese professional leagues. Japan also introduced the game to Korea, another colonial possession. In the years after World War II, the game flourished in all three countries. Triumphs in the United States brought a particular element of pride. In 1969 a team from Taiwan became national heroes by winning the Little League World Series, and the annual tournament has become a national festivity in Taiwan. Koreans have avidly followed the progress of pitcher Chan Ho Park, and the Japanese revel in the success of Hideo Nomo, Ichiro Suzuki, and other players in the American major leagues. Australia has also begun to send a stream of athletes to the United States.

The major leagues have responded by scheduling special games in Mexico, Japan, and Puerto Rico. The Baltimore Orioles played an exhibition game in Cuba, providing a rare thaw in U.S.-Cuban relations. True international competition occurs in the Pan-American and Olympic Games and other tournaments.

When Spalding and his players had returned from their world tour in 1889, a Philadelphia journalist toasted them for their "missionary work" in introducing America's game to other nations. Baseball, he boasted, with a touch of hyperbole, had made "the world better for its presence."

More than one hundred years later no one can question the validity of that vision.

—Jules Tygiel

◆ Uncle Sam makes a pitch for baseball as "our national game" on the cover of *Baseball Magazine*, July 1908, just in time for "our national holiday," Independence Day.

Our National Game **Our National Holiday**

THE BASEBALL MAGAZINE

JULY
1908

**Shall We
Have
Sunday
Baseball?**

—Wm. F. Kirk

PRICE
15 CENTS
$1.50
A YEAR

Practical, Invigorating Articles and Stories by Henry Chadwick, Richard Carle, Fred Tenney, T. H. Murnane, J. C. Morse, Coach Glaze of Dartmouth College, and others.

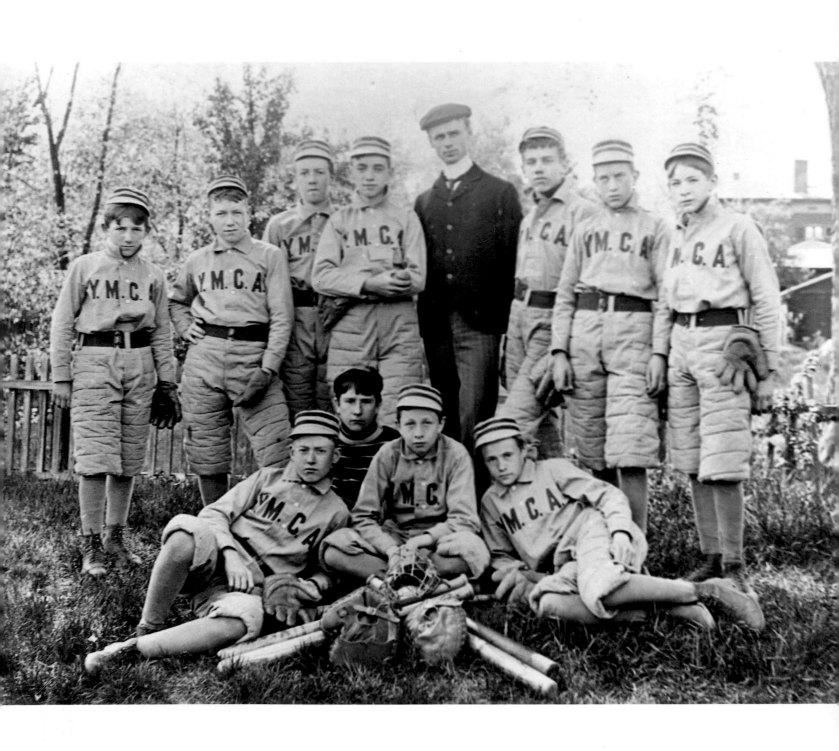

God's Country and Mine

THE GODS DECREE A HEAVYWEIGHT MATCH only once in a while and a national election only every four years, but there is a World Series with every revolution of the earth around the sun. And in between, what varied pleasure long drawn out!

Whoever wants to know the heart and mind of America had better learn baseball, the rules and realities of the game—and do it by watching first some high school or small-town teams. The big league games are too fast for the beginner and the newspapers don't help. To read them with profit you have to know a language that comes easy only after philosophy has taught you to judge practice. Here is scholarship that takes effort on the part of the outsider, but it is so bred into the native that it never becomes a dreary round of technicalities. The wonderful purging of the passions that we all experienced in the fall of '51, the despair groaned out over the fate of the Dodgers, from whom the league pennant was snatched at the last minute, give us some idea of what Greek tragedy was like. Baseball is Greek in being national, heroic, and broken up in the rivalries of city-states. How sad that Europe knows nothing like it! Its Olympics generate anger, not unity, and its interstate politics follow no rules that a people can grasp. At least Americans understand baseball, the true realm of clear ideas.

That baseball fitly expresses the powers of the nation's mind and body is a merit separate from the glory of being the most active, agile, varied, articulate, and brainy of all group games. It is of and for our century. Tennis belongs to the individualistic past—a hero, or at most a pair of friends or lovers, against the world. The idea of baseball is a team, an outfit, a section, a gang, a union, a cell, a commando squad—in short, a twentieth-century setup of opposite numbers.

Baseball takes its mystic nine and scatters them wide. A kind of individualism thereby returns, but it is limited—eternal vigilance is the price of victory. Just because they're far apart, the outfield can't dream or play she-loves-me-not with daisies. The infield is like a steel net held in the hands of the catcher. He is the psychologist and historian for the staff—or else his signals will give the opposition hits. The value of his headpiece is shown by the ironmongery worn to protect it. The pitcher, on the other hand, is the wayward man of genius, whom others will direct. They will expect nothing from him but virtuosity. He is surrounded no doubt by mere talent, unless one excepts that transplanted acrobat, the shortstop. What a brilliant invention is his role despite its exposure to ludicrous lapses! One man to each base, and then the free lance, the trouble shooter, the movable feast for the eyes, whose motion animates the whole foreground.

◆ The famous quotation by Jacques Barzun, which leads off the second paragraph, above, is often cited without the reference to small-town teams. The YMCA team at left epitomizes the essence of baseball as an American game of vigor, values, and grass-roots local pride.

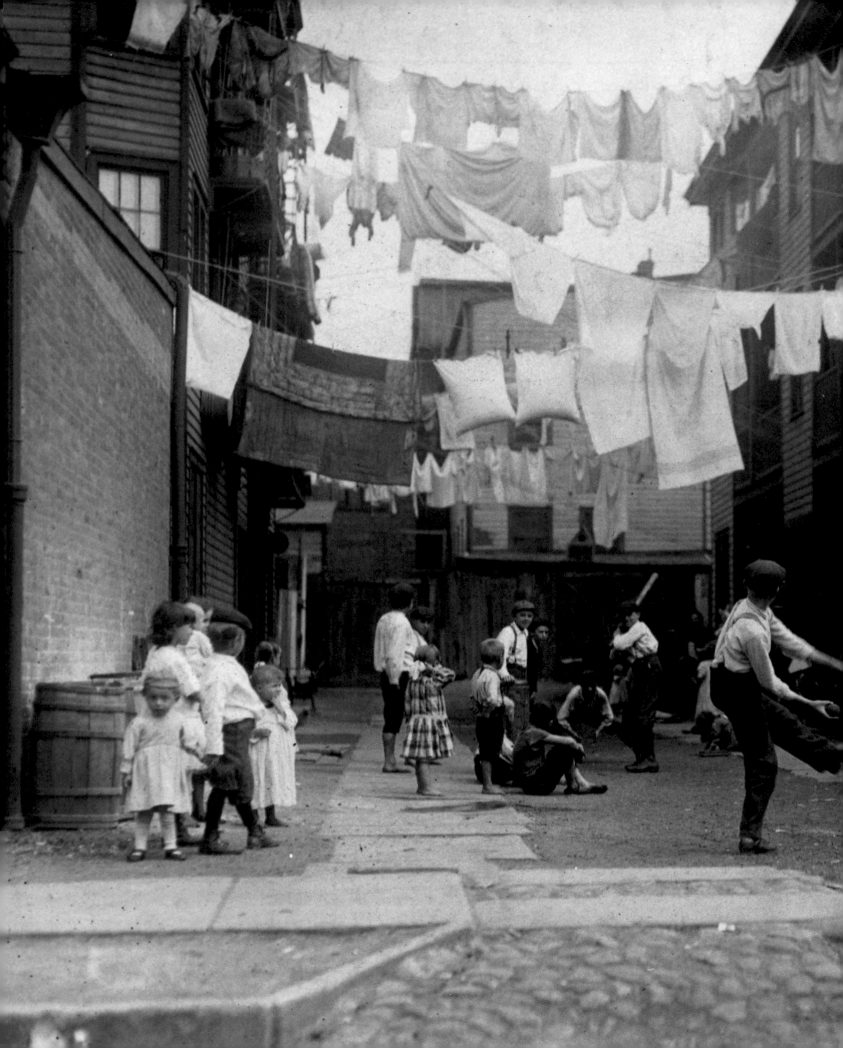

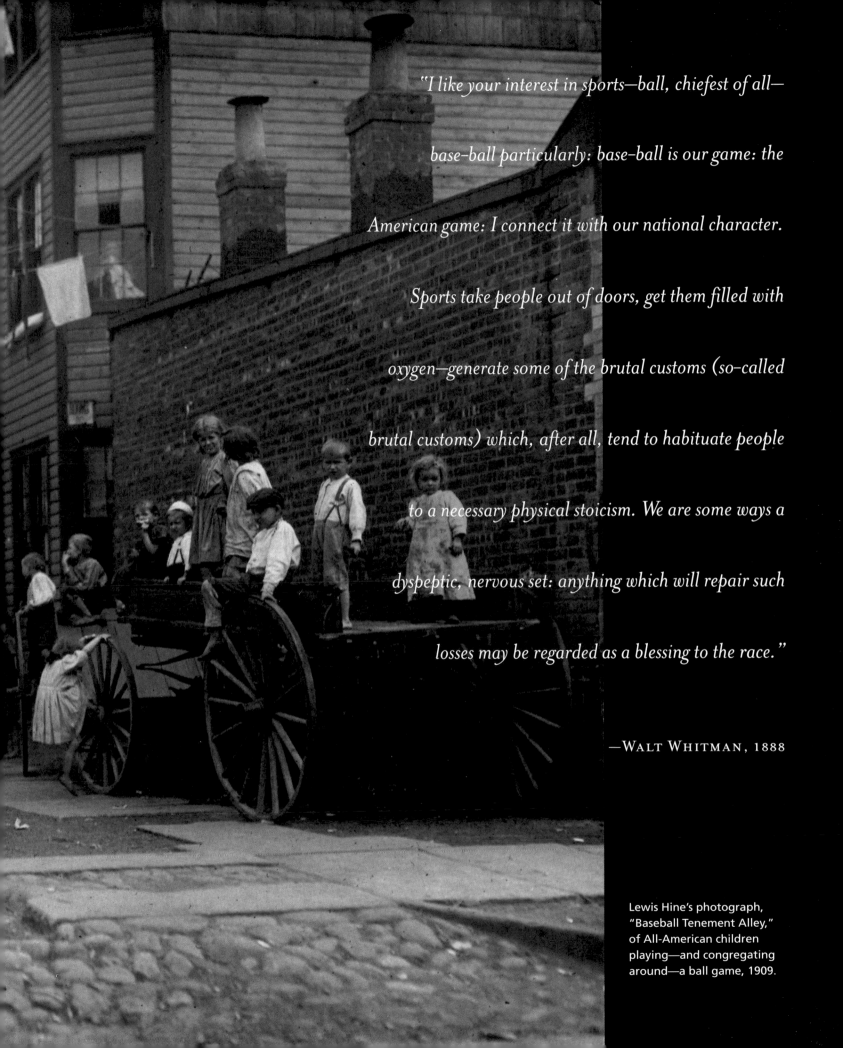

"I like your interest in sports—ball, chiefest of all—

base-ball particularly: base-ball is our game: the

American game: I connect it with our national character.

Sports take people out of doors, get them filled with

oxygen—generate some of the brutal customs (so-called

brutal customs) which, after all, tend to habituate people

to a necessary physical stoicism. We are some ways a

dyspeptic, nervous set: anything which will repair such

losses may be regarded as a blessing to the race."

—WALT WHITMAN, 1888

Lewis Hine's photograph,
"Baseball Tenement Alley,"
of All-American children
playing—and congregating
around—a ball game, 1909.

In 1913, as America claimed an ever larger place on the world stage, the All-Americans and Chicago White Sox traveled abroad to spread the gospel of baseball and "transplant America's game"—neither the first nor last such voyage. The text below comes from the 1913-1914 tour's promotional program, shown at right.

1913

To the Patriotic Lovers of America's Game

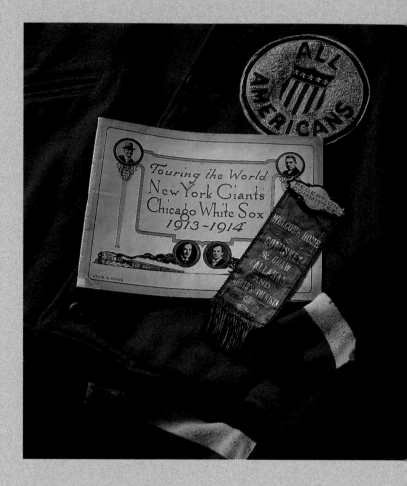

THE OBJECT AND AIM OF THE TOUR of the world by America's two great baseball teams from its two largest cities, namely, New York and Chicago, has a twofold object.

One is to exhibit America's National Game in foreign lands—by the game's greatest exponents, namely, the New York Giants, champions of the National League, and the Chicago White Sox, members of the American League.

But the higher and greater object of this trip of the world is to try and transplant America's game in athletic and sport-loving countries—who desire to adopt some game that has both the athletic and mental attributes—conducive to the physical development of the youth of their country.

Baseball has all those qualities, which has led to its great popularity in America. This circuit of the globe by those two major league clubs, led by the game's two greatest leaders and sportsmen, namely, Chas. Comiskey, president of the Chicago White Sox, and John McGraw, leader of the New York Giants, is a tour that is not a money-seeking affair. The outlay of this circle of the world by the two ball teams and their necessary attendants will exceed by thousands of dollars any revenue collected at the gates for the exhibition of games.

The foreign countries that will be visited by those two great major league clubs are Japan, China, Philippines, Australia, India, Egypt, Italy, Austria, Belgium, France, Germany, Ireland, England and Scotland.

Some of those countries have already taken up America's National Game—and the request from some of

the officials of those foreign countries to see two great teams of the two major leagues has had a great deal to do in influencing Messrs. Comiskey and McGraw in making this present tour of the world.

As the foreign world in the last fifty years has been taking and adopting America's inventions for their commercial progress—beginning with steam as a motive power, then to telegraphy, sewing machines and farming implements—and last, but not least, the inventions of the electric wizard of the world, Tom Edison.

They now wish to see the machinery of America's National Game in action, and to decide whether they will adopt it for the physical development of their people and for the recreation of the indoor workmen of their nation. The National Game of America they will see by this great visit of America's two major league clubs—the White Sox of Chicago and the New York Giants of New York.

◆ ABOVE: Souvenir booklet and welcome-home ribbon from the 1913-1914 world tour. Catcher Moe Berg wore this jacket when he toured Japan in 1934. OPPOSITE: Over the off-season of 1888-89, Albert Spalding sponsored a world tour of his Chicago White Stockings and the New York Giants, with the aim to open foreign minds—and markets—to the glorious American game of baseball.

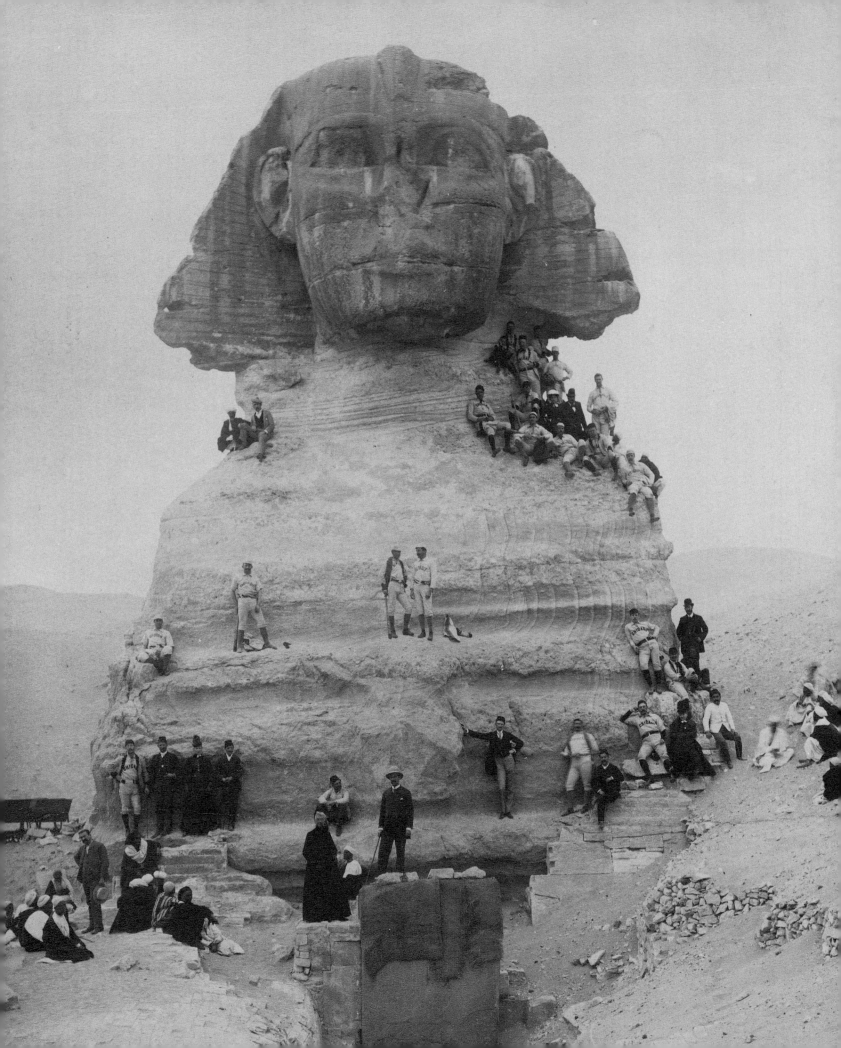

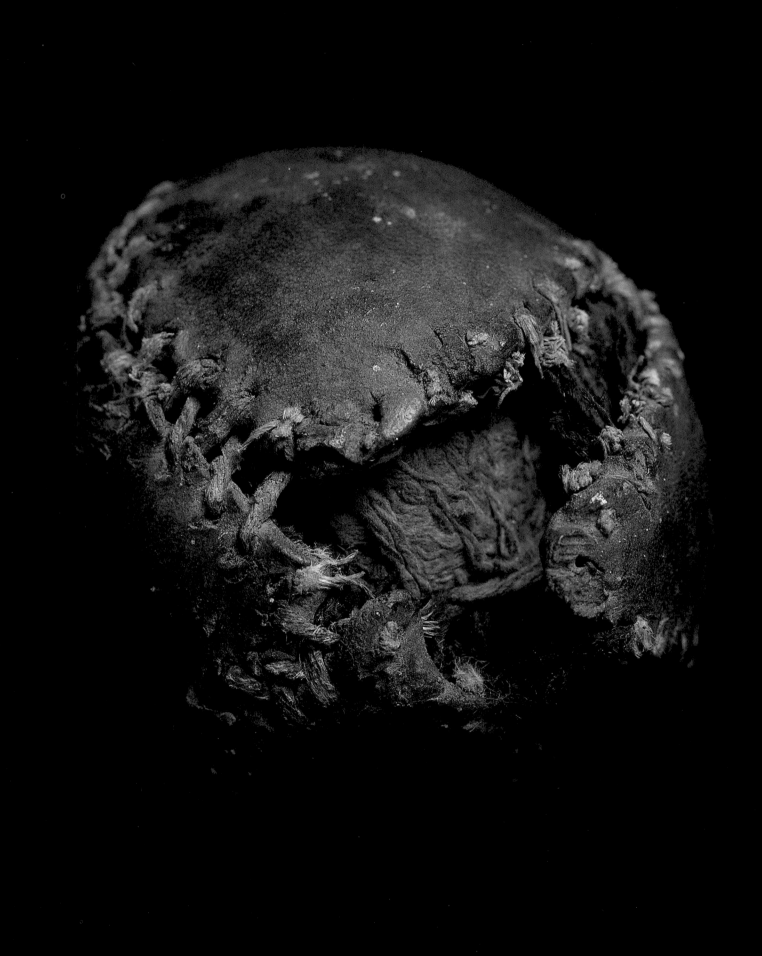

TOM SHIEBER AND TED SPENCER

Spalding's Commission

In 1908, a special commission assembled by sporting goods mogul A.G. Spalding reported its official findings on the origin of baseball: Abner Doubleday invented the game in Cooperstown, New York, in 1839.

The way the commission arrived at its pronouncement echoed William Randolph Hearst's "manufacturing" of the Spanish-American War a decade earlier. When illustrator Frederick Remington requested to leave a peaceful Havana, the powerful newspaper mogul reportedly replied, "Please remain. You furnish the pictures and I'll furnish the war."

Spalding, a former baseball star-turned-entrepreneur, whose sporting goods empire afforded him impressive power, successfully influenced the commission and the general public to believe a new American myth—that the Civil War hero Doubleday was the inventor of our national pastime. In light of the recent discovery of two scrapbooks containing correspondence used to create the final report for the commission's review, we now know the extent to which Spalding influenced the outcome of the famed investigation into baseball's beginnings.

Spalding first proposed a "commission to investigate the origin of base ball" in his *Spalding's Base Ball Guide* of 1905. Accompanying the call for the commission, Spalding presented two theories regarding baseball's prehistory. The first was the long-held belief that baseball had evolved from the English game of rounders. The second theory, championed by Spalding, traced the game back to the early American game of One Old Cat.

The most vocal proponent of the rounders theory was Henry Chadwick, a pioneering baseball reporter who had covered the sport for more than 50 years and was an employee of the Spalding conglomerate. Familiar with Chadwick's rounders theory, Spalding rejected the notion that America's national pastime descended from an English children's game. After all, Spalding owed much, if not all, of his American success story to baseball. It was baseball that gave Spalding his start as a professional pitcher. It was baseball that allowed him to found his sporting goods business. And it was baseball that propelled him and his business to their lofty status in the world of sport.

The second theory, the one that traced the game back to the early American game of One Old Cat, was much more palatable for Spalding. In fairness, the rival One Old Cat theory did have its merits—but what was most appealing to Spalding was that it linked baseball back to an American game, familiar to American men and one most assuredly distinct from any played by English schoolboys.

Spalding somehow felt that his patriotism and self-worth were threatened by the proposition that baseball had descended from rounders. He simply would not stand for it. As Spalding noted in a letter to longtime sportswriter Tim Murnane just prior to the call for the commission: "Our good old American game of base ball must have an American Dad." Clearly this was Spalding's goal. In order to fulfill it, he set about to create a seemingly impartial commission, made up of distinguished and reputable men, that

◆ The "Doubleday Baseball," found in a trunk in a Cooperstown attic in 1934, symbolizes the legendary first baseball game played in Cooperstown in 1839. The Mills Commission in 1908 stated that "the first scheme for playing it [baseball], according to the best evidence obtainable to date, was devised by Abner Doubleday at Cooperstown, New York."

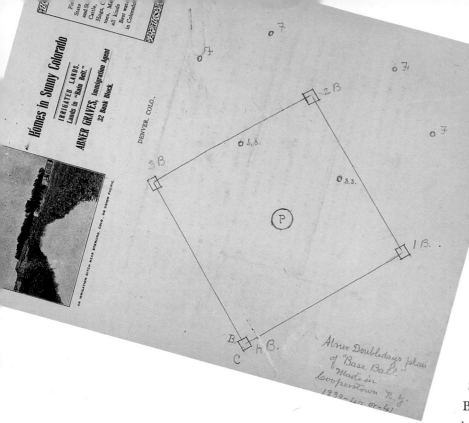

DENVER, COLO.

2 B

3 B

S.S.

P

1 B.

S.S.

7

7

7

7

B. h B.
 C

Abner Doubleday's plan of "Base Ball" Made in Cooperstown N. Y. 1839-40 or-41

would come to a predetermined conclusion: Baseball was a purely American sport.

In 1905, Spalding appointed James Sullivan, president of Spalding's own American Sports Publishing Company, to act as secretary of the commission and collect "all possible facts, proofs, interviews, etc., calculated to throw light on this subject." The groundwork for the study had already begun, however. The year before, Spalding had started researching the history of the game as he prepared for a talk at the YMCA Training School in Springfield, Massachusetts. It was at this institution that Dr. James Naismith had, in fact, earlier invented the game of basketball in 1891.

Spalding attacked the rounders theory, both in and out of the public eye. In an article in his 1905 baseball guide, he referred to rounders as "juvenile" and "asinine," making the comparison of baseball and rounders as distasteful as possible. He attempted to discredit Chadwick by implying the reporter was not impartial, and his ad hominem attack on Chadwick rings humorous today: "Mr. Chadwick, who, by the way, is of English birth, was probably rocked in a Rounders' cradle." In the same article, Spalding employed a skewed sense of logic, revealing a jingoistic fervor that

blinded his ability to reason: Spalding posited that, because it was unpatriotic to believe that baseball descended from an English schoolboys' game, it therefore could not have done so.

In preparing for his talk at Springfield, Spalding corresponded with various old-time players, reporters, and other baseball men, asking them for information on the origin of the game. In so doing, he identified individuals sympathetic to his anti-rounders cause.

In November of 1904, Spalding corresponded with sporting goods executive and former baseball star Al Reach regarding his recollections of early baseball. Spalding closed his letter: "I am determined to establish Base Ball as purely and entirely of American origin and that it has nothing whatever to do with the English juvenile game of Rounders." Reach wrote back a few days later: "I certainly hope you will have every success in doing and establishing what you are now trying to do." Months later, Reach was appointed to the commission. After his appointment, Reach wrote to a friend, encouraging him to correspond with Sullivan and "make up something as strong as you can proving the game is of Am[erican] origin."

In January of 1905, after receiving details of the One Old Cat theory, A.G. Mills, former president of the National League, wrote to Spalding: "On the whole, I am inclined to accept your version of the inception of the game." Months later, Mills was also appointed to the commission.

In November 1904, Spalding "tested the waters" in a letter written to John Lowell, a pioneering ballplayer who played a major role in establishing baseball in New England. In the letter, Spalding confided, "I am trying to convince myself and others that the American game of Base Ball is purely of American origin, and I want to get all the facts I can to support that theory. My patriotism naturally makes me desirous of establishing it as of American origin, if possible, and, as the same spirit will probably prompt you, I would like your ideas about it." In his response, Lowell

◆ A page from Abner Graves's letter to A.G. Spalding, November 17, 1905, accepted as evidence that Abner Doubleday invented baseball at Cooperstown, New York, in 1839. Graves's diagram represents his recollection of the plan supposedly drawn by Doubleday in 1839. Note that Graves's version involved eleven players, including a fourth outfielder and dual shortstops.

wrote, "Chadwick may be right that all games of Base Ball may have been handed down to us from the English game of Rounders." Lowell was not approached to be a member of the commission, and Spalding ended his correspondence with him. Lowell's opinion was excluded from the report. Several similar testimonies were omitted, and none of the rounders proponents found their way onto the commission.

Also omitted was the testimony of John A. Mendum. The 83-year-old Mendum claimed to have played baseball in Portsmouth, New Hampshire, as early as 1830 and that a contemporary of his claimed that his grandfather played the game in his youth. Mendum thus concluded that he was "inclined to credit Mr. Chadwick's statement that the game of baseball is of English origin and that its age is greater than anyone now living." That last phrase points out another inadequacy of Spalding's "research." Correspondents were frequently asked if they had heard of rounders. When no one responded in the affirmative, Spalding concluded that baseball could not have descended from the English game. He ignored the possibility that rounders may have evolved into baseball well before the lifetime of any of those with whom he corresponded.

With the aid of Sullivan, Spalding created a final report of material for review by the members of the commission. Using the scrapbook in which all commission correspondence was kept, individual letters were carefully selected, culled, and set into a second scrapbook. The new compilation was then edited, transcribed, and submitted to the five-man commission in the late summer of 1907. Beyond random correspondence between Spalding and individual members of the committee, this new brief was all that each commission member was given in order for them to determine the origin of baseball. The report contained 66 pages supporting the One Old Cat theory—and but a page and a half supporting the rounders theory.

The commission was further urged to pay special attention to two letters submitted by Abner Graves, a mining engineer from Denver, Colorado, whose recollections of 65 years earlier placed Abner Doubleday in Cooperstown as the inventor of baseball. In presenting Graves's case, Spalding displayed his patriotic tendencies: "It certainly appeals to an American's pride to have had the great national game of Base Ball created and named by a Major-General in the United States Army."

A.G. Mills reviewed the material and relayed his opinion on the matter to Sullivan in a letter dated December 30, 1907. The letter was then circulated among the other commission members, and all signed their names, signifying their unanimous agreement with Mills's sentiments.

To his credit, Mills discounted Spalding's rationale that American patriotism would not allow for an English ancestry to baseball. Indeed, Mills's initial remarks were somewhat of a slap in the face to Spalding: "If the fact could be established by evidence that our national game, 'Base Ball' was devised in England, I do not think that it would be any the less admirable nor welcome on that account." However, the biased material supplied to the commission was overwhelming, and Mills went on to conclude that "'Base Ball' had its origin in the United States" and "the first scheme for playing [baseball], according to the best evidence available to date, was devised by Abner Doubleday at Cooperstown, N.Y., in 1839."

Just before the turn of the century, Frederick Jackson Turner noted that the American frontier, a defining element of our nation's identity, was gone. As America forged into the 20th century, its people searched for new ways to establish their unique character, to reinforce their commonality, and to distinguish themselves from their ancestral cousins. Enter Spalding and his commission. With the proceedings carefully crafted by Spalding's patriotic sentiments, Spalding successfully orchestrated the commission's conclusion.

The result of what later became known as the Mills Commission did nothing more than cause controversy over a moot issue: the origin of baseball. That baseball was, and is, an inseparable part of America, the American identity, and the American spirit is undeniable. That it may or may not have evolved from an English game is irrelevant.

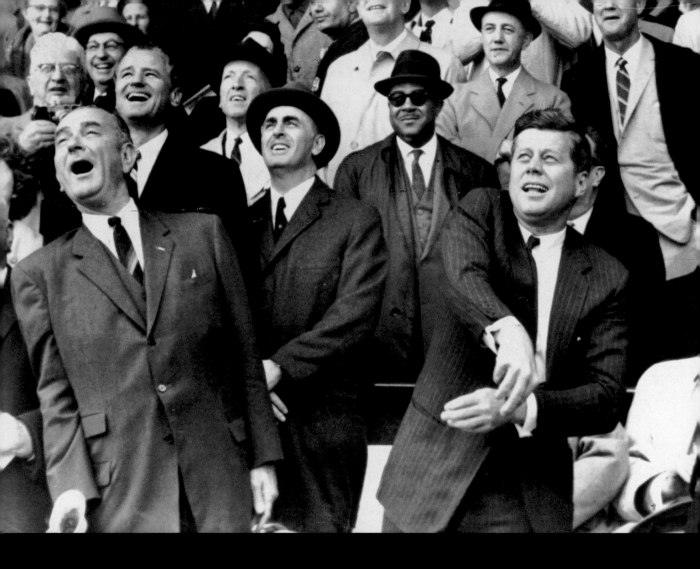

With Vice President Lyndon Johnson looking on, President John Kennedy throws out the opening-day pitch in 1961, the last opener played at Washington's Griffith Stadium. He threw perhaps the longest and hardest pitch ever tossed by a President. A huge sports fan, especially of baseball, the Boston Red Sox, and Ted Williams, Kennedy had an aide he called his "Undersecretary of Baseball," whose responsibility was to keep him apprised of scores, standings, and statistics. OPPOSITE: These presidential baseballs bear the signatures of Warren G. Harding, Herbert Hoover, Calvin Coolidge, Franklin Delano Roosevelt, Dwight Eisenhower, Lyndon Johnson, Richard Nixon, Jimmy Carter, and George Bush. Many of the earlier signatures were collected by Hall-of-Famer Walter Johnson, usually the Washington Senators' opening-day pitcher in the 1910s and 1920s.

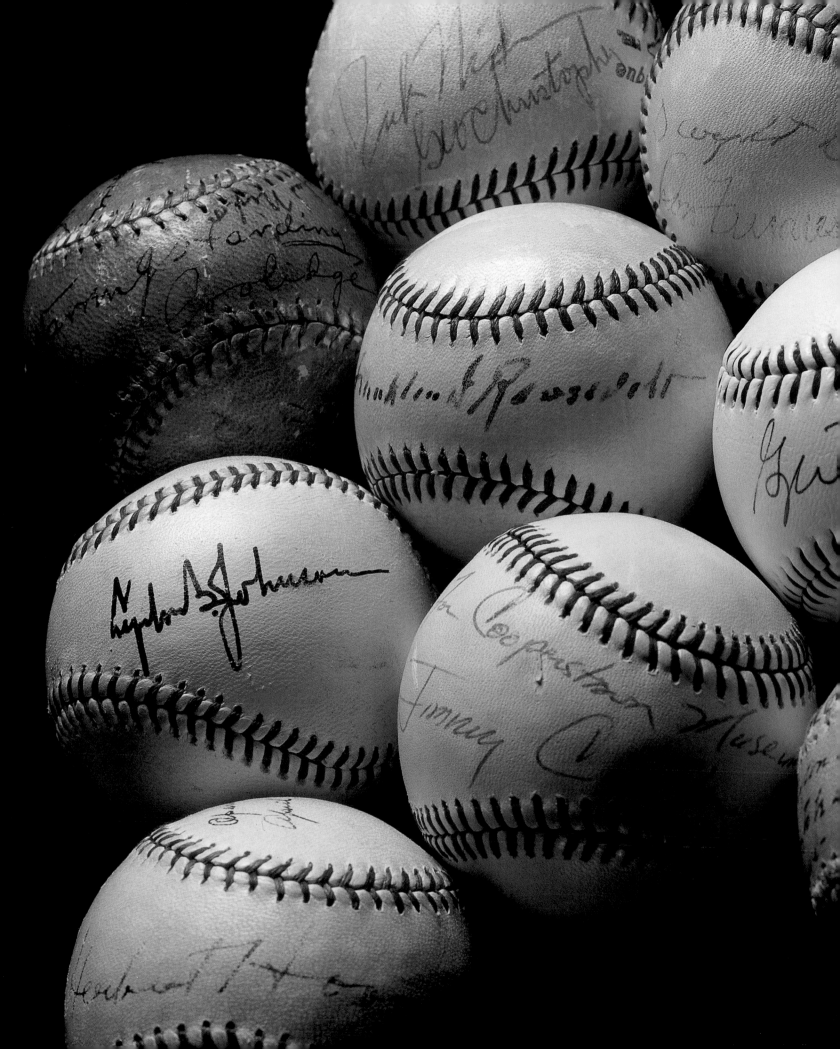

JAPAN VS. AMERICA

Grand Base Ball Match

1931

日米大野球戦グラフ

讀賣新聞社運動部編

世界最強チーム来朝の趣旨
及リーグの沿革 …………市岡忠男

来朝選手略歴 …………鈴木惣太郎

全日本代表選手の小傳 …………市岡忠男

定價貳拾錢

共益社クラブ印刷所

WILLIAM KELLY

Baseball in Japan: The National Pastime Beyond National Character

BASEBALL IS THE NATIONAL PASTIME of a number of countries in the Caribbean, Asia, and North America. First played in Cuba in the 1860s, it spread to other parts of the Caribbean and Central America shortly thereafter. The sport began in Japan in the 1870s and flourished.

By the 1890s, baseball was the prestige club sport at Japan's elite preparatory schools, and First Higher School's victories over teams of American fleet sailors and Yokohama residents electrified the Tokyo populace at a time when the country was trying to renegotiate the unequal treaties with the Western powers.

Throughout the 20th century, baseball remained the most significant sporting tie between two nations whose relative economic power and political relationship have oscillated wildly. From the early 1900s, baseball moved up into the new universities, whose teams soon began traveling to the U.S. for extended series against minor league teams and American universities.

Barnstorming tours of Japan by U.S. players began in 1908, and the 18-game tour in 1934, led by Babe Ruth and Lou Gehrig, solidified Ruth as a national hero in Japan and helped stimulate the organization of a professional Japanese league, which began play in 1936. General Douglas MacArthur cleared the munitions out of the baseball stadiums that had been requisitioned by the military during the war and encouraged baseball's revival after World War II. The growth of Little Leagues spread, an annual U.S.-Japan college series began, and major league teams made frequent post-season exhibition tours.

Since the 1950s, players from the U.S. minor and major leagues have been recruited by the 12 Japanese professional teams (which are divided into two leagues, with the respective champions meeting in a Japan Series). In 2001, approximately 70 players, or 10 percent of the professional rosters, were foreign. Japanese baseball has been forged by a long history of binational connections.

Any sport that moves across national boundaries becomes a set of local permutations on a common body of rules, techniques, and structures. Baseball in Japan exhibits this double quality of being recognizably different from and fundamentally the same as the game played elsewhere. There is, however, a very seductive, but deeply flawed, tendency to exaggerate the differences and attribute them to indelible, underlying radical contrasts in the American and Japanese character. This has become the dominant frame for comparing baseball in the two countries, by Americans and Japanese alike.

It is a pitfall that has proved unavoidable for even our most eloquent and influential American commentator on Japanese baseball, Robert Whiting, who has lived in Japan for 30 years and has authored a shelf of insightful, best-selling books and articles, in both English and Japanese. The opening sentences of his first book in 1977, *The Chrysanthemum and the Bat*, set the tone for decades of subsequent opinion:

"At first glance, baseball in Japan appears to be the

◆ Program from the American baseball tour of Japan, 1931, featuring Lou Gehrig on the cover. The tour pitted an American All-Star team, organized by sportswriter Fred Lieb and including Gehrig, Lefty O'Doul, Mickey Cochrane, and Frankie Frisch, against an All-Japan team sponsored by the *Yomiuri Shimbun*, a leading newspaper. The Americans swept the tour, winning all 17 games.

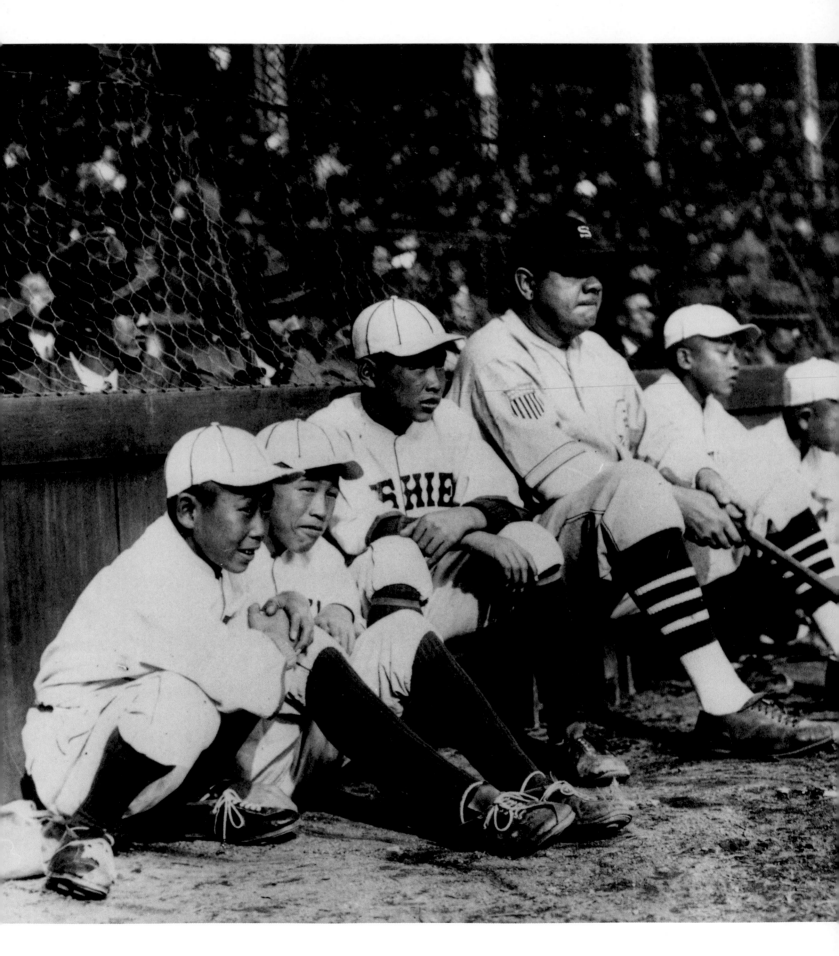

same game played in the U.S.—but it isn't. The Japanese view of life stressing group identity, cooperation, respect for age, seniority and "face" has permeated almost every aspect of the sport. Americans who come to play in Japan quickly realize that Baseball Samurai Style is different. For some, it is fascinating and exciting; for others, exasperating, and occasionally devastating."

This is baseball reduced to an extension of national character, asserting that the Japanese play baseball the way they lead their lives—by following others, by submerging themselves in the grinding Japanese collective, and by not insisting on asserting themselves as individuals.

Such a character portrait is obviously simplistic. How could a society of 125 million and a sport history of 125 years be summed up by the notion these are latter-day samurai playing with bats instead of swords? It's illogical as well; all team sports, especially baseball, demand complex mixes of teamwork and individual effort. Most of all, the point of view is troubling for its disparaging tone. It suggests the Japanese can copy the form of the sport, but they miss its true feeling.

For real fans of baseball, the wrapping of the sport in national character garb precludes a real appreciation of just how the game is played in Japan and what is at stake—to the players, the teams, and the spectators.

Consider, for example, one of the most famous incidents involving an American player. It took place on October 25, 1985, in the final game of the Central League regular season between the Hanshin Tigers of Osaka and their archrivals, the Yomiuri Giants of Tokyo. After fielding a mediocre team for several seasons, the Tigers had remarkably clinched the 1985 Central League championship and were going on to the Japan Series the next week. Much of their success was due to their colorful and popular American power hitter, Randy Bass. Coming into this final game, Bass had hit 54 home runs and was one short of tying the great Sadaharu Oh's single-season record.

This last game was in Korakuen, the Giants' home

◆ Babe Ruth and Japanese children during the 1934 Asian tour by big league ballplayers. Ruth's iconic status in America was magnified in Japan, where he was sometimes called "The God of Baseball."

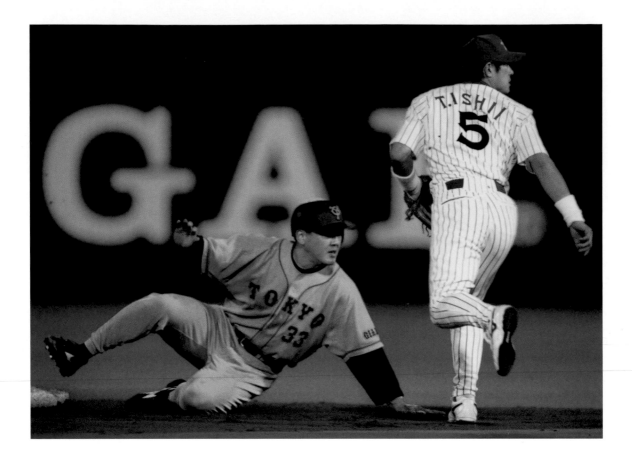

stadium. Bass was deliberately walked in his first two at-bats. The Giants' pitcher tried to pitch around him again his third time up, but Bass reached out and swung anyway, managing a single. The pitchers were more careful in his fourth and fifth at-bats and never gave Bass a pitch he could put into play, so he failed to break Oh's record, which was matched but not broken by American Tuffy Rhodes in 2001.

The Bass story was widely reported in the American press and was interpreted as an extension of indelible national character. The *New York Times* headline the next day was "The Japanese Protect Oh's Record." The message was clear: That's the Japanese for you. The Japanese people will just not accept foreigners. The *New York Times* reporter used a religious metaphor, suggesting "it is fine for [foreigners] to come into the church, but they cannot sit in a front pew."

In other words, the message was the Japanese are simply a clannish people and will never treat foreign players equitably, so national character trumped sportsmanship. But this interpretation of Bass's treatment solely as an outgrowth of national pride doesn't take into account other factors.

Consider that the passionate Giants fans at Korakuen booed the pitchers, not Bass, and a popular Japanese columnist was quoted as deploring the pitchers' actions as "disgraceful," according to that same *New York Times* article. It was not "the Japanese" who walked Bass, but rather the Giants' pitchers, and I think they had many more reasons for doing so than the simple fact they were Japanese.

For one thing, the Giants wanted to win that final game very much, because they could salvage some pride by clinching the season series against their bitter, long-standing rivals, the Tigers. One cannot exaggerate the intensity of what was for decades not only a rivalry of teams

◆ Akira Eto of the Tokyo Yomiuri Giants slides into base safely as he and All-Star shortstop Takuro Ishii of the Yokohama Baystars follow the action in a May 2001 game at Yokohama Stadium in Japan.

 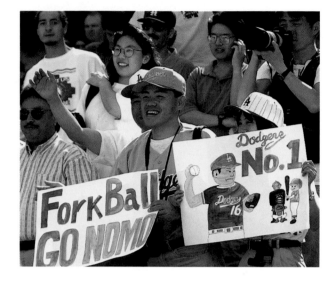

but also the pitting of second-city Osaka pride against national-capital Tokyo dominance. That year, the Giants had been preseason favorites to win the league title but slipped disappointingly and embarrassingly, while the Tigers were celebrating a rare success. With the Giants desperate for a victory, it was obvious strategy for them to pitch around the Tigers' most potent hitter, who nevertheless became the second foreigner to win the Triple Crown in as many years.

Furthermore, the record the Giants' pitchers were protecting belongs to their manager, who was standing in the dugout watching them. Manager Oh was perhaps remembering another controversial game against the Tigers from his own playing days, when Oh himself was thrown at twice by the Tigers' pitching ace, Gene Bacque, known as the "Ragin' Cajun." The second time Bacque threw at Oh produced a bench-clearing brawl, during which Oh's

batting coach, Arakawa Hiroshi, stormed the mound and was punched out by Bacque. Perhaps, too, Oh and his pitchers were recalling the belittlement of Oh's career home run record by the American baseball world.

Most baseball fans, Japanese and American, felt it was unfortunate that the Giants' pitchers avoided pitching to Bass. But the incident was much more revealing about the Giants, the Tigers, and that season than it was about the Japanese as a people. Personal histories, bitter team rivalries, city pride, and our nations' past interactions were all part of what happened that evening. A simplistic interpretation solely in the context of a broad-brushed national character is not an explanation. A love of the game and its pleasures should encourage us to appreciate the subtleties of baseball in Japan with the same knowledge and passion that we bring to the sport here at home.

◆ Bursting on the scene in 1995, Japanese pitcher Hideo Nomo's success heightened interest in baseball among Japanese Americans and paved the way for more Japanese players, including Seattle Mariner standouts Kazuhiro Sasaki and Ichiro Suzuki.

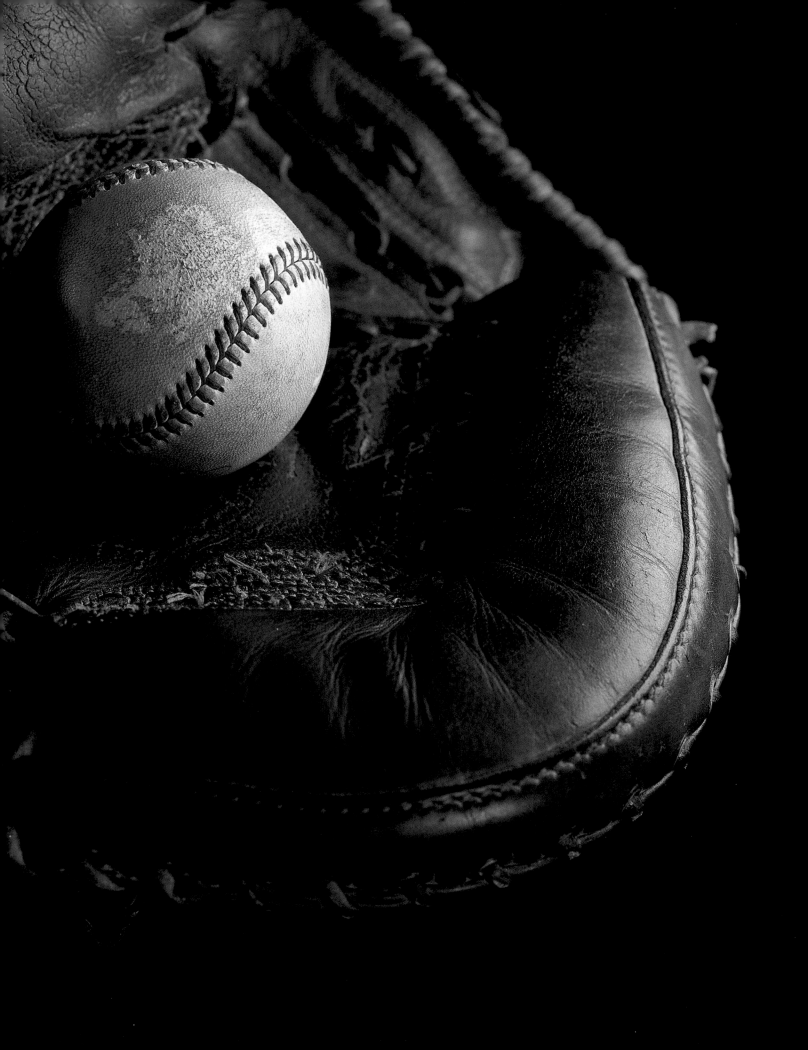

NEIL HARRIS

The Rise of the World Series

IN EARLY OCTOBER 1910, a special train left Chicago carrying a group of local athletes off to Philadelphia. These athletes carried with them, announced the *Chicago Tribune* portentously, "the knowledge that the hearts and hopes of more than 2,000,000 Chicagoans and uncounted hosts of admirers throughout the land followed them into the camp of the enemy, where they have gone to do battle."

What merited such attention? The Cubs were playing the Athletics in the World Series, a sporting event in the process of attaining the status once enjoyed by mythic epics. As an invented ritual, the World Series possesses no hoary ancestry; however, the special interest the Series arouses, the associations it has acquired, and the uneven course of its ascendancy make for a gripping story.

As sport in America expanded at the end of the 19th century to meet many needs—class, civic, personal, ethnic, nationalizing—it developed special contests to define mastery and test the skill of selected combatants. Medals, cups, and titles went to the victors. Baseball was no exception, and because newspapers assumed responsibility for covering and publicizing the national game, the World Series ritual would rely heavily on journalistic nurturing.

In existence since 1876, the National League had its teams vying for a championship pennant almost from the start. An 1884 series between the National League champions and those of the rival American Association has sometimes been labeled the first World Series, and a string of them followed. But rules, prize monies, and procedures varied from year to year. In the 1890s, the two leading National League teams competed for a postseason Temple Cup, but this ended after only four competitions.

The World Championship got a new start, in what would become the familiar format, in 1903, with the first encounter between the National and American Leagues. The respective winners of pennants—Pittsburgh in the National, Boston in the new American league—played a best-of-nine competition for what they termed the world's championship. It took eight games for Boston to achieve victory, more than 100,000 fans attended, and the owners gave the players a share of the gate receipts. After a 1904 hiatus, the Series resumed (as a best-of-seven, except for the brief employment of a best-of-nine formula from 1919 to 1921) and, with the John T. Brush rules, secured codification. Postseason play was no longer optional.

◆ OPPOSITE: The ball and glove from the only perfect game in World Series history, pitched by Don Larsen and caught by Yogi Berra (above) on October 8, 1956, at Yankee Stadium. The Yankees beat the Brooklyn Dodgers 2-0 and went on to win the Series in seven games.

Both fans and newspapers valued a regularized World Championship, and its powerful commercial potential gave the Series great appeal. For one thing, it offered a powerful challenge to the advancing football season. Colleges and universities now yielded some of their unquestioned early October sports supremacy. Club owners candidly relished the gate receipts, along with the games.

Boosterism, urban rivalries, and journalistic ballyhoo together nourished these early Series. Owners had already developed many instruments to gain attention during the regular season—special ballpark days, parades, celebrity invitations—but there was no unified orchestration to the growth of World Series interest, which was instead fueled by gamblers, newspapers, and fan loyalty. In 1906, Chicagoans embraced the institution because its two teams played one another in the first intra-city World Series. Such wild enthusiasm, however, was not guaranteed.

For example, in 1908 the drama of two unprecedented pennant races eclipsed the Series. That year, the Detroit Tigers clinched the American League pennant by beating the White Sox in the last game of the season, attracting the greatest weekday crowd in the Chicago ballpark's history until then. The National League hosted an even more extraordinary finale. Because of a disputed game—the result of the notorious missing of a base by Fred "Bonehead" Merkle—the Cubs and Giants faced each other at the Polo Grounds in a playoff. In front of 40,000 spectators, the Cubs' Mordecai Brown beat Christy Mathewson. As many as 250,000 attempted to get into the ballpark, according to some reports. Never "since the days of Rome and its arena tests," intoned the *New York Times*, "has a people been pitched to such a key of excitement.... It is impossible to believe, after what happened yesterday at the Polo Grounds, that the earth is still on the same track...."

What could top this? The ensuing World Series between the Tigers and the Cubs was clearly an anticlimax, neither all that exciting nor well attended. In 1911, reacting to the role of speculators in ticket distribution, the *New*

York Times complained that "mismanagement and cupidity" had "cast their blight" on the Series. And, in 1913, the *Chicago Tribune* claimed the Series was doing baseball more harm than good, endorsing Commission Chairman Garry Herrmann's proposal to end the season a month earlier and then top it off with an inter-league competition in which all 16 teams contended. As it was, as many as three or four baseball series—intra-city, intra-state, inter-league—competed with the World Series for fan attention.

But continuity, record keeping, and journalistic enthusiasm ensured the World Series' eventual triumph as an institution. The timing of the Series has always had a bittersweet quality. Summer had ended; school and work patterns had resumed; holidays were a long way off. But this was more than a momentary pause. The World Series went on, often for seven full games, and with rain delays they sometimes went on and on and on. No one pretended that baseball's championship could be determined by a single encounter, a super game. Such a match would violate the rhythm of the lengthy season.

Taken just as seriously were the commercial stakes, not surprising considering that American-invented traditions built the drama of moneymaking into the heart of their appeal. From the start, newspapers focused on gate receipts and player shares. In the early years, even a loser's share could approach an annual salary. Fan interest in the financial issues gave the Series special fascination. When Fred Snodgrass of the Giants dropped a fly ball, giving the Red Sox the World Championship in 1912, one newspaper headline read, "Snodgrass Drops Easy Ball, Costing Teammates $29,524." The same Series was rhapsodized by this newspaper as having helped President William Howard Taft forget "the bitter assaults that have been made on him" and easing a former President, Theodore Roosevelt, recovering from an assassination attempt, "of his pain by his interest in it."

The World Series became popular because of its high stakes, but it took a generation (if one starts from the 1880s) for the Series to reach its magic perch. In 1915,

◆ OPPOSITE: The Florida Marlins celebrate after winning the 1997 World Series in seven games against the Cleveland Indians. The team, which seemed to come from nowhere, included numerous free agents and was dismantled almost immediately after the Series.

Woodrow Wilson, a true fan, became the first sitting President to attend a Series game, buying his own tickets and bringing his fiancée to Philadelphia to watch the Red Sox beat the Phillies.

In one sense—like film, vaudeville, and syndicated theater—the World Series was part of the nationalizing mass culture that would challenge, swamp, or reshape the local elite, ethnic, and working-class systems that had waxed for much of the previous century. It permitted political and economic interests to smile benignly at what they held up as a triumph of free enterprise and democratic life. Baseball had always emphasized the democracy of its fandom, banker and stevedore sitting side by side to cheer on their team. Social integration through spectatorship was its rhetorical contribution to a democratic ceremony, simultaneously elaborate and informal.

There were, of course, occasional lapses of enthusiasm, some embarrassments, and the catastrophic 1919 Black Sox scandal. But these were quickly absorbed into the ongoing success of the larger rituals. The annual gatherings of celebrities, the stringing of special wires, the creation of electric bulletin boards, the use of theaters and auditoriums for re-creation of the games, and the respectful attention of mayors, governors, magnates, and Presidents, were firmly integrated into an extended family of associated events, lovingly detailed by the press.

World Series news became front-page news everywhere. And winning cities were consumed by the event. When the Washington Senators (finally) brought that city its first pennant, those "armored knights of the bat and ball" paraded down a crowd-lined Pennsylvania Avenue to the Ellipse south of the White House. Here they were welcomed by President Calvin Coolidge (who had attended three games) and his Cabinet and formally acknowledged as champions. This was the Series tradition in its climactic phase.

In the decades that followed, World Series rituals have been reshaped by many things, including changing work patterns, preliminary rounds of playoffs, and the adoption of a nighttime schedule. But, though challenged by newer competitive pageants and modified by shifting rules, the World Series remains unique for many Americans—a carefully managed and lovingly tended ritual of extended competition that rewards the time-tested champions of the national game.

◆ FOLLOWING PAGES: Pregame shot of the Huntington Avenue Grounds in Boston as it hosts the first modern World Series, in 1903. The roof of another ballpark, South End Grounds, home of Boston's National League team, is visible just beyond the first base grandstand.

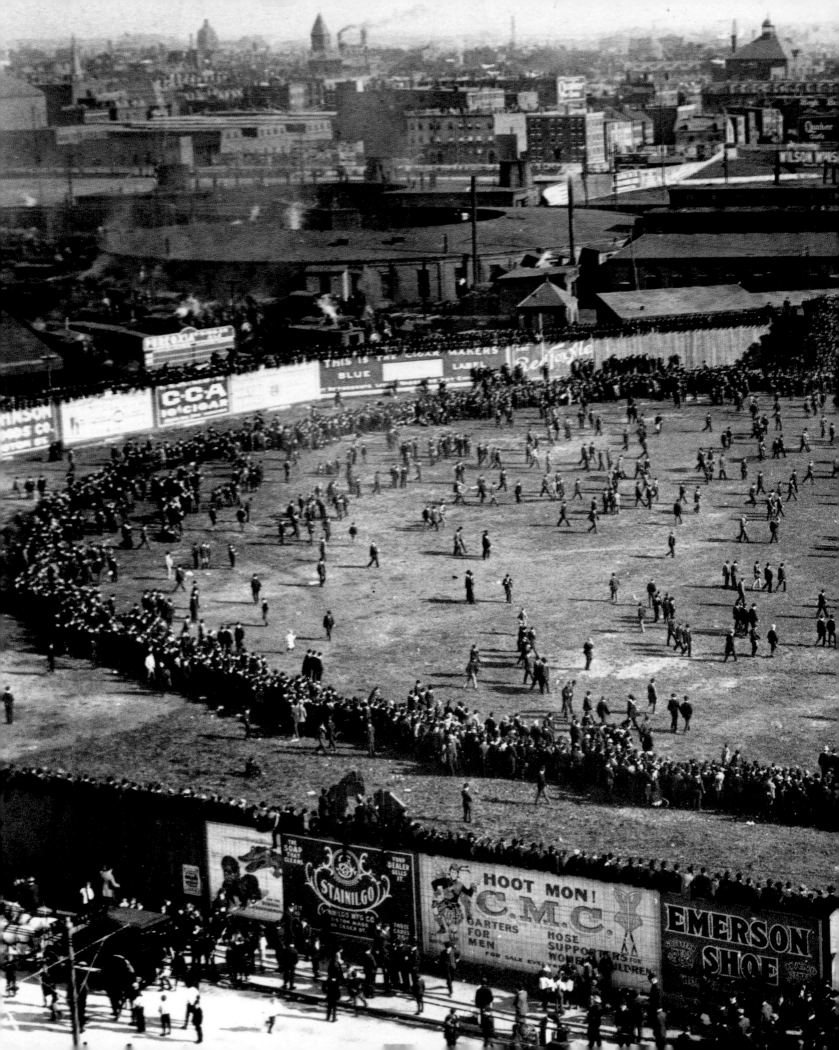

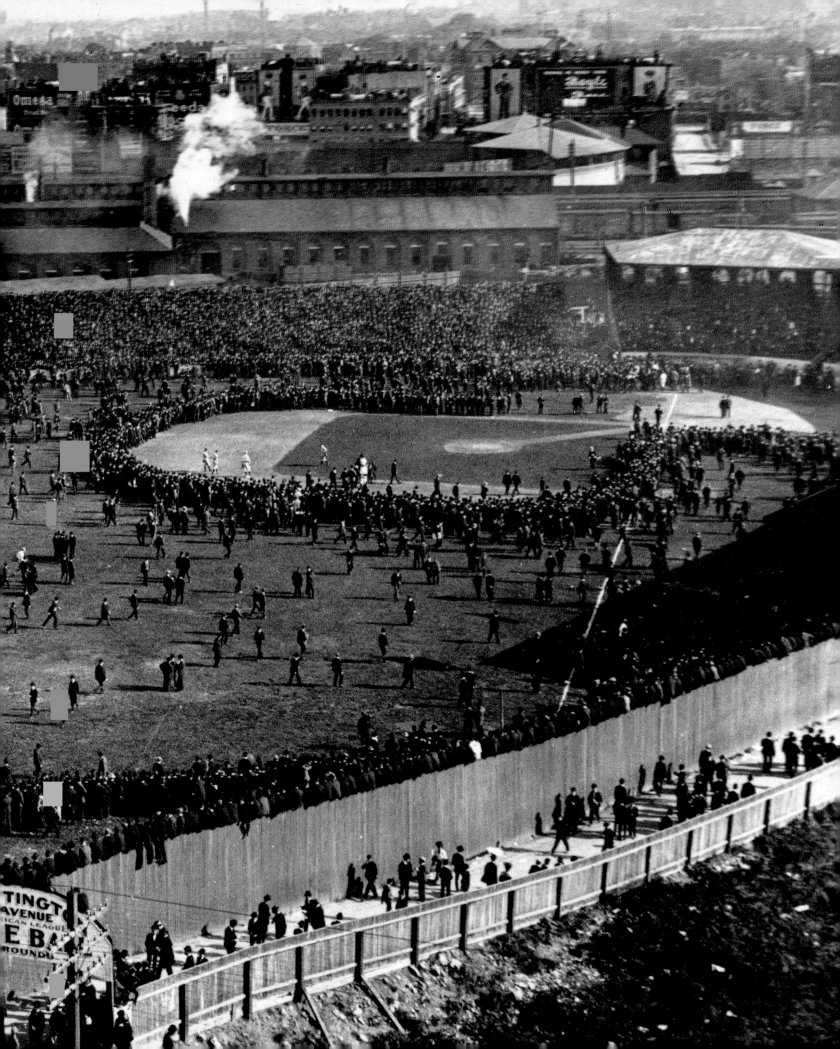

A. D. Richardson 1864

Letter from Military Prison

Military Prison, Salisbury, N.C.
Friday, Feb'y. 12th 1864

My Dear Sister:

... This is my seventh Southern prison. If the authorities
continue to keep me revolving, I shall soon have a very
fair idea of those institutions throughout the Confeder-
acy. I have been "cheerful" and "comfortable" the most
of the time, but when you say "happy" that is a little too
strong.

The last change I like very much, for here I am in
the open air nearly all the time – to me after the active,
outdoor life of the last 7 years an inestimable privilege.
We have a well-shaded yard of four acres, surrounded by
two fences eleven feet high, with sentinels posted on the
inner one.

For the last few days we have played base ball sev-
eral hours daily – the only time I have done so, with one
exception, since the Fast Days & Old Elections of boy-
hood. I enjoy it just as well as I did then, & after 9 mos.
confinement it does me vastly more good....

Affectionately your brother,
A. D. Richardson

Lith of SARONY, MAJOR & KNAPP 449 Broadway, N.York.

UNIO

RISONERS AT SALISBURY, N.C.

DRAWN FROM NATURE BY ACT.MAJOR OTTO BOETTICHER.

◆ Union prisoners play ball at Salisbury, North Carolina, in this 1863 color lithograph based on a
drawing by Otto Boetticher, a Union soldier and commercial artist from New York. Held prisoner at
the Confederate prison at Salisbury for a period during 1862, Boetticher was a captain in the 68th
New York Volunteers and was later promoted to major.

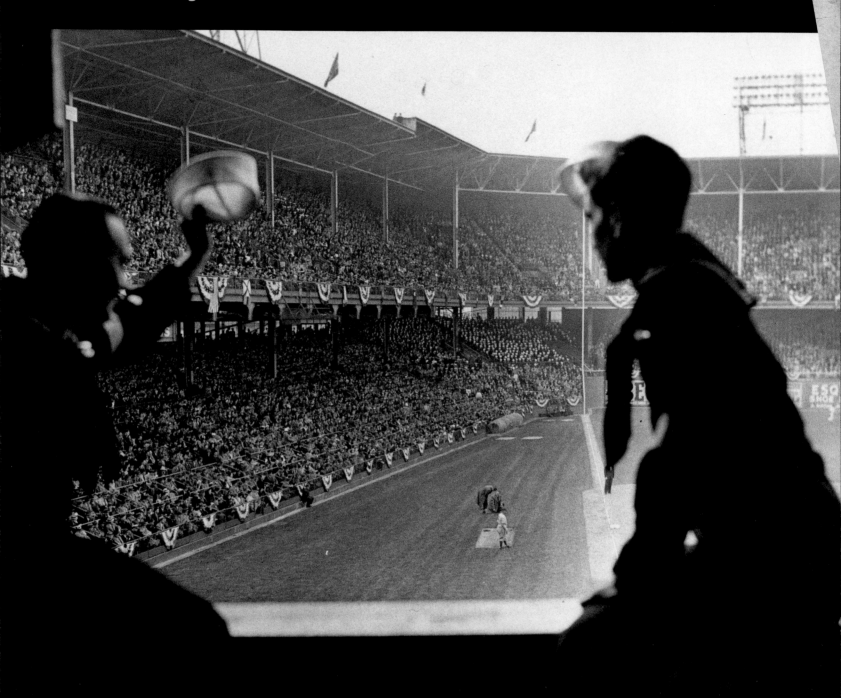

◆ Is sport appropriate during a national emergency? Five weeks after Pearl Harbor, Baseball Commissioner Kenesaw Landis asked President Roosevelt whether baseball "should continue to operate." Roosevelt's resounding "yes," citing the employment and uplift it would bring, spoke volumes about the importance of the game to American society, particularly to these two sailors watching a game. (The 300 teams Roosevelt cites are the number of major and minor league clubs in 1942.)

January 15, 1942.

My dear Judge:-

Thank you for yours of January fourteenth. As you will, of course, realize the final decision about the baseball season must rest with you and the Baseball Club owners -- so what I am going to say is solely a personal and not an official point of view.

I honestly feel that it would be best for the country to keep baseball going. There will be fewer people unemployed and everybody will work longer hours and harder than ever before.

And that means that they ought to have a chance for recreation and for taking their minds off their work even more than before.

Baseball provides a recreation which does not last over two hours or two hours and a half, and which can be got for very little cost. And, incidentally, I hope that night games can be extended because it gives an opportunity to the day shift to see a game occasionally.

As to the players themselves, I know you agree with me that individual players who are of active military or naval age should go, without question, into the services. Even if the actual quality of the teams is lowered by the greater use of older players, this will not dampen the popularity of the sport. Of course, if any individual has some particular aptitude in a trade or profession, he ought to serve the Government. That, however, is a matter which I know you can handle with complete justice.

Here is another way of looking at it -- if 300 teams use 5,000 or 6,000 players, these players are a definite recreational asset to at least 20,000,000 of their fellow citizens -- and that in my judgment is thoroughly worthwhile.

With every best wish,

Very sincerely yours,

Franklin D. Roosevelt

Hon. Kenesaw M. Landis,
333 North Michigan Avenue,
Chicago,
Illinois.

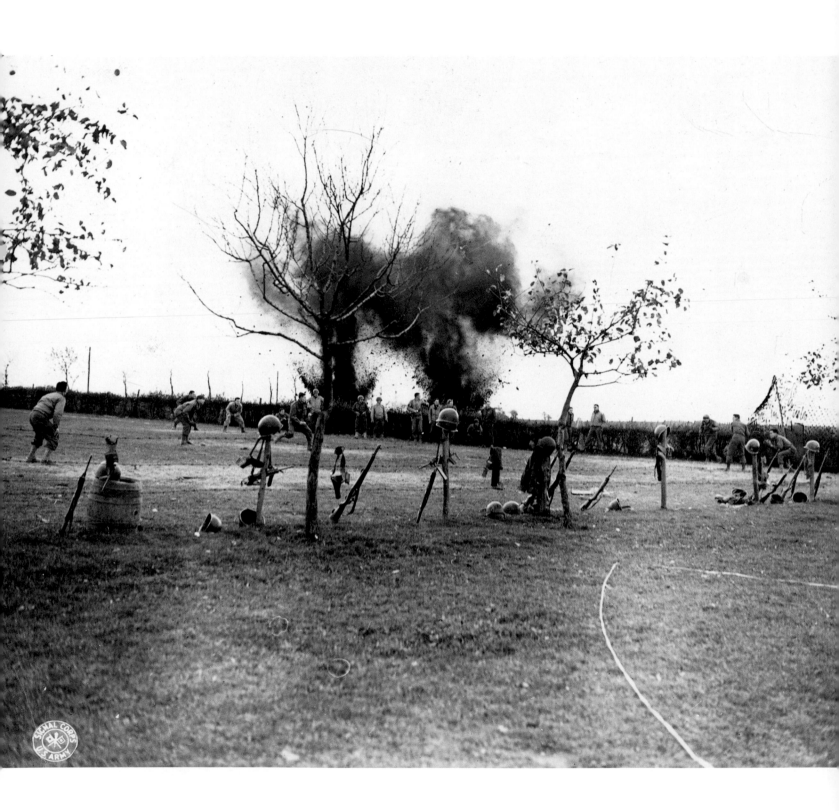

BASEBALL AS AMERICA

The Front Lines to the Backyard

For all of the recent challenges to the claim that baseball is our national pastime, no other sport touches the chord of patriotism in quite the same way.

Why is that? Some of the Super Bowl halftime shows have been extravagant appeals to pride in America. And who could forget the image of the U.S. Olympic hockey team members draped in the American flag following their "miracle on ice" at the 1980 winter games? Yet baseball, much more than the other sports, has that Yankee-Doodle dandy, it's a grand old flag, from sea to shining sea, rockets red glare kind of feeling.

I think there are several reasons. It was during World War I that baseball games became a kind of pep rally for the boys who were over there, fighting the war that was supposed to end all wars. Francis Scott Key's anthem was installed as a pregame fixture during that time. Red, white, and blue bunting decorated the ballparks.

By the time the United States got involved in World War II, baseball was indisputably a national obsession. While professional basketball and pro football were struggling to get established, major league baseball was deeply rooted in the American psyche. Families thousands of miles from big league cities were known by the team for which they rooted or the player who won their lasting loyalty. Radio broadcasts of important games, especially the World Series, were practically national holidays.

So when major leaguers were drafted or they volunteered for military service it was a Movietone moment, a highlight of the newsreels that played in every movie theater in the country. The biggest stars—Joe DiMaggio, Ted Williams, Hank Greenberg, Bob Feller—were all in uniform. No recruiting poster or piece of government propaganda could equal the effect of these baseball heroes giving up the prime years of their careers to serve their country. Williams, in fact, devoted four and a half seasons in the prime of his career to military service, in both World War II and Korea. He wasn't doing desk duty, either. He was using his perfect vision and perfectionistic work ethic to fly fighter planes.

In the movies, when American G.I.s wanted to trick a German posing as an American, they'd ask a baseball question. "You're from the States, huh? So who did you like in the '41 Series?"

In the end, baseball has an enduring connection to the idea of America because it is really an extension of democracy. It is played in all of the levels of our national life, from small town to big city, from the reservation to the barrio, from manicured suburban fields to rocky pastures.

In its most elemental form, there's room for all, whatever their athleticism, ethnicity, or economic status. The fabric of America can be found in a pick-up game with a granddad umpiring, a fat kid in right field, a woman at the plate, a cheering section of relatives, and strangers who wander by, unable to resist the spectacle of so many people having so much fun.

If there's any further doubt, remember the final two words in our national anthem: "Play ball!"

◆ OPPOSITE: American soldiers in World War II play ball in Europe while military engineers detonate land mines in the background. ABOVE: After the outbreak of World War II, 130 American news reporters, diplomats, and their families were rounded up and confined in central Germany. During their five-month detention the group created a baseball league for recreation, complete with this bat, hand-made from a fallen limb.

"I honestly feel it would be best for the country to keep baseball going. There will be fewer people unemployed and everybody will work longer hours and harder than ever before. And that means that they ought to have a chance for recreation and for taking their minds off their work even more than before."

—FRANKLIN D. ROOSEVELT

January 15, 1942

One of the seven baseball diamonds set up by U.S. troops at Camp Marshall, Lyautey, Africa (present-day Morocco) in July of 1943.

ALLAN H. (BUD) SELIG

Baseball in a Time of Crisis

FOR MORE THAN A CENTURY, Major League Baseball has been uniting and entertaining people in times of peace and prosperity, and in times of crisis. More than just another spectator sport or entertainment option, baseball is a much-loved and much-needed social institution.

Rarely has baseball's unique place in the social fabric of this nation been more evident than in the days immediately following the tragic events of September 11, 2001.

Not since Pearl Harbor has the United States been faced with an attack of such magnitude. Even though Pearl Harbor had occurred in December—during baseball's "off season"—the question of whether or not the 1942 season should be played was soon on the minds of many.

Was it appropriate for players to take the field with the United States fighting a war to preserve the American ideals of democracy and freedom? In his famous "green light" letter to Commissioner Kenesaw Landis, President Franklin D. Roosevelt expressed his belief that baseball must continue for the good of the nation.

President Roosevelt's letter not only gave Major League Baseball the impetus to continue during wartime but also legitimized baseball's position as a valued social institution.

When terrorists attacked the United States on September 11, baseball was in the home stretch of another exciting season. Barry Bonds was pursuing a new single-season home run record; the Seattle Mariners were pursuing an all-time record for wins; several exciting pennant races had yet to be decided; and fans in Baltimore and San Diego were preparing to bid farewell to retiring legends, Cal Ripken, Jr., and Tony Gwynn. The question of whether baseball should continue and, if so, when, had to be addressed immediately.

To cease playing baseball as a result of those attacks would go against the ideals of our great nation. While it was important—and appropriate—to suspend play for a period of time to honor those who had lost their lives in the attacks, it was also necessary to heed the words of President George W. Bush, who urged U.S. citizens to return as soon as possible to their normal way of life. The decision was a difficult one; I decided it was best to wait through that first weekend and begin play on the Monday following the attacks. I believe the timing was right, as was the response of our clubs and players. The outpouring of sympathy for the victims; the reverence for the true American heroes, the firefighters, policemen, and rescue workers; and the display of patriotism were memorable, proving once again that baseball, as a social institution, can play an important part in the healing of our great nation.

◆ A week after the September 11, 2001, terrorist attacks on the United States, the Los Angeles Dodgers, San Diego Padres, and members of the Los Angeles Police and Fire Departments joined to resume the baseball season, unfurling an American flag at Dodger Stadium before the game. Weeks later, New York City firefighter and Battalion Chief Vin Mavaro discovered a baseball in the World Trade Center debris, opposite. "Being a baseball fan, coach and player," he writes, "this item has become a symbol of hope for me. Baseball is the American Pastime, a great game from a great country."

"INDIAN BOB" JOHNSON

CHAPTER

2

In March 1911, the *Sporting Life,* a popular weekly newspaper, offered a tribute to baseball as a symbol of American freedom and inclusiveness. In an editorial entitled "Know[s] No Race," the journal wrote, "In the United States base ball deserves its title of the national game, not only because it has more devotees than any other amusement and not alone because this country perfected the sport and brought it to its present form,

IDEALS AND INJUSTICES

but also because it is essentially a game of no one race or creed." The *Sporting Life* noted the presence of players of Irish, German, French, Polish, Italian, and Swedish ancestry. Pitcher Charles Bender and catcher John Meyers represented the "original Americans." The Cincinnati Reds had recently signed two Cuban players. "In the stress of a contest...all nationalities merge and race prejudice are forgotten," concluded the writer, "as every fan remembers only that he is an American watching his favorite play the game of games." ◆ The *Sporting Life* commentary was written with neither irony nor dishonesty. Its celebratory tone encapsulated the torturous racial ideology of the United States during the Progressive Era. For most immigrants, baseball embodied the "melting pot" ideal that people from many lands and backgrounds could come together and become acculturated in the American way of life. Yet the *Sporting Life* seemed oblivious to the broader inconsistencies inherent in its depiction. It did not mention that newsmen had automatically designated both Bender and Meyers, as Native Americans, with the nickname "Chief;" that fans gave Indian war whoops when they came to the plate; or that the signing of light-skinned Cuban players Armando Marsans and Rafael Almeida had triggered a controversy as to whether they were really of "pure Castilian blood," untainted by racial mixing. Nor did the editorial acknowledge that Organized Baseball

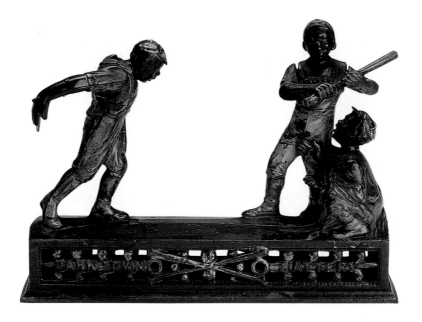

would not accept darker Cubans or that many of the very best ballplayers born in America, like pitcher Rube Foster or shortstop John Henry Lloyd, were barred from participation due to the color of their skin. Asian athletes also fell outside the accepted racial and ethnic mainstream, unlikely to be welcomed at baseball's highest levels. Women who attempted to play the game often faced ridicule.

Indeed, baseball in the 21st century comes far closer to fulfilling the ideals suggested by the *Sporting Life* in 1911 than at any time in its history. On the field, the game is thoroughly integrated: Native-born Caucasians and Hispanics play alongside African Americans; athletes from the Dominican Republic, Puerto Rico, Mexico, Venezuela, Nicaragua, and other Caribbean nations have joined Cubans on the baseball diamond. Japanese stars Ichiru Suzuki and Hideo Nomo have captivated fans of two nations, while Korean players have also entered the game.

Jackie Robinson, the man who broke Major League Baseball's color line in 1947 and paved the way for these developments, has become the game's predominant historical symbol. In 1997, on the 50th anniversary of Robinson's pioneering achievement, baseball staged a year-long celebration, culminating in a formal ceremony attended by President Bill Clinton and the permanent retiring of Robinson's number, 42, by all major league ball clubs. The spirit of Robinson hovers over baseball as a constant reminder of all that the game and the nation aspire to in the realm of equal opportunity and freedom.

But freedom in the United States has always been marked as much by its limits as its promise, and the Jackie Robinson legacy has similarly been a double-edged sword. Robinson appeals to "the better angels of our nature," but his specter also reminds us of the long years of exclusion and the arduous struggle for redemption. From its earliest years, baseball erected an increasingly stringent color bar-

◆ PAGE 68: Robert "Indian Bob" Johnson baseball card, produced by the Play Ball card company, 1941. Born in Pryor, Oklahoma, Johnson was an All-Star outfielder for the Athletics, Senators, and Red Sox from 1933 to 1945. His nickname derived from his Cherokee heritage.

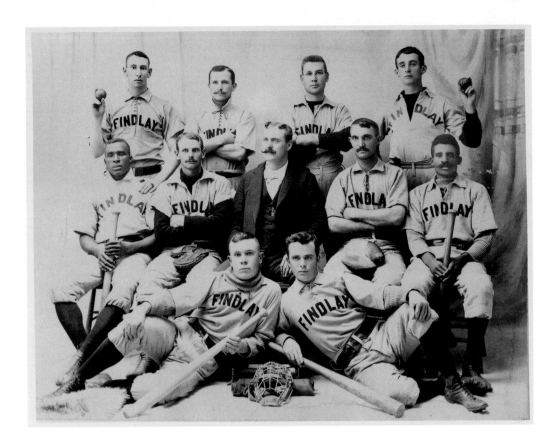

rier. In 1867, the National Association of Base Ball Players, the first organized league, barred "any club which may be composed of one or more colored players." Nine years later, the new National League adopted an unofficial ban on blacks that would endure for 70 years.

The irregularly organized minor leagues of the late 19th century offered opportunities to a handful of individuals and a few all-black clubs, but the opening proved limited and short-lived. Talented players like Bud Fowler, Bob Higgins, George Stovey, Moses Fleetwood Walker, and Frank Grant appeared in the International League in 1887. Walker even had a short major league stint when his Toledo club was absorbed into the American Association in 1884. African-American teams like the New York Gorhams and Cuban Giants played in the lower minor leagues. By the late 1890s, however, the color line had become impenetrable.

In imposing its own brand of Jim Crow, baseball emulated the broader society. But as in other areas of cul-

ture, segregation produced its own beautiful flowers. African-American teams and later-organized Negro leagues sprang up in black population centers. And because impoverished African-American communities could rarely give consistent financial support to these squads, the teams began to travel widely, barnstorming throughout the land and spreading the fame of stars like Satchel Paige, "Cool Papa" Bell, and Josh Gibson. Teams included José Mendez, Martín Dihigo, and other great Afro-Latino stars of the Caribbean. Major league owners often defended their restrictive policies by arguing that Negro league players lacked the skills to compete at the highest levels of the game. But time and again contests pitting black against white players—in the winter leagues of the Caribbean or on the postseason barnstorming tour—disproved this assertion. Shortstop Jake Stephens, who starred for a half dozen Negro league teams in the 1920s and 1930s and faced white ballplayers on numerous occasions, echoed the sentiments

◆ OPPOSITE: The cast-iron "Darktown Battery," ca 1888, was reissued in the 20th century as the "Hometown Battery" with the players' faces painted white. ABOVE: This Findlay, Ohio, team, ca 1894, includes two black players on an otherwise all-white team. As late as 1885, an estimated 60 black players could be found on minor league teams. By the end of the 1880s, a color line had been drawn.

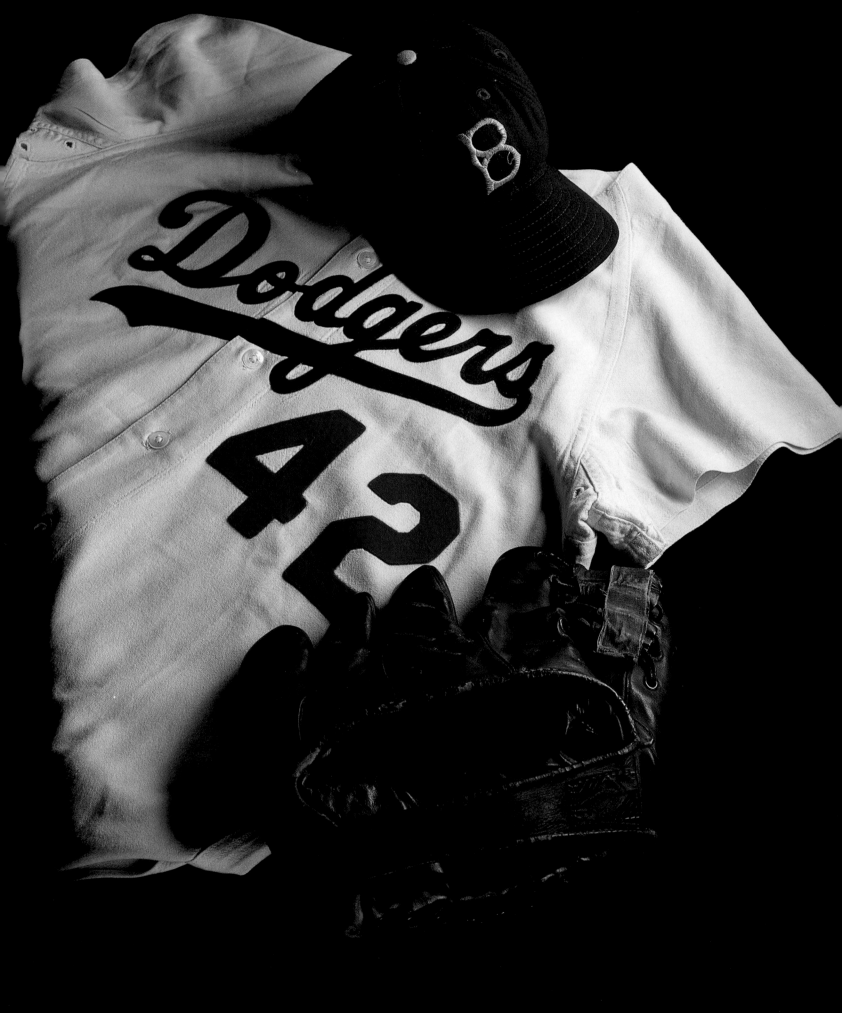

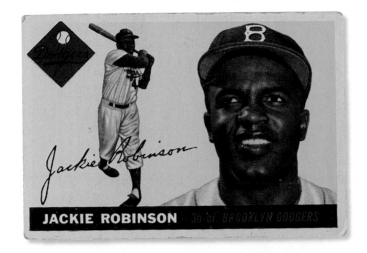

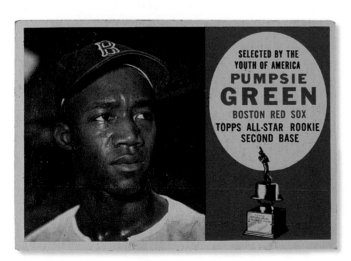

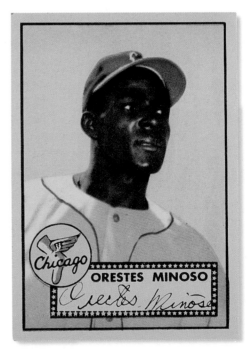

◆ OPPOSITE: A Brooklyn Dodgers jersey, cap, and glove worn by Jackie Robinson. In 1997, to commemorate the 50th anniversary of Robinson's major league debut, Major League Baseball took the ultimate step, retiring Robinson's number 42 on all teams permanently. ABOVE: A gallery of firsts—Jackie Robinson along with other pioneers of major league integration, each the first black player on the pictured team. Clockwise from Robinson: Larry Doby, who integrated the American League just weeks after Robinson's debut; Orestes "Minnie" Miñoso of the Chicago White Sox; Pumpsie Green, who integrated the last all-white team, the Boston Red Sox, in 1959; and Elston Howard, the first black player for the New York Yankees.

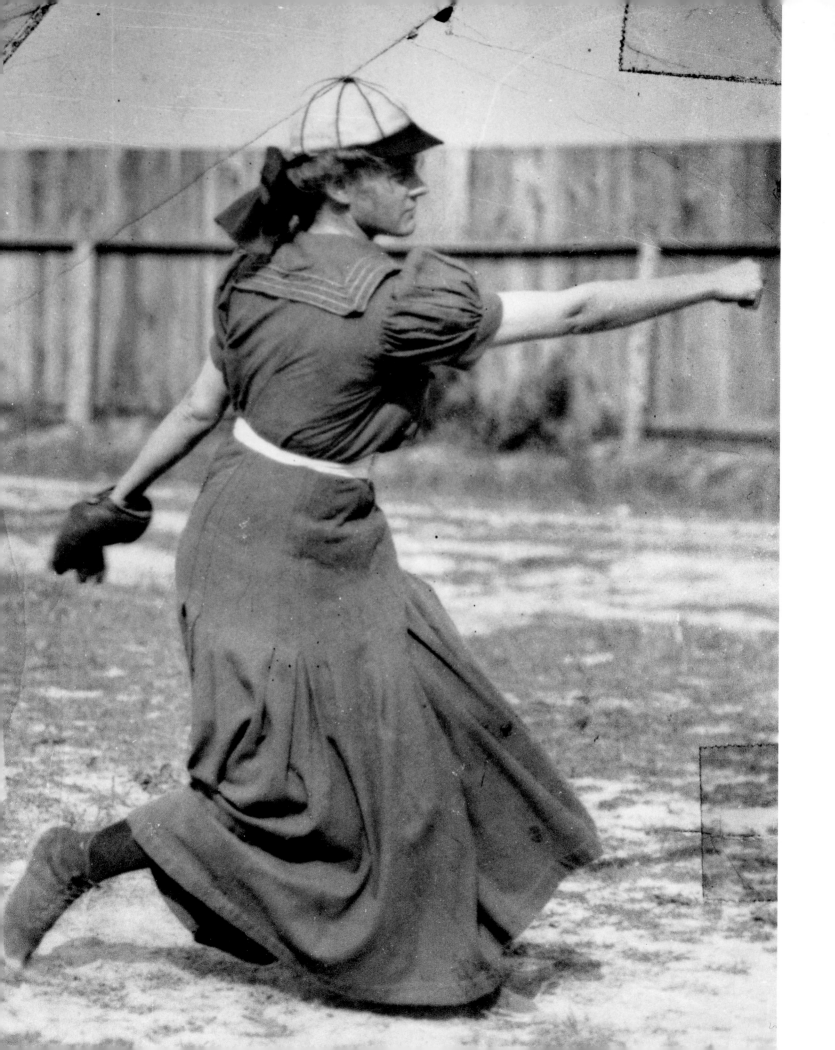

of numerous Negro leaguers. "You knew you were better than the major leaguers. You just knew it," he exclaimed.

The Negro leagues flourished in the prosperous 1920s and again in the late 1930s and during World War II. They played an exciting brand of baseball, blending power and speed, unorthodox strategies, and wildly impromptu improvisations. Yet integration ultimately doomed their existence. In the late 1940s when Jackie Robinson, Larry Doby, and others moved across the color line, African-American fans abandoned the Negro leagues to see their heroes perform in an integrated setting. "Nothing was killing Negro baseball but Democracy," explained black sportswriter Wendell Smith. "The big league doors suddenly opened one day and when Negro players walked in, Negro baseball walked out." But integration, while widely desired, also had its decidedly negative side. Since Organized Baseball moved slowly to recruit black players and disdained African Americans as coaches, scouts, and managers, hundreds lost their jobs when the Negro leagues collapsed. While opportunities expanded for stars like Willie Mays and Hank Aaron, who ascended to the majors, they contracted for most others. Ironically, fewer African Americans would earn their living from baseball after 1950 than in the first half of the 20th century.

Nor was the road to integration rapid or easy. Most major league teams moved "with all deliberate speed" to recruit black players. As late as 1953 only six teams fielded African Americans. The Boston Red Sox remained all white until 1959. Many teams had informal quota systems that limited the number of nonwhites. In spring training, and even in several major league cities, African-American players had to live separately from their teammates and eat their meals on team buses while others ate in restaurants. The acceptance of African Americans also opened the doors to Afro-Latino players. Cuban Orestes "Minnie" Miñoso, Puerto Rican Roberto Clemente, and Dominican Felipe Alou set the stage for a vast influx of Latin American stars. These players, isolated not only by skin color, but by language and cultural differences, also experienced the brunt of North American discrimination.

For racial minorities, the meaning of freedom embodied in baseball was clearly defined. It meant the ability of individuals to be included and to rise to whatever level their talent might merit. For women, who could not realistically aspire to compete at the top echelons of the game, baseball represented a different kind of freedom—the freedom to participate and to move freely, unencumbered by heavy garments or social strictures. A handful of women made their mark as players in the semiprofessional and barnstorming leagues, including Alta Weiss in the 1900s; first baseman Elizabeth Murphy, who played on men's teams in the 1920s and 1930s; and Jackie Mitchell, who as a 17-year-old struck out Babe Ruth and Lou Gehrig in an exhibition game. The All-American Girls Professional Baseball League filled a void for fans in the Midwest during World War II, playing first softball, but then a sharply competitive brand of hardball for most of its existence. The Negro leagues in their waning days in the 1950s featured three women as regular performers. More recently the Colorado Silver Bullets, an all-women's team, toured the nation. Ila Borders pitched first in college ball and later in the independent minor leagues. Women, however, have found the most widespread acceptance on softball fields, where they compete at the scholastic, collegiate, independent, and Olympic levels, partaking in an American tradition often unavailable to their forebears.

Baseball, of course, like American society, is not entirely free of the remnants of discrimination. Minorities and women remain underrepresented in the ranks of ownership and management. Episodes of racism and sexism periodically mar the game. Because of its often painful history and its close association with American values, baseball's social practices often come under closer scrutiny than that of other sports and establishments. Yet, as a whole, the notion that the sport "knows no race" now seems credible and viable, rather than hypocritical. If freedom implies an openness of opportunity unimpeded by artificial barriers or obstacles, baseball has achieved that ideal as well as any other American institution.

—Jules Tygiel

◆ Alta Weiss, the "girl wonder" of northern Ohio. Weiss was quite a pitcher in the first decade of the 20th century, playing on and against men's teams, and frequently winning. She grew to be such a draw that charter trains would arrive from Cleveland to see her pitch. She had a blazing fastball and, although "it's a little indelicate to say it," she once said, "I also learned to throw a spitball."

In 1907, Sol White's *History of Colored Baseball* illustrated how the national game had long reflected America's racial landscape. In writing this first comprehensive history of African Americans in baseball, White, the captain of the pre-Negro leagues Philadelphia Giants, also foresaw a day when attitudes might change.

Sol White 1907

History of Colored Baseball

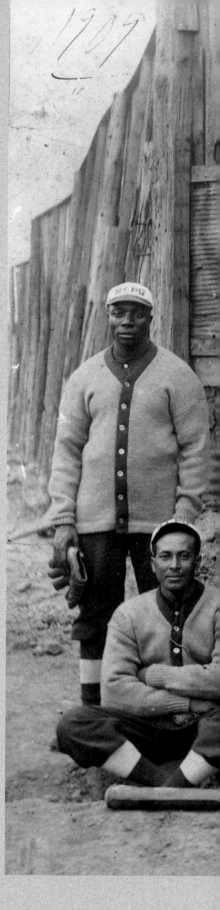

BASE BALL IS A LEGITIMATE PROFESSION. As much so as any other vocation, and should be fostered by owners and players alike. It is indisputably a masculine game, demanding all manly qualities and powers to the extreme. It is immune from attacks from all critics. From a scientific standpoint it outclasses all other American games. It should be taken seriously by the colored player, as honest efforts with his great ability will open an avenue in the near future wherein he may walk hand-in-hand with the opposite race in the greatest of all American games—base ball.

In no other profession has the color line been drawn more rigidly than in base ball. As far back as 1872 the first colored ball player of note playing on a white team was Bud Fowler, the celebrated promoter of colored ball clubs, and the sage of base ball.

The colored players are not only barred from playing on white clubs, but at times games are cancelled for no other reason than objections being raised by a Southern ball player, who refuses to play against a colored ball club. These men from the South who object to playing are, as a rule, fine ball players, and rather than lose their services, the managers will not book a colored team.

The situation is far different today in this respect than it was years ago. At one time the colored teams were accommodated in some of the best hotels in the country, as the entertainment in 1877 of the Cuban Giants at the McClure House in Wheeling, W. Va., will show.

The cause of this change is no doubt due to the condition of things from a racial standpoint. With the color question upper-most in the minds of the people at the present time, such proceedings on the part of hotel-keepers may be expected and will be difficult to remedy.

It is said on good authority that one of the leading players and a manager of the National League is advocating the entrance of colored players in the National League with a view of signing "Matthews," the colored man, late of Harvard. It is not expected that he will succeed in his advocacy of such a move, but when such actions come to notice there are grounds for hoping that some day the bar will drop and some good man will be chosen from out of the colored profession that will be a credit to all, and pave the way for others to follow.

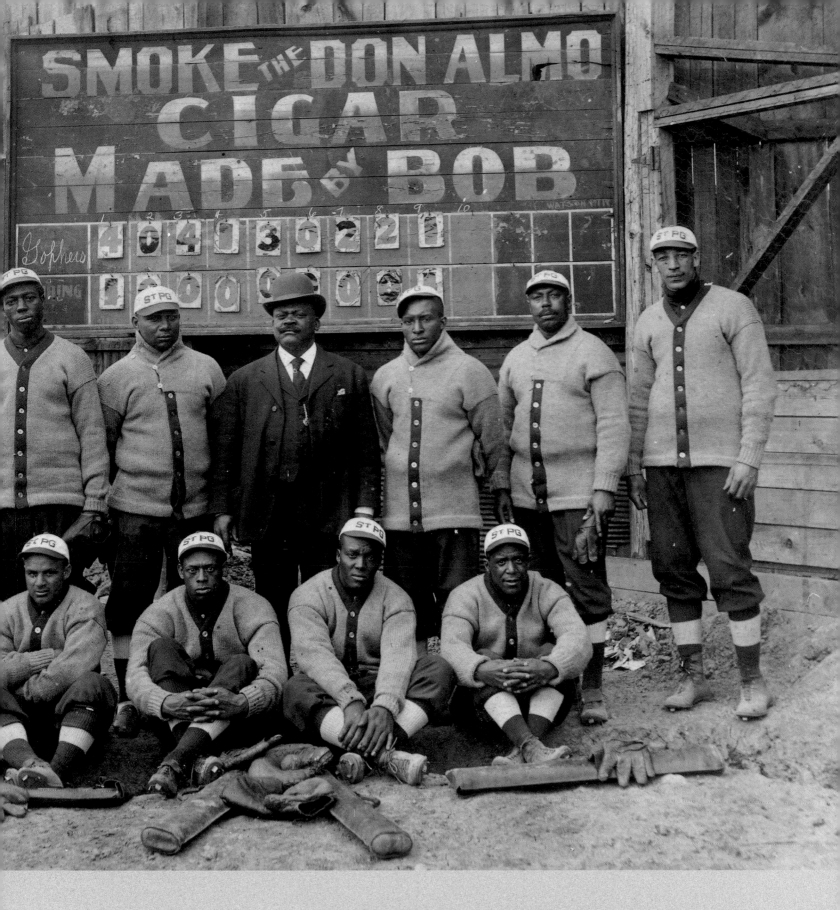

◆ The independent St. Paul Gophers. After defeating another all-black team, the Chicago Leland Giants, in a three-game series, the Gophers declared themselves the "Colored World's Champions" in 1909.

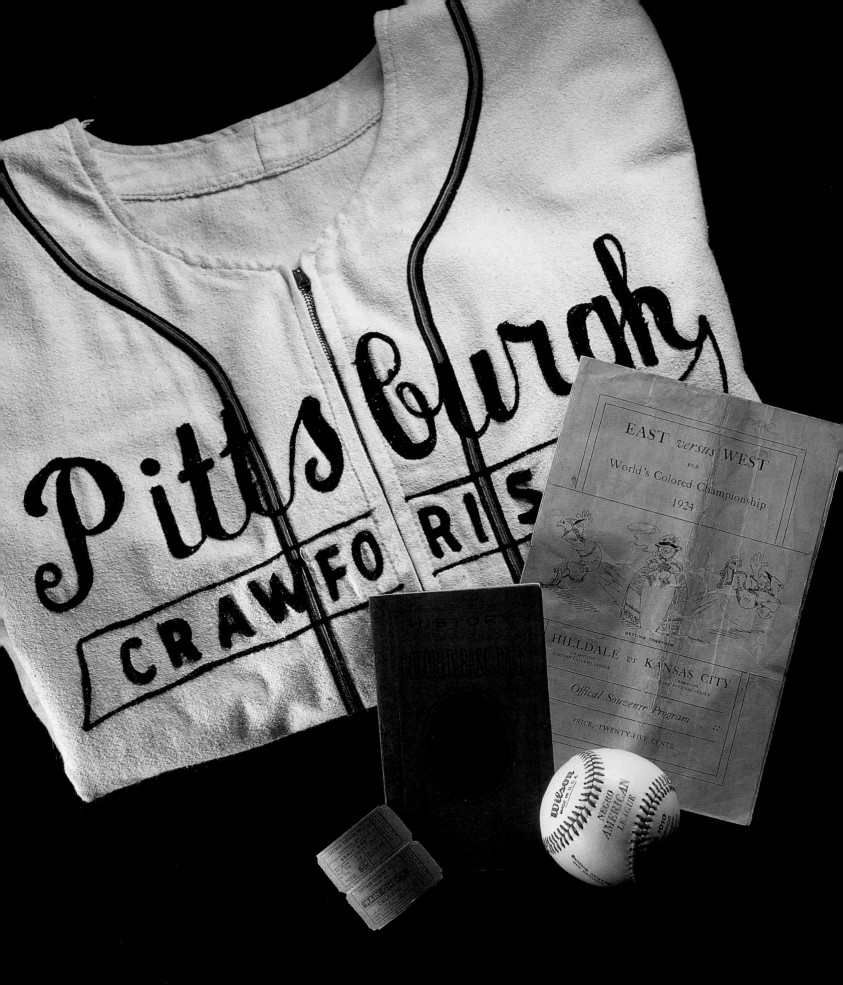

This Morning

The Washington Post

ORLANDO, FLA., APRIL 6 — There's a couple of million dollars worth of baseball talent on the loose, ready for the big leagues yet unsigned by any major league clubs. There are pitchers who would win 20 games this season for any big league club that offered them contracts, and there are outfielders who could hit .350, infielders who could win quick recognition as stars, and there is at least one catcher who at this writing is probably superior to Bill Dickey.

Only one thing is keeping them out of the big leagues —the pigmentation of their skin. They happen to be colored. That's their crime in the eyes of the big league club owners.

Their talents are being wasted in the rickety parks in the Negro sections of Pittsburgh, Philadelphia, New York, Chicago and four other cities that comprise the major league of Negro baseball. They haven't got a chance to get into the big leagues of the white folks. It's a tight little boycott that the majors have set up against colored players.

It's a sort of gentlemen's agreement among the club owners that is keeping Negroes out of big league baseball. There's nothing in the rules that forbids a club from signing a colored player. It's not down in black and white, so to speak. But it's definitely understood that no club will attempt to sign a colored player. And, in fact, no club could do that, because the elasticity of Judge Landis' authority would forbid it. And the judge can rule out of baseball any character whose presence he may deem "detrimental" to the game.

Just how a colored player would be detrimental to the game has never been fully explained, but that seems to be the light in which they are regarded by the baseball brass hats. Perhaps it is because there is such an overwhelming majority of Southern boys in big league baseball who would not take kindly to the presence of colored athletes and would flash a menacing spike, or so. Perhaps it's because baseball has done well enough without colored players. It's a smug, conservative business not given to very great enterprise and the introduction of new and novel features.

There have been campaigns aimed at smashing the boycott. One New York newspaper openly advocated the signing of Negro players, and Heywood Broun has often berated the baseball magnates for drawing the color line. But despite the presence of thousands of colored customers in the stands, the club owners have blithely hewed to the color line. They are content, seemingly, to leave well enough alone and make no concerted play for Negro patronage.

A $200,000 Catcher

But in its restricted localities, Negro baseball has flowered. There are Negro teams which now might do very well in big league competition even if they played as a Negro entity. The Homesteads of Pittsburgh are probably the best colored team. They train here in Florida each spring, even as do the American and National league teams. The other evening at Tinker Field, the Homesteads met the Newark Eagles of the same colored league. Curious Washington players flocked to the game, went away with a deep respect for colored baseball.

◆ A 1924 souvenir program from the first Colored World Series; a ball from the Negro American League, active until 1960; an original copy of 1907's *History of Colored Baseball*, by Sol White, captain of the Philadelphia Giants; two tickets to the colored-seating section of an Eastman, Georgia, Dodgers game in 1953; and a Pittsburgh Crawfords jersey from 1938.

Walter Johnson sat in a box at the game, profoundly impressed with the talents of the colored players. "There," he said, "is a catcher that any big league club would like to buy for $200,000. I've heard of him before. His name is Gibson. They call him 'Hoot' Gibson, and he can do everything. He hits that ball a mile. And he catches so easy he might just as well be in a rocking chair. Throws like a rifle. Bill Dickey isn't as good a catcher. Too bad this Gibson is a colored fellow."

That was the general impression among the Nats who saw the game. They liked the Homestead catcher, and they liked the big lanky Negro pitcher for the Homesteads who struck out 12 Newark players in five innings. They liked the centerfielder who can go a country mile for the ball, and they liked the shortstop, who came up with fancy, one-handed plays all night. They had to like 'em. They were swell ball players.

Johnson Was Mistaken

Negro baseball is now a flourishing game, but as long as 30 years ago, the colored folks had their swell ball teams. Walter Johnson, on a barnstorming trip in 1909 went to Harlem to pitch for a colored team against the Lincoln Giants.

"I didn't know it was to be a colored team," Johnson was saying, "but they were paying me $600 for the day's work and that was big money. I went up there with my catcher, Gabby Street. Gabby was from Huntsville, Ala., and he didn't like the idea of playing colored baseball, but the $300 he got was too much to overlook.

"It was the only time in my life that I was ever 2-to-1 to lose. Those were the odds they were offering against me. I'll never forget the first hitter I faced. He was an outfielder they called 'Home Run Johnson.' Up at the plate, he says to me, 'come on, Mr. Johnson, and throw that fast one in

Until last season there was a colored pitcher around named "Satchel" Page [sic]. The colored folks have a penchant for picturesque names for their idols and "Satchel" Page [sic] was so-called because of the size of his feet. He was 6 feet 3, a left-hander and a whale of a pitcher. "He retired last year at the age of 44," said Jimmy Wasdell, "and he was still a great pitcher. I've been on clubs that barnstormed against Negro teams and in a dozen games against this Page [sic] we never beat him. He beat Paul and Dizzy Dean one night, 1-0, and we got only one hit off him. I was the only minor leaguer on our club."

here an' I'll knock it over the fence.' That's what he did, too. But it was the only run they got off me and I won the game, 2-1.

"I didn't like the way this 'Home Run' Johnson was crowing about his hit, so the next few times up there I buzzed a couple close to his head just to scare him. He was hitting the dirt all day. Then in the last inning, he didn't even wait for me to cut loose. He ducked before I let the ball go. Then he got up off the ground to see what had happened and stuck his head in the way of a slow curve I had just cut loose."

◆ New York Black Yankees pennant. The Black Yankees played in the Negro National League from 1936 to 1948.

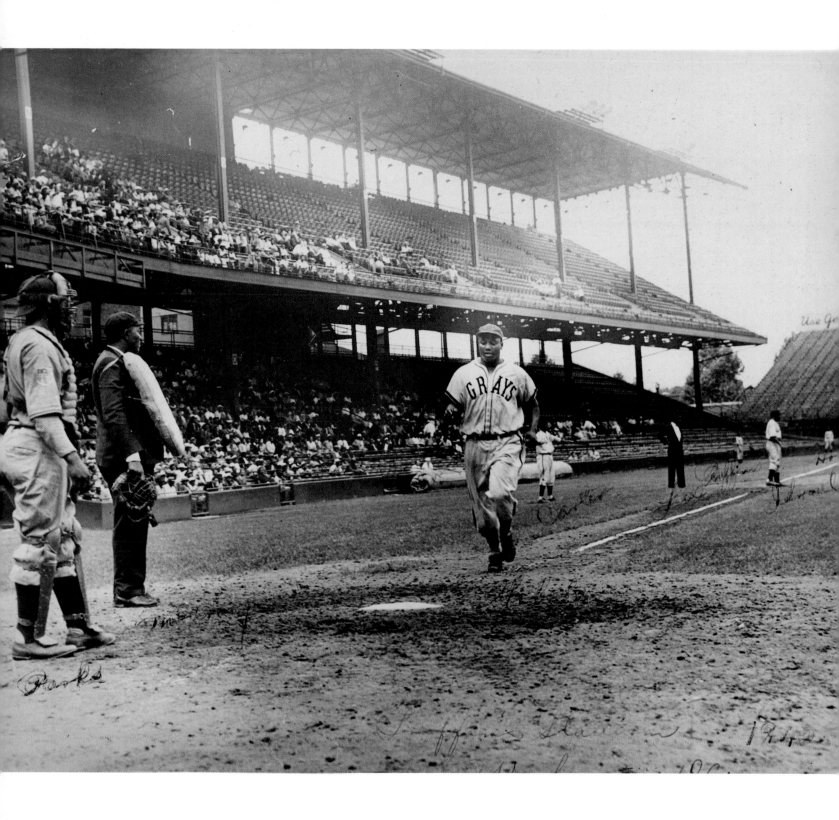

◆ In 1942, Josh Gibson of the Homestead Grays scores at Griffith Stadium in Washington, D.C., as
Newark Eagles catcher Charles Parks and umpire Fred McCrary look on. Negro league teams frequently
shared major league stadiums, playing while the white teams were on the road.

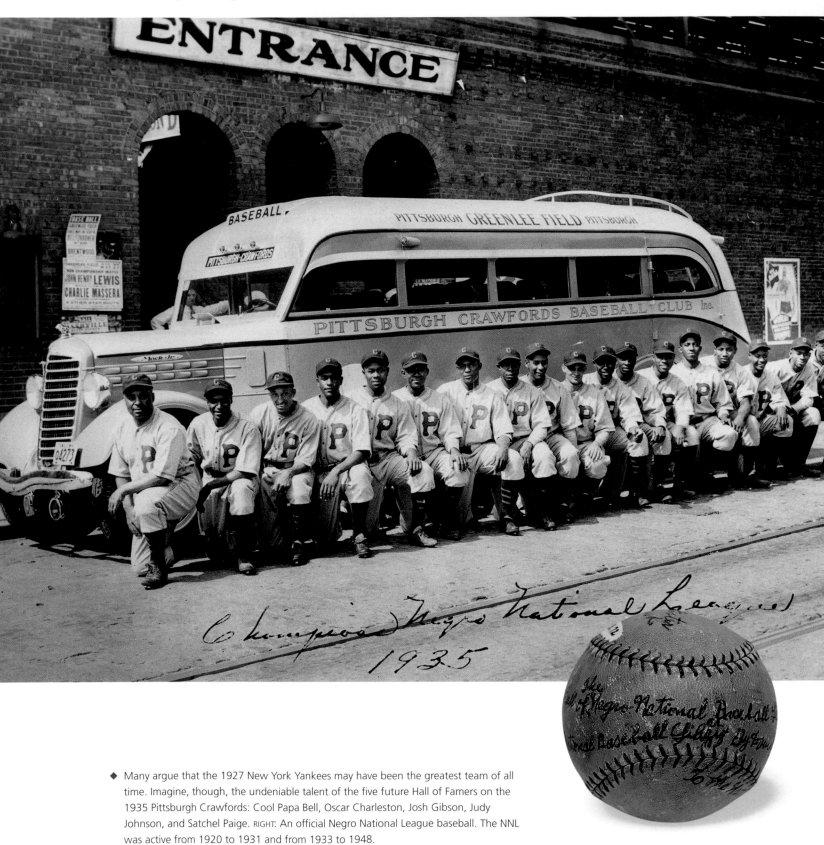

◆ Many argue that the 1927 New York Yankees may have been the greatest team of all time. Imagine, though, the undeniable talent of the five future Hall of Famers on the 1935 Pittsburgh Crawfords: Cool Papa Bell, Oscar Charleston, Josh Gibson, Judy Johnson, and Satchel Paige. RIGHT: An official Negro National League baseball. The NNL was active from 1920 to 1931 and from 1933 to 1948.

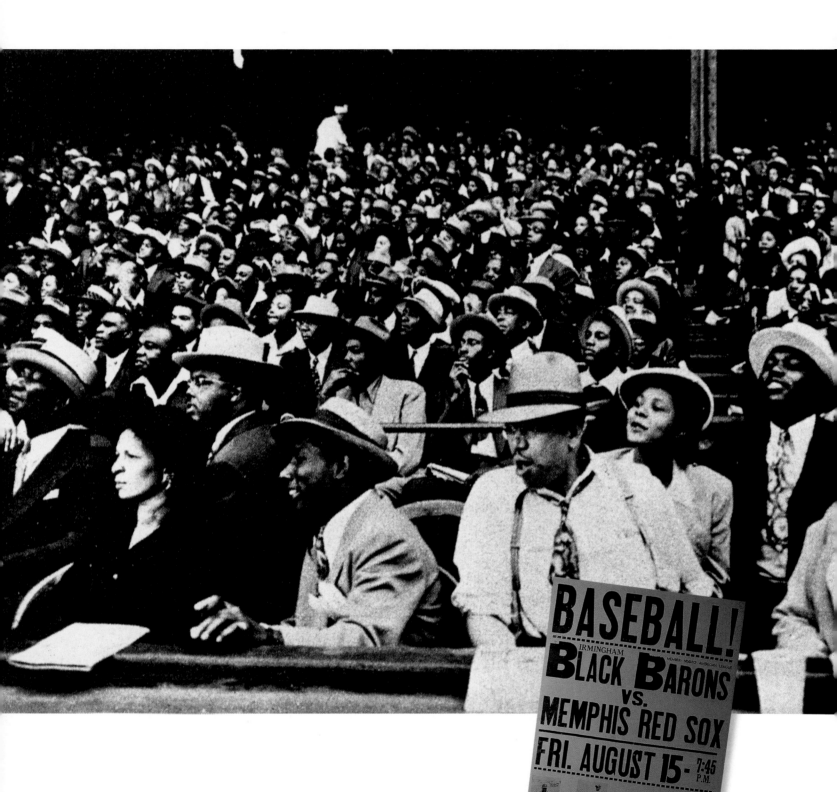

◆ Thousands of fans turned out to see the great Negro league teams play, and the games were an important recreational activity and source of pride for the African-American community. Teams played regular schedules and also "barnstormed," picking up games wherever possible, as this poster depicting a game between Memphis and Birmingham, held in Indianapolis, attests.

F. H. LaGuardia 1945

Letter of Invitation

My Dear Dr. Johnson:

For some time there has been a great deal of discussion concerning the color line in organized baseball. Everyone knows that baseball is our national game. It is enjoyed and played by all from childhood up regardless of race, creed or color. Perhaps the best proof of complete assimilation has been given by ball players, the sons of recent immigrants. I am sure you will agree that we should do everything possible to avoid anything marring our national game.

The subject has not been overlooked by the officials of the two major leagues. A preliminary survey has been made by the Mayor's Committee on Unity. Many conferences have been held between the Executive Director of the Committee, baseball officials and people interested in the game. It is my understanding that the National League has designated Mr. Branch Rickey, Sr. of the Brooklyn Ball Club and the American League has designated Colonel Larry MacPhail of the New York Baseball Club. Mr. Dan W. Dodson, Executive Director of the Committee on Unity, has conferred with both of these gentlemen. It seems to me at this point that while everybody is interested, nothing is being done.

Therefore at the request of Mr. Charles E. Hughes, Jr., Chairman of the Committee on Unity, I am appointing a Committee to give this one subject thorough study and make specific recommendations to the major leagues. Any plan accepted by the major leagues would automatically revert to the minor leagues.

Because of your interest in baseball as well as the racial aspects involved, I would greatly appreciate your acceptance to serve on this committee. While I know that this will take some time and careful consideration, the matter really is of such public interest that I feel free to call upon you.

Very truly yours,

F. H. LaGuardia
Mayor

⬦ Two groups of Chattanoogans clutch their Walter Johnson board games and await the arrival of their favorite star. While assembled for the same purpose, white and black citizens were kept separate on such occasions by law and traditions.

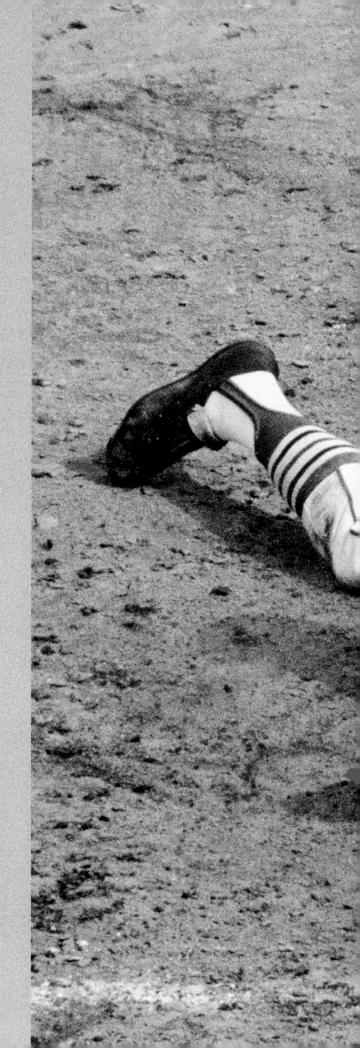

Racial integration was not a single event but a gradual process. Former Chicago Cubs coach Buck O'Neil, recalling fan pressure against a majority black lineup, describes the decision to trade African-American Lou Brock for Ernie Broglio in 1964. Brock went on to play for 15 more record-setting years, ultimately entering the Baseball Hall of Fame.

Buck O'Neil

It Didn't Happen Overnight

PEOPLE ASK ME ABOUT how quickly baseball changed after Jackie Robinson broke the color barrier. I tell them it wasn't just baseball; it was all of us. And it didn't happen overnight; it took time. There were men in the Negro leagues who should have been in the major leagues, but during that time there was an unwritten quota system. They didn't want but so many black kids on a major league ballclub. That held true even after the Negro leagues were gone.

In the early 1960s, I was a coach for the Chicago Cubs. We had four black kids playing there and the fifth one was Lou Brock. He was a good outfielder, but we already had three black outfielders; our first baseman was Ernie Banks, and the decision was made to trade Brock to St. Louis. I spoke to our general manager, John Holland, and said, "I don't think we should trade Brock, because I don't think we'll have our best ball club on the field." And Mr. Holland said, "Buck, I want to show you something. Look at that basket." And he started pulling out letters and notes from people, season ticket holders, saying that their grandfather had season tickets here at Wrigley Field, or their grandmother had season tickets here at Wrigley Field, and their families had come here for years. And do you know what these letters went on to say? "What are you trying to make the Chicago Cubs into? The Kansas City Monarchs?"

So we traded Lou to the St. Louis Cardinals in the middle of the 1964 season, where he helped them win a couple of World Series. He went on to set all-time stolen base records—season and career— and earned himself a plaque in Cooperstown. People always ask me if I felt bad about trading him away, but I just felt happy for Lou.

Well, this is the way it was then, but we changed all that, and we did it all together, baseball and America. That's what's important to remember.

◆ Future Hall-of-Famer Lou Brock dives back into first base against the Boston Red Sox during Game Three of the 1967 World Series. Brock stole a record 938 bases over his career to break Ty Cobb's 60-year-old modern mark.

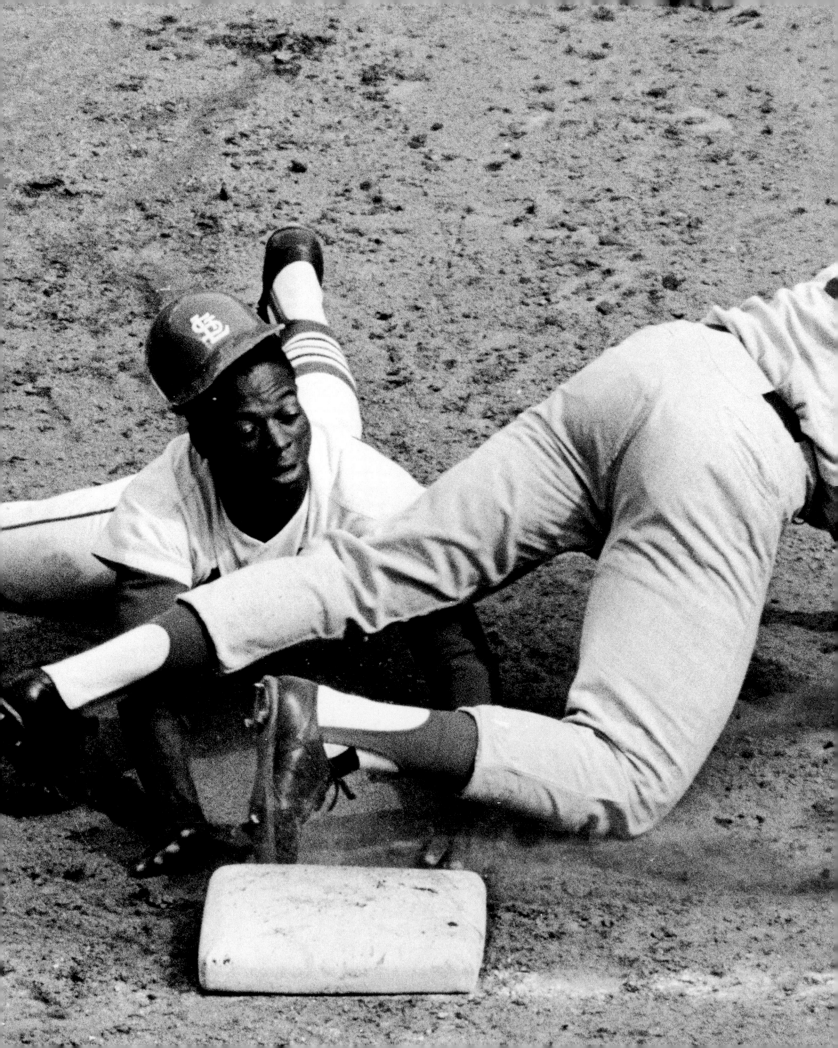

Baseball and Ethnicity

BASEBALL TODAY IS A WORLDWIDE GAME. The major leagues include a broad cross section of Americans, as well as men from such distant lands as the Dominican Republic, Canada, Australia, Korea, and Japan. Recruitment patterns were originally far different, however.

Most players in the first major league, the National Association (1871-1875), were White Anglo-Saxon Protestant (WASP), and the rest were nearly all well-acculturated second-generation Irish or German. For the next

> "NOTICE TO FIRST BASEMEN --The National Club of Washington are looking for a first baseman about here. They have been to Brooklyn, but they were not successful in obtaining one. Terms -- First-rate position in the Treasury Department; must work in the Department until three o'clock, and then practise at base ball until dark. 'No Irish need apply.'"

25 years, approximately 90 percent of the players in the National League (1876-) and American Association (1882-1891) were WASP, Irish, or German.

The WASP proportion declined a bit in the early days of the National League, when the occupation had little prestige, yet rose around the turn of the 20th century with the lure of higher salaries and enhanced status. Irish Americans, the poorest of the old European immigrant groups, were baseball fanatics and saw baseball as a vehicle of social mobility. Stars like Mike "King" Kelly and the large numbers of Irish fans misled the public into believing that the Irish dominated the game. Yet they were outnumbered both by WASPs and German

Americans, who comprised 30 percent of rookies.

There were also African-American players in the late 19th century, and from 1883 through 1898, 74 played in organized baseball, mostly on all-black teams. They included Moses Fleetwood Walker and his brother Welday, who in 1884 played in the majors for Toledo of the American Association. Fellow players and fans, however, mistreated them—a reflection of the pervasive racism of Jim Crow America—and teams simply stopped signing them in the years prior to the turn of the century.

Despite American racial prejudices, about 20 Native Americans had played in the majors by 1920. The public saw this as evidence of the sport's democratic recruitment policies. The Native Americans included Louis Sockalexis, who played for Cleveland (NL) from 1897 to 1899; Jim Thorpe, hero of the 1912 Olympics; and Albert "Chief" Bender, star pitcher for the Philadelphia Athletics.

Colonial Cuba was one of the first foreign lands to adopt the American national pastime, with many players viewing the game as a symbol of freedom and democracy. Professional teams visiting Cuba in the early 1900s encountered such strong competition there that, in 1911, Clark Griffith of the Cincinnati Reds decided to sign Armando Marsans and Rafael Almeida, carefully noting they were white Cubans with pure Spanish blood. Racism, however, blocked the recruitment of Afro-Cubans in America, other than those signed by the Negro leagues.

Few of the players in the early 1900s were

◆ Job advertisement from the *American Chronicle of Sports and Pastimes*, July 2, 1868. Though the National Club of Washington needed a first baseman badly enough to advertise, they were not willing to take on Irish applicants, as the last line states. Within a decade, the Irish would not only integrate but, arguably, dominate baseball.

second-generation eastern or southern Europeans. Many in this group loved baseball, viewing the sport as a means to become real Americans and a chance to embrace such values as teamwork and a respect for authority. But, they had insufficient playing experience to become professionals. These inner-city youths lacked accessible ball fields and often did not stay long in school, therefore missing out on interscholastic competition. Furthermore, if they harbored baseball ambitions, their dreams generally met with little parental support. As entertainer Eddie Cantor put it, "To the pious people of the ghetto, a baseball player was the king of loafers."

There were just seven Bohemian, Jewish, or Italian rookies in the years of 1901 to 1906, none in 1910, and three in 1920—and they encountered a lot of discrimination. According to David Spanier's article on Jewish ballplayers in *Total Baseball*, the first five "Cohens" in the majors all employed pseudonyms (Sammy Bohne, Ed Corey, Reuben Ewing, Harry Kane, and Phil Cooney) to protect themselves against anti-Semitism.

In the 1920s, the New York Giants tried to recruit Jewish players to bring in Jewish fans, with one of the rare successes being Andy Cohen, in 1928 to 1929. During the 1930s, though, ballplayers of eastern and southern European extraction became increasingly visible, growing from 7 percent of the rookies in 1930 to nearly 20 percent by 1940. Thanks to the effects of greater assimilation, Hank Greenberg, Al Simmons (Aloys Szymanski), and Joe DiMaggio lived in cities and neighborhoods with baseball diamonds, stayed longer in school, and became very skilled players.

The best contemporary African-American ballplayers were limited to touring squads and the popular Negro National League, founded in 1920. The teams were popular institutions that promoted community pride and provided a setting for stars like Satchel Paige and Josh Gibson to demonstrate their prowess. In 1946, of course, the color line was broken when the Dodgers' Branch Rickey signed Jackie Robinson for the Montreal Royals of the International League. In 1947, Robinson arrived in Brooklyn and his dignity and restraint in the face of prejudice from opponents and spectators, combined with his Rookie of the Year achievements on the field, blazed a path. But, even though African Americans won the Rookie of the Year award five times and the MVP award three times in the 1949 to 1953 seasons, reintegration in baseball moved slowly. Until September 1953, only six teams had African-American players, and the last team to integrate was the Boston Red Sox, in 1959.

By 1960, the proportion of black Americans in the majors reached 9 percent, just a hair under the group's share of the national population, according to Gerald W. Scully's article "Discrimination: The Case of Baseball" in *Government and the Sports Business*. That percentage peaked in 1974 at 26 percent. Since then, many outstanding black athletes have opted for football and basketball, and their representation in baseball had fallen to 14 percent in 1998. On the other hand, there has been a dramatic increase among Latin Americans, from 4 percent in 1950 to over 20 percent in 2000. The Dominican Republic, where baseball is a passion and a means to escape poverty, produces nearly one-tenth of all major leaguers today.

◆ Silver trophy presented to Cleveland Indians pitching star Stan Coveleski by the "Polish Boys of Cleveland," who were saluting one of their own. The trophy features the original spelling of his name: Kowalewski.

The Internment Camp Champions

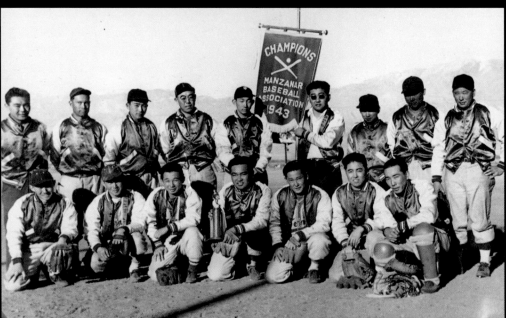

Team photo and jersey from the San Fernando Aces in Manzanar internment camp, 1943.
The Aces, a prominent prewar Japanese-American team, went into Manzanar nearly intact and
won that camp's baseball championship in 1943. OPPOSITE: Wooden home plate, made by
internees at the Gila River Relocation Center in Arizona, 1943.

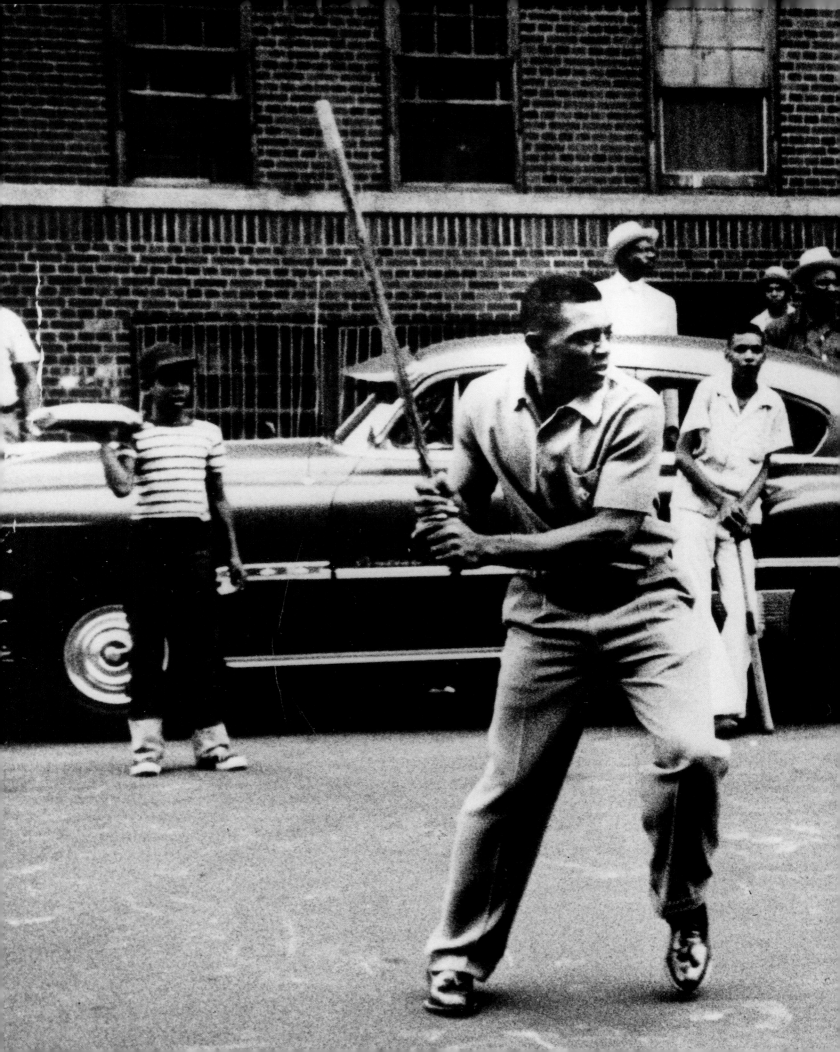

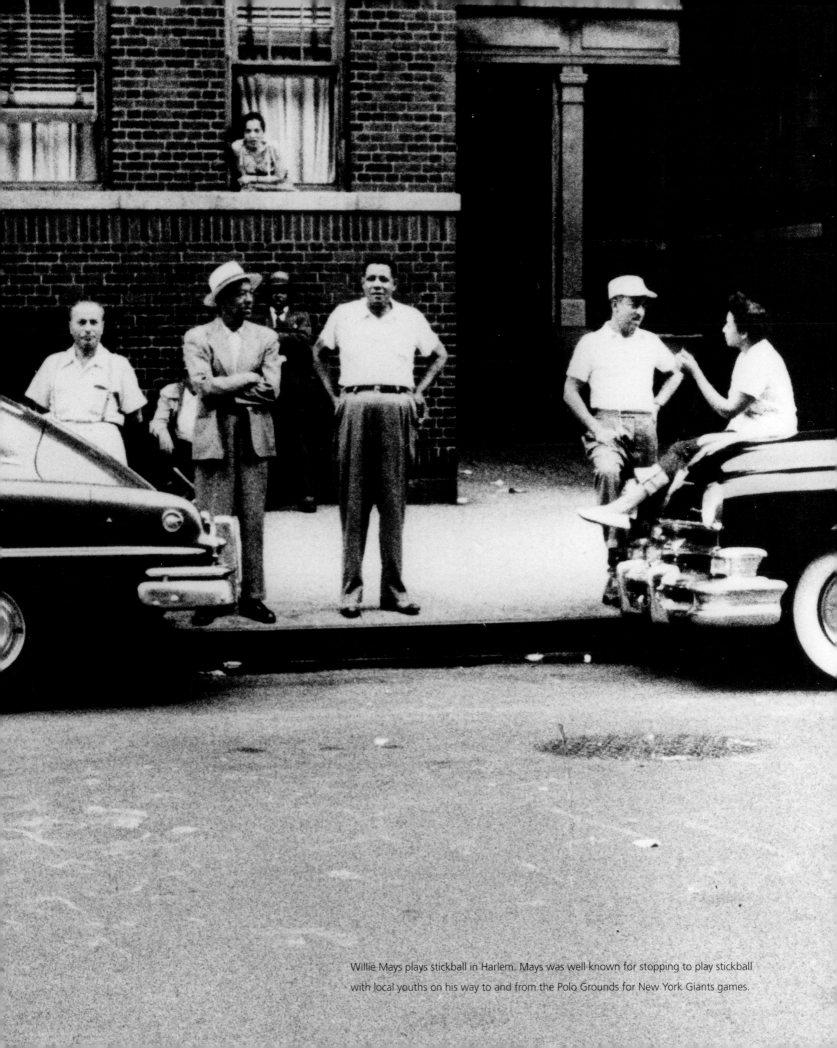

Willie Mays plays stickball in Harlem. Mays was well known for stopping to play stickball with local youths on his way to and from the Polo Grounds for New York Giants games.

My Baseball Years

IN ONE OF HIS ESSAYS, George Orwell writes that though he was not very good at the game, he had a long hopeless love affair with cricket until he was sixteen. My relations with baseball were similar. Between the ages of 9 and 13, I must have put in a forty-hour week during the snowless months over at the neighborhood playfield—softball, hardball, and stickball pick-up games—while simultaneously holding down a full-time job as a pupil in the local grammar school; as I remember it, news of two of the most cataclysmic public events of my childhood—the death of President Roosevelt and the bombing of Hiroshima—reached me while I was out "playing ball." My performance was erratic; okay for those easy-going pick-up games, but lacking the calm and the expertise that the naturals displayed in stiff competition. My taste, and my talent, such as it was, was for the flashy, whiz-bang catch rather than the towering fly ball; running and leaping I loved, all the do-or-die stuff—somehow I lost confidence waiting and waiting for the ball lofted right at me to come down. I could never make the high school team, yet I remember that in one of the two years I vainly (in both senses of the word) tried out, I did a good enough imitation of a baseball player's style to be able to fool (or amuse) the coach right down to the day he cut the last of the dreamers from the squad and gave out the uniforms.

My disappointment, keen as it was, did not necessitate a change in my plans for the future. Playing baseball was not what Jewish boys of our lower-middle class neighborhood did in later life for a vocation. Had I been cut from

the high school itself, then there would have been hell to pay in my house, and much confusion and shame in me; as it was, my family took my chagrin in stride and lost no more faith in me than I actually did in myself. They probably would have been shocked if I had made the team.

Maybe I would have been, too. Surely it would have put me on a somewhat different footing with this game that I loved with all my heart, not simply for the fun of playing it (fun was secondary, really), but for the mythic and esthetic dimension that it gave to an American boy's life (particularly one whose grandparents hardly spoke English). For someone whose roots in America were strong but only inches deep, and who had no experience, such as a Catholic child might, of an awesome hierarchy that was real and felt, baseball was a kind of secular church that reached into every class and region of the nation and bound us together in common concerns, loyalties, rituals, enthusiasms, and antagonisms. Baseball made me understand what patriotism was about, at its best.

To sing the National Anthem in school auditorium every week, even during the worst of the war years, generally left me cold; the enthusiastic lady teacher waved her arms in the air and we obliged with the words: "See! Light! Proof! Night! There!" Nothing stirred within, strident as we might be—in the end just another school exercise. But on Sundays out at Ruppert Stadium (a green wedge of pasture miraculously walled in among the factories, warehouses and truck depots of Newark's industrial "Ironbound"

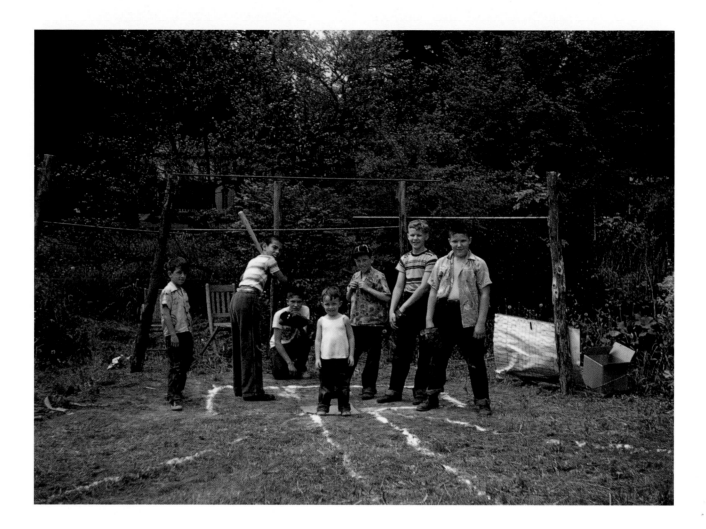

section), waiting for the Newark Bears to take on the enemy from across the marshes, the hated Jersey City Giants (within our church the schisms are profound), it would have seemed to me an emotional thrill forsaken, if we had not to rise first to our feet (my father, my brother, and me—together with our inimical countrymen, Newark's Irishmen, Germans, Italians, Poles, and out in the Africa of the bleachers, Newark's Negroes) to celebrate the America that had given to this disparate collection of men and boys a game so grand and beautiful.

Not until I got to college and was introduced to literature did I find anything with a comparable emotional atmosphere and as strong an esthetic appeal. I don't mean to suggest that it was a simple exchange, one passion for another. Between first discovering the Newark Bears and the Brooklyn Dodgers at age 7 or 8 and first looking into Conrad's *Lord Jim* at age 18, I had done some growing up. I am only saying that my discovery of literature, and fiction in particular, and the "love affair"—to some degree hopeless, but still earnest—that has ensued, derives in part from this childhood infatuation with baseball. Or, perhaps more accurately, baseball, with its lore and legends, its cultural power, its seasonal associations, its native authenticity, its simple rules and transparent strategies, its longeurs and thrills, its spaciousness, its suspensefulness, its peculiarly hypnotic tedium, its heroics, its nuances, its "characters," its language, and its mythic sense of itself, was the literature of my boyhood.

◆ Backyard boys play ball in rural New York.

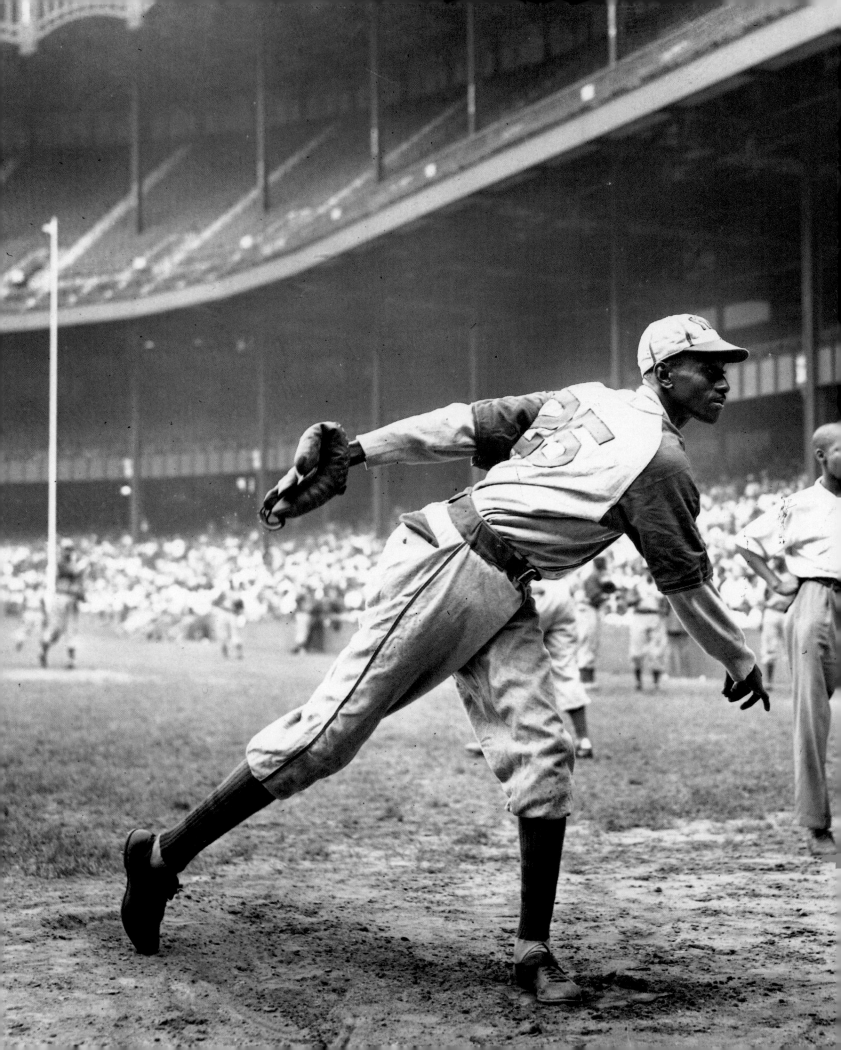

When Ted Williams stood to accept his induction into the National Baseball Hall of Fame in 1966, listeners expected a typical "thank you." Instead, the Boston Red Sox outfielder, and one of baseball's greatest hitters, surprised the crowd with a call to honor African Americans Satchel Paige and Josh Gibson, excerpted here.

Ted Williams 1966

Induction Speech

INSIDE THIS BUILDING are plaques dedicated to baseball men of all generations and I'm privileged to join them. Baseball gives every American boy a chance to excel, not just to be as good as someone else, but to be better than someone else. This is the nature of man and the name of the game, and I've always been a lucky guy to have worn a baseball uniform, to have struck out or to hit a tape-measure home run. And I hope that someday the names of Satchel Paige and Josh Gibson in some way can be added as a symbol of the great Negro players that are not here only because they were not given a chance. [Applause] As time goes on, I'll be thinking baseball, teaching baseball, and arguing for baseball to keep it right on top of American sports just like it is in Japan and Mexico, Venezuela, and other Latin and South American countries.

◆ Legendary pitcher Satchel Paige of the Kansas City Monarchs warms up at Yankee Stadium. Though Negro league statistics are sketchy, Paige is widely considered one of the greatest pitchers of all time, in either the Negro leagues or the majors.

History hails Jackie Robinson for breaking baseball's color barrier in
1947. But his triumph as a civil rights pioneer often overshadows his
greatness and skill as an athlete. In Robinson's ten years with the
Dodgers, the future Hall of Famer led the team to six pennants, batted
.311, and was named to six All-Star squads.

Jackie Robinson 1972

World Series Speech

I WOULD JUST LIKE TO SAY that I was really just a spoke in the
wheel of the success that we had some 25 years ago, and per-
sonally want to say thank you to a great captain, a guy who was
a leader of our ball club and who really set the pace in many,
many areas. Pee Wee [Reese], thanks so much for being here
today.

I would like to also say that it would be a real, real pleas-
ure if Mr. Rickey could have been here with us today, but to the
members of his family my entire love and gratitude for the
things that he's done over the years.

And I also want to say how pleased I am that my family
can be here this afternoon, and to thank baseball for the tremen-
dous opportunities that it has presented to me and also for this
thrilling afternoon.

I am extremely proud and pleased to be here this after-
noon, but must admit I'm gonna be tremendously more pleased
and more proud when I look at that third base coaching line
one day and see a black face managing in baseball.

Thank you very much.

◆ Lobby card used to promote the 1950 movie *The Jackie Robinson Story*.
The film, in which Robinson played himself, was notable in that it was
one of the earliest films in which an African-American hero was marketed
to an audience of all Americans, black and white.

JACKIE ROBINSON
"The Pride of Brooklyn"
as HIMSELF

MINOR WAT
as "Branch Rick
BILLY WAYNE as "Clyde S

Copyright 1950 Pathe Industries, Inc.

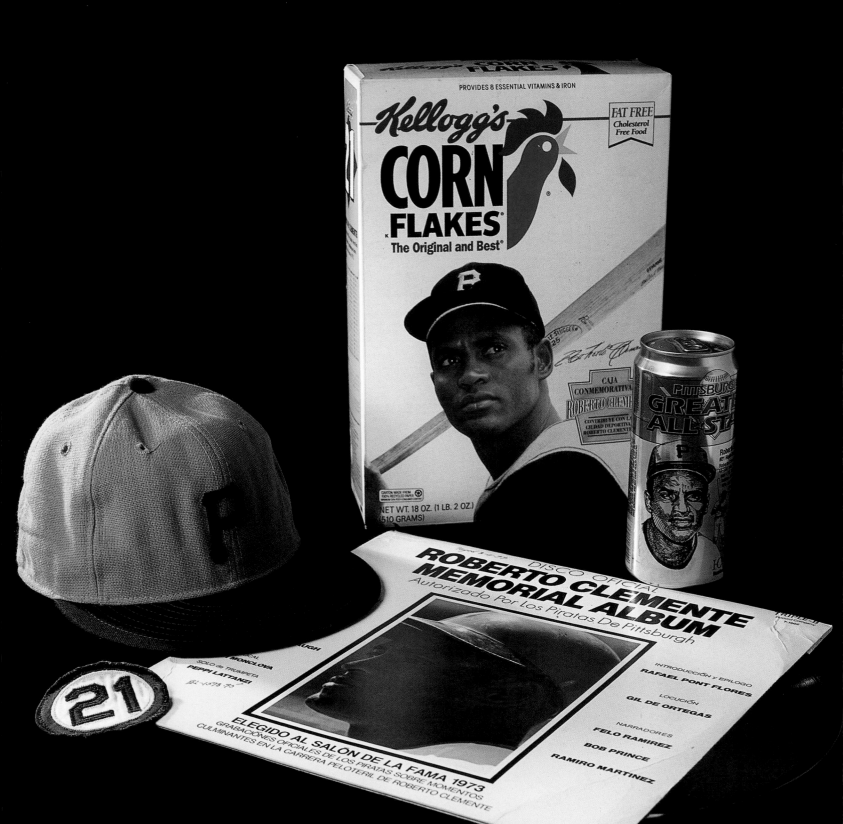

BRUCE MARKUSEN

Roberto Clemente: Activist and Pioneer

WHEN ROBERTO CLEMENTE REPORTED to the Pittsburgh Pirates' spring training camp for the first time in 1955, he encountered racism almost immediately. Due to a sports segregation ordinance adopted in 1954, the Pirates' three dark-skinned players could not dress for an exhibition game in Birmingham, Alabama. For the first time in his life, Clemente had been told he could not play because of the color of his skin.

However, overt racism ranked as only one of many ethnic problems that the native of Puerto Rico faced. "He was in a cultural twilight zone," former teammate Nellie King said of Clemente, who was forced to adjust to a completely different set of behavioral patterns in the United States.

For example, Clemente bristled when others called him "Bob" or "Bobby" in an ignorant, perhaps inadvertent attempt to Americanize him, evidenced even in the baseball cards of the day. Prior to 1970, most of Clemente's cards portrayed him as "Bob Clemente." Yet, Clemente preferred to be known as Roberto—a reflection of pride in his Puerto Rican heritage.

Clemente also had to grapple with the English language, which made his relationship with the media especially contentious. As Hall of Famer Bill Mazeroski wrote in the November 1971 issue of *Sport* magazine, Clemente struggled to overcome the language barrier during his early years.

"He went through some years when he didn't trust writers, and I don't blame him. Some of them put words in your mouth," Mazeroski wrote. "He was just learning to handle the language and he couldn't express what he felt

... and it frustrated him. Writers who couldn't speak three words of Spanish tried to make him look silly, but he's an intelligent man."

The language barriers that made Clemente uncomfortable with reporters also created problems in game situations. During a 1955 exhibition game, both Clemente and Cuban-born Román Mejías ran through their third base coach's stop signs, costing the Pirates two potentially high-scoring innings. After the game, manager Fred Haney held a meeting with the two rookies, whose inability to fully understand their coach's words had contributed to their base-running mistakes. To his credit, Haney took some initiative, buying a Spanish-language dictionary that would help him communicate with the confused men.

Although Haney had made an effort to communicate with Clemente in Spanish, few of his teammates extended olive branches. The Pirates of 1955, like most ball clubs, consisted of several fragmented units. There were the fading veterans who wanted to hold on to their tenuous positions with the team and therefore made little effort to help rookies who, like Clemente, posed a threat to their playing time. There were several white players who showed little tendency to associate with black players, a group that included the dark-skinned Clemente.

Unfortunately, major league teams of that era did not feature employees who could bridge the gap between the white veterans and the youthful minorities on the Pirates. "Remember it was only eight years after [Jackie] Robinson broke the color barrier," said Luís Mayoral, a friend of

◆ Roberto Clemente of the Pittsburgh Pirates, the first Latin American superstar, died in 1972 when his plane crashed as he attempted to deliver relief supplies to Nicaraguan earthquake victims. The Pirates wore a patch with his uniform number, "21," the following season, and various other memorial and commemorative items continue to be produced.

Clemente who has served as a liaison for Latin American players with the Texas Rangers and Detroit Tigers. "So, Roberto had his struggles. There was not, like me, a guy to … help the Anglos bridge with the Latinos. And remember he was alone. He was alone in a country he didn't know."

Other than his roommate, Mejías, Clemente had only one other Latin American teammate during his first season, Mexican outfielder Felipe Montemayor. He had only one teammate of African-American descent, infielder Curt Roberts, the first black player in the history of the Pirates. Clemente didn't like the way that opposing players taunted Roberts with racial slurs. Sometimes, Clemente walked to the far end of the dugout, so he wouldn't have to hear words like "nigger" coming from opposing players. Clemente also resented that his teammates failed to defend Roberts from the opposition's racial slurs and were also guilty of treating him with disrespect.

Rather than let such behavior pass without comment, Clemente took a stand. "I didn't like some of the things the white players said to Roberts," Clemente recalled in an interview with UPI baseball editor Milton Richman, "so I said some things to them they didn't like." Despite the tension, Clemente eventually became a star, winning the first of his four batting titles in 1960 and emerging as the game's premier defensive right fielder. Fortunately, the Pirate players' treatment of their black teammates improved during the early 1960s, when the team's racial composition gradually started to shift. As additional blacks and Latinos joined the major league roster, Clemente's play improved even more, and he began to feel more comfortable with his surroundings. More importantly, he started to assert his own leadership skills.

Clemente proved helpful in the ways that he made rookie players on the Pirates—especially Latinos—feel welcome. "[Roberto] reacted more to rookies than to guys who had been around for a while," Steve Blass wrote in a 1973 edition of *Sport* magazine, "maybe because he would've liked someone to have helped him when he was a rookie."

In 1967, a 23-year-old Panamanian catcher made his major league debut with the Pirates. As a young Latino, Manny Sanguillen endured his share of problems adjusting to life in the National League. Blass wrote, "[Roberto] had known the same problems—the new language, getting acclimated to the big league atmosphere, the way to deal with the media, where to eat on the road, how to dress." Not surprisingly, Clemente and Sanguillen soon became the best of friends.

As the team's resident superstar—and one of the game's greatest all-around players of the 1960s—Clemente also acted as an intermediary between the Latin American players on the Pirates and the team's administration. If a Latino player had a complaint, Clemente tried to resolve the situation by providing advice, which included sharing his own experiences of the obstacles he had encountered.

The Pirates of the late 1960s and early '70s featured the most ethnically diverse makeup of any team in the major leagues, supplying the atmosphere ripe for racial tension. Such problems rarely occurred, however. Clemente, Steve Blass, Gene Clines, Dave Giusti, and Willie Stargell, along with coach Dave Ricketts, helped instill feelings of racial harmony. They kept the clubhouse atmosphere light by instigating friendly verbal bouts. Clemente and Giusti often needled each other to the point of hysterics, drawing roars of laughter from other players.

"The by-play between him and Dave Giusti became almost a ritual for us," Blass wrote. "Any subject and suddenly they'd be hollering and insulting each other. [Roberto] was our player rep before Dave and when something would come up, he'd say, 'When I was the player rep, we never had these kinds of problems, but you give an Italian a little responsibility and look what happens.'"

On other teams, such racial jousting might have led to warfare in the clubhouse, but with the Pirates, players generally doled out ethnic humor good-naturedly and did not take the banter personally. Two players, in particular, deserved much of the credit for promoting clubhouse unity.

"The reason why we did get along so well is because

of the leadership that we had with a Clemente and a Stargell, mainly," Giusti said. "It was just understood that there was instant respect for those two, and also respect for anybody else. Clemente was outstanding in that area. I can recall a number of times when people were having problems, and he would sit people down … and just go over things, that baseball is not everything, [that] it's your family and how you get along with people that are more important …. And I think that more than anything else was the answer to why we got along so well with each other."

Clemente's concerns for Latino players stretched beyond the Pirates to include Latino players on other major league teams. His hope for improved racial relations throughout baseball reached a pinnacle prior to the 1971 season. That winter, Clemente made a stirring speech at the annual baseball writers' dinner in Houston where he received the Tris Speaker Award for contributions to the game. Rather than recite a clichéd baseball speech, Clemente

spoke sincerely about his own philosophical views.

"We must all live together and work together, no matter what race or nationality," Clemente told 800 guests at the Astroworld Hotel ballroom. At the end of his speech, the large crowd of baseball writers and dignitaries showered Clemente with a standing ovation. According to the *Sporting News*, one writer called it "the best talk any baseball player ever made." In the most important part of his speech, Clemente urged the members of the audience to become active in improving their communities.

"Any time you have the opportunity to accomplish something for somebody who comes behind you and you don't do it," said Clemente, "you are wasting your time on this Earth."

Those words became possibly the most famous uttered by Clemente during his 38 years and characterized the philosophy of one of the game's most caring humanitarians and racial pioneers.

◆ Until late in his career, the press and others tried to anglicize Clemente's image, calling him Bob instead of his preferred "Roberto." A 12-time All-Star with a lifetime batting average of .317, Clemente led the National League in batting average four times, was known as an excellent defensive outfielder, and helped the Pirates to world championships in 1960 and 1971.

MILTON JAMAIL

Baseball Migrants: Dreaming in Dominican

DREAMING OF PLAYING IN THE MAJOR LEAGUES is as Dominican as sugarcane or merengue, the national music. Introduced to the Dominican Republic in the 1890s by Cubans associated with the sugar industry, baseball soon became the national sport and a national passion.

"In the Dominican Republic, baseball has a place all out of proportion to the normal one of sport in society," writes Alan Klein in his study of Dominican baseball, *Sugarball.* "There is nothing comparable to it in the United States, nothing as central, as dearly held as baseball is for Dominicans."

In the United States, baseball competes with basketball, football, and soccer for the top athletes; in the Dominican Republic, the most talented young men choose baseball. The sport is so prevalent in the island nation that one is reminded of the sandlot games played by children after school in New York City during the 1940s and 1950s. Alongside any road in the rural areas or in the cities and towns of the Dominican Republic, boys can be seen playing on makeshift diamonds.

And all roads are perceived as possibly leading to the big leagues.

Quite simply, Dominicans are so good at baseball today because it is the preferred game of young boys, who embrace and understand the sport and live in a tropical climate that allows for year-round play. The intense drive to excel in baseball is derived from the love of a game that permits young men to dream of escaping poverty. This route to a better life doesn't exist in Haiti, the country that shares the island of Hispaniola with the Dominican Republic. In Haiti, the national sport is soccer, and its stellar athletes dream of playing in the World Cup, not the World Series.

These days, with the amazing success of three-time Cy Young winner Pedro Martínez and slugger Sammy Sosa among so many others, it is difficult to imagine a time when there were no Dominicans in the majors. However, although Cuban, Mexican, Puerto Rican, and Venezuelan players had arrived on the scene by 1942, it was not until 1956—when Ozzie Virgil played for the New York Giants—that the first Dominican-born player debuted in the majors. The only Dominican currently in the Hall of Fame is the brilliant Juan Marichal, one of the dominant pitchers of the 1960s.

One of the main factors keeping Dominicans out of the majors was, of course, racial discrimination in the United States. Another was the conflict caused by the Dominican baseball season being contested in the summer. In 1955, the Dominican league began to play in the winter, and the opportunities for Dominicans to play professionally in the United States increased. In the ensuing years, Dominicans have had a significant impact on baseball in the United States.

Although Dominicans have come to the majors from every corner of the country, one town—San Pedro de Macorís—is particularly noted for its production of talent. The port city of 100,000 people, located about 60 miles east of Santo Domingo, is the home of Sosa, 1998 National League MVP; George Bell, 1987 American League MVP; Pedro Guerrero, co-MVP of the 1981 World Series; and

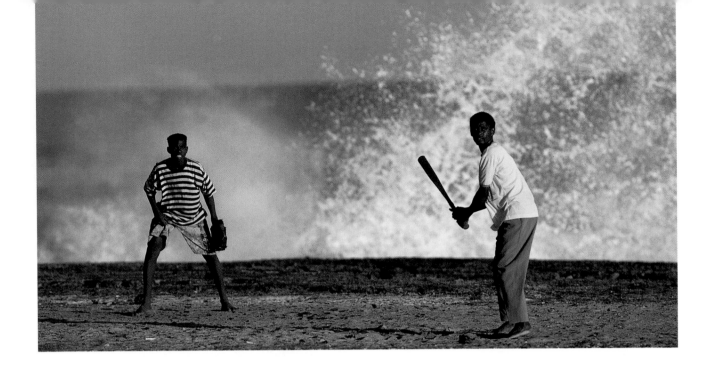

Rico Carty, the National League batting champ in 1970. San Pedro de Macorís is known as the birthplace of many remarkable shortstops, the best of whom is Tony Fernández, a four-time Gold Glove winner. Other outstanding Macorisano shortstops include Julio Franco, who led the American League in hitting in 1991, Alfredo Griffin, José Offerman, and current New York Yankee, Alfonso Soriano (now a second baseman).

Today, approximately 10 percent of all players in the majors are from the Dominican Republic. They are not immigrants, but migrants—migrant superstars, if you will, but migrants, nonetheless. They are invited to come and play, but they must return home at the end of the season.

The United States Department of Labor restricts the number of foreign-born baseball players allowed to enter the country. Each of the 30 organizations is allotted an average of 35 temporary work visas for its minor league system. Although foreign-born players at the major league level also require visas, they are given a status reserved for those with "extraordinary ability in the sciences, arts, education, business and athletics," and the numbers are less restrictive.

Major league organizations are developing more talent in Latin America and Australia, Asia, and Europe than the U.S. government is willing to let compete in the United States. The result is that some foreign-born players are passed over, some are released early to open up visa slots for other players, and some never receive an opportunity to come to the U.S. This quota imposed by the U.S. government is the greatest single factor limiting the participation of foreign-born players—the majority of whom are from the Dominican Republic—in organized baseball in the United States.

Dominicans and most other players on visas who do play in the United States have to make the difficult transition of living in a new country and culture, eating new foods, and understanding a foreign language at the same time they are making the necessary on-the-field adjustments to get to the big leagues. Even after they reach the majors, some Dominicans fear an interview in English more than a Randy Johnson fastball.

These days, there are also players from the Dominican immigrant community in the United States—including All-Stars Manny Ramírez and Alex Rodríguez, the highest-paid player in major league baseball as of the start of the 2001 season—excelling at the game. The vast majority of Dominican players in professional baseball, however, are young migrants searching for economic opportunities and the fulfillment of their childhood dreams of playing in the majors.

◆ To call baseball the national pastime in the Dominican Republic would be an understatement. In addition to heroes Sammy Sosa and Pedro Martínez, approximately 10 percent of today's major league players hail from the Dominican Republic.

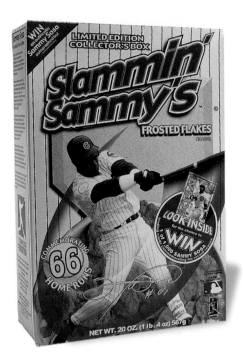

Sammy Sosa is a hero not only in the Dominican Republic but also to American sports fans, consumers, and this group of young ladies. The Texas Rangers lineup card below shows the prominence of Latino players in the major leagues today.

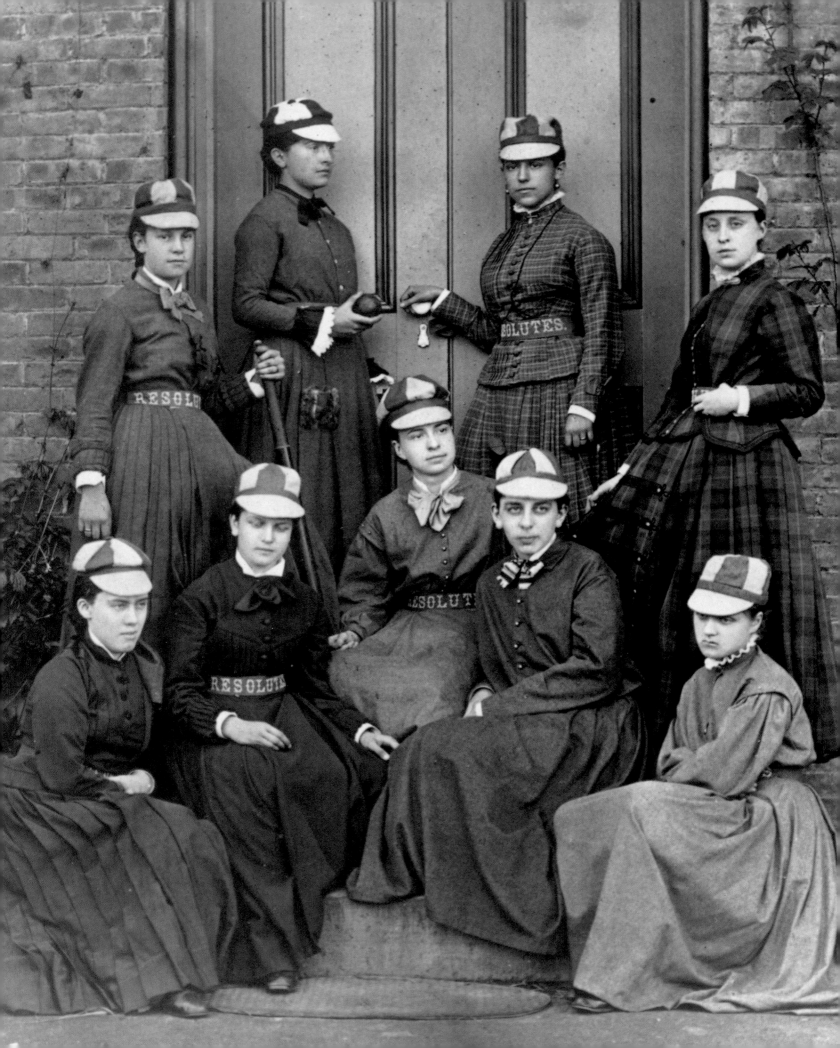

Annie Glidden 1866

Enjoying It Hugely

Vassar College April 20, 1866

My dear Brother,

… They are getting up various clubs, now, for out-door exercise. They have a floral society, boat-clubs, and base-ball clubs. I belong to one of the latter and enjoy it, hugely I can assure you. Our ground was measured off this morning. We think after we have practiced a little, we will let the Atlantic Club play a match with us. Or, it may be, we will consent to play a match with the students from College Hill: but we have not decided yet ….

Your loving sister,
Annie

The earliest known photograph of a women's baseball team, the Vassar College Resolutes of 1876. Turn-of-the-century women's physical education textbooks encouraged young ladies to use their long skirts to trap ground balls.

Diamonds for Girls

The Sporting News

THIS COLUMN IS SCARCELY the proper place to discuss the women's liberation movement for equal rights, except that some girls in New Jersey want to play Little League baseball.

Acting on a complaint filed by the National Organization for Women, the state Division of Civil Rights ruled recently that exclusion of girls because of their sex was discriminatory. Little League officials reacted as if they had been deprived of their manhood.

While threats were being made that many boys' teams would dissolve rather than take in girls, Little League Baseball, Inc., the national organization, took the civil rights ruling to court and lost.

In a majority opinion, a three-judge panel of the appellate division of New Jersey's Superior Court rejected all of the Little League's arguments against opening its games to girls.

Little League has refused to give up the fight to retain its boys-only policy. The organization's executive committee, meeting at Williamsport, Pa., instructed its attorneys "to proceed immediately to initiate appeal from the civil rights order to the Supreme Court of New Jersey."

While this was going on, a boys' league at Ridgefield, N.J., dropped its connection with Little League and organized on an independent basis, but the maneuver was batted out by a Superior Court judge as circumventing the law. The judge acted after a fifth-grade girl filed suit through her parents.

In addition to the legal questions, a number of reasons have been advanced for excluding girls from boys' baseball. It has been argued that girls would be more susceptible to injuries than boys, that they are not anatomically as strong as boys, that their privacy of person would be violated, that the egos of boys would be hurt if the girls outplayed them and that baseball is not considered ladylike activity.

Donald Singleton of the *New York Daily News* checked with a number of experts and reported that many of them agreed that exclusion from organized sports ought to be done on an individual basis and not by sex alone. Furthermore, some of the experts had negative things to say about Little League itself.

Dr. Bruno Bettelheim, an eminent child psychologist, said, "What's wrong with Little League is that it's too competitive. Winning is everything. They should be teaching children to play for the fun of playing. And there is absolutely no reason why girls can't have as much fun at it as boys."

As for the boys' egos, Dr. Bettelheim remarked, "Any boy whose ego is destroyed by being outplayed at baseball by a girl didn't have much of an ego to begin with."

Dr. Joyce Brothers, the noted psychologist who is well known to television audiences, took issue with the notion that baseball is unfeminine and said, "It's perfectly

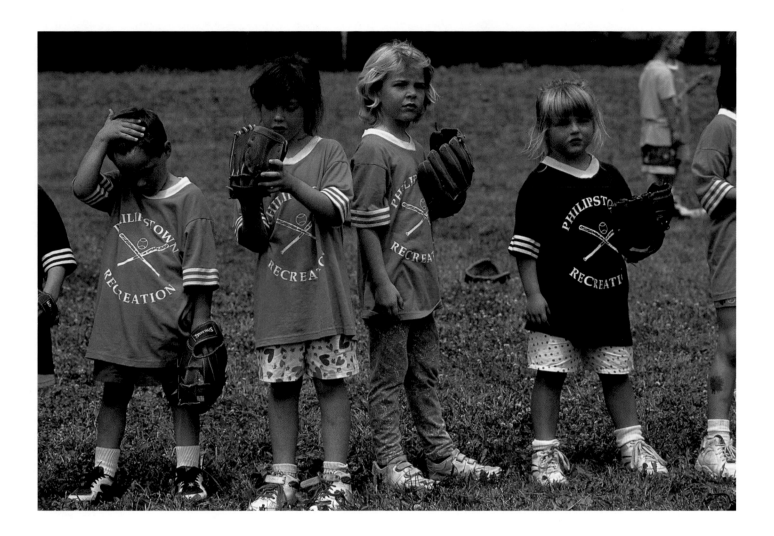

possible and proper and right that girls should be allowed in Little League."

Dr. Ernest W. April, assistant professor of anatomy at the Columbia University School of Medicine, said, "I know of no difference which would make a girl's bones more fragile or which would make a girl inferior to a boy in baseball."

Singleton commented in his article, "What it all comes down to is this: some people happen to be better than other people at playing baseball, and some of the people who happen to be better happen to be girls. It's as simple as that."

While this may be a difficult truth for Little League to grasp, we believe the organization will have to do so, sooner or later, especially now that women are working alongside men in almost every type of job we can think of.

◆ Children at play in a recreational baseball league. Little League was officially integrated by court order in 1974.

BARBARA GREGORICH

Muscle in the Bud

HUCK WAS STUCK—Huck Finn, that is—trying to disguise himself as a girl. Exposed because he couldn't handle the confining dress he wore, Huck returned to trousers. Unlike Huck, girls and women of the 19th century were really stuck, restricted to dresses that inhibited them from playing the game everybody was passionate about: baseball.

Women couldn't play baseball, or much of anything, without replacing their cumbersome clothing with more functional garb. It was a conflict between appearance and performance: To perform the way they wanted, women had to alter their appearance.

Suffragist Amelia Bloomer invented the Turkish trousers that bear her name. Worn under dresses, these full trousers allowed women to wear slightly shorter and less cumbersome dresses.

Until Bloomer invented her eponymous clothing, women who defied society by playing baseball might have been able to hit a ball, but they could not run the bases—at least not without picking up their heavy skirts with both hands and tripping down the base paths in their high-top shoes. The "properly dressed" woman of that time wore nearly 30 pounds of clothing, most of it hoops, petticoats, and skirts.

After Amelia, the deluge. First, of course, came the Bloomer Girls—women who played professional baseball on sexually integrated teams. Barnstorming the nation, Bloomer teams challenged all-male teams, drawing large crowds. The earliest of the Bloomer Girls wore skirts over their bloomers.

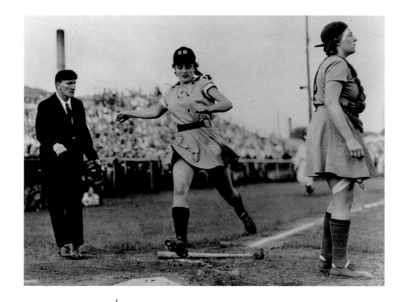

Alta Weiss, a doctor's daughter whose father bought her a baseball team so she could pitch her way to satisfaction, started her career near Cleveland in 1907 wearing a proper skirt, but that fashion choice proved impossible. "I found that you can't play ball in skirts," she told a reporter. "I tried. I wore a skirt over my bloomers and nearly broke my neck. Finally, I was forced to discard it, and now I always wear bloomers."

Amanda Clement found wearing dresses totally appropriate, but she was an umpire, not a player. Known as "The Lady in Blue," Clement umpired games throughout the Dakotas at the turn of the 20th century. Of course, standing behind the plate while clicking a ball-and-strike

◆ OPPOSITE: Uniform worn by star pitcher Gloria Cordes Elliott of the Kalamazoo Lassies of the All-American Girls Professional Baseball League during the circuit's final season, 1954. ABOVE: Grand Rapids Chicks' player scores a run.

counter takes less physical freedom than hitting a baseball and requires less mobility than fielding, throwing, running, and sliding.

American culture has not been unique in its insistence that women's appearance is important. Throughout history, women of the upper classes have had to dress in a confining way. The manner of dress designed to suggest fragility also, of course, contributed to it.

Certain they weren't frail, women designed, stitched, and wore more functional clothing to ride bicycles and play baseball. These outfits celebrated bone and sinew in the body—muscle in the bud. Before long, many women discarded cumbersome compromises in favor of real baseball uniforms: shirts and pants.

In fact, Maud Nelson, the short giant of Bloomer Girl ball, posed in a true baseball uniform as early as the 1890s. And by the 1920s, when the Philadelphia Bobbies toured Japan, women ballplayers wore uniforms. In 20 years, the idea of playing in a dress had come to seem like rubbish. Uniforms—which not only liberated the body for movement, but also hid differences and stressed similarities between men and women—became the accepted outfit of anybody at bat or on the field.

Then came the Great Depression, and with it came softball and shiny new textiles and bright colors and fast underhand pitching and lights. People flocked to see women play softball. And recognizing that fans loved the leg-and-arm-revealing uniforms, baseball magnate Philip K. Wrigley outfitted players in short, flashy skirts in 1943 when he started what became the All-American Girls Professional Baseball League (AAGPBL). The game that was played by great athletes such as Joanne Winter, Connie Wisniewski, Dorothy Kamenshek, and Jean Faut evolved rapidly from underhand-pitch softball to overhand-pitch baseball. The uniforms, however, did not evolve.

The women of the AAGPBL, managed by former major leaguers such as Max Carey and Jimmie Foxx, played baseball with all the skill and muscle they had. They learned, they grew, they played better and better. Their managers and fans testified to that. Carey, a Hall of Famer, thought the greatest game he ever saw in his life was the last game of the 1946 AAGPBL World Series, in which Sophie Kurys's terrific slide into the plate allowed her to score on a single by Betty Trezza in the 16th inning to give the Racine Belles a 1-0 victory.

It is one of the ironies and oddities of history that the only professional league of female ballplayers in the U.S. played in short skirts, which did not protect them from the dirt they had to slide on in a stolen-base-oriented league. They ignored their apparel—and their slide-induced wounds, which sometimes left permanent scars—and got the job done.

In the Negro leagues, Toni Stone, Connie Morgan, and Mamie Johnson wore regular uniforms. On teams featuring both men and women, this has always been the case, whether it was Lizzie Murphy playing in a New England semipro league or Ila Borders pitching in high school, college, or the Northern League.

By the time girls and their parents fought for the right of girls to play in Little League, there was no thought of these girls playing in anything but regulation uniforms. Appearance would not detract from performance, neither for girls in Little League nor for the Silver Bullets some of them grew up to become.

On the ballfield, the battle has been won: Performance has conquered appearance; however, other battles remain. American culture does not have a place for professional women's baseball on the major league level, nor are the official minor leagues willing to let women play.

But there remains sheer joy in throwing, fielding, and hitting—joy in the muscles, joy in the mind. This is a joy that will not die, that believes in the field of dreams. Today women play baseball in several nonprofessional leagues. Tomorrow, who knows?

◆ Mary Pratt, a pitcher for the Rockford Peaches and the Kenosha Comets in the All-American Girls Professional Baseball League, decorated her suitcase for the league's inaugural year, 1943.

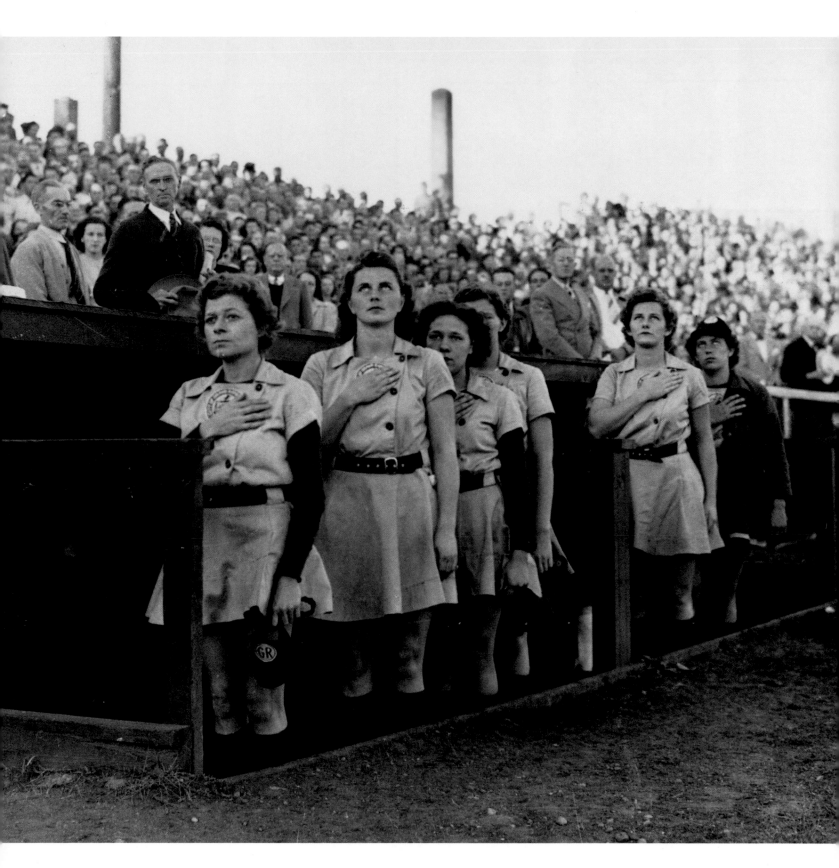

◆ Founded by Chicago Cubs owner Philip K. Wrigley in 1943 to keep home-front morale high during
World War II, the All-American Girls Professional Baseball League continued until 1954.

"I found that you can't play ball in skirts. I tried.

I wore a skirt over my bloomers and nearly

broke my neck. Finally, I was forced to discard

it, and now I always wear bloomers."

—ALTA WEISS

Barred from playing on her high school team, Julie Croteau gained national attention when she later earned a spot on the men's baseball team at St. Mary's College of Maryland. Croteau played first base for the Seahawks from 1989 to 1991.

For the true fans, the game-day ritual begins in the morning, over breakfast. They retrieve the morning paper, turn first to the sports section, and carefully peruse the box scores of the previous day's games, noting the highs and lows, the batting stats and pitching performances, and the minutia of who stroked extra-base hits and who was caught stealing. They check out the league leaders and the day's probable pitchers, their records

ROOTING FOR THE TEAM

and recent performances, and they read not just the game accounts but the team notes and transactions. The day has begun with a healthy serving of baseball. ◆ The rituals continue en route to the ballpark. One might take a streetcar, bus, or subway surrounded by other fans in their jackets, jerseys, and other baseball regalia, rehashing previous games and discussing the home team's prospects. Or one might drive to the game, taking the back-road shortcuts that only the regulars know, while listening to radio talk shows or pregame features. Outside the stadium the fan buys a scorecard and then passes through the turnstiles into the dark interior recesses, climbs the ramps with other fans, and bursts suddenly into the bright sunlight or arc lights illuminating the field. She might purchase a ballpark specialty: a bratwurst in Milwaukee or garlic fries in San Francisco. Or she might remain devoted to the time-tested favorites: hot dogs, peanuts, and beer. She makes her way up or down to her seat, then settles in to watch the final preparations on the field: the athletes playing catch and stretching, the groundskeepers raking and smoothing the diamond dirt. She records the starting lineup in her scorecard. ◆ Moments before the scheduled starting time, a local celebrity, businessman, or representative of a group in attendance strides to the mound to throw out the ceremonial first pitch, frequently bouncing it in front of the plate. The fans all rise and

remove their hats for the national anthem, which might be a recording projected over a loudspeaker or a live performance, rendered, for better or worse, crisply or painstakingly drawn out, by a local performer or group. The final line, "and the home ... of the ... brave," gets swallowed by loud cheering and applause, and the game begins.

Each fan has his or her own way of watching a game. Some focus on the pitcher; others on the batter or fielders. Some observe in intense silence; others maintain a constant stream of chatter. Many fans record each pitch and each play on their scorecards, referring back frequently to earlier innings to detect patterns of play. Some enjoy tight pitching duels; others prefer slugfests. But for all, the familiar rhythms of the game provide an exhilarating, yet comforting experience. After the top half of the seventh inning, the home-team fans all rise again and join in singing baseball's time-worn anthem, "Take Me Out to the Ball Game," enjoying the traditional seventh-inning stretch. After the seventh, some fans begin to stream down the aisles toward the exits; others begin to sneak into the higher-priced seats, trying to catch a few innings from the intimacy of the field-level sections. The true fan, however, remains firmly planted, regardless of the score until the final pitch has been thrown and the final out has been recorded. He then begins the long journey home, shuffling slowly along with the exiting crowd, emerging into the street or parking lot, and climbing onto mass transit or into an automobile, reliving the game's highlights and controversial strategies along the way.

Most fans live out their baseball lives in blissful anonymity, content to enjoy the game from afar. Others obtain a measure of notoriety for their constancy or peculiarities. At Brooklyn's Ebbets Field, Hilda Chester reigned in center field. Equipped with a loud cowbell and a placard reading, "Hilda is Here," Chester led the cheers for the Dodgers from the 1930s through the 1950s, becoming a local celebrity and icon. Less flamboyant, but even more persistent, was Boston's Lib Dooley. Over more than a half century, Dooley attended in excess of 4,000 consecutive games, a familiar fixture for Red Sox fans and players alike. At Shea Stadium, during the Mets' miracle season in 1969, there was Karl Ehrhardt—the "sign man"—who sat in the box seats, flashed one- or two-word commentaries on the action, and became an integral part of the spectacle. In the current Oakland and Cleveland parks, drummers have established themselves in the bleachers to pound out encouragement for the A's and Indians.

Away from the field, fans attempt to immerse themselves in the games in a variety of ways. Many collect trading cards adorned with player pictures and statistics, carefully sliding the cards into plastic sleeves in large-ringed binders for protection. Others accumulate autographs. Barry Halper of New Jersey collected cards (over a million of them) and autographs (of every man in the Hall of Fame and others). He also acquired uniforms, programs, buttons, posters, books, trophies, and remnants of old ballparks and historic moments, ultimately amassing the largest aggregation of baseball memorabilia outside the Baseball Hall of Fame. Bill James collected not artifacts, but statistics. Working as a boiler-room attendant at a food-packing plant in the 1970s, James pored over box scores and the *Macmillan Baseball Encyclopedia*, inventing new ways to analyze baseball statistics. With a core of other hardy souls gathered together into the Society for American Baseball Research (SABR), James created a new science of baseball analysis, revolutionizing the way people looked at the game.

Dan Okrent also wanted more from baseball than what was offered by the regular games and rituals. In the late 1970s and early 1980s, Okrent and a group of friends met at La Rotisserie Francaise, a New York restaurant, and devised a way in which fans could actually own and manage their own teams, stocked with real major league players, competing in imaginary leagues. These Rotisserie leagues, as they came to be known, attracted first thousands, then tens of thousands, then hundreds of thousands of participants. Each morning, Rotisserie team owners devour box scores with a new intensity to see how their ballplayers, spread across the real major leagues, have done. Businesses have sprung up to compute the complicated

◆ PAGE 118: Fans reach for a foul ball during batting practice at Dodger Stadium, July 13, 1993. In what other sport do the fans bring along a piece of equipment, such as a glove, in hopes of snagging a wayward souvenir?

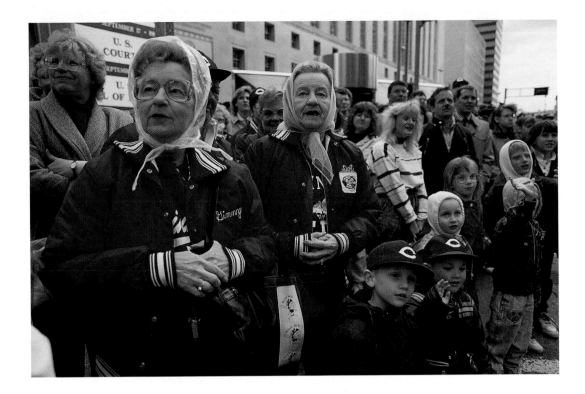

standings. For many, the fantasy became reality.

The Rotisserie leagues represent a relatively new fan ritual. Indeed, many of our most familiar rituals surrounding baseball are of surprisingly recent origin. Although baseball cards themselves appeared as early as the 1880s, usually packaged with tobacco products, it was not until the 1930s—when the Goudey Gum Company put cards in with their gum—that the items began to appeal to children. In 1948, Bowman Gum Company issued the first widely popular cards. Three years later, Topps, the foremost bubblegum/trading card entity, entered the field. Children in the 1950s commonly traded cards, gambled them in card-flipping games, and placed them in the spokes of bicycles before storing them haphazardly in shoe boxes, most of which were thrown out when the children left home. Several decades passed before these cards became collectibles and acquired unexpected value.

Singing "Take Me Out to the Ball Game" during the seventh-inning stretch is also a surprisingly recent addition to stadium ritual. Not until 1976, when announcer Harry Caray began leading White Sox fans in a rousing version of the tune, did the practice catch on at other ballparks. Other rituals have far deeper roots. The seventh-inning stretch itself dates back as far as 1869, though it probably did not become commonplace until the 1910s. The practice of having the President of the United States throw out the first pitch of the season began in 1910.

Baseball is composed of a multitude of such rituals, but the sport itself has also come to encompass an even more significant rite. The game, as former commissioner A. Bartlett Giamatti has written, "begins in the spring, when everything else begins again, and it blossoms in the summer, filling the afternoons and evenings, and then as soon as the chill rains come, it stops and leaves you to face the fall alone."

Fans measure the seasons of their lives and the passage of time with the rhythms of the baseball calendar. The final out of the World Series marks the beginning of a prolonged hibernation, but in our reveries we know that spring training is never far off.

—*Jules Tygiel*

◆ Cincinnati Reds fans, garbed in their team's colors, line the street to see the city's annual Opening-Day parade. The "Rosie Reds" bag marks these women as members of the team's fan club—Rooters Organized to Stimulate Interest and Enthusiasm in the Reds.

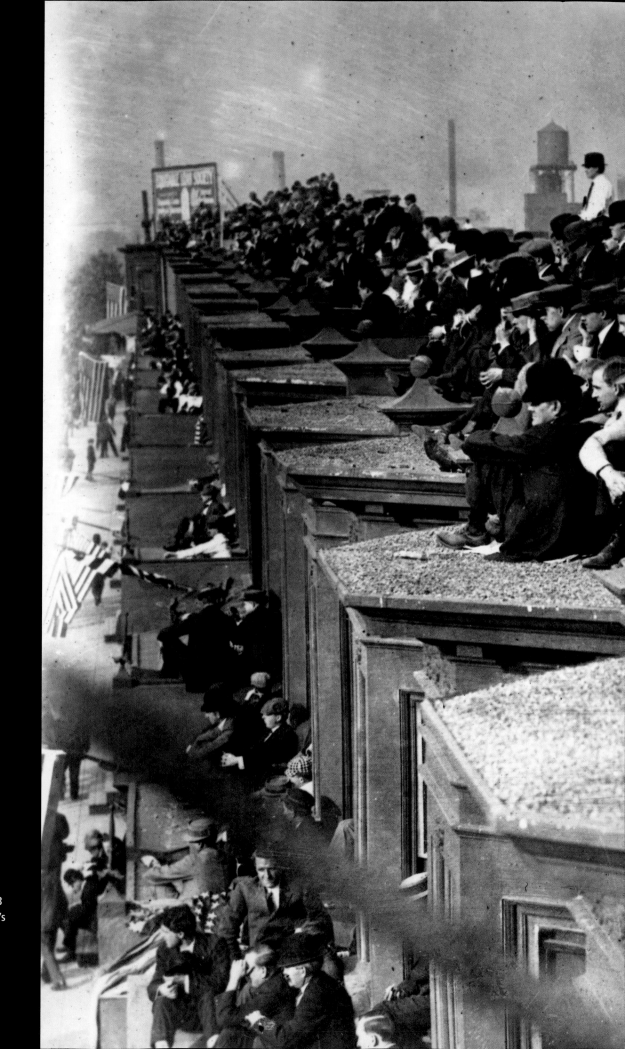

Fans crowd the rooftops across 20th Street from Philadelphia's Shibe Park, 1910. During the Great Depression, the right field wall was raised to 50 feet, 13 feet taller than Fenway Park's famous "Green Monster," to prevent such freeloading.

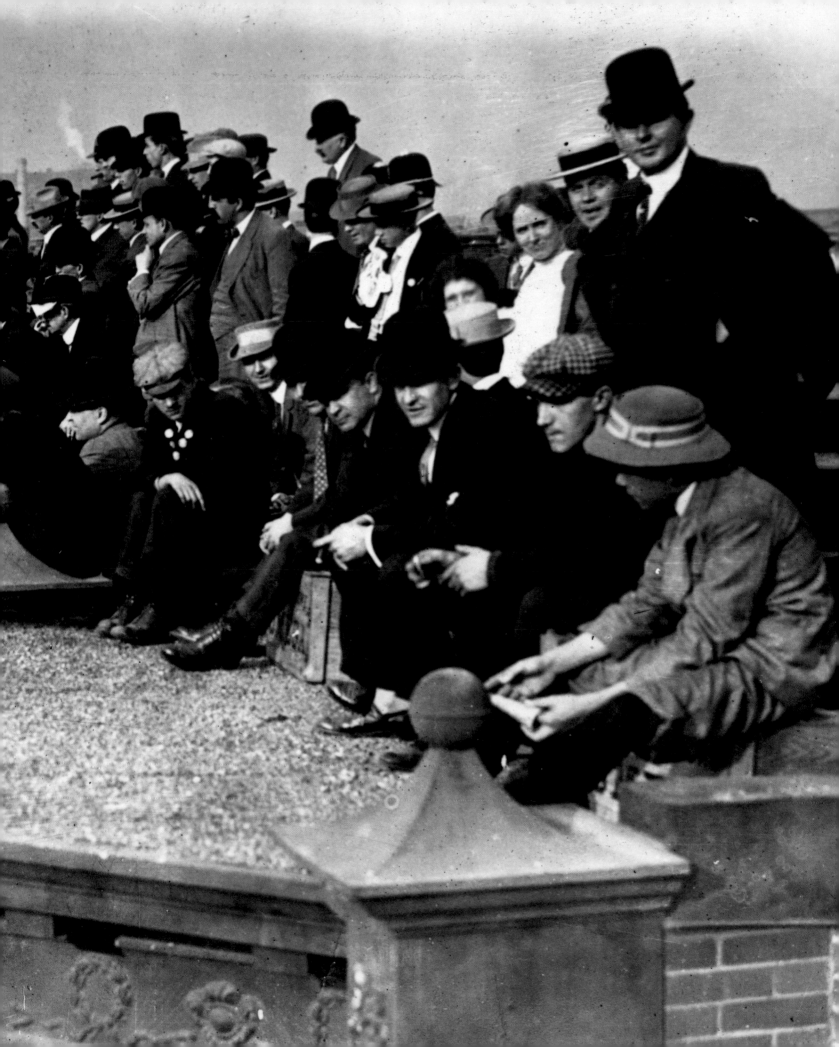

The Natural, Bernard Malamud's 1952 novel, captures the dynamic relationship linking fans and teams. Malamud's description of a New York Knights' winning streak evokes the mercurial ups and downs of affection, frustration, and excitement that ebb and flow with a ball club's changing fortunes.

Bernard Malamud 1952

The Natural

THE ORIGINAL KNIGHTS "FANS," those who had come to see them suffer, were snowed under by this new breed here to cheer the boys on. Vegetables were abolished, even at the umps, and the crowd assisted the boys by working on the nerves of the visiting team with whammy words, catcalls, wisecracks, the kind of sustained jockeying that exhausted the rival pitchers and sometimes drove them out of the game. Now the old faithful were spouting steam—the Hungarian cook outcrowed a flock of healthy roosters, Gloria, the vestibule lady, acquired a better type customer, and Sadie Sutter gave up Dave Olson and now beat her hectic gong for the man of the hour. "Oh, you Roy," she screeched in her yolky cackle, "embracez moy," and the stands went wild with laughter. Victory was sweet, except for Otto Zipp, who no longer attended the games. Someone who met him waddling out of a subway station in Canarsie asked how come, but the dwarf only waved a pudgy palm in disgust. Nobody could guess what he meant by that and his honker lay dusty and silent on a shelf in the attic.

◆ Hilda Chester, Brooklyn's first lady among baseball fans, would yell and bang on a frying pan in exhorting the Dodgers. Growing tired of the racket, the players bought her a cowbell (above). Chester was a fixture at Ebbets Field from the 1930s well into the 1950s. OPPOSITE: Andre Dawson, star outfielder for the Chicago Cubs from 1987 to 1992, returns to Wrigley Field as a player for the last time, in September 1996. Fans renewed their tradition of bowing to Dawson with both arms raised, and Dawson reciprocated the gesture.

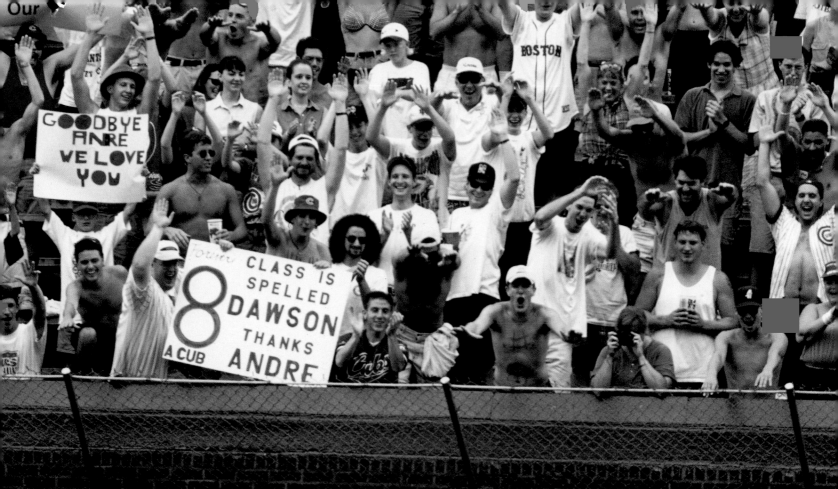
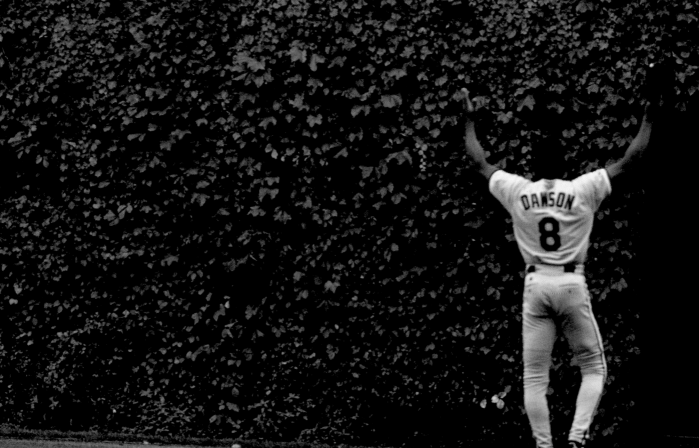

Obituary of Elizabeth Dooley

The Boston Globe, 2000

THERE MUST BE A HARDBALL GOD. The Red Sox lost to the Yankees by a score of 22-1 on the day Elizabeth Dooley died.

Dooley, the greatest Red Sox fan of them all, died yesterday afternoon at the age of 87 after a season-long illness. While the Red Sox were getting smoked by the Yankees (giving New York a 1,010-828 all-time series lead), Helen Robinson was working the switchboard at Fenway, trying to reach Ted Williams to tell him of the death of the Sox' most devoted fan.

"I know Ted would want to know," said Robinson.

Robinson has worked the Sox phones since 1941. Dooley was Fenway's daily communicant from 1944-99. Ted was a rookie in '39.

There's something irreplaceable in all of this. A veteran switchboard operator of 56 years sits in her perch at an 88-year-old ball yard, trying to reach the greatest hitter who ever lived to tell him of the passing of a woman who saw more than 4,000 consecutive Fenway games. Something tells me they don't have moments like this at the BOB in Phoenix.

"Forever, she's the greatest Red Sox fan there'll ever be," Williams said of Lib Dooley in 1996. "Every time I get a chance to get around her, I like to do it because she's really a big-league gal."

Her consecutive-game streak—one that shattered those of Lou Gehrig and Cal Ripken—came to a halt when she took ill last season. She made it to Opening Day 2000, and the Red Sox Hall of Fame dinner in May, but those were her final appearances around the team.

She got her first season ticket during World War II and didn't miss a game for the next half century. She sat in the first row behind the Red Sox on-deck circle (Box 36-A) and brought Oreos and Starbursts for the ballplayers. She was Ted's favorite fan. Any Bostonian's visit to the Kid would prompt Ted to bellow, "How's Lib Dooley? You tell her I said hello."

When he manned the microphone behind Fenway's home plate, it was not unusual for the legendary Curt Gowdy to tell his listeners that Lib Dooley was wearing a new yellow hat.

One of the great things about the Fenway Experience is the old-timers who are part of the furniture at the ancient ballyard. Robinson was hired by Tom Yawkey before Pearl Harbor. Johnny Pesky has been around since 1942 and groundskeeper Al Forester goes back 60 years. Intrepid traveling secretary Jack Rogers and groundskeeper Joe Mooney were on the job at Fenway in the late 1960s.

If you visit the yard on a regular basis, you probably have a favorite veteran usher, ticket taker, hot dog maker, or corner cop. These are the people who make game day special, and Dooley was the grande dame of Fenway.

The Sox honored her with a brief statement and a moment of silence before the series opener against the Yankees. David Leary, her 24-year-old grandnephew, sat in 36-A with a friend.

◆ OPPOSITE: Two grandes dames—Lib Dooley, who attended every Boston Red Sox home game for 55 straight years, stands before her beloved Fenway Park.

"This is the first game of the next era of Red Sox baseball," said Leary. "She talked a lot about this year, this team. She loved Carl Everett and thought Nomar [Garciaparra] and Pedro [Martínez] could take them all the way."

Her dad, John Stephen Dooley, helped the upstart American League franchise get a home at the Huntington Grounds in 1901. He was also instrumental in getting conservative Boston to go for Sunday baseball. According to family lore, Dooley attended every Boston baseball opener from 1894 until his death at the age of 97 in 1970.

Lib Dooley never married. She taught in the Boston school system for 39 years and moved into an apartment in Kenmore Square in 1956. She threw out the first pitch in the 1985 home opener and two years later presented commemorative pins to members of the 1967 Impossible Dream team.

She took at least one road trip a year. She claimed to have seen five no-hitters. Despite her primo location, she fielded only one foul ball—a pop off the bat of Carroll Hardy in the early 1960s. She broke two fingers making the grab and never tried to catch another.

Williams, Pesky, Bobby Doerr, and Dom DiMaggio were her favorites.

"She was just a perfect lady," DiMaggio said last night. "I remember so well when she presented us with our American League championship rings after we won in 1946. She was so thrilled. The Red Sox were practically her whole life from what I could gather."

Jim Rice was a favorite in the 1970s and '80s. Most recently, Dooley was favored by Mike Stanley and Nomar Garciaparra.

"Nomar would give her a wink when he came into the on-deck circle," said Leary.

Her wake is tomorrow in Milton. The funeral is Thursday. Leary got a ball from last night's game to place in her casket—a ball from a lopsided loss to the dreaded Yankees.

" 'Dislike' was the word she used for the Yankees," said Leary. "She never used the word 'hate,' but she felt very strongly about the Yankees."

The Sox were beaten by the Yankees, 22-1, last night, but they suffered a tougher loss earlier in the day.

◆ FOLLOWING PAGES: A young fan, glove at the ready in case of a foul ball, stakes out his territory early before a game at old Dudley Field, former home of the Double-A El Paso Diablos.

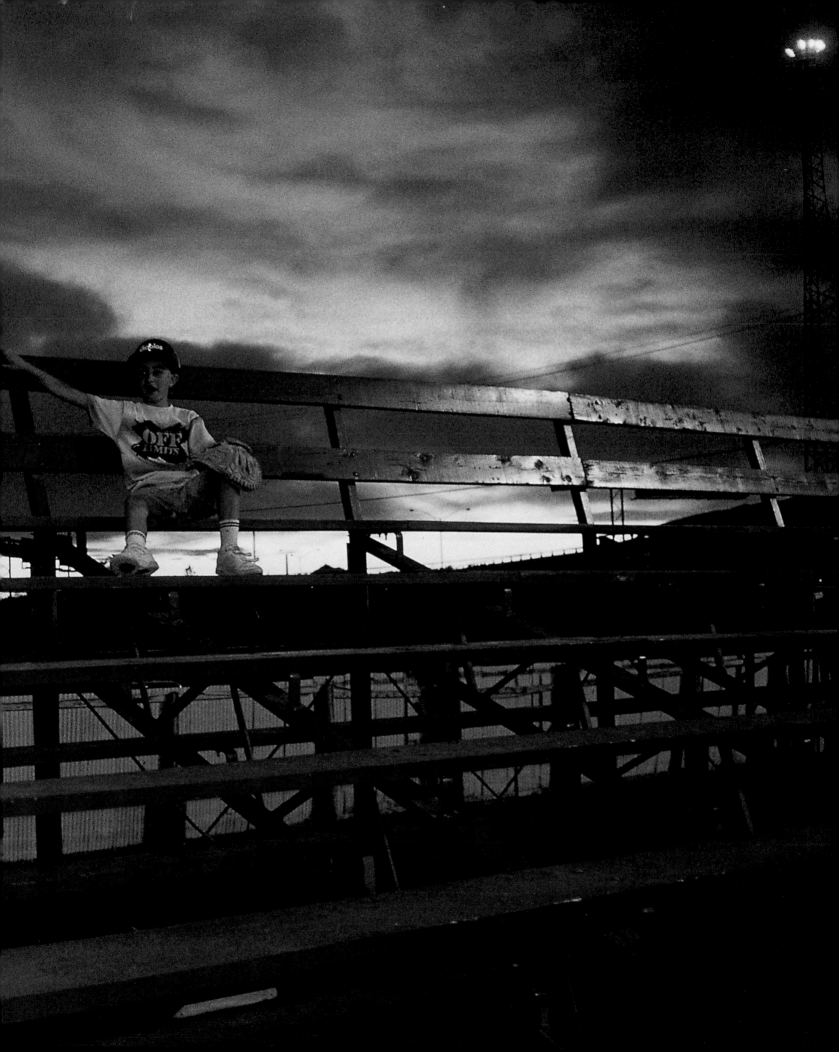

TAKE ME OUT TO THE BALL GAME
 BY JACK NORWORTH

KATIE CASEY WAS BASE-BALL MAD
 HAD THE FEVER AND HAD IT BAD,
JUST TO ROOT FOR THE HOME ~~TEAM~~ TOWN CREW
 EVERY SUE — KATIE BLEW
ON A SATURDAY, HER ~~FRIEND JOE~~ YOUNG BEAU
CALLED TO SEE IF SHE'D LIKE TO GO
TO SEE A SHOW BUT MISS ~~KATE~~ SAID NO,
I'LL TELL YOU WHAT YOU CAN DO —

TAKE ME OUT TO THE BALL GAME
TAKE ME OUT ~~TO~~ WITH THE ~~RAIN~~ CROUD
BUY ME SOME PEANUTS AND CRACKER JACK
I DON'T CARE IF I NEVER GET BACK
LET ME ROOT, ROOT, ROOT FOR THE HOME TEAM,
IF THEY DON'T WIN ITS A SHAME,
FOR ITS ONE, TWO, THREE STRIKES, YOUR OUT
AT THE OLD BALL GAME

TIM WILES

Music of the Sphere

LONGTIME NEW YORK BROADCASTER Warner Fusselle calls the ritual singing of "Take Me Out to the Ball Game" during the seventh-inning stretch "the happiest minute in sports," and it remains one of baseball's most beloved customs. To many devoted fans, no visit to the ballpark is complete without a hot dog, a home-team victory, and a short break between halves of the seventh to sing communally of the game's glories: the game itself, the crowd, the peanuts, and Cracker Jack.

Cracker Jack, not Cracker Jacks. Let's get that straight—*Cracker Jack,* so it rhymes with "never get *back.*" While we're at it, it is "take me out *with* (not *to*) the crowd, and I don't care if I *never* (not *ever*) get back."

One glance at the song's manuscript—a true treasure of not just the Hall of Fame's collections, but of American musical culture—will confirm the proper lyrics, double negatives be damned. But why quibble? The song is pure joy, and any approximation will do. In fact, there are two verses that are rarely heard in this song, which is actually an appeal from a lady to her beau that he not take her to see a show, but out to the ball game instead.

The manuscript itself also tells a most improbable story, of a tin-pan-alley lyricist named Jack Norworth and his music-writing partner, Albert Von Tilzer. One afternoon in 1908, while Norworth was riding the subway toward the northern tip of Manhattan, his eyes fell on a poster that announced, "Baseball Today—Polo Grounds." He was instantly struck by the idea for a song, as hungry songwriters

are wont to be. In 15 minutes, Norworth had created the lyrics of one of America's most popular songs, along with "The Star-Spangled Banner" and "Happy Birthday."

Norworth, a co-writer of the classic "Shine on Harvest Moon" with Norma Bayes, co-authored more than 2,500 songs with Von Tilzer. But here's the improbable truth: Neither Norworth nor Von Tilzer had ever been to a baseball game before writing the game's anthem. In fact, Von Tilzer would not make it to a game for 20 more years, and Norworth didn't attend his first for 32 years—until he was honored on Jack Norworth Day at Brooklyn's Ebbets Field in 1940. Once he finally bathed in the game's waters,

◆ Jack Norworth's manuscript of "Take Me Out to the Ball Game" shows the importance of central character Katie Casey, all but forgotten today when we only sing the refrain.
ABOVE: A nickelodeon slide shows Katie feverishly studying the baseball news.

Norworth became a fervent fan and, after moving to California at the start of his sunset years, was instrumental in establishing Little League Baseball in that state.

The song was first made popular by nickelodeons, predecessors of today's movie theaters, where the admission price was just five cents. Customers would drop a nickel into a machine, and illustrated glass slides would "play," depicting the songs. MTV it wasn't, but the song caught on quickly, and soon was garnishing large sheet music sales. Since its advent, the song has been recorded more than a hundred times, by artists as diverse as Frank Sinatra and the Goo Goo Dolls, the Andrews Sisters and Arthur Fiedler's Boston Pops, Dr. John and Doc Watson. It inspired a 1949 movie musical starring Sinatra, Gene Kelly, and Esther Williams, and a collaboration between two of baseball's greatest showmen, owner Bill Veeck and broadcaster Harry Caray.

Many fans assume that the tradition of singing "Take Me Out to the Ball Game" each day during the seventh-inning stretch is as old as baseball itself, or at least dates back to the song's composition in 1908. Not so.

The seventh-inning stretch can be traced back as far as 1869, when future Hall of Famer Harry Wright of the undefeated Cincinnati Red Stockings wrote to a friend: "The spectators all arise between halves of the seventh inning, extend their legs and arms and sometimes walk about. In so doing, they enjoy the relief afforded by relaxation from a long posture upon hard benches."

Though nothing seems more naturally fitting for a ballpark than a little organ music wafting through the breeze on a sunny day, it was not until 1941 that the Chicago Cubs installed the first ballpark organ in the big leagues, thus paving the eventual way for this ritual. Organists would play all sorts of popular songs between innings, including "Take Me Out to the Ball Game," "Camptown Races," "Auld Lang Syne," and other beloved tunes.

Veeck, the visionary Chicago White Sox owner, had designs on the seventh-inning stretch, however, and tried frequently, without success, to attach "Take Me Out to the Ball Game" to the stretch ritual. "I tried it in Milwaukee, Cleveland, and St. Louis, but it never worked," he commented. "Finally, I got the right guy (to sing it)." Veeck was

◆ One of more than a hundred recordings of "Take Me Out to the Ball Game," this time sung by Yankees and Dodgers stars.

referring to flamboyant broadcaster Harry Caray. In 1976, Veeck noticed that Comiskey Park organist Nancy Faust frequently played the song during the stretch and Caray would sing along, without the aid of a microphone, to those fans just outside the press box. The oft-repeated story is that Veeck secretly installed a microphone in the booth and one day flipped it on. According to the legend, a surprised Caray found himself amplified, the fans loved it and sang along, and a tradition was born.

In actuality, Caray, often dismissed as a shameless self-promoter by some baseball purists, wanted no part of the deal. In a recent interview with Veeck's son, Mike, then an employee of the White Sox and now the owner of the colorful St. Paul Saints independent league team in Minnesota, new details were revealed for the first time.

"Harry was one of the great embellishers of all time, but the actual truth was we begged Harry for weeks to sing," said Mike Veeck. According to Veeck, Caray had to be blackmailed into singing the first time.

"We told him that we had a cassette copy of him singing the song, and that we were going to play it whether he wanted us to or not, so he might as well sing live. He had no idea that everyone in the ballpark would stand up and that this would become his signature moment."

The rest, as they say, is history. A half dozen years later, Caray moved across town to the Cubs and Wrigley Field, where almost every game was carried on WGN, available on cable systems coast to coast. The custom caught on, and the song is now played in most major and minor league ballparks throughout the land.

"What Italian has sung to the most people?" Caray would ask his longtime broadcast partner Steve Stone. "Frank Sinatra? Luciano Pavarotti? No, it's me! I was born Harry Carabina, and I sing to 30,000 people every afternoon, and countless more on TV and radio."

The appeal is simple to understand. The song is easy to sing, and everyone knows the words. There is a communal sense of goodwill when tens of thousands of fans stand and sing together. For most of the game, we pay attention to the action on the field, the main event. But, during that most happy minute, we are the main event, and the game is ours once again.

◆ Harry Caray and two of his trademarks: the heavy black glasses, thick as soda bottles, and his waving microphone as he leads another 35,000 Cub fans in his ritual singing of "Take Me Out to the Ball Game," 1996.

MOLLY O'NEILL

Fathers Eating Hot Dogs with Sons

I GREW UP IN THE CHURCH OF BASEBALL.

My grandfather played semipro baseball in Nebraska. My father, Chick, played in the minor leagues in California. My youngest brother, Paul O'Neill, played right field for the New York Yankees, beginning his pro career when he was 18 years old in 1981, a rookie league ballplayer in Billings, Montana. Paul had 18 years under his belt by the time our family first heard about my great grandfather having played in the barnstorming leagues in Billings. This made the hair on our forearms stand at attention and made us feel like parts of one big, beating heart.

Baseball connects the past and the present. If you grew up with baseball, continuity is a spiritual experience. For this reason, you eat hot dogs at a ballpark. It's because, when your father took you to your first game, he bought you a hot dog. It's because his father bought him a hot dog. Because generations of parents and progeny have shared the snap and burst of a wiener, the carefree shock of it, exploding salty and not-quite-good-for-you in the mouth.

Of course, hot dogs would not have become baseball's edible repetitive if they didn't epitomize something fundamentally American. A 19th-century European observer described America as a nation of "grab, gobble and go." We like meals that can be held in the hand, consumed while doing something else, such as chasing the American dream. Eating a hot dog—like sipping soda through a straw (another national habit born of baseball)—allows a fan to keep an eye on the ball.

The flavor of a frank is everything that Americans love—the salty, the sweet, the fatty. A hot dog's texture, the initial crack followed by the firm interior mush, is all-American, too. The culture that gave the world the potato chip is partial to a good crunch. And the nation that turned mashed potatoes, macaroni and cheese, brownies, and ice cream into staples dotes, as well, on the soft and the smooth. A hot dog has it all: soft bread, a crackling skin, a soft interior.

It is no coincidence that peanuts and Cracker Jack, the other mainstays of ballpark menus, also offer the portability that allows for easy, almost unconscious consumption; those sweet and salty sensations; enough crunch to suggest the aggressiveness of a baserunner taking out a middle infielder at second with a slide; and enough warm softness to offer comfort at the sight of a potential game-winning home run being pulled back into the park.

Most important, snacking on stadium food lends a sense of being a part of something larger than oneself—something universal and eternal.

When the country was small towns instead of suburbs, before television, when people (and players) stayed in one place and championed that place, ballparks served regional food. Indeed, you can still get a good crab cake at a pushcart outside Camden Yards, a terrific sausage in Cincinnati that heralds back to the River City's days as "Porkopolis," and splendid barbecue in Texas and Kansas City. But the sales volume of these items is trivial compared

to the sales of hot dogs, according to Joel White, director of merchandising at Yankee Stadium. As its people have become more mobile and rootless, America became hungrier for a universal connection than for a regional one.

Ballpark vendors—who tend to be independent operators paying rent to the team owners—have been relentless in courting trendier appetites; indeed, it's good business. To boost sales, health-conscious menu selections and gourmet items are regularly test-marketed in stadiums throughout both leagues. But vendors say that fans don't buy it. Hot dogs, beer, and soda continue to make up 70 percent of all food concession sales in ballparks, a dominance that has not wavered for nearly a century.

While it is close to impossible to gauge the precise number of hot dogs sold, Mr. White estimates that he serves about 600,000 hot dogs annually and knows for sure that "if you took all the hot dogs we serve in a season and laid them end to end, they'd reach from Yankee Stadium to Camden Yards." The hot dogs sold in Baltimore over the course of a season might stretch to Pittsburgh, and a season's worth of hot dogs sold at PNC Park could extend to Cinergy Field in Cincinnati. If the hot dogs sold in a season in all the nation's ballparks formed a highway, the road could connect every major league ballpark in the country. That is approximately 15,600,000 hot dogs a year. Each one is like a link that joins the game to the national dream, unites the fan and the player, or knits generations together. It is not wise to disrupt this.

On Opening Day of 1997, I took sushi to Yankee Stadium. Maybe I was on a diet, or eager to display my finely honed, forward-looking taste. I can't remember. But I remember the stares, coughs, and gagging sounds that emanated from fans in the surrounding seats. I remember my sense of shame. The feeling grew and was finally manifested in sushi-revulsion when the Yankees lost the pennant that year.

◆ All-Star hot dogs: Wade Boggs (who preferred eating chicken on game days), Paul Molitor, and Joe Carter talk things over before the 1993 All-Star Game in Oriole Park at Camden Yards.

CHARLES CAMP

Leave the Plate at Home

OVER THE PAST CENTURY, food has formed an attachment to baseball that has become as recognizable and distinctive as the game itself. Consider how the call of a hot dog vendor—or legendary announcer Chuck Thompson's trademark exclamation "Ain't the beer cold!"—can conjure the game as fully as the sound of bat meeting ball.

The connections between food and baseball are found on both sides of the foul line—in the design of ballparks and the behavior of fans and players. Tailgating has become a common pregame ritual, but purchases from roving vendors or rushed between-innings trips to concession stands have also become inseparable from the fans' experience of the game. As kinds of food have become greater in number and variety, the local character of some parks' offerings has diminished. They still sell bratwurst in Milwaukee, serve crab cakes in Baltimore, and dress hot dogs in Cleveland with can't-get-it-anywhere-else stadium mustard. But it has grown more difficult to spot these defining items among today's concession-stand offerings, which increasingly tend toward the pizza, nachos, soft ice cream, and soft pretzels found at these types of entertainment events.

In 1887, five years after emigrating from England, Harry M. Stevens began applying his catering expertise and instincts to baseball, first at an amateur park near Niles, Ohio, then at New York's Polo Grounds. Stevens produced and sold the first scorecards, as an advertising opportunity for turn-of-the-century companies. By 1901, Stevens had

persuaded the Polo Grounds to permit his army of vendors to work the grandstands, selling a steamed sausage that would later be named the hot dog.

Ten years later, on April 14, 1911, those grandstands were destroyed by fire. Stevens had prospered so significantly that he loaned Giants owner John T. Brush the money to rebuild them. The Harry M. Stevens Company continued to garner concessionaire contracts at major league parks across the country, and it served baseball spectators as a family business until 1994. Needless to say, others have continued the tradition.

Just 15 years after its introduction at the World's Columbian Exposition in 1893, an invented food was celebrated in a song destined to become baseball's virtual anthem. At the exposition, Frederick William Rueckheim, a Chicago popcorn vendor, passed out samples of a mix of molasses-coated popcorn and peanuts. Orders for the nameless product swamped Rueckheim's small business, and in 1896 Louis Rueckheim emigrated from Germany to help his brother ship the confection in wooden tubs. By the time the product name was copyrighted by the Rueckheims, "crackerjack" had begun to appear as sports slang for high performance.

When Cracker Jack came to be packed in small boxes—a prize in each—the snack emphasized its ties to baseball with a series of player cards and toys that are currently among the most sought-after items of baseball memorabilia. The famous prescription of peanuts and Cracker Jack in

the 1908 song "Take Me Out to the Ball Game" has been taken as seriously as rooting for the home team. Like the song, the appeal of foods most closely associated with the game has endured.

Advertisements featuring product endorsements by big leaguers have historically reflected the competing images of the game that management, players, and fans bring to consumer decisions. Early player endorsements of tobacco and alcoholic beverages were as much to blame as any on-field behavior for the low-life image attached to early professional baseball. In the age of heroes that followed, endorsements of more wholesome products helped sell

baseball to younger fans by placing it literally within reach.

On America's many fields of play, only ballplayers habitually chew on something other than a mouth guard. Fans are similarly encouraged to chew when they play or think about baseball. Early baseball cards were packaged with tobacco, and later bubble gum was sealed in packs of cards. Today, sunflower-seed shaped candy and shredded bubble gum come in packages resembling tins of snuff and pouches of chewing tobacco.

This unity of player and spectator, ballpark and back porch is the contribution that food continues to make to baseball and baseball to the world of food.

◆ Like a conductor at the symphony, a vendor holds up two bottles of soda in his timeless effort
to move as many bottles as he can.

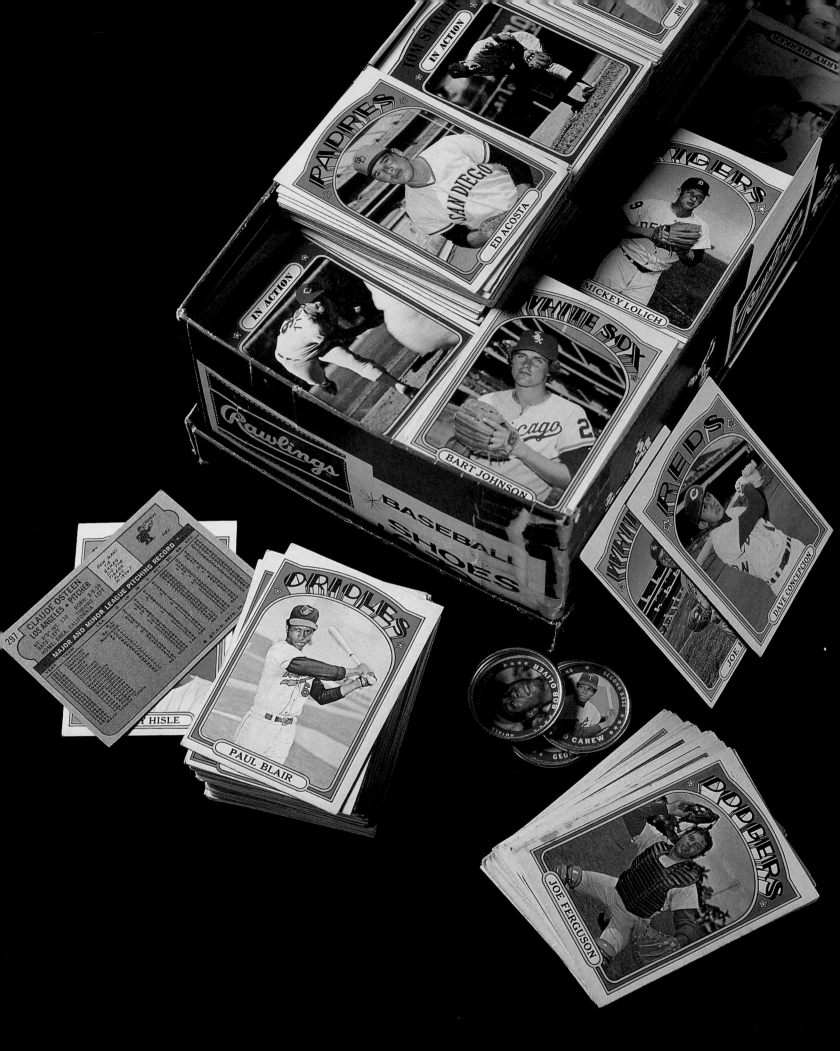

A Gift

I GOT A PACKAGE FROM MY FATHER TODAY—a small, padded Jiffy envelope containing two neat little bundles wrapped in white tissue paper, folded and pleated and sealed up in their pouch with a slightly neurotic precision that is characteristic of my father and that he inherited, I believe, from his mother, Irene, who wrapped everything, even the unpeeled oranges on her kitchen counter and the silverware in her drawer. He'd neglected to include a note or a card, but my 28th birthday is a week off and I took this package to be my gift from him.

I unwrapped the first neat little bundle and found, in their clear plastic sleeves, four baseball cards, printed by the Bowman Gum company in 1952, the year my father was 14. There was a Bobby Adams, and a Billy Goodman, and two pitchers named Howie, Judson and Pollet. I consider myself a baseball fan and a moderately accomplished student of baseball history, but I confess that I had never heard of any of these players. Thinking that I had inadvertently opened the "auxiliary" portion of my birthday present—perhaps some duplicate cards from my father's collection that he had thrown in as a kind of bonus—I tore open the other bundle and found three more cards. They were also Bowmans, also in their archival plastic, PVC-free sleeves: a Mickey Harris, a Vern Bickford, and then a Randy Gumpert.

Despite the note of faintly derisive disappointment inherent in any sentence that ends in the word "Gumpert," I was not at all disappointed in my father's gift. The 1952 Bowman cards are among the most serenely beautiful exemplars of a popular art form not notable, it must be admitted, for works of great beauty, serene or otherwise. Throughout its 100-odd-year history, the baseball card, for all its recent popularity among collectors like my father, generally has been an object supremely suited for insertion into the spokes of a bicycle wheel. An awkward old photograph of some square-jawed, wall-eyed fellow named Carlton Molesworth, in a peaked beanie, staring off into the outfield on some vanished sepia afternoon, may have a kind of poignant charm to the baseball fan. And some of the cards of the '30s and '40s, such as National Chicle's Diamond Star and those issued by the Leaf Gum Company, have a kind of flat, primary-colored crudeness that makes them look like so many tiny Warhols. However, most baseball cards are, as specimens of the photographic and design arts, at best uninteresting to look at and, far more frequently, downright ugly.

The 1952 Bowmans are different; accidentally, perhaps, they attain a cool and evocative beauty. For one thing, there is no printed text on the obverse of the cards, no goofy bird or Injun. There is no sock in the case of Randall P. Gumpert, only a small, simulated autograph—modest, dignified, perfectly legible—stitched across the portrait of the Boston right-hander. And the portraits themselves! The ballplayers have been depicted not with the usual glum mug shots or the clumsy, hand-drawn caricatures found on cards of earlier years, but rather in an odd combination of painting and photograph—

◆ Thanks to all those mothers who didn't throw them away—a vintage collection of 1972 baseball cards, nestled away inside a shoebox that once held baseball cleats.

photographs not merely tinted and retouched, but painted over, transformed. There are blood-red Boston B's on caps, radium-white uniforms, dreamy, powder-blue, textbook skies—all the colors running rich and surreal. The lace cornices of Yankee Stadium, seen over the shoulder of Randall P. Gumpert, are a luminous cake-icing green and his resolute mouth is a jet-black cartoon line. One feels that these are unquestionably idealized paintings of ballplayers. But all the men have been caught, in mid-windup, or after letting fly, or stooping to short-hop a grounder, as only a photograph can catch a man—with his mouth open, or his teeth clenched, or his forehead furrowed in candid anxiety over the location of this next pitch, or with his thoughts patently elsewhere, his eyes looking strangely lost and vacant, the way eyes can in photographs.

And then, inexorably, you turn the card over. Because the great secret theme of baseball is Loss (and its teammate, Failure), reading the backs of baseball cards is always an exercise in pity, and this is particularly true of the reverse of an older card like a 1952 Bowman, where the details of a ballplayer's career are generally given not in the clean, bloodless statistical charts of today but in terse, prose paragraphs, where they take on some of the mighty sadness of narrative. Each card can become the tiniest of novels, whose plot is the familiar tale of futility and squandered promise and a ballclub giving up on him. Howie Pollet "began the 1951 season with Cards. In 6 games for them, with no wins and 3 losses. With the Pirates Howie took the mound 21 times, with 6 wins and 10 losses. Season's record: 6 and 13. Led League in 1946 with 21 wins. Had 20 wins in 1949. Broke into majors with Cardinals." At the bottom of every card is the send-away offer of a baseball cap of your favorite major league team ("a $1.00 value"), for five wax wrappers and fifty cents.

The thing is, I don't really collect baseball cards, and I think that my father knows this. During the winter of the lockout, just before my marriage ended, in the miserable grip of a Seattle January that consisted, without exaggeration, of

◆ A Pair of Sox: 1951 Bowman baseball cards featuring Billy Goodman of the Boston Red Sox
and Howie Judson of the Chicago White Sox.

30 full days of rain, I dabbled in the hobby, out of a kind of desperate yearning for a season that, it then appeared, might never have its Opening Day. But I don't have the collecting temperament—not the way my father has it—and it has been over a year now since I bought my last card. But that isn't important. I have a little-used copy of *Dr. Beckett's Price Guide*, in which I can look up the values of the seven cards and see that my father's gift is a generous one—but that isn't important, either.

That's what I'm thinking, anyway, as I pull down the copy of *Macmillan's Baseball Encyclopedia* that was my father's gift to me 22 years ago this week, and discover that Billy Goodman was actually a pretty good ballplayer who in 1950 led the American League in hitting with a .354 average, and that Vern Bickford, in the same year, pitched the season's only no-hitter. It's not important that I don't collect 1952 Bowmans nor care what they're worth (not really). It's not important that when I'm finished turning each card over and over and wondering at that lost expression in

Howie Pollet's eyes, I'll probably just put them all away in my sock drawer and lose them for a while.

What is important is the nature of the gift: my father saying to me—after 28 years during which we have lost Roberto Clemente and our beloved Washington Senators and my father's mother and father and have split two divorces between us, and have known all the usual guilt and bitterness and recrimination, and have moved, in modern and terrible fashion, to opposite ends of the continent—"Here, son, have seven baseball cards." What's important is that baseball, after 28 years of artificial turf and expansion and the designated hitter and drugs and free agency and thousand-dollar bubblegum cards, is still a gift given by fathers to sons.

◆ Creating scrapbooks is a popular way for fans to express their love for a favored team or player. Often meticulously prepared, such volumes may include everything from newspaper accounts of the ongoing season to baseball cards, scorecards, and other personal items. A young fan made the open scrapbook (above) in 1909.

KARAL ANN MARLING

Why the Minnesota Twins Have Such Big Heads

THE TWINS HAVE HAD THEIR UPS AND DOWNS—mostly small-market downs—in recent years, down somewhere near the murky bottom of the American League. And the one bright spot in the 2000 season wasn't a promising rookie with a swing like Babe Ruth, sent to deliver Minnesotans from the slough of despair. No. The high point amid the valleys of a dismal millennial season was a bobblehead doll. Or rather four bobblehead dolls. These were figurines with big, fat faces wired to springs, so they nodded in enthusiastic agreement—even when asked if the Twins would win a World Series again in our lifetimes.

The dolls were an inspired bit of desperation marketing from the head office—blatant "come-ins" designed to

lure fans back to an almost empty Metrodome. The promotion worked, too. Bobblehead seekers camped out at the entry gates, since only the first umpteen thousand customers would get a free statue. Canny veterans of the late Beanie Baby craze bought up blocks of tickets, handed them out to surrogates, and lurked in the bar across the street to collect their haul of figurines during the seventh-inning stretch. Some people walked through the turnstiles, picked up their prizes, and walked right out again to log onto eBay and make a killing in the resale trade. Although the Twins

couldn't win on the field, they surely won the great "Major League Giveaway Contest of 2000" by four runs—with Kent Hrbek, Kirby Puckett, Tony Oliva, and Harmon Killebrew nodding solemnly in silly syncopation.

The bobble quartet consists of the Twins' mightiest all-time heroes. Bobble art is not a flattering medium at the best of times. Bobble Killebrew—a tribute to the slugger with a great, weird name and those six AL home-run titles in the 1950s and '60s—was, perhaps, the oddest-looking of the bunch, with a huge, lumpish nose. Bobble Hrbek came closest to capturing the look of the original—the beefy, genial, hometown kid who made good with the hometown team. The bobblehead incarnation of the great Kirby Puckett—our 2001 Hall of Famer and auteur of our two fondly remembered World Series championships—resembled its inspiration in one regard: Both Kirby and the doll were black. And, as for Bobble "Tony O"—an homage to another Minnesota idol of the Killebrew era—well, you had to use your imagination.

The Minnesota Twins are fortunate to share their field of dreams with General Mills of Minneapolis, the maker of Wheaties cereal, "The Breakfast of Champions." Wheaties has stood at the forefront of the sports tie-in business for a long time, continuing a tradition of selling beer, tobacco, soft drinks, tea, and even dog food with the images of ballplayers. Since the 1870s, the picture—and sometimes just the name—of a major leaguer has been enough to enhance the consumer appeal of candy bars, bicycles, green

beans, and canned milk. The notion was that, if the Babe was associated, however tangentially, with a tube of shaving cream, it ought to be good enough for the anonymous fan in the stands.

The Wheaties boxes that celebrated the Twins' World Series triumphs of 1987 and 1991 became instant collectors' items, spawning a cottage industry in cereal-box protective covers, tailored to fit the precious talisman of victory. Here in Minnesota, we all have a pair of slip-covered Wheaties boxes stashed in our attics.

But the best and possibly, in retrospect, the strangest ad-related Twins item is the "Homer Hanky." A 15-inch square of white muslin bearing a modern likeness of a baseball in red, the hanky appeared during the 1987 pennant drive, a copyrighted promotional gimmick of the local newspaper, the *Star Tribune*. Fans bought them in bulk. Every home game was aflutter in a sea of waving hankies that, for distraction value, almost equaled the noise generated inside the Dome by some 50,000 hysterical fans flapping their little signal flags for the sheer excitement of it all. I have a hanky, of course, stained with relish, mustard, and tears of joy.

There was a second edition bearing the legend, "Just As Great in '88." Alas, it was not to be, and by the time 1991 rolled around, I was a pro who turned up in the third-base, lower-deck seats with an old dish towel, large enough to flick at a brace of southern-fried supporters of that other team from Atlanta seated only two rows away.

In 2001, the Twins were a winning club again for

the first time since 1994—before Hrbek retired, Puckett was sidelined by glaucoma, and the baseball strike tarnished the silvery glow of the national pastime. I hope that fans will come back to the game without all the come-ons, without free autographed balls or magnets imprinted with the schedule, and without hankies, ads on the radio, or the promise of new Wheaties boxes.

But if they want to make some more bobblehead dolls—Gary Gaetti, Frankie Viola, and Tom Kelly maybe—I'd be the first in line.

OFFICIAL NATIONAL LEAGUE SOUVENIRS	
CUSHION (Paper)	.15
PICTURE SET (SET OF 12)	.25
POST CARDS (SET OF 6)	25¢
ROOTER BADGE	.25
SUNSHADE	.25
CREW HAT	1.60
PICTURE SET (SET OF 25)	50¢
PENNANT OR PICTURE BADGE	.50
BUNNY DOLL	$2.00
DOLL (SMALL PLAYER)	.75
PEN & PENCIL SET	
SUN GLASSES	.75
CAP (ALL SIZES)	1.00
FIELD GLASSES	1.00
BAT RACK BANK	1.50
LADIES SPORT CAP	1.50
DOLL (Washable Plastic)	$1.50
CUSHION (Washable Plastic)	$1.50
RAINCOAT (MEN'S OR LADIES')	$1.50
FIELD GLASSES (LARGE)	$2.00
SCARF (PURE SILK)	$2.00
BASEBALL CAP (WOOL-EYELET)	1.50

◆ OPPOSITE: Kirby Puckett bobblehead doll, 2000. ABOVE: Souvenir price board from the Polo Grounds, ca 1956. With today's manufactured nostalgia and limited editions, the world of souvenirs has changed, but the idea remains the same: Take home a memory of your ballpark experience.

It's their sons' first Little League game. When Marion and Dot arrive for the game, the air is alive with the excitement and expectation, pomp and pride, as the town turns out to celebrate. This vignette from Shirley Jackson's novel *Raising Demons* captures many parents' feelings.

Shirley Jackson 1953

Raising Demons

SUDDENLY, FROM FAR DOWN THE BLOCK, we could hear the high-school band playing "The Stars and Stripes Forever," and coming closer. Everyone stood up to watch and then the band turned the corner and came through the archway with the official Little League insignia and up to the entrance of the field. All the ballplayers were marching behind the band. I thought foolishly of Laurie when he was Barry's age, and something of the sort must have crossed Dot's mind, because she reached out and put her hand on Barry's head. "There's Laurie and Billy," Barry said softly. The boys ran out onto the field and lined up along the base lines, and then I discovered that we were all cheering, with Barry jumping up and down and shouting, "Baseball! Baseball!"

"If you cry I'll tell Laurie," Dot said to me out of the corner of her mouth.

"Same to you," I said, blinking.

The sky was blue and the sun was bright and the boys stood lined up soberly in their clean new uniforms holding their caps while the band played "The Star-Spangled Banner" and the flag was raised. From Laurie and Billy, who were among the tallest, down to the littlest boys in uniform, there was a straight row of still, expectant faces.

◆ New York City fetes the Mid-Island Little League team from Staten Island after winning the Little League World Series in 1964. When Carl Stotz founded Little League in Williamsport, Pennsylvania, in 1939, he thought it might be nice for kids to have uniforms, just like their big league heroes. Did he also envision ticker-tape parades?

Growing up with the Game

MY FIRST MEMORY of throwing and catching a baseball goes back to the age of five, or maybe six—those years are not that clear. It was not a leisurely game of catch with my father, nor was it a pickup game in the neighborhood. It was beside an old barn, at the edge of a cotton field in rural Arkansas, with a man I would never see again. But I would always remember him.

I was throwing with Juan, a migrant Mexican worker on our farm. I had a ball and glove that I'd found under the Christmas tree months earlier. Juan had neither. His hands were like leather and he could throw a baseball from our house to our barn, which seemed like a mile. We worked on my fastball and my curve, and I have often suspected that Juan was the first of many to realize the severe limits of my talent. But he was patient, and after a long day of picking cotton I could always coax him into another game of catch. We would throw until dark, then I would walk to the front porch and listen to a game on the radio. Juan would go to sleep.

We were Cardinals fans, and the highlight of every day was the sound of Harry Caray's voice coming to us all the way from St. Louis. My grandfather had followed Dizzy Dean and the Gashouse Gang. My father worshipped Stan Musial. My Cardinals were Bob Gibson and Lou Brock. Baseball links generations like no other sport and few other traditions. Our church and family were the most important institutions. Baseball was a very close third.

After we left the farm, we moved each summer to a different town around the deep South. My brothers and I could instantly judge the quality of life in every new place by a quick inspection of the local ball fields. We usually arrived too late to register for the youth leagues, and so we spent hours each day playing pickup games with the neighborhood kids.

I was ten before I wore my first uniform. I wore it badly and played even worse, but when I was dressed for a game I felt like a Cardinal. The coach wisely kept me on the bench, but because he was a good coach he taught me my first lesson from baseball. If you want to play more, then practice more.

The second lesson quickly followed the first. We lost every game but two. Winning is easy, but losing with grace takes guts. Our coach made us smile after each loss. Baseball is a game of failure, he said. Get three hits out of ten at-bats, and they'll put you in the Hall of Fame.

My career peaked when I was twelve. I had some nice stats. I made the all-star team and realized that the major leagues would indeed be just a few years away. This brought about the third lesson. The game will humble you. Get cocky, believe it when others say you're good, and a slump will arrive overnight and last two weeks.

In the spring and summer, our lives revolved around the ballparks in those small towns. We would play all day on the fields, then run home, clean up, put on our uniforms, and hustle back, lay the chalk, rake around the bases, cut the grass, fill the water coolers, warm up, and get ready for the real games.

Since there was little else to do in town, everyone came to the ballpark. The fathers and the old men brought their lawn chairs and sat behind home plate where they corrected the umpires and yelled instructions to those of us on the field. Between innings they relived their youths with tales of home runs hit over trees and sliders that would buckle knees. The mothers and grandmothers would gather near the bleachers where they would watch the toddlers, and maybe the game, and plan church socials and weddings and talk about the urgent social matters of the town. The older teenagers would hang together behind a dugout. Some would hold hands and sneak away; others would actually hide in bushes and smoke. There was always a crying baby or two because everybody came to the games.

I remember all sorts of activities taking place during our games. Peas were shelled, quilts knitted, checkers played, votes solicited and promised, fights started and settled, romances carried out in the shadows behind the bleachers. And through it all you could hear Harry Caray somewhere in the background, in his colorful, scratchy voice, describing every play of our beloved Cardinals.

The languid and sporadic pace of baseball allows folks to visit, to engage, to catch up on important matters. No other sport is less rushed.

My fondest childhood memories are of those long, hot summer nights at the ballparks with everyone I knew gathered close by, watching us boys play our games. I can still feel the heavy air, and the dust from the infield, and the sweat of action, and I still hear the sounds of the game—the chatter from infield, the shouts from the coaches, the calls from the umpires, the idle laughter of the old men behind the backstop, the cheers from the mothers, the encouragements from the fathers, the babies, the Cardinals on the radio.

As children, we were not only allowed to play baseball every day, we were expected to. It made us laugh and cry, win and lose; it broke our hearts and it made us feel like champions. And it brought everyone together.

Baseball was life in those wonderful days.

◆ The statistics of pitching great Christy Mathewson, who played his last game in 1916, still fascinate young players in the 1960s. This painting, by James Bama, was used by the firm Brown and Bigelow in a popular series of calendars and other promotional products called "Remembrance Advertising."

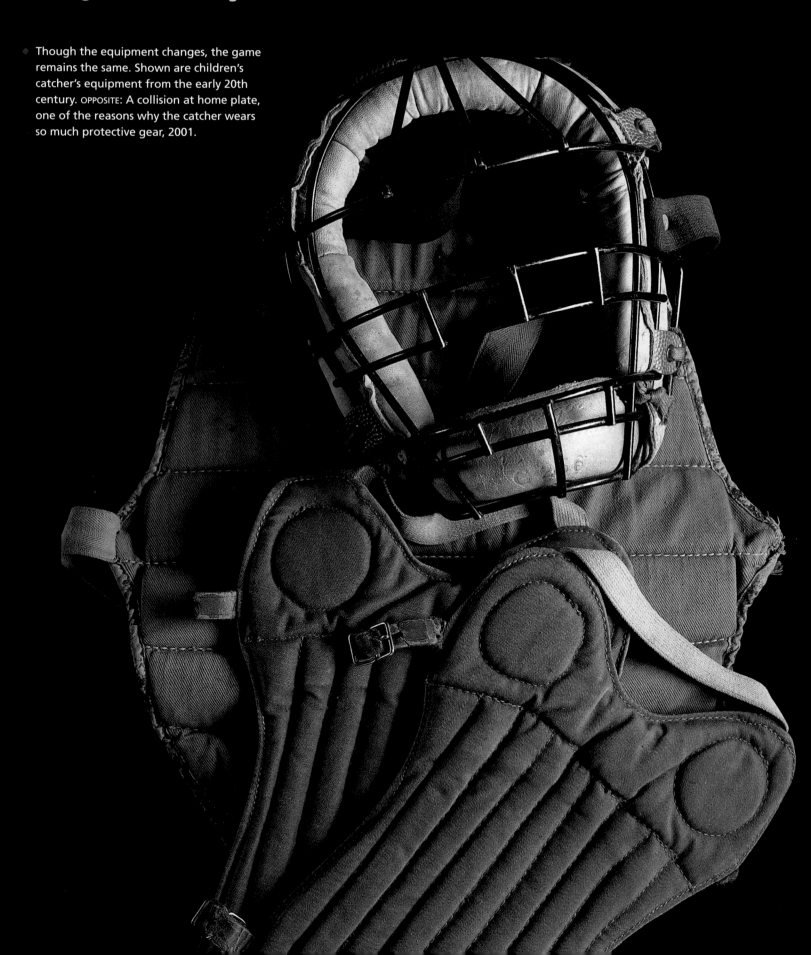

The Big Time of Little League

◆ Though the equipment changes, the game remains the same. Shown are children's catcher's equipment from the early 20th century. OPPOSITE: A collision at home plate, one of the reasons why the catcher wears so much protective gear, 2001.

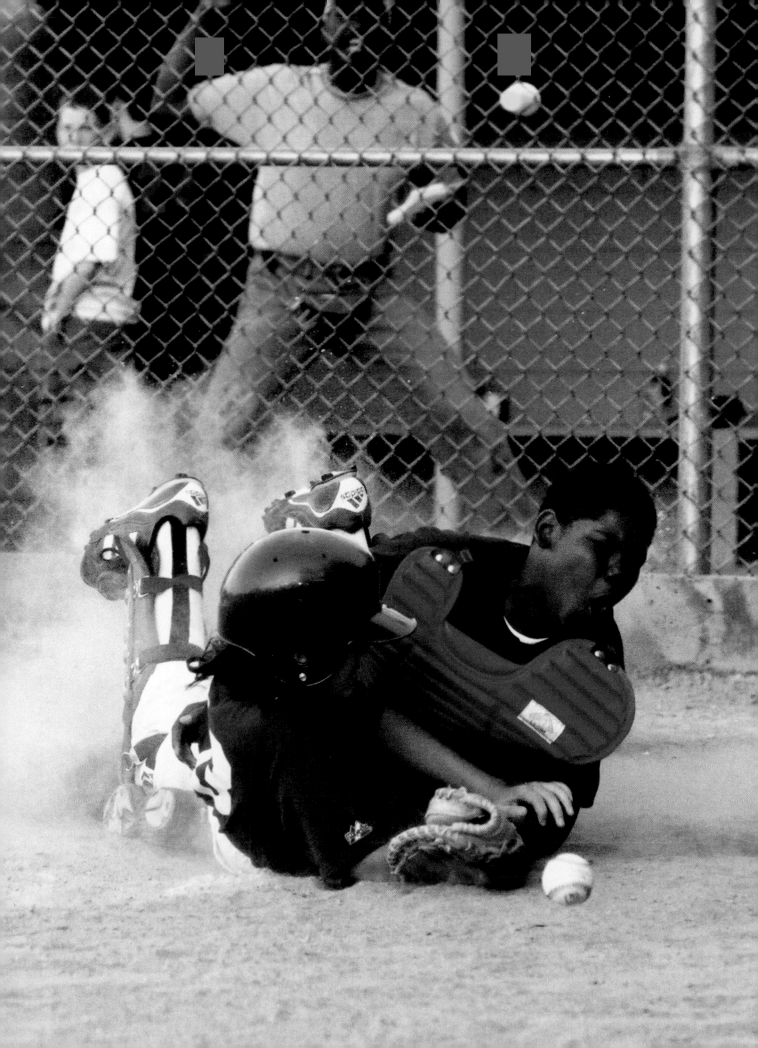

"As children, we were not only allowed to play baseball every day, we were expected to. It made us laugh and cry, win and lose; it broke our hearts and it made us feel like champions. And it brought everyone together. Baseball was life in those wonderful days."

—JOHN GRISHAM

Exuberant boys imitate their major league heroes (or do the big leaguers imitate the boys?) as they celebrate winning an invitational tournament in suburban Maryland.

Our National Pastime

AS I PONDER THE START of yet another baseball season, what is left of my mind drifts back to the fall of 1960, when I was a student at Harold C. Crittenden Junior High ("Where the Leaders of Tomorrow Are Developing the Acne of Today").

The big baseball story that year was the World Series between the New York Yankees and the Pittsburgh Pirates. Today, for sound TV viewership reasons, all World Series games are played after most people, including many of the players, have gone to bed. But in 1960 the games had to be played in the daytime, because the electric light had not been invented yet. Also, back then the players and owners had not yet discovered the marketing benefits of sporadically canceling entire seasons.

The result was that in those days young people were actually interested in baseball, unlike today's young people, who are much more interested in basketball, football, soccer and downloading dirty pictures from the Internet. But in my youth, baseball ruled. Almost all of us boys played in Little League, a character building experience that helped me develop a personal relationship with God.

"God," I would say, when I was standing in deep right field–the coach put me in right field only because it was against the rules to put me in Sweden, where I would have done less damage to the team–"please please PLEASE don't let the ball come to me."

But of course God enjoys a good prank as much as the next infallible deity, which is why, when He heard me pleading with Him, He always took time out from His busy schedule to make sure the next batter hit a towering blast that would, upon re-entering the Earth's atmosphere, come down directly where I would have been standing, if I had stood still, which I never did. I lunged around cluelessly in frantic, random circles, so that the ball always landed a minimum of 40 feet from where I wound up standing, desperately thrusting out my glove, which was a Herb Score model that, on my coach's recommendation, I had treated with neat's-foot oil so it would be supple. Looking back, I feel bad that innocent neats had to sacrifice their feet for the sake of my glove. I would have been just as effective, as a fielder, if I'd been wearing a bowling shoe on my hand, or a small aquarium.

But even though I stunk at it, I was into baseball. My friends and I collected baseball cards, the kind that came in a little pack with a dusty, pale-pink rectangle of linoleum-textured World War II surplus bubble gum that was far less edible than the cards themselves. Like every other male my age who collected baseball cards as a boy, I now firmly believe that at one time I had the original rookie cards of Mickey Mantle, Jackie Robinson, Ty Cobb, Babe Ruth, Jim Thorpe, Daniel Boone, Goliath, etc., and that I'd be able to sell my collection for $163 million today except my mom threw it out.

My point is that we cared deeply about baseball back then, which meant that we were passionate about the 1960 Pirates-Yankees World Series matchup. My class was evenly divided between those who were Pirate fans and those who

were complete morons. (I never have cared for the Yankees, and for a very sound reason: The Yankees are evil.)

We followed every pitch of every game. It wasn't easy, because the weekday games started when we were still in school, which for some idiot reason was not called off for the World Series. This meant that certain students—I am not naming names, because even now, it could go on our Permanent Records—had to carry concealed transistor radios to class. A major reason why the Russians got so far ahead of us, academically, during the Cold War is that while Russian students were listening to their teachers explain the cosine, we were listening, via concealed earphones, to announcers explain how a bad hop nailed Tony Kubek in the throat.

That Series went seven games, and I vividly remember how it ended. School was out for the day, and I was heading home, pushing my bike up a steep hill, listening to my cheapo little radio, my eyes staring vacantly ahead, my mind locked on the game. A delivery truck came by, and the driver stopped and asked if he could listen. Actually, he more or less told me he was going to listen; I said OK.

The truck driver turned out to be a rabid Yankee fan. The game was very close, and we stood on opposite sides of my bike for the final two innings, rooting for opposite teams, him chain-smoking Lucky Strike cigarettes, both of us hanging on every word coming out of my tinny little speaker.

And of course if you were around back then and did not live in Russia, you know what happened: God, in a sincere effort to make up for all those fly balls he directed toward me in Little League, had Bill Mazeroski—Bill Mazeroski!—hit a home run to win it for the Pirates.

I was insane with joy. The truck driver was devastated. But I will never forget what he said to me. He looked me square in the eye, one baseball fan to another, after a tough but fair fight—and he said a seriously bad word. Several, in fact. Then he got in his truck and drove away.

That was the best game I ever saw.

◆ Unlike Dave Barry, young Daniel Allen caught a fly ball at a T-ball game on the White House lawn, May 6, 2001. Allen is delighted to receive congratulations from the Famous (nee San Diego) Chicken.

DAVID LAMB

The Minors: Touching the American Heart

BOWEN FIELD, BUILT IN 1939 on the fairgrounds in Blue-field, West Virginia, sits in a hollow, surrounded by thick woods. At dusk, the lights of houses down the dirt road shine through the tall trees, and from the grandstands you can see kids riding their bicycles toward the flickering beacons of home.

Beyond the outfield fence, on land owned by the local Baptist college, a steep hill rises. Miners too poor to afford the price of a ticket watched the games from there in the '50s, lighting small fires to keep warm. The elms and maples were shorter then, and to fans inside the ballpark, the silhouettes of the miners huddled around their burning logs were almost as distinct and recognizable as those of the ballplayers themselves.

The park is the home of the Bluefield Orioles in the rookie Appalachian League, the low-rent district of baseball's minor league system, and on a summer night there are few places I'd rather be. The play on the diamond tends to get a bit sloppy, but the feel of the setting is picture-perfect.

In an era when baseball is defined by multimillion-dollar salaries and players with edgy attitudes, it is in towns like Bluefield that I choose to believe the heart of professional ball now lies. This is the bush leagues—long bus rides, Big Macs for dinner, and cheap apartments shared by three or four players not yet spoiled by fame or fortune. This is where Norman Rockwell would have brought his paint brush to record the face of America.

I discovered Bowen Field when I returned to the United States after nearly a decade working in Africa as a journalist. Feeling a need to reconnect with my homeland after being away for so long, I bought an RV and, on the first day of the minor league season, headed for the open road to discover America (and tour the minor leagues, developed by Branch Rickey in the 1920s as a training ground for aspiring major leaguers).

Over five months, I wandered 16,000 miles, through cities with Triple-A teams like Richmond and Omaha, through Single-A towns from Stockton, California, to Elmira, New York, and rookie league outposts that stretched from Bluefield to Butte, Montana. By the time I got home in September, I had visited 40 or 50 ballparks and become convinced the communities that had minor league teams—232 of them in 21 leagues stretched coast to coast—were better places in which to live than those that didn't.

The *Salt Lake Tribune* editorialized in 1887: "Salt Lake has for a number of years fostered the game of baseball. In fact, our city would not be up in modern ideas did she not do so. In these times baseball clubs are almost an imperative necessity."

After so many years, the basic premise still holds: A minor league franchise is part of a city or town's civic identity. Like the game of baseball itself, it represents continuity between past and present. It offers wholesome family entertainment, a modest boost to the local economy, and

◆ OPPOSITE: Patriotic satin uniform for the American Association minor league All-Star team of 1938. This may have been the first use of the fabric in a baseball uniform, which reflected the lights used in night games. Brooklyn and the Boston Braves both experimented with satin in the 1940s but abandoned it as too hot and not durable enough.

an intimacy between fan and player that long ago disappeared from the majors.

I can still see season-ticket-holder Mary Gunstone at the railing beyond the dugout at Kindrick Field in Helena, Montana, calling the Brewers aside, one by one, to give each a photographic chronicle of the season that she had put together. Each album was inscribed with the player's name. "Mary, why don't you just give them doughnuts?" the owner of the bakery where she worked had asked. "No," she replied. "You can't take doughnuts home. I want to give them something to remember their summer in Montana by."

I remember asking Bob Kaplcr, the blind organist at Sam Lynn Ballpark in Bakersfield, California, if he "saw" the same game on the field that I did. He said, "No, I don't know what colors look like. I don't know what darkness is. But I think I appreciate baseball more than other sports, because it's a game my mind can grasp. It's not just a rush of people playing against a clock. It's got pacing and orderliness, a sort of structure."

I had no doubt that the lives of people like Mary Gunstone and Bob Kapler—and so many others I met during the season I stole from adulthood—were enriched by the presence of minor league baseball. I know mine had been. The minors had put me back in touch with America. They had rekindled my appreciation for thc simple pleasures of a summer night and for young men who dared to dream big dreams.

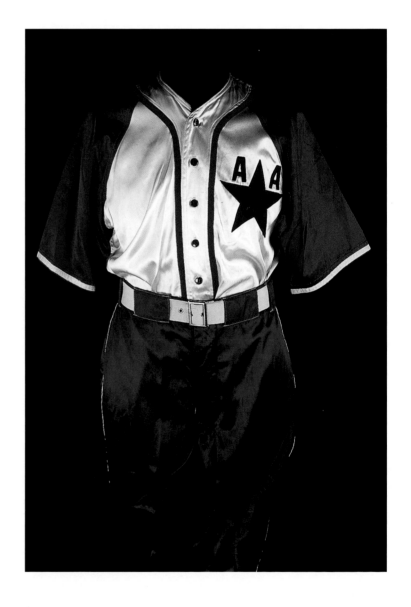

◆ FOLLOWING PAGES: Minor leaguers in the Milwaukee Brewers farm system compete at the Brewers' minor league facility near Phoenix, Arizona, 1990.

ROGER KAHN

We Never Called Them Bums

EARLY IN THE 1950S, when the *Brooklyn Eagle*, once edited by Walt Whitman, was forced permanently to shut down, a sardonic baseball writer named Tom Meany offered an interesting comment. "Brooklyn," Meany said, "is now the only American city of two million people without a newspaper, a mayor or a left fielder."

Meany's remark crackled with truth. Of course, technically, Brooklyn was and is a borough, not a city, with a borough president, not a mayor. And, back in the '50s, characters as varied as Dick Williams and Junior Gilliam played left field in Brooklyn, but with limited success. Meany's comment is most memorable because it captured Brooklyn's fierce, masked passion for its team. Across a half-century of disorder and triumph, the Dodgers fixed a love-lock on Brooklyn's vibrant heart. When the team was ripped away to perform among California lotus leaves, that heart suffered a wound from which it has not yet recovered. "They are a lot of fools, the people who say you get over things—your old loves, your old poems," Robert Frost once told me. "I never do."

Brooklyn, a seaport community fashioned first by Dutch and English settlers, attracted a swelling immigrant population late in the 19th century, and these people came from Irish, German, Jewish, and Italian stock. They scrapped and struggled against each other, as disparate people will, but also banded together in various ways. One common ground was rooting for a usually not very good baseball team sequentially called the Bridegrooms, the

Superbas, the Robins, and finally the Brooklyn Dodgers.

Who owned New York? Jarring John McGraw and his New York Giants won six National League pennants before 1918. In 1920, the New York Yankees acquired Babe Ruth and tramped onto a path of domination. By contrast, Brooklyn—the Dodgers and the borough itself—receded, becoming nothing more than Topeka-by-the-sea, at least so it seemed. What was once called "the City of Churches" became "Manhattan's bedroom." Comedians forced jokes. "Hey, youse from Brooklyn? Know any goils?" Thomas Wolfe wrote a harsh short story, "Only The Dead Know Brooklyn."

To make matters worse, after 1920, the Brooklyn baseball team went 20 years without a pennant. Twenty years. Half of Moses' time in the wilderness. But, was this bleak to those who actually lived in Brooklyn? No, not at all.

I went to a Brooklyn prep, Froebel Academy, and, losses be darned, we were proud of our Dodgers. Boys on the highly vincible Froebel baseball varsity said, "Criminy, at least we've got a big-league team. Think of all the places that don't." At Ebbets Field, we watched Jersey Joe Stripp make diving stops at third. (The ones he didn't stop were doubles.) Van Lingle Mungo threw overhand fastballs out of a cartwheeling motion nobody dares to use today. The amazin' Casey Stengel managed for a while, and when he got fired, Burleigh Grimes replaced him. Grimes was mean, all right. After one tough defeat, he punched an urchin who

wanted his autograph. But Grimes, "Ol' Stubblebeard," was *our* mean guy.

Like Stengel, Grimes was fired, and the next year, 1939, the Great Awakening began. Two gifted baseball men, Larry MacPhail and Leo Durocher, patched together a Brooklyn team that finished third. In 1940, the Dodgers came in second. In 1941, they won the pennant.

After World War II, Branch Rickey brought Jackie Robinson to play in Brooklyn and, of course, break the color line, baseball's cotton curtain that had been barring blacks from the major leagues since 1884. The great and liberating Dodger team featuring Robinson and Pee Wee Reese won six pennants in ten years. In 1955, for the first and only time in the history of our planet, the Brooklyn Dodgers won the World Series. Backwater? Hell, no. Brooklyn was now First Place, USA. The drab comedians faded. People stopped reading Thomas Wolfe.

But the extraordinary American success saga, fashioned in Brooklyn, came to a sorry end. Two years after Brooklyn's Series victory, the Dodgers' owner, Walter O'Malley, moved the franchise to Los Angeles. He had been making good money. He wanted more. In the process, O'Malley abandoned tradition, sportsmanship, and honor—at least that is how Brooklynites felt and feel to this day.

But I meant to tell you about the genesis of the term "bums." Certain Manhattan columnists and cartoonists disliked making the trip to Brooklyn to cover games. They

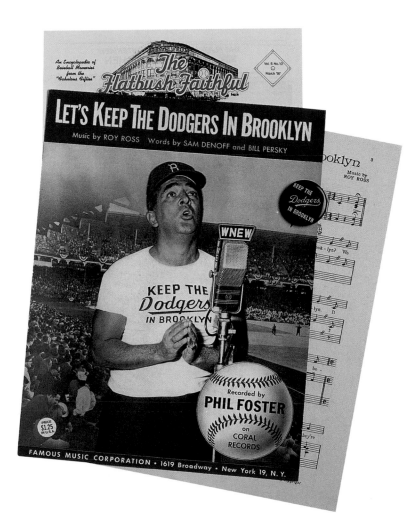

wrote about Dodger teams and Brooklyn in disparaging ways and finally settled on the demeaning nickname "Dem Bums." Bums? Robinson, Gil Hodges, Reese? Please. Reese, Robinson, and even Jersey Joe Stripp weren't bums at all. They were heroes. The real bums were the sports writers who laid the word "bum" on the community of Brooklyn, probably because a three-letter word was easy for them to spell.

◆ Pin and sheet music pleading for the Dodgers to stay in Brooklyn instead of moving to Los Angeles. Background is a copy of *The Flatbush Faithful,* a newsletter for unreconstructed Brooklyn Dodger fans, in publication since 1991.

The Language of Numbers

STATISTICS ARE NOT INCIDENTAL TO SPORT. Sport, like music, is an eruption of the universal anxious urge to organize our perceptions. You have a group of 15 or 20 kids; everybody sort of knows which ones are the fastest, but they're going to race anyway, just to be sure.

The musician takes the vast universe of sounds, strips it to a relative few that are pleasing to the ear, and arranges those relative few into combinations that are esthetically satisfying. An athletic contest takes the vast universe of physical actions, plucks out a few that are pleasing to watch, and arranges them into combinations that make a satisfying event.

It is surprising how easy it is to punch out the details here. A pitch is analogous to a note, an at-bat to a measure, an inning to a movement, a game to a symphony, a series to a concert. A team is analogous to an orchestra, the manager to a conductor, the pitcher to the first violin, the outfielders to the brass, the dugout to the orchestra pit, the uniform to the tux. Connie Mack can be likened to Mozart, Billy Martin to Mick Jagger, and Don Zimmer to Meatloaf. Please stop me before I get to the on-deck circle.

Resin is a substance that is used by violinists and pitchers and seldom heard about in other contexts. The violinist requests the "pitch" by which everyone else is tuned. The scorecard is analogous to the score. At this point, the analogy begins to crumble, thank God. While there is a more-than-coincidental similarity in appearance and name between a scorecard and a musical score, there is an obvious difference: A score is written before the event and dictates the sequence of events, while a scorecard is an after-the-fact record of a sequence that could not have been anticipated in more than the most general manner. Music is more organized than sport, more controlled; even jazz is regimented, compared to baseball.

When the musician organizes the universe of sounds, what emerges is not simply organization and noise. It is music—rich, diverse, evocative, and emotional. When a baseball game is played, what emerges is not simply an organized competition, but a small human drama, filled with promise and uncertainty, hope and disappointment.

And when the statistics from those games are compiled, what emerges is not simply an organized record of the contest, but rather….

Well, what is it? Can a baseball statistic evoke an image, or an emotion? Yes, it can.

Suppose that I were to describe to you a player who had 194 hits, among them 41 doubles, 12 triples, and 17 home runs. Do you have an image of that player? If you are a baseball fan, you do.

Is this player young or old? Obviously, he is young. Is this player fast or slow? Obviously, he is fast. Does this player drive the ball to the gaps? Obviously, he does. Is this player committed to playing almost every day, motivated and self-disciplined? Almost certainly. We *know* the answers to these questions—and yet this player is hypothetical.

As music acquires the powers of the soul, statistics

◆ Brooklyn Dodgers scorecard featuring a prominent advertisement. At this time, the Dodgers were alternately known as the Bridegrooms or the Superbas.

have acquired the powers of language. The way in which baseball statistics are understood widely is as language, and not at all as numbers are usually perceived. Suppose that you see the number 37 in a player's home-run column. Do you think about 37 of something? Do you think about 37 apples or 37 oranges or 37 in-laws? Absolutely not. You think about Manny Ramirez, Frank Thomas, Eddie Mathews, and Jim Thome. You think about *power*.

In the home-run column, the number 37 works not as a number, not as a count of something, but to evoke an image—as a word does, as music does. The existence of universal standards—a .300 average, 100 RBI, 20 wins, 30 homers—converts the steady march of humdrum statistics into a peculiar, precise form of language. We all know what .306 means. We all know what 14 triples means, and what zero triples means. We know what zero triples means when it is combined with zero home runs (slap hitter), and we know what it means when it is combined with 44 home runs (big guy with an uppercut who can't run). Each number in each column draws on its relationship to the millions of others that any baseball fan has seen in the same column and in the other columns to evoke images.

Let us start with the number 194 in the hit column, and with the assertion that it is impossible for a player who doesn't play hard and almost every day to get 194 hits in a season. It is possible for a creep to do this, for some jerk whom you wouldn't wish on your worst enemy to do this. But to get 194 hits in a season demands a consistency, a day-in, day-out devotion, a self-discipline, and a willingness to play with pain that could never co-exist with a lack of concentration and commitment to the sport.

It is entirely possible, on the other hand, for someone lacking that concentration and commitment to hit 37 homers. Hitting 37 homers is a thing that can be done by large, dull men who stride boldly to the plate and hack viciously at pitches out of their reach and stride boldly back to the dugout, chin up, when they strike out.

However, to get back to the 194 hits, is there not someone who comes to mind when I say "194 hits"? In my mind,

it is Dave Cash, a smart, tough little second baseman of the 1970s. Cash, who had 206 and 213 hits in 1974 and 1975, never had exactly 194 hits in a season, but he should have.

In no case does an image/number stand alone; standing beside it are those other nine columns. Every combination of columns forms a unique image: 194 hits with 40 doubles and 7 homers suggests some Dave Cash type, while 194 hits, 25 doubles, and 29 homers suggests Al Kaline or Bill White or Ryne Sandberg. I have dealt with only three columns and with only one year. When the numbers melt into the language, they acquire the power to do all of the things that language can do, to become fiction and drama and poetry. A combination of 194 hits with 29 homers can tell one story when that season climaxes a ten-year growth process and a greatly different story when the same numbers represent the highlights of a declining veteran's long-ago youth.

And thus it is not just baseball that these numbers describe, through a fractured mirror. It is character. It is psychology. It is history, power, grace, glory, consistency, sacrifice, courage. It is success and failure. It is frustration and bad luck, ambition, overreaching, discipline. And it is victory and defeat.

Numbers, simple numbers. They swagger and drool, they feint and punch, they rock and roll, they pray and beg, they gamble and steal. Am I imagining things? Do not the numbers of Roger Maris reveal opportunity and pain? Does not the record of Warren Spahn speak of almost unnatural determination? Do not the stressed and unstressed syllables of Willie Davis's prime suggest an iambic indifference? How else can one explain the phenomenon of baseball cards and that an industry has been built on selling math to fifth-grade boys?

One simplification of the political universe is that Republicans believe fundamentally that we all have the responsibility to take care of ourselves, and Democrats believe fundamentally that we all have the responsibility to care for one another. One of the great charms of team sports is that they unite these two world views: They are

a Republican enterprise, sustained by a Democratic illusion.

A sports team provides the simplest and truest model of a community based on shared and interdependent responsibility—a Democratic experience. However, the reality is athletics are an overwhelmingly Republican pursuit for an obvious reason: Nobody else can make you an athlete. You have to do it yourself.

Statistics are a way of reaching into the Democratic activity—the team game—and extracting the Republican essence of the players, identifying not merely their skills, but their natures. We play the games to enjoy the communal experience and the illusion that we somehow "belong" to that community. We go to games for the experience of the wind in our face, for the vicarious adrenaline rush when the game is on the line. We are sustained by a fantasy that the athletes care as much about us as we do about them. But what do we take from the game? Memories and statistics. Until the statistics are compiled, we have not organized the athletes.

Baseball without statistics would be trees falling unheard in the forest.

In my childhood, I knew a master storyteller who had lived his life as a rodeo cowboy. He was a professional athlete, a man who did his work in front of cheering or indifferent crowds, exactly as did Hank DeBerry and Lew Fonseca and Willis Hudlin in the same era. He retired and did rope tricks at rodeos, delivered milk to my neighborhood, and committed suicide at age 82, 20 years ago, and nobody knows or cares about him because he has no numbers. When I am dead, he will be forgotten, because he has no autobiography in the record books, while Willis Hudlin will be remembered as long as there is baseball, because he will always be a part of it.

The scorecard is no mere by-product of a baseball game, but rather as essential to its appeal as the contest itself. The scorecard is as central to baseball as the score is to a piece of music, as central as the election is to politics. Without it, the game is just noise.

◆ Scorecard from Don Larsen's perfect game in the 1956 World Series, signed by Larsen.

DANIEL OKRENT

You, Too, Can Be a General Manager!

HOW DID IT HAPPEN? I know where, and when, and even sort of why, but no matter how many times I've been asked over the past two decades I can't quite summon the actual thought process that led to the invention of Rotisserie baseball. I was on a flight from Hartford to Dallas. It was the off-season of 1979-80, and staring from the post-World Series precipice into the long days of November and beyond, I was bereft of baseball. I longed for the nourishment provided by a daily breakfast of box scores.

I had always felt that although I never had had the strength or speed or skill to play in the major leagues (or, for that matter, even for my high school team) there was one big league job I could perform as well as any of the incumbent professionals, and it was the one job that saw meaningful action in the off-season: I could be a general manager.

Like every other fan, I felt I could sign the talent, make the trades, and determine the roster *just* as well as the men who did it for a living. Rotisserie ball, named after La Rotisserie Francaise–a New York restaurant in which some baseball pals and I used to waste afternoons talking about the Philadelphia Phillies–was an idea every bit as simple as the *Random House Dictionary's* definition would eventually indicate: "a game in which participants compete by running imaginary baseball teams whose results are based on the actual performances of major-league players."

The three idle hours I had to fill on that plane were simply animated by an unexplained burst of imagination, a spasm sufficiently perverse to inspire the rules for a game that, I've been told, would change the way some Americans perceive baseball. I won't make that claim myself–despite the millions estimated to be playing Rotisserie or its generic, non-trademarked counterpart, fantasy baseball; despite the countless Web sites devoted to record-keeping, statistics-compiling, and talent-rating for those millions; despite the magazines, the newspaper columns, the call-in shows; despite the fact that Rotisserie players are more familiar with the skills of the 25th man on the roster of the Tampa Bay Devil Rays than most fans are with the 3-4-5 hitters on the New York Yankees, and are the most informed baseball public the sport has ever known. Despite all this, Rotisserie baseball is nothing more than an elaboration of all the dice games, spinner games, and statistical analysis games that are not merely its spiritual antecedents, but its blood relatives.

For me, it began when I was maybe six or seven and spent countless hours playing out pennant races with decks of cards: Aces were home runs, black kings triples, queens and red kings doubles, jacks and tens … well, you get the idea. By the time I was ten, I had graduated to Cadaco's All-Star Baseball, building a nearly permanent callous on my right index finger from the hours spent spinning the metal arrow over round cards marked off in segments appropriate to a specific player's skills. The segment marked "1" denoted a home run, and Mickey Mantle's was huge, Albie Pearson's nonexistent. The stacks of statistical records I

kept, month after month, would have abashed a Certified Public Accountant.

But it wasn't until I discovered Strat-O-Matic in my young adulthood, and Robert Coover a few years later, that I saw the life-affirming (and, it turned out, wife-alarming) possibilities in these games. The wait for a new season's Strat-O-Matic cards was nearly as agonizing as their ultimate arrival was rewarding. The highly codified, almost hieroglyphic columns of numbers defining each major leaguer's tendencies may have been unintelligible to most people, but to me and the rest of the Strat-crazed, they were as thrilling as an epic poem. Coover's novel, *The Universal Baseball Association Inc., J. Henry Waugh, Prop.,* showed how fine and how faint was the line between

addiction to an invented baseball game and the pathology of the truly crazy.

And maybe that explains my moment of inspiration in the skies over southern Illinois and eastern Missouri, back in November of 1979. Maybe the idea for Rotisserie arose from some deeply embedded, nearly psychotic portion of my consciousness, desperate to express itself in a socially acceptable way. Apparently, it has done the same for millions of others, allowing them to sublimate the megalomania that makes them think they actually know how to judge major league baseball talent.

If that doesn't sound sufficiently crazy, maybe this will convince you: I don't make a dime from a single one of them.

◆ With much media coverage, fans hold a simulated All-Star Game during the 1981 baseball strike. The actual All-Star Game was played a month late, on August 9, 1981.

The Home Game

Whatever it is that fascinates Americans about baseball, it is clearly not just physical. Surrogate versions of the national pastime are almost as old as the game itself, and the hundreds of such games run the full range from crude games involving spinners and dice, to sophisticated computer models and startlingly lifelike video games. This game used a vibrating electric field of play to move runners around the bases, 1960.

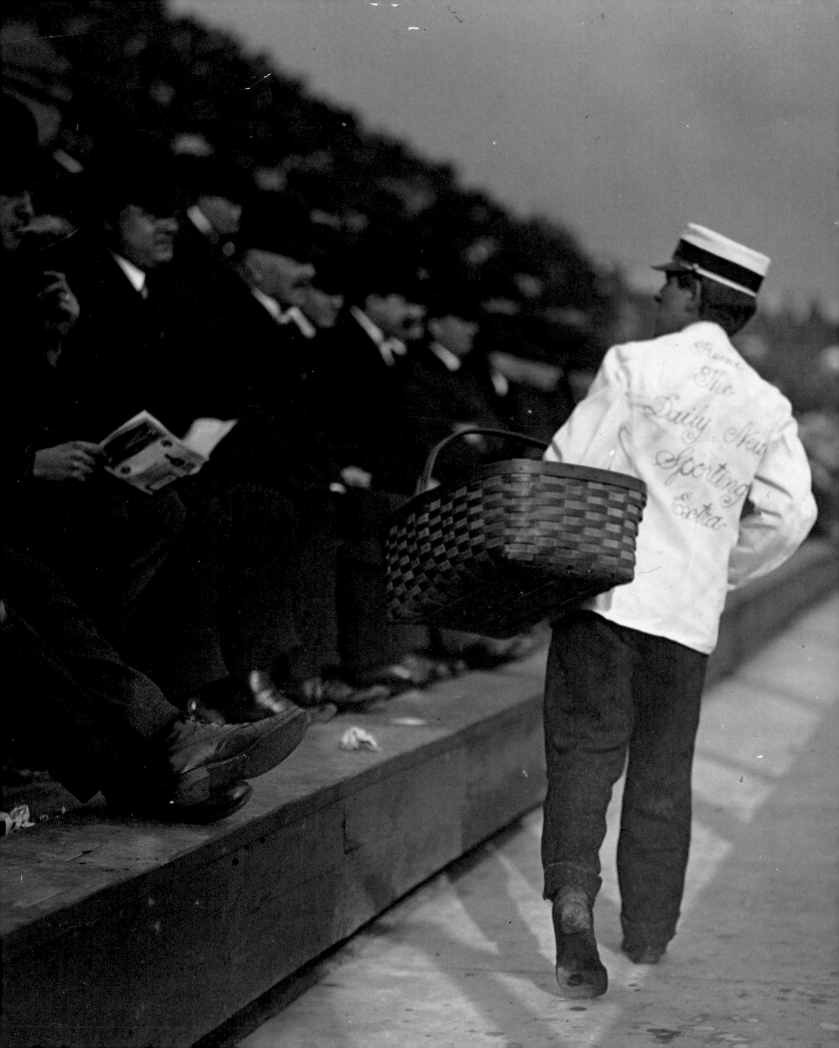

CHAPTER

4

"Everything is possible to him who dares." ✦ This motto adorned the desk of Albert Goodwill Spalding, the 19th-century baseball player and entrepreneur who, more than any other individual, personifies the promise of baseball in America. For Spalding, growing up in the 1860s, baseball offered an escape from his inherent shyness and the loneliness of small-town life. It would ultimately provide a quintessential rags-to-

ENTERPRISE AND OPPORTUNITY

riches tale, as Spalding rose from modest origins to untold fame and wealth as a model for those seeking to take advantage of the opportunities, both on and off the field, offered by the national pastime. ✦ As a teenager, Al Spalding became a standout pitcher on the Rockford, Illinois, team sponsored by local businessmen. In 1867, he defeated the touring Washington Nationals, one of the best teams in the nation. By 1871, when he left Rockford to pitch for the Boston Red Stockings of the new National Association of Professional Base Ball Players, baseball had become his profession. Over five seasons with Boston, Spalding won 204 games and lost only 53. In 1875, he posted a 54-5 record. Widely acknowledged as the greatest hurler in the game, Spalding abandoned Boston for Chicago, where even greater opportunities awaited him on the diamond and beyond. ✦ In Chicago, Spalding joined the White Stockings as player-manager. He also became a key figure in the founding of the National League, the prototype for professional sports organizations. In the NL's first season in 1876, Spalding led the league in wins with 47 and guided his team to the pennant. Of even greater significance, Spalding parlayed his fame into a new "baseball and sporting goods emporium," A.G. Spalding & Bros., which he opened in Chicago in 1876. The following season, although still near the peak of his pitching prowess, Spalding retired as a player to devote his energies to

owning and managing the White Stockings and running his sporting goods business.

Over the next decade, Spalding's White Stockings became the dominant franchise in the National League, while he emerged as the guiding force behind the success of the new league. His business enterprise prospered through what modern marketers would call synergy. A.G. Spalding & Bros. became the official voice of the National League, publishing the annual *Spalding's Official Base Ball Guide*, a compendium of baseball's official rules and records. The firm also supplied the league with baseballs and other equipment. The Spalding name became synonymous with sporting goods. In an age of industrial entrepreneurship, writes economist Ralph Andreano, Spalding's business accomplishments ranked "on a par with the achievement of the Rockefellers, Mellons, Morgans, and the like."

Thousands of boys and young men sought to emulate Spalding, using baseball as a path out of rural, small town, and urban poverty. Charles Comiskey, Connie Mack, and John McGraw—the sons of Irish immigrants—and Clark Griffith, a Missouri farm boy, emerged as Spalding's heirs in the late 19th century.

Each man became a star player renowned for an innovative spirit and willingness to bend the rules to secure victory. Each quickly rose to the status of field manager and carved out a successful career and substantial reputation as a leader of men. The four men joined former journalist Ban Johnson to establish the upstart American League, which challenged the solidly entrenched National League in 1901. Comiskey, Mack, and McGraw became franchise owners. Griffith managed Comiskey's new Chicago White Stockings before purchasing the Washington Senators a decade later. By the second decade of the new century, they had won widespread acclaim as "incarnation(s) of success," exemplars of "clean living and quick thinking," and men "who have made baseball of such commanding influence in the sporting world." They represented the possibilities that baseball held as a means of mobility in a fluid American social structure.

Yet if Spalding, Comiskey, Mack, McGraw, and Griffith had risen through the ranks to become men of wealth and prestige, their triumph had been made possible by the "reserve clause," a peculiar mechanism that exploited the talents of other athletes and limited their earning potential. Baseball's reserve clause, first adopted in 1879, gave teams the right to automatically renew a player's contract at the end of each season. While management could sell or trade a player to another squad, or release him entirely, a player, no matter how skilled, could never seek a new baseball employer or negotiate his salary in a free market. The reserve clause thus greatly capped an athlete's earning potential.

Owners like Griffith called the reserve clause the "backbone of baseball," but players howled for its removal. In the mid-1880s, under the leadership of John Montgomery Ward, they formed the Brotherhood of Professional Base Ball Players, a labor union that demanded, among other things, an end to the reserve clause. Ward evoked the image of slavery, asking, "Is the Ballplayer a Chattel?" In 1890, most of the National League's leading players (including Comiskey and Mack) bolted to form a rival circuit, the Players League, a cooperative venture owned in part by the athletes themselves. The National League, however, under the able generalship of Spalding, defeated the breakaway venture, reimposing both the reserve clause and a salary cap.

Owners rationalized the reserve clause by emphasizing the stability it brought to the game's finances and the alleged parity it brought to the playing field. Restrictions on player movement, they argued, despite ample evidence to the contrary, prevented the richer teams from corralling the best talent. Furthermore, they noted, the reserve clause notwithstanding, players made more money than they might in other professions. Throughout the 20th century, many athletes attempted to challenge the reserve clause, but they repeatedly failed to win their case in the courts, particularly after 1922 when the U. S. Supreme Court ruled

◆ PAGE 170: A vendor at Chicago's South Side Park, home of the White Sox, sells copies of *The Daily News Sporting Extra*, 1905.

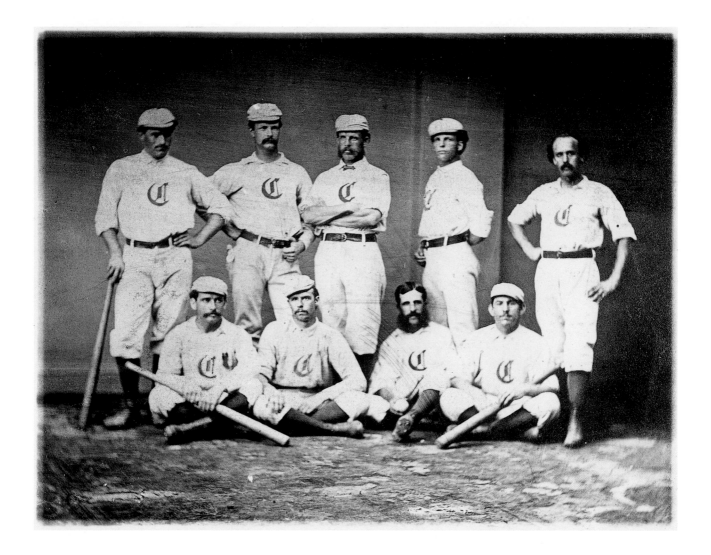

that baseball was exempt from federal antitrust laws. The sharpest test came in 1970, when St. Louis Cardinal outfielder Curt Flood refused to be traded to the Philadelphia Phillies and sued Major League Baseball. Echoing Ward, nearly a century earlier, Flood noted that a slave, even one making $90,000 a year, was still a slave. Flood's case reached the U.S. Supreme Court, but the justices refused to invalidate the reserve clause.

Its days were nonetheless numbered. As the Flood case worked its way through the courts, the Major League Baseball Players Association, the modern heir to Ward's Brotherhood, had won the right for an impartial arbitrator to hear grievances against management. In 1975, an arbitrator ruled that the reserve clause could not be applied into perpetuity. A player's services could only be reserved for one year at the end of their contracts, after which they became free agents eligible to negotiate with all teams. The decision doomed the reserve clause and realigned the power balance between owner and athlete. The average baseball salary jumped from $45,000 in 1975

◆ Baseball's first all-professional team, the Cincinnati Red Stockings of 1869. Traveling nearly 12,000 miles that year, the Red Stockings went undefeated, winning more than 60 games against top-level opponents.

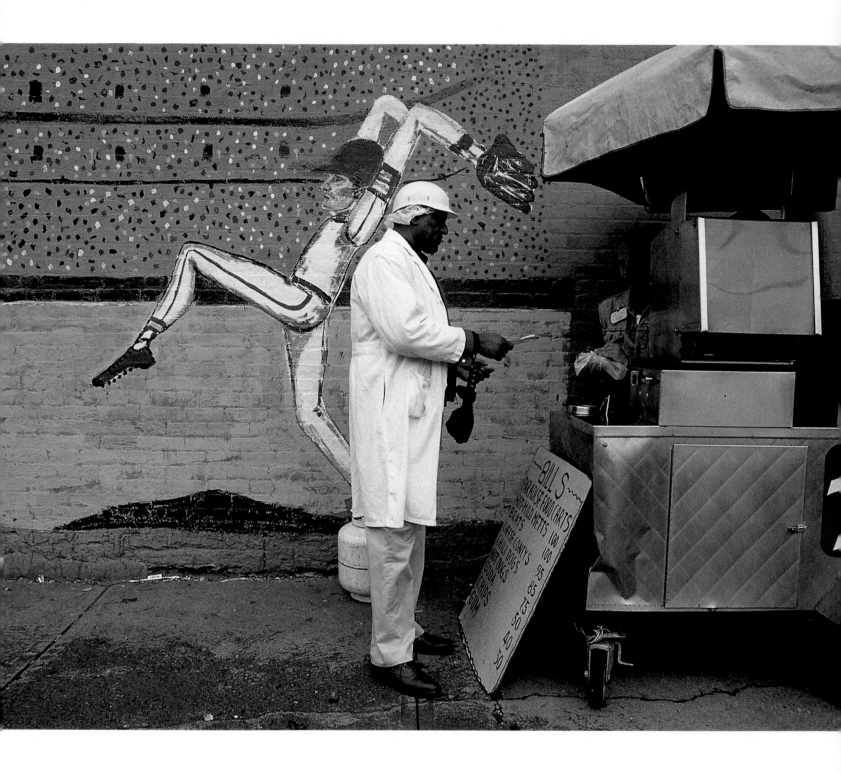

◆ A street vendor does business at Cincinnati's annual Opening Day parade.

to over a million dollars in the 1990s. Multimillion dollar contracts became commonplace. A new age of opportunity had dawned for baseball players, who now could achieve riches that only a relative handful of Americans could even contemplate.

Owners and players were not the only people who capitalized on the opportunities presented by the national game. As early as 1866, reporters warned about the "evil" inherent in "the betting of thousands of dollars upon the results of championship contests," and the fear of gamblers "hippodroming" or fixing games. Indeed, much of the popularity of the early game stemmed from the potential returns offered by wagers among the "sporting" classes common in urban America. For decades, gamblers sought to enhance profits by surreptitiously paying players, many of whom had close ties to the urban underworld, to throw games. Yet, for baseball to achieve respectability among its widest possible audience, the outcome of the games had to be above suspicion. Major league owners fought a half-hearted battle, generally seeking to obscure rather than eradicate corruption. Not until the 1919 Black Sox Scandal severely tarnished baseball's reputation, testing the "faith of fifty million fans," did the owners crack down, imposing severe penalties on players and managers who consorted with professional gamblers.

Other, less unsavory or unscrupulous, entrepreneurs also saw their opportunities in the national pastime and took them. Harry M. Stevens created an empire selling hot dogs, peanuts, soft drinks, and beer at the ballparks. Advertisers readily signed on, posting billboards in the outfield and signing players to endorsement contracts. The classic stadiums of the 20th century featured advertising for beer, cigarettes, and other commodities. In the Polo Grounds in New York, a large center-field display promoted Chesterfield cigarettes, and informed fans on close scoring decisions, with the "H" lighting up for a hit, and the "E" lighting up for an error. In Ebbets Field, clothier Abe Stark's billboard promised that a player

hitting the sign would win a suit. In the modern era, the stadiums themselves have become billboards as corporations seek to promote their names and share in the goodwill emanating from an affiliation with baseball. A fan touring the baseball arenas on the West Coast might travel from Qualcomm Stadium in San Diego to Pacific Bell Park in San Francisco to Network Associates Coliseum in Oakland and Safeco Field in Seattle.

Players have often supplemented their incomes by endorsing a wide variety of products. Christy Mathewson posed as a model for dress shirts. Jackie Robinson recommended Old Gold cigarettes, even though he never smoked. Not surprisingly, Babe Ruth held the record for endorsements. During the 1920s and 1930s, Ruth surfaced in ads for cigarettes, clothing, sporting goods, milk, appliances, kennels, pajamas, underwear, automobiles, and many other products. He sold his name to items as diverse as Babe Ruth sweaters, caps, gum, home run shoes, and smoking tobacco. Advertising images have become inseparably intertwined with the reality of the game.

However, baseball has always embodied more than entrepreneurial opportunity. From the moment it was transformed from the gentleman's game of the 1850s to a professional sport in the 1860s, baseball has shined as a beacon of social mobility for American youth. In the late 19th century, Irish and German immigrants poured into the game. Others found escape from the oppressive mines and factories of the industrial age. Since the 1940s, African Americans have escaped urban and rural poverty, and Latinos from destitute nations have found riches and fame in the game.

Opportunity in baseball has taken many forms, but at its core remains the overriding image of a young man from almost any background, with a strong arm or a sharp batting eye, who can reinvent himself and achieve celebrity and perhaps even fortune on the ball field—"everything possible to him who dares."

—*Jules Tygiel*

♦ FOLLOWING PAGES: Boston's Huntington Avenue Grounds, August 9, 1911. By 1910, there were approximately 150 Bull Durham tobacco signs at major and minor league ballparks. If a player hit a sign, the tobacco company gave him $50 and a carton containing 72 packs of tobacco. Relief pitchers liked to sit in the shade of the signs, leading to the term "bullpen," some speculate.

WARREN JAY GOLDSTEIN

Never Far from the Counting House

DESPITE OUR POWERFUL FEELINGS that baseball used to be more free from the influence of the dollar, especially in the game's infancy, the fact is that from its very earliest years the national pastime has been embedded in the world of money.

Long before player contracts and league structures and sweetheart deals with desperate municipalities, the first teams wanted to win badly enough to pay their best players under the table, violating club and association rules.

The game's first entrepreneurs, the owners of enclosed fields, charged admission to contests beginning in 1858 and usually split receipts with the contending clubs. Reporters and fans often accused clubs of fixing games (especially the second game in a best-of-three series) in order to assure more lucrative series finales.

The only big money in the game belonged to gamblers, who plied their trade in ballparks during games, often changing their odds from inning to inning. The historian John Thorn has argued that, without gambling, baseball might never have gained the prominence it did during the late 1850s and early 1860s.

By the late 1860s, most of the top New York teams paid some, if not most, of their best players. But the first club to admit doing so was the undefeated 1869 Cincinnati Red Stockings, who signed its professionals to contracts and also hired the best manager in the game, Harry Wright.

Even then, the key to baseball economics lay in its "labor relations." When the Red Stockings could not produce another undefeated season, the club directors invented complaints about the players' inordinate salary demands and "dissipated" habits to justify folding the team the following year. That year, the Red Stockings made exactly $1.35 on a budget of roughly $35,000. Wright promptly took his best players to Boston to join the first professional league, the National Association of Professional Base Ball Players, which Boston dominated until William A. Hulbert founded the National League of Professional Baseball Clubs in 1876.

By the late 19th century, baseball "clubs" became joint-stock companies whose actions mirrored developments in the rest of the corporate economy. Owners battled players over salaries and unionization and eventually established the Reserve Clause to hold down salaries and give themselves control over the services of their player employees.

Along the way, club owners hired Pinkerton detectives to tail players, assembled a blacklist of "drinkers" and "troublemakers," and established cartels (leagues) controlling the demand for baseball players and the supply of baseball "exhibitions." Unlike today, when even small-market baseball "clubs" enjoy generous tax advantages as well as lucrative cable TV contracts, making money from baseball used to be a much chancier business.

It's a small wonder that the late 19th-century baseball landscape was littered with failed franchises, ruined careers, and the wreckage of many would-be "fields of dreams." The real measure of baseball's importance to Americans at the time was that fan loyalty survived such economic mayhem.

◆ OPPOSITE: Dinner program welcoming home the Cincinnati Red Stockings after their 1870 tour. After going undefeated throughout 1869 and the first half of 1870, the Red Stockings finally lost a game to the Brooklyn Atlantics in June. After the 1870 season the Red Stockings disbanded, but the key players took their nickname, moved to Boston, and found a berth in the new National Association.

WELCOME HOME RED STOCKINGS.

Menu.

Huitres.

Potage.
Consommé de perdreaux à la Sevigné.

Hors d'œuvres.
Variés. Variés.

Timbal à la Monglas.

Releves.
Truite à la Génoise, au pommes gastronome:
Filet de Bœuf braisé, à la Moderne.

Entrees.
Ris de Veau à la Sainte Cloud:
Poulets nouveaux à la Toulouse:
Mayonaise de homards en belle-vue:
Cotelettes d'Agneau, aux petit pois.

Rotis.
Canard: Poulets nouveaux.

Entremets.
Petits pois: Tomates farcies: Asperges: Croute au Champignons.

Sucres.
Gelée aux ananas: Meringues à la Chantilly:
Paniere de Perette: Glaces Napolitaine.

Pieces Montees.

Fruits et Dessert.

GIBSON HOUSE,
Cincinnati, June 29th, 1870.

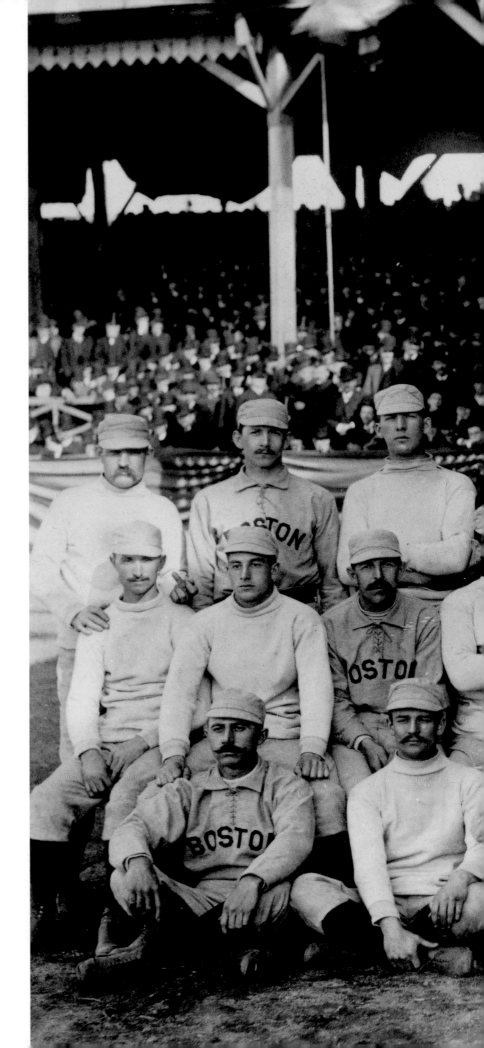

◆ Opening Day game between the Boston Red Stockings and New York Giants, both of the National League, 1886. In 1912 the Boston team became the Braves, the name it retained while moving to Milwaukee and Atlanta. As charter members of both the National Association (1871) and the National League (1876), the Braves are baseball's oldest continuing team.

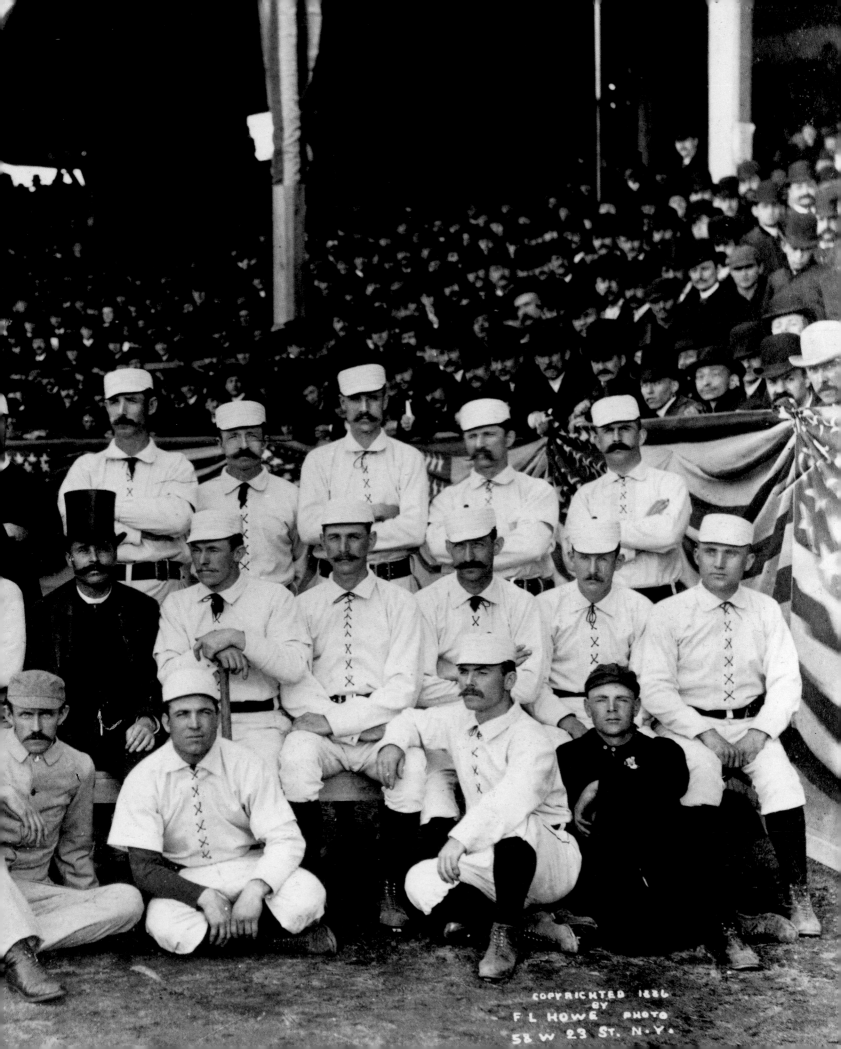

ELIOT ASINOF

A Ball, a Bat, and a Bet

A BALL, A BAT, AND A BET. Baseball was all three from the beginnings of its history: At first a gentleman's game where club members could take their women to enjoy an outlet for the pleasures of betting; then, as the game became popular with the rougher talents of working men, a fan's way of "putting his money where his mouth is." When the game became professional, players were paid, spectators were charged admission, club owners made money—and the growing influence of gamblers was always in evidence. An outfielder might be hit by a stone as he settled under a crucial two-out fly ball. Sometimes, gunfire peppered the ground at a player's feet. Hardly had the National League been formed in 1876 when the leading Louisville club took a dive down the stretch, and four star players were banned for taking bribes. No one seemed to care that they had done so because the club had failed to pay their salaries.

"Baseball, as a professional pastime, has seen its best days in St. Louis" reported *The Spirit of St. Louis* in 1878. "The amount of crooked work is indeed startling and the game will undoubtedly meet the same fate elsewhere unless strong measures are taken to prevent it."

When the end of the 19th century marked the lessening of America's roughhouse mentality, baseball games became more controlled. Even umpires were treated with a semblance of respect. As America entered the World War in 1917, baseball had become the biggest entertainment business in the country. When the U.S. government shut down the race tracks for the duration of the war–but not the ball parks–a horde of professional gamblers shifted their expertise from the oval to the diamond, where they quickly relearned how to manipulate the odds. They mingled with ballplayers, wined and dined them, always ready with a friendly manner, a good cigar, an extra-special woman.

They'd learn how a pitcher's arm wasn't holding up, when a clean-up hitter was having serious marital problems, and most important of all, which players were the most disgruntled at an especially abusive club owner. Indeed, gamblers would brag about controlling ball games the way they had controlled horse races. They even had a number of ballplayers on weekly salaries. Outfielders became adept at "short-legging" a long fly ball: Make a desperate dive but miss the catch, and an out would become a triple. Or a shortstop might twist his body to make a routine play seem like a brilliant one, but his throw would be a split second too late for the putout. Subtlest of all were the pitchers. Who could tell when business was being done? Crookedness became commonplace. Gamblers had reached the pinnacle of power and prominence throughout the sporting world. How else could anyone explain the astonishing machinations of the great first baseman Hal Chase, who would bet against his own team then manipulate the outcome with artful errors? Incomparably brazen, in 1917 he approached a relief pitcher taking warm-up throws on the mound, offering a bribe if he failed to hold the lead. When the pitcher reported this, the matter was buried for "insufficient evi-

◆ Spikes worn by Joseph Jefferson "Shoeless Joe" Jackson, who acquired his nickname in the minor leagues when he played without shoes one day due to foot pain caused by breaking in a new pair. Jackson was one of the eight Chicago White Sox who admitted their involvement in a plot to throw the 1919 World Series.

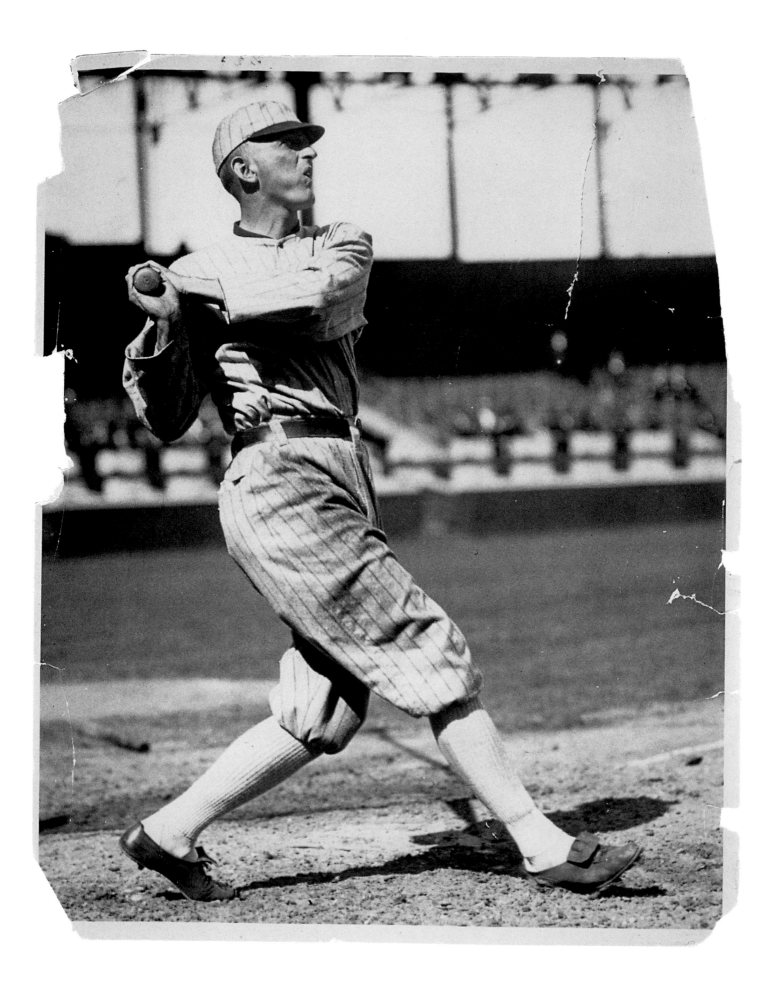

dence." Ballplayers knew of such incidents but were advised to keep their mouths shut. Writers knew, but their newspapers refused to print those stories for fear of libel. Most damaging of all were the club owners: They knew but kept everything under the rug lest the fans lose faith in the honesty of the game. And so it continued, an unstoppable tide of corruption.

With such a compromised history, the national pastime was ripe for the Black Sox scandal when eight players of the Chicago White Sox conspired with gamblers to throw the 1919 World Series to the Cincinnati Reds. The fix itself was a travesty of bungled communications and broken promises, of "cheaters cheating cheaters." It took a year before the chaotic story finally went before the Cook County Grand Jury. The great Shoeless Joe Jackson was caught in its web, undermining the faith of millions as "Say it ain't so, Joe" became part of our language. The owners, now frightened by the disgust of the fans, combined to appoint a commissioner to restore honesty to the game that had never been honest. Judge Kenesaw Mountain Landis immediately banned all eight players for life ("Birds of a feather flock together"), and none ever played professional baseball again.

But no one could stop people from gambling. BETTING PROHIBITED signs proliferated in big league stadiums, but cries of "A quarter he does!" and its counter-cry "A quarter he doesn't!" could be heard as a hitter came to the plate in an endless medley of bettors at play. Then, too, there were baseball pools in big league cities and big-time bookies handling the odds emanating from Las Vegas. Because of Babe Ruth's heroics through the twenties and thirties, America forgot the scandals and embraced the rejuvenated national pastime as never before. Baseball survived strikes and lockouts, revolutionary upheavals in labor relations, the advent of free agency, and multimillion dollar salaries. The era of fixed games was definitely over, and for 60 years baseball seemed immune from the influences of a gambling culture.

Then there was Pete Rose, who starred with the

Reds, Phillies, and Expos from 1963 to 1986. Rose played ball like a man possessed, but his downfall began when he started gambling. Inevitably, his excesses became too much to ignore and brought on his expulsion. Baseball Commissioner Bart Giamatti concluded that Rose had bet on baseball in violation of its rules. At the summit of his disgrace, Rose was likened to Shoeless Joe, the most celebrated banned ballplayer in baseball's history. But Rose and Jackson were not comparable. Jackson never gambled, and Rose was never involved in a fixed game. Jackson was an underpaid star victimized by the seductions of corrupt money in corrupt times. Rose, in his time, was a highly paid star who could not resist indulging his obsessions.

In the end though, the gambling world managed to do them both in.

◆ OPPOSITE: The batting stroke of Shoeless Joe Jackson, which Babe Ruth copied in developing his own swing, produced the third highest lifetime batting average of .356, behind only Ty Cobb and Rogers Hornsby. Jackson remains on Major League Baseball's "Permanently Ineligible" list and is not enshrined in the Baseball Hall of Fame. ABOVE: The 1933 betting guide above shows that betting remained popular with fans even after the Black Sox scandal.

ANDREW ZIMBALIST

The Peculiar Business of Baseball

MAJOR LEAGUE BASEBALL (MLB) is the only unregulated, legal monopoly in the United States. Ever since the Supreme Court decided that baseball was a sport and not involved in interstate commerce in 1922, MLB has been exempt from the nation's antitrust laws.

This exemption has meant many things.

Major League Baseball has not been seriously challenged by a rival since 1914, distinguishing it from the pro leagues in football, basketball, and hockey. Before the players successfully challenged the player reserve clause in 1975, the absence of a competitor to MLB had a limiting effect on player salaries because neither teams nor leagues competed for player services. The depressed salaries, in turn, led to greater player unrest, their need for the Players Association to conduct collective bargaining, and, ultimately, free agency first being introduced in baseball.

Baseball's antitrust exemption also has enabled it to maintain its minor league system. When drafted high school and college players sign their first professional baseball contracts, they are obliged to stay with the signing team for up to seven years in the minor leagues and another six in the majors before becoming free agents. And, in the minors, a player's pay is strictly limited by MLB rules. The only alternative available to a minor leaguer is playing in one of several independent leagues. A large reason that MLB

172
MAJOR LEAGUE BASEBALL
PRESENTS
THE
1992
EXPANSION
DRAFT
TUESDAY,
NOVEMBER 17TH
2:00PM
(DOORS OPEN AT 1:00PM)

NEW YORK
MARRIOTT
MARQUIS
1535 BROADWAY
NEW YORK, NY
BROADWAY BALLROOM
6TH FLOOR

ENTRANCE ON
6TH FLOOR
ADMITS ONE

is able to legally operate its minor leagues in their present form is baseball's antitrust exemption; and it is this control over minor league talent that in part has made it more difficult to form a rival major league in baseball than in the other team sports.

Further, until 1998, MLB's exemption probably contributed to its notoriously turbulent labor relations. Not only did the exemption historically contribute to depressed salaries, it also made it impossible for baseball players to defend their interests in court when the owners threatened to impose restrictive labor market conditions.

In 1987, the National Football League Players Association ended a three-week strike and took its case against the league owners' "Plan B Free Agency" to court, eventually winning in 1993. Today, Major League Soccer players are attempting to defend their antitrust interests in court rather than risk the future of their fledgling league with a strike. Without the alternative of court action—which wasn't available until 1998, when Congress partially lifted MLB's exemption as it pertained to collective bargaining—baseball players could only defend themselves by going on strike.

Also, baseball's exemption probably has enhanced franchise stability. No MLB team has moved to a new city since 1972. Without an exemption, when a league prevents an owner from moving his or her team, it is imposing a

◆ OPPOSITE: In search of greener pastures, the Athletics migrated twice, from Philadelphia to Kansas City, and then to Oakland, where they have experienced both on-field success and off-field financial woes.
ABOVE: A ticket to the 1992 Expansion Draft, when baseball optimistically added two more teams.

restriction on free trade and subjects itself to possible litigation. The NFL has attempted to prevent certain teams from moving but has failed (the Raiders have played musical chairs with Oakland and Los Angeles, the Rams fled Los Angeles for St. Louis, and the Colts bolted Baltimore for Indianapolis). Thanks to its exemption, however, baseball was able to prevent the Giants from moving to Tampa Bay in the early 1990s, and today San Francisco is enjoying a baseball renaissance with its spectacular ballpark by the bay.

But the baseball business involves far more than its special exemption.

Unlike rivals General Motors and Ford, which derive no benefit from their continued competition, the Yankees would not become a stronger franchise if they helped drive the Red Sox out of business. The core dilemma of any team sports league is finding ways to provide a strong financial incentive to win and, at the same time, to engender a significant degree of competitive balance among the teams. The incentive to win creates excellence and legitimacy, but competitive balance is what fuels the excitement that comes with greater uncertainty about how games and races for the postseason will turn out. In the right mix, these two factors produce maximum interest and intensity among the fans.

Because the fan base for teams in cities with populations of eight million differs so greatly from that of teams in cities that must draw from a pool of only one million, and because some teams play in new facilities and others in old ones, it is tricky to simultaneously promote excellence and balance. If there were competition between leagues, the excellence/balance problem would tend to resolve itself as the leagues scrambled to situate their teams in the most lucrative markets. For instance, if the National League and the American League were separate and competing business entities, it is likely that each would rush to fill viable markets (like Washington, D.C.) before the other did. Also, if team locations were more greatly determined by competitive market forces, cities like New York (with a media market population of 6.94 million television homes)

likely would find themselves with three or more teams before cities like Milwaukee (with a media market population of 0.83 million homes) found themselves with one. And, if New York had three or four major league teams instead of two, the Yankees' competitive advantage would be significantly reduced.

Absent the challenge of a competing league, each sport has had to fashion its own internal mechanisms toward the end of a desirable excellence/balance mixture. The NFL has extensive revenue sharing that dates back to its inception in the early 1920s and a salary cap set at 63 percent of defined gross revenues. This system, many believe, produces excessive balance and insufficient excellence.

MLB shares national television and licensing revenues equally among its teams (around $19 million yearly per team in 2001, out of average team revenues of nearly $100 million). It also has a revenue sharing system that transferred approximately $165 million from the top to the bottom revenue teams in 2001 (roughly $22 million of this went from the Yankees to the Expos). Even after these transfers, however, the revenue disparity between the top and bottom teams is still greater than three-to-one, and the team payroll disparity is greater than six-to-one. Thus, baseball is at the other end of the excellence/balance spectrum from football, with competitive balance suffering.

Baseball's owners complain that half or more of the teams lose money in any given year. Allowing for the fact that baseball profit accounting is subject to massive manipulation, it is clear that the lower-end teams in MLB have shakier finances than their equivalents in the NFL.

Accordingly, Commissioner Bud Selig has expressed grave concerns that baseball's economic system needs to be reformed. Substantial change, however, is no simple matter. Baseball's rich teams strenuously resist increased revenue sharing and the Players Association militantly rebuffs calls for a salary cap or stiff luxury taxes.

Nonetheless, fans can be buoyed by the evidence that despite labor problems and big-market vs. small-market disparities, the game always seems to find a way to go on.

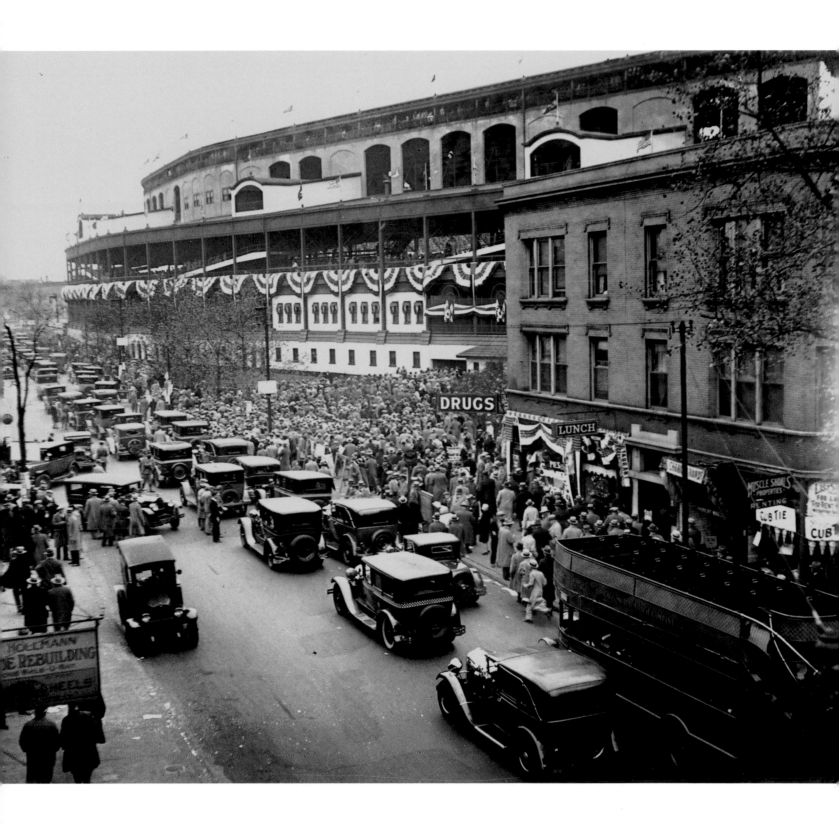

◆ After a second tier of seats was added in 1927, Chicago's Wrigley Field hosted the World Series in 1929, 1932, 1935, and 1938. This festive shot could be from one of those dates, or perhaps from an Opening Day in the same era.

GARY S. BECKER

Leveling the Playing Field

BASEBALL GAMES AND OTHER ATHLETIC contests have characteristics that have been insufficiently appreciated by economists. If these contests were like most commodities, spectators would care mainly about the absolute quality of the play by individuals and teams. Of course, there is interest in absolute performance, but that interest is dwarfed by concern about the relative standing of favorite teams and relative performance of favorite players.

Will a favorite team win a lot of games, make the playoffs, and even win the World Series? Will a pitcher win more games than others and possibly receive the Cy Young Award?

This larger interest in relative outcomes explains why revenues from attendance and television audiences are greater when baseball games are close, when races are tight, and perhaps when there is greater turnover in the teams that play in the World Series from year to year. To the extent that relative performance is crucial to fans, the competitiveness of teams and leagues matters as much as, or even more than, the absolute level of play.

The budget-expanding measures taken by competing baseball teams in the hope of establishing an edge can be analagous to the heightening of an arms race among antagonistic nations. If nations increase their weaponry uniformly, there likely will be no change in the balance of power. Similarly, if teams uniformly improve themselves by spending more on salaries, by recruiting free agents, and by more aggressively scouting the world for prospects, the relative performance of those teams and the interest of fans

may be largely unaffected, despite the expenditures.

During the nasty baseball strike of 1994, I wrote a column for *Business Week* magazine that made two suggestions about how the major leagues might avoid futile "arms races" and make pennant races more competitive.

The first suggestion was that baseball should tax total spending by major league teams on players, player development, and anything else that may improve a team's record. For example, baseball might impose a 33 percent tax on all spending for those purposes by a team above $40 million—approximately the average amount spent by major league clubs.

I argued that badly maintained teams should be induced to improve their performance through a formula penalizing their failures—in contrast to the many procedures that provide unsuccessful teams with additional advantages. I proposed the league tax teams that consistently perform below average. The more losses that a team incurs over several years, the larger the "failure tax" that it would be assessed. Such a tax would give weak teams a monetary incentive to improve their management in the quest to perform better.

The major leagues introduced a "luxury" tax on teams with oversize payrolls, designed to inhibit their spending. But if baseball is concerned about making races more competitive, it should impose a failure tax on bad teams. A luxury tax combined with a failure tax would be effective in stimulating greater fan interest by making pennant races closer and the outcomes of games more uncertain.

◆ "Waving" goodbye. Atlanta Braves fans do the wave at a July 1994 game and express their hope
for a settlement as the labor-management issues loom ahead. That strike, which lasted into the
1995 season, cancelled 921 regular season games and the 1994 World Series.

"Kill the ump!" was more than just a figure of speech in the early 20th century, a rough-and-tumble era when passions ran high…and nervous umps often ran fast. Harry "Steamboat" Johnson, who spent 37 years calling minor league strikes and balls, remembers a close call followed by a close call.

Harry "Steamboat" Johnson 1935

Standing the Gaff

I WILL NEVER FORGET some of the jams we got into that year [1913, in the Three-I League], especially one at Davenport, Iowa, when Danville, Ill., was the visiting club. I was working alone that day. I had begun carrying a six-inch snap-blade knife in my hip pocket during the stormy days in the Western League, and I had it on me then.

Two men were out in the ninth when a Davenport outfielder hit a three-bagger down the left field line. In rounding first base he missed the bag, but I never gave any indication that I had seen it.

When the ball was relayed to the infield, the Danville first baseman called for the ball and touched the bag. I immediately called the runner out, which ended the game, Danville winning.

As I started for the dressing room the crowd began tumbling over the front of the grandstand and moving toward me. I reached into my hip pocket, pulled out my knife, snapped the blade open, and began cutting my fingernails. I pretended to be paying no attention to them. They stopped, and took it out in calling me names. Then I started walking along, trimming my nails as I went. I walked to the gate and out to the streetcar, still wearing my protector and carrying my mask under one arm, and was not molested. I never had any more trouble in Davenport that season.

Baseball's rule book continues to evolve as situations that have never happened before occur on the field. Will this process ever end, or is there something in the design of the game that defies ultimate description and codification?

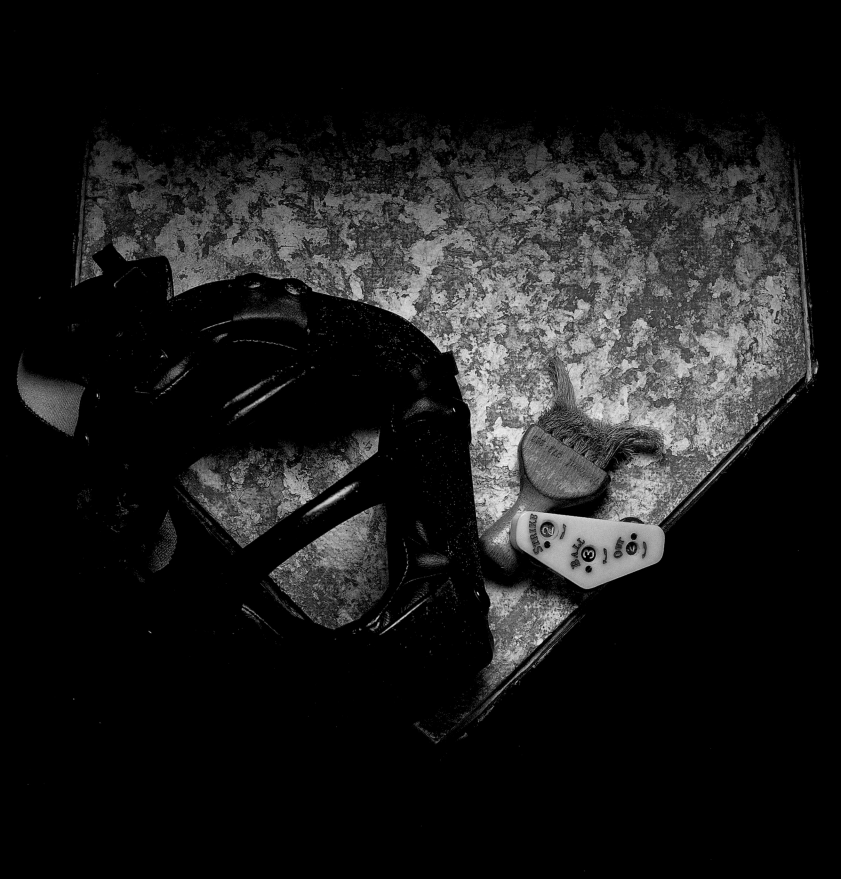

LARRY GERLACH

Umpires and Rules

THERE IS WISDOM in Jacques Barzun's famous adage that "whoever wants to know the heart and mind of America had better learn baseball, the rules and realities of the game." Baseball's rules not only shape the structure and dynamics of the game but also embody the high values that Americans place on order, tradition, and democracy and the impartial administration of justice.

Reflecting the technological and scientific mindset of the 19th century, baseball's symmetrical rules create a precisely patterned game based arithmetically on threes and fours and a field marked geometrically by squares and rectangles within circles. The only geometrical deviation is the pentagonal home plate, the game's keystone. That the basic dimensions of the diamond have remained constant for more than a century prompted sportswriter Red Smith to observe, "Ninety feet between home plate and first base may be the closest man has ever come to perfection."

Baseball rules changed frequently as the game evolved in the 19th century: nine innings and 90 feet between the bases (1857), three strikes (1879), four balls (1889), 60 feet and 6 inches between home and the pitcher (1893), and the current dimensions of the ball (1872) and bat (1895). Since 1900, there have been minimal changes in how the game is played, the major exception being the American League's adoption of the designated hitter in 1973. This continuity in rules makes baseball unique in that the sport would be familiar to players and fans of a century ago. It fosters an historical lore that links generations of fans and encourages comparisons of player performances from different time periods. It was compelling for fans when Barry Bonds competed with Mark McGwire, who had competed with Roger Maris, for the single-season home run record.

The rules express the basic principles of a democratic society: fairness, honesty, individualism, and equal opportunity. Rules against "doctored" pitches and bats and contrived double plays (Infield Fly Rule, 1895) are designed to promote fair play. Administrative rules imposing severe penalties for dishonest play and gambling (including a lifetime ban for betting on one's own team) protect the integrity of the game. More than other team sports, baseball places a premium on individual performance and uniquely is not governed by a clock, thereby giving each side an equal opportunity to win. Because the rules do not privilege those of a certain height or weight, participation is egalitarian; anyone from six-foot-ten Randy Johnson to five-foot-five Freddie Patek can play this sport.

Umpires enforce baseball laws, and that leads to appeals, like the enforcement of the laws that govern society leads to litigation. Since baseball alone allows players and coaches to argue officials' decisions on the field of play, umpires are frequently subjected to heated verbal challenges. Cries of "Kill the Umpire" have subsided, but the boos and arguments continue. Though historically vilified as folk villains, umpires are also esteemed as symbols of integrity and the impartial authority essential to the game.

It is said that umpiring is the only profession where

◆ The tools of the umpire's trade, including a mask; a counter used to keep track of balls, strikes, and outs; home plate; and a well-worn brush used to keep it clean.

you have to be perfect your first game and then improve thereafter. That's no easy task. Umpires make far more judgment calls than most other sports officials because most baseball rules are necessary conditions of play: ball or strike, safe or out, fair or foul. Plate umpires call more than 300 pitches in most games. And umpires must also decide whether it is wiser to apply the letter or the spirit of a rule; that was the choice the umpires faced when George Brett lost a home run because of a ruling concerning pine tar on the hitting surface of his bat in 1983.

Umpiring has changed greatly over the years. A single umpire had the difficult task of calling the game until 1910, when two umpires—one behind the plate and one on the field—became standard. Three umpires were the norm by 1935, and the four-man crew was adopted in 1952. Until coming under control of the Commissioner's Office in 2001, major league umpires were hired and supervised by the respective league presidents, resulting in differences in uniforms, equipment, and positioning behind the plate and on the field. Most conspicuously, National League umpires wore chest protectors inside their jackets when calling balls and strikes while American League umpires used inflated "balloon" protectors worn outside of their jackets.

The first umpire training school opened in 1935, and professional umpires have received a formal education in the rules, mechanics, positioning, and the ability to handle pressure for more than a half century.

Unionization in the 1960s greatly increased the salaries and benefits of major league umpires. But not everyone can be an umpire. Learning the rules and techniques is easy. Making split-second decisions on 90-mile-an-hour fastballs and sharply breaking curveballs is difficult. Knowing how to "run the game"—handling players and managers, ignoring pressures and the boos of fans—is very difficult. It has been said the ideal umpire should combine the integrity of a Supreme Court justice, the physical agility of an acrobat, the endurance of Job, and the imperturbability of Buddha.

And he should love the game.

◆ The infamous "pine tar bat" used by George Brett of the Kansas City Royals on July 24, 1983. Brett homered against the Yankees, but the hit was disallowed when Yankees manager Billy Martin complained that Brett had pine tar too far up the bat, violating an arcane rule. After the Royals protested, American League President Lee MacPhail reversed the ruling and let the home run stand. The remaining outs of the ninth inning were played at a later date, the Royals holding on to win, 5-4. Such situations are addressed in umpires' manuals, supplements to the actual rulebook, which clarify "sticky" situations. An early example is this 1875 DeWitt's manual (opposite).

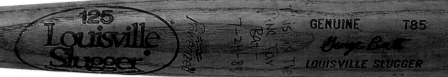

"It ain't nothin' until I call it," said the immortal umpire Bill Klem. No amount of pleading could get umpire Augie Donatelli to change his mind after he called Bud Harrelson out in the tenth inning of Game Two of the 1973 World Series at Oakland. Willie Mays, on deck as the play developed, pleads in vain.

"If I played in New York, they'd have to name a candy bar after me," said the Oakland Athletics' Reggie Jackson. Reggie did come to the New York Yankees, and a bar was born. Jackson was not the first player who lent his name and fame to a product. From Ted Williams's fishing tackle to Joe DiMaggio's coffee maker to Lou Brock's soda, players have endorsed everything under the sun, and many advertisers subtly imply that the star quality will "rub off." The Wheaties slogan, "Breakfast of Champions," suggests that consuming the product bestows the hero's strength and performance. Among all endorsements, candy bars and cereal boxes seem to be particularly honorific, reserved for iconic players such as (opposite, clockwise from top right) Nolan Ryan, Mark McGwire, Cal Ripken, Jr., and Roger Clemens.

Keep your ivory on the ball: In 1912, Mooney's elephant troupe began performing their baseball routine. Featuring at least three pachyderms in the roles of pitcher, catcher, and batter, the complex routine mimicked baseball, even down to a conference on the mound as the count reached 3-2. On the payoff pitch, the batter would strike the ball, circle the bases, and slide into home plate.

THE BARNUM

NEW YORK

CHICAGO

COPYRIGHT 1913 BY
THE
STROBRIDGE
LITHO. CO.
CINCINNATI & NEW YORK.

MOONEY'S "GIANTS

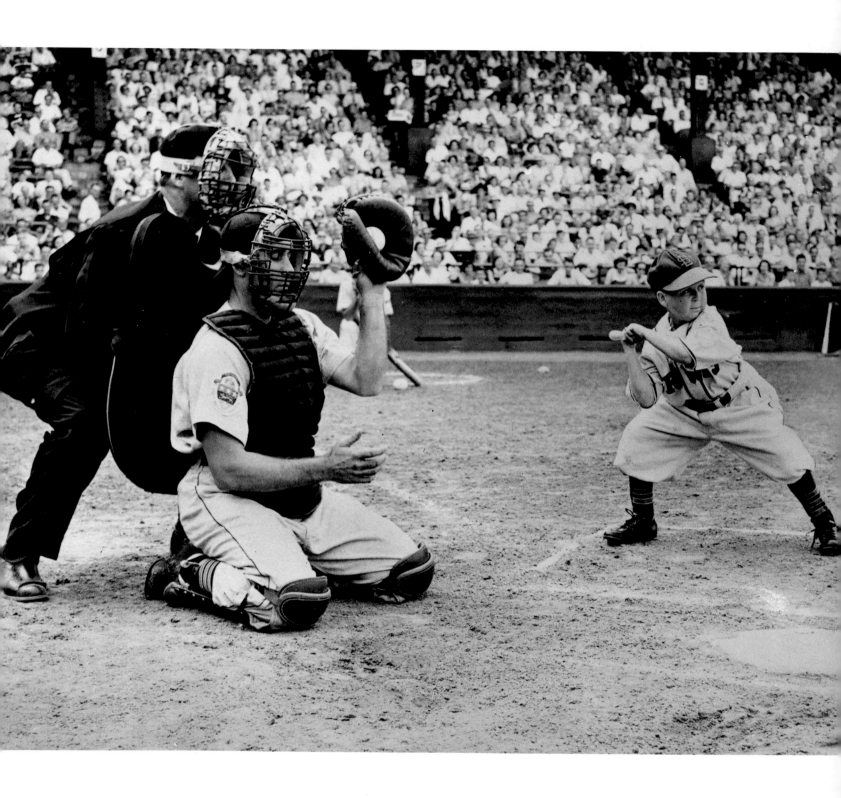

A Can of Beer, a Slice of Cake—and Thou, Eddie Gaedel

IN 1951, IN A MOMENT OF MADNESS, I became owner and operator of a collection of old rags and tags known to baseball historians as the St. Louis Browns.

The Browns, according to reputable anthropologists, rank in the annals of baseball a step or two ahead of Cro-Magnon man. One thing should be made clear. A typical Brownie was more than four feet tall. Except, of course, Eddie Gaedel, who was 3' 7" and weighed 65 lbs. Eddie gave the Browns their only distinction. He was the best darn midget who ever played big league ball. He was also the only one.

Eddie came to us in a moment of desperation. Not his desperation, ours. After a month or so in St. Louis, we were looking around desperately for a way to draw a few people into the ball park, it being perfectly clear by that time that the ball club wasn't going to do it unaided. The best bet seemed to be to call upon the resources of our radio sponsors, Falstaff Brewery.

It happened that 1951 was the Fiftieth Anniversary of the American League. It seemed to me that if I could throw a party to celebrate the birthdays of both the American League and Falstaff Brewery, the sponsors would be getting a nice little tie-in and we would have their distributors and dealers hustling tickets for us all over the state. The day we chose was a Sunday doubleheader against the last-place Detroit Tigers, a struggle which did not threaten to set the pulses of the city beating madly.

What can I do, I asked myself, that is so spectacular that *no one* will be able to say he had seen it before? The answer was perfectly obvious: I would send a midget up to bat.

When he first heard what I wanted him to do, Eddie was a little dubious. I had to give him a sales pitch. I said, "Eddie, you'll be the only midget in the history of the game. You'll be appearing before thousands of people. Your name will go into the record books for all time. You'll be famous, Eddie," I said. "Eddie," I said, "you'll be immortal."

Falstaff came through nobly. We had a paid attendance of better than 18,000, the biggest crowd to see the Browns at home in four years. Since our customers were also our guests for the Falstaff Birthday Party, we presented everybody with a can of beer, a slice of birthday cake and a box of ice cream as they entered the park.

As we came up for our half of the first inning, Eddie Gaedel emerged from the dugout waving three little bats. "For the Browns," said Bernie Ebert over the loudspeaker system, "number one-eighth, Eddie Gaedel, batting for Saucier."

Suddenly, the whole park came alive. Eddie Hurley, the umpire behind the plate, took one look at Gaedel and started toward our bench. "Hey," he shouted out to our manager, Zach Taylor, "what's going on here?"

Zach came out with a sheaf of papers. He showed Hurley Gaedel's contract. He showed him the telegram to headquarters, duly promulgated with a time stamp. He even showed him a copy of our active list to prove that we did have room to add another player.

Hurley returned to home plate, shooed away the photographers who had rushed out to take Eddie's picture and

◆ In his most celebrated and audacious promotion, Bill Veeck exploited the rule book definition of the strike zone, from the batter's knees to his armpits, by sending three-foot-seven-inch Eddie Gaedel to the plate. No pitcher could hit the one-and-one-half-inch zone, and Gaedel drew the expected walk, notching the highest on-base percentage of all-time.

motioned the midget into the batter's box. The place went wild. Bobby Cain, the Detroit pitcher, and Bob Swift, their catcher, had been standing by peacefully for about 15 minutes, thinking unsolemn thoughts about that jerk Veeck and his gags. I will never forget the look of utter disbelief that came over Cain's face as he finally realized that this was for real.

Bob Swift rose to the occasion like a real trouper. If I had set out to use the opposing catcher to help build up the tension, I could not have improved one whit upon his performance. Bob, bless his heart, did just what I was hoping he would do. He went out to the mound to discuss the intricacies of pitching to a midget with Cain. And when he came back, he did something I had never even dreamed of. To complete the sheer incongruity of the scene—and make the newspaper pictures of the event more memorable—he got down on both knees to offer his pitcher a target.

Fortunately, Cain started out by really trying to pitch to him. The first two deliveries came whizzing past Eddie's head before he had time to swing. By the third pitch, Cain was laughing so hard he could barely throw. Ball three and ball four came floating up about three feet over Eddie's head.

Eddie trotted down to first base to the happy tune of snapping cameras. He waited for the runner, one foot holding to the bag like a pro, and he patted Jim Delsing on the butt in good professional exhortation before he surrendered the base. He shook hands with our first-base coach and he waved to the cheering throng.

If the thing had been done right, Delsing, running for Gaedel, would have scored and we would have won the game, 1-0. As it was, there being a limit to the amount of help you can expect from either the St. Louis Browns or fortune, Delsing got as far as third base with only one out and was then left stranded. We lost the game, 6-2.

It's fine to be appreciated for a day; I recommend it highly for the soul. It's better for the box office, though, to be attacked for a full week. I was counting on the deacons to turn Gaedel into a full week's story by attacking me for spitting in their Cathedral. They didn't let me down, although I did feel the words "cheap and tawdry" and

"travesty" and "mockery" were badly overworked. The spirit was willing, but I'm afraid the rhetoric was weak.

Something else happened, though, that I was not disposed to be so amiable about. The good deacons of the press had been wailing that unless Commissioner Will Harridge acted immediately, the name of Eddie Gaedel would desecrate the record books for all time. Harridge dutifully decreed that Gaedel's appearance be stricken from all official records. This I wouldn't stand for. I had promised Eddie that he would live forever in the record books, which are cast in bronze, carved in marble and encased in cement. Immortality I had promised him, and immortality he would have. I reminded Harridge that Gaedel had a legal contract and had been permitted to bat in an official game presided over by the league's own umpires. If Gaedel hadn't batted, I pointed out, it would also mean that Bobby Cain hadn't thrown the pitches and that Swift hadn't caught them. It would mean that Delsing had come in to run for no one, and that Saucier had been deprived of a time at bat. It would mean, in short, that the continuity of baseball was no longer intact, and the integrity of its records had been compromised. If Desecration was the game they wanted to play, then I held a pretty strong hand myself.

Eddie crept back into the record books and remains there today. When he died, he got a front-page obituary in the *New York Times,* a recognition normally accorded only to statesmen, generals and Nobel Prize winners.

I have done a few other things in baseball, you know. But no one has to tell me that if I returned to baseball tomorrow, won ten straight pennants and left all the old attendance records moldering in the dust, I would still be remembered, in the end, as the man who sent a midget up to bat. It is not the identification I would have chosen for myself when I came into baseball. And yet I cannot deny that it is an accurate one. I have always found humor in the incongruous, I have always tried to entertain. And I have always found a stuffed-shirt the most irresistible of all targets.

I'm Bill Veeck, the guy who sent a midget up to bat? Fair enough.

◆ Eddie Gaedel's diminutive jersey was originally worn by St. Louis Browns batboy Bill DeWitt, Jr., whose father owned the team. The boy went on to become the owner of the St. Louis Cardinals.

DAVID ROCKWELL

Beyond the Bleachers: Enhancing the Fan Experience

ONE GREAT THING ABOUT BASEBALL is that the ballpark is a place where a captured audience accepts the presence of corporate sponsorship, in a merging of product and pastime. What else would you expect from America's Game?

It's the proverbial "win-win" situation.

In fact, the relationship is so intertwined that even the song "Take Me Out to the Ball Game" features a certain packaged snack item consisting of "candy-coated popcorn, peanuts and a prize."

These days, major league ballparks are swimming in ads competing for the fans' attention. More so than any other sport, baseball offers built-in time for its spectators to take their eyes off the game and notice their surroundings. The demand for having something else besides "the game" as part of the ballpark experience is how we got involved in stadium design in the first place.

Currently, a total of 13 of 30 major league ballparks are named after a corporate sponsor. This is the ultimate sponsorship, the logical conclusion to a trend that began with little leagues putting local businesses on the back of teams' uniforms for a fee. Our attractions at Turner Field for Coca-Cola and Enron Field for Minute Maid are examples of corporate America wishing to give back to, and be a part of, baseball. These attractions give parents and their youngsters a heightened fan experience.

The strategy we took when designing each of these projects was to convince the sponsor to allow the game, the very basics, to help define the space and the experience for the fan. In other words, let a little bit of the child out of the corporate shell and have fun with it. Towards that end, the projects are first and foremost about baseball.

Creating a 45-foot-tall sculpture at Turner Field out of authentic baseball equipment was the big idea for Coca-Cola, but having it shaped like a recognizable corporate icon made it friendly and familiar. This part of the park, known as SkyField, is a picnic area situated high above left field with real grass, oversize lawn chairs, and an authentic looking first-base path for children to run down. At one point, it was estimated that 70 percent of the youngsters who come to Turner Field visit SkyField.

At Enron Field in Houston, the focus was on baseball skills. Minute Maid named it the "squeeze" play. Youngsters can race a 20-foot-tall Astro down the third-base line to home plate, send a fastball across the plate at 100 miles per hour (with the aid of a custom slingshot), or step into the "splatting" cage and hit a ball of water with an oversize bat. And, if all that activity makes them thirsty, Minute Maid is there to serve them lemonade from a "relief" pitcher.

Corporations' love affair with America's game is unending—they are inexorably linked from the little league field of dreams to the newest major league stadium—and baseball is smart enough to let the courtship continue. And fans benefit from the relationship. The experience of going to the ballpark today is more diverse, immersive, and entertaining than ever before. Fans take away not only familiar souvenirs, but new and better memories of going out to the ballpark.

◆ OPPOSITE, TOP: The retractable roof at Miller Park in Milwaukee gives fans inside games in April and outside ones during the summer. OPPOSITE, BOTTOM: The Rockwell-designed SkyField at Atlanta's Turner Field illustrates the growing trend to make everything about attending a baseball game more entertaining.

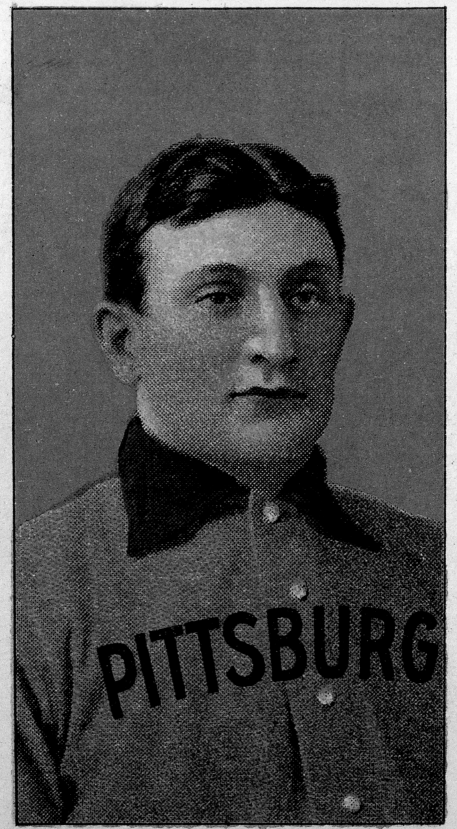

WAGNER, PITTSBURG

RICHARD MERKIN AND LAWRENCE S. RITTER

Baubles, Bangles, and Bubble Gum: Baseball Collectibles

ANTHROPOLOGISTS TELL US that many thousands of years ago mankind made a great leap forward, changing from a nomadic lifestyle based on hunting to a more geographically stable existence focused primarily on farming. In due course, homesteads followed wherein harried mothers started finding pine cones, seashells, and Indian arrowheads haphazardly stored in cigar boxes in corners of the playroom. The Era of Collecting had begun! With the passage of time, adults joined their offspring in collecting everything from stamps, coins, and comic books to toy soldiers, teddy bears, and Beanie Babies. Almost anything can become a "collectible." Rarity is usually a necessary condition, but it is not sufficient. Desirability, attractiveness, and anticipated appreciation in value are also important. Collectibles often fulfill some deep-seated acquisitive need in those who acquire them.

When it comes to baseball, the most popular collectible has always been trading cards, featuring images of major league ballplayers. They became known as "trading cards" because kids traditionally traded them among themselves, each trying to replace duplicate holdings with scarce ones. Kids also flipped them (heads or tails, odds or evens), tossed them against a wall or stoop (closest one wins), or stuck them between spokes on a bicycle (so they produced a whirring sound when the bike moved).

When professional baseball was in its infancy, late in the 19th century and early in the 20th, baseball cards came as inserts with packs of cigarettes. Subsequently, manufacturers of candy, baked goods, and other products—including clothing—used cards as a gimmick to boost sales. However, the "modern" era of card collecting dates from 1933, when the Goudey Gum Company included cards with bubble gum—a slab of pink bubble gum plus a baseball card for a penny. Goudey's initial set of 239 cards, each of which carried the logo "Big League Chewing Gum," thus cost all of $2.39. That set, in mint (perfect) condition, is now valued in the neighborhood of $48,000!

In the early 1950s, Topps Chewing Gum Company took over as the leading issuer of bubble gum cards, dominating the field for 30 years until joined by Donruss and Fleer in 1981. Today, baseball cards are issued under more than a half dozen brand names (Topps, Donruss, Fleer, Score, Upper Deck, Stadium Club, etc.) and are more popular than ever. The gum, however, has disappeared: New cards are now packaged alone, about ten in a pack, generally priced at between two and five dollars.

In the 1960s, collectibles across the board started to rise in value as persistent inflation caused the public to lose confidence in the long-run purchasing power of the dollar. To safeguard their wealth, many investors switched from stocks and bonds to "nonfinancial" assets—such as antiques, art, coins, stamps, and sports cards. Additionally, waves of nostalgia for the "good old days" augmented the demand for vintage baseball cards as well as for memorabilia in general, including game-used uniforms, gloves, bats, and even personal items (such as

◆ The famous Honus Wagner T206 baseball card, 1909. Although not the rarest of baseball cards, the Wagner card has developed a mystique that makes it the most highly prized—and most valuable—of all baseball cards. The current record price paid for the best example of this card exceeds one million dollars.

Ty Cobb's dentures—auctioned for $7,475 in 1999 at Sotheby's in New York!).

The value (price) of any particular existing card depends on supply and demand: The smaller the supply and larger the demand for a card, the higher its price. The cards of Babe Ruth, Mickey Mantle, Joe DiMaggio, Ted Williams, and Mark McGwire are currently in greatest demand and thus the most valuable. Nevertheless, the most valuable baseball card of all is a rare 1909 Honus Wagner; in July of 2000, one was sold at auction for $1,265,000.

The condition of a card is also important in determining its price: Everything else being equal, a card in mint condition is worth more than one with scratches or bent corners. (Condition is also a significant consideration in determining the value of nonbaseball collectibles, such as coins, stamps, and antiques.)

Autograph collecting is as popular as card collecting, perhaps more so. Ballplayers have been signing baseballs, scorecards, scraps of paper, and Lord knows what else ever since the first umpire stood at home plate and bellowed,

"Play Ball." But, autograph collectors are constantly plagued by the problem of forgeries: Since autographs can be replicated by anyone skilled in penmanship, collectors are always worried about whether a signature is authentic or fake. The more valuable an autograph—say a Babe Ruth or a Mickey Mantle signature—the greater the temptation for a charlatan to make a counterfeit copy and pass it off as the real thing. The fact of the matter is that about the only way a person can be absolutely sure a signature is genuine is to actually see the player sign it.

Baseball collecting has become big business in the United States. Occasionally, it even reaches bizarre proportions. Mickey Mantle, for example, was fond of recalling the time he ordered room service in his hotel room when the Yankees were on a road trip. When breakfast arrived, Mickey was busy clipping his toenails. After placing the tray on a table, the waiter seemed mesmerized as he stared at the Yankees outfielder carefully trimming his last few toenails.

"Mr. Mantle," he finally blurted out, "do you think I could have the clippings?"

◆ ABOVE: Snoopy is a traditionalist when it comes to baseball cards, 1981. OPPOSITE: Philadelphia Phillies pitcher Larry Andersen signs autographs at Doubleday Field in Cooperstown before the 1994 Hall of Fame Game between the Phillies and the Seattle Mariners.

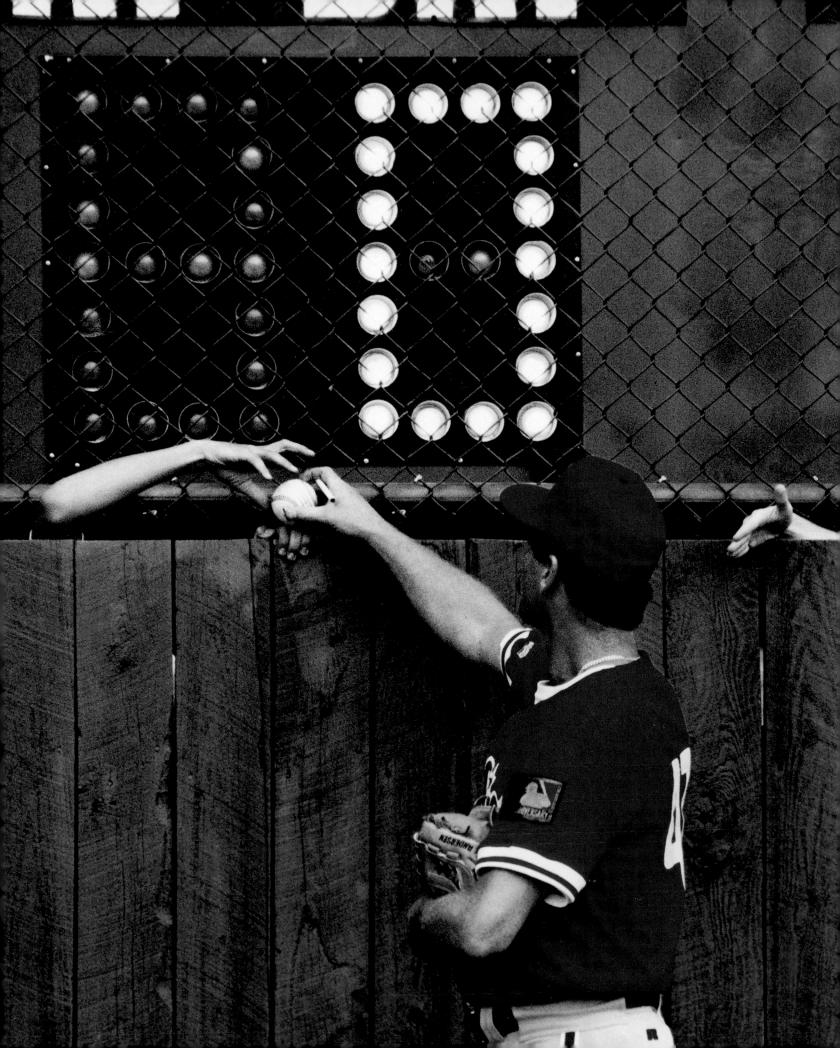

CURT FLOOD & ASSOC., INC.

CURT FLOOD STUDIOS

8007 Clayton Road
St. Louis, Missouri 63117
PArkview 5-3550

December 24, 1969

Mr. Bowie K. Kuhn
Commissioner of Baseball
680 Fifth Avenue
New York, New York 10019

Dear Mr. Kuhn:

After twelve years in the Major Leagues, I do not feel
that I am a piece of property to be bought and sold
irrespective of my wishes. I believe that any system
which produces that result violates my basic rights as
a citizen and is inconsistent with the laws of the
United States and of the several States.

It is my desire to play baseball in 1970, and I am
capable of playing. I have received a contract offer
from the Philadelphia Club, but I believe I have the
right to consider offers from other clubs before making
any decisions. I, therefore, request that you make
known to all the Major League Clubs my feelings in this
matter, and advise them of my availability for the
1970 season.

Sincerely yours,

Curt Flood

Curt Flood

CF/j

CC - Mr. Marvin J. Miller

 - Mr. John Quinn

When 12-year-veteran Curt Flood was traded from St. Louis to Philadelphia in 1969, he objected to rules that gave him no say in his future. Though Flood's appeal to Commissioner Bowie Kuhn failed, their encounter was a milestone on the road to abolishing the "reserve clause" binding players to teams.

Curt Flood / Bowie Kuhn 1969

Fighting the Reserve Clause

December 30, 1969

Dear Curt:

This will acknowledge your letter of December 24, which I found on returning to my office yesterday.

I certainly agree with you that you, as a human being, are not a piece of property to be bought and sold. That is fundamental in our society and I think obvious. However, I cannot see its applicability to the situation at hand.

You have entered into a current playing contract with the St. Louis club, which has the same assignment provision as those in your annual major league contracts since 1956. Your present contract has been assigned in accordance with its provisions by the St. Louis club to the Philadelphia club. The provisions of the playing contract have been negotiated over the years between the clubs and the players, most recently when the present basic agreement was negotiated two years ago between the clubs and the Players' Association.

If you have any specific objection to the propriety of the assignment, I would appreciate your specifying the objection. Under the circumstances, and pending any further information from you, I do not see what action I can take and cannot comply with the request contained in the second paragraph of your letter.

I am pleased to see your statement that you desire to play baseball in 1970. I take it this puts to rest any thought, as reported earlier in the press, that you were considering retirement.

Sincerely yours,

Bowie Kuhn

◆ OPPOSITE: Curt Flood's 1969 Topps baseball card. When the photo for this card was taken, the veteran ballplayer had no reason to believe that his life would be disrupted by a trade. His request to Commissioner Bowie Kuhn touched off perhaps the most profound changes ever in the baseball industry.

In the 1980s, a new phrase entered the American lexicon. It first appeared in an off-beat novel by W. P. Kinsella, entitled *Shoeless Joe*. It gained wider currency in 1989, when Kinsella's book was turned into a movie, *Field of Dreams*. Both book and film depict a young, struggling Iowa farmer named Ray who one day hears a voice tell him: "If you build it, he will come." Ray understands that "it" is a baseball diamond in his cornfield

SHARING A COMMON CULTURE

and "he" is former baseball star Shoeless Joe Jackson, who was banished from the game for conspiring to throw the World Series in 1919. Ray painstakingly constructs the diamond; Jackson and his teammates return, and, along with Ray, acquire redemption. The simple, yet hypnotic invocation, "If you build it, he will come," transmitted via literature and cinema, instantly became a national catchphrase, evoking a sense of mysticism and optimism that appealed to the American spirit. ◆ Kinsella's contribution to our popular culture is but one of many such baseball touchstones embedded in our lives. An earlier baseball trinity remains even more familiar to people across the generations. "Casey at the Bat," "Take Me Out to the Ball Game," and "Who's on First"—a poem of the 1880s, a turn-of-the-century song, and a Depression era comedy routine—have each carved a unique place in American culture. By placing their stories in the most familiar of American venues, the never changing, ever changing ballpark, these three works spoke clearly to their own eras, yet created a setting that could captivate subsequent generations with the common experience and language that is provided by baseball—perhaps uniquely among American institutions. ◆ "Casey at the Bat," tellingly subtitled "A Ballad of the Republic," was written by Ernest Lawrence Thayer and

published in the *San Francisco Examiner* in 1888. It told the tale of a local team, the Mudville Nine, and its indomitable, seemingly invincible slugger, the mighty Casey. Though the action takes place on the field, the perspective is always that of the 5,000 fans in the stands, who ward off "deep despair" and cling "to that hope which springs eternal in the human breast," that their standard bearer might lead their team to victory. Casey displays an unmistakably American swagger and arrogance. He is confident in his abilities, charitable toward the umpire, determined in his demeanor. That he ultimately fails lends a cautionary flavor to the tale, a seeming corrective to American hubris in the emergent industrial age where everything seemed possible and success inevitable.

"Casey at the Bat" might easily have been forgotten. But, in 1888, journeyman actor and avid baseball fan DeWolf Hopper performed the piece at a special "baseball night" at Wallack's Theater in New York, attended by members of the New York Giants and Chicago White Stockings. The audience greeted Hopper's dramatic rendering with tumultuous enthusiasm. Casey soon became a regular part of Hopper's repertoire. Audiences, though no longer surprised by the ending, could not get enough of it. Hopper estimated that he performed the verse at least 10,000 times. "Casey at the Bat" has been the subject of movies (including a 1915 feature starring Hopper), cartoons, satires, parodies, and scholarly treatises. Its denouement, where the mighty Casey strides to the plate with a chance to win the game, has become the center around which most baseball fiction, movies, and dramatizations swirl. In all likelihood, no single American poem has been reprinted as often or recited as frequently.

It was 20 years later that songwriters Jack Norworth and Albert Von Tilzer, two men who had never attended a baseball game, captured the optimistic spirit of the Progressive Era in "Take Me Out to Ball Game." The song told the tale of a liberated woman named Katie, who wanted not to be wined and dined by her beau, but rather to be escorted to the ballpark, where she could eat "peanuts and Cracker Jack" and "root, root, root for the home team." The chorus simultaneously evoked and defined the baseball experience for generations to come. The nation's number one hit in 1908, it has remained perhaps the most familiar of all American tunes and has been sung not only during the seventh-inning stretch at most ballparks, but as a children's song, a lullaby, and a folk song.

"Who's On First" has had a more unpredictable popularity. The routine sprang from the minds of popular comics Bud Abbott and Lou Costello, who, among their other talents, specialized in clever wordplay. Costello, an avid baseball fan, wanted to know the names of the players on the team. Abbott, the quintessential straight man, attempted to assist him. The trick was that the names themselves, when coupled with their positions, were both questions and answers. "Who" played first base. "What" played second. "I Don't Know" played third. Costello could not ask a question—"Who's on first?"—without simultaneously answering it. Abbott gave straightforward factual responses—"What's on second"—that could only confound Costello.

As sportswriter Frank Deford has noted, the routine succeeded so beautifully precisely because it was situated on a baseball field, the most recognizable and predictable of all American venues. Costello, though wandering through a highly familiar landscape, found naught but confusion.

"Who's on First" worked, and continues to work, not simply because it is uproariously funny, but because it captures the complexities of the rapidly changing modern world, where the commonplace can challenge the unwary overnight. It took on added meaning in the Depression world of the 1930s, where simple questions like who? what? or why? no longer always had clear-cut answers.

"Who's on First," like "Casey at the Bat" and "Take Me Out to the Ball Game," became a staple of American culture. Abbott and Costello performed it thousands of

◆ PAGE 216: Douglas Tilden's bronze sculpture, "The Baseball Player," 1888-1889. Tilden's life-size statue, originally exhibited in Paris, now stands in San Francisco's Golden Gate Park. The Baseball Hall of Fame collections contain one of the two known smaller replicas.

◆ Albert Dorne's painting of *The Mighty Casey*, central figure of Ernest Lawrence Thayer's poem "Casey at the Bat."

times—on the stage, on radio, in movies, and later on television. President Franklin D. Roosevelt loved the routine and invited the duo to perform it at the White House on numerous occasions. Today, decades after Abbott and Costello have passed on, "Who's on First" remains a popular, easily recognizable slice of Americana, reproduced in books and on CDs, posters, and numerous Internet Web sites, transmitted anew from fathers and mothers to sons and daughters.

Throughout the past century and a half, baseball has entered American popular culture in myriad other ways as well. Songs, like "Slide Kelly Slide" in the 1880s or "Joltin' Joe DiMaggio" in 1941 and "Did You See Jackie Robinson Hit That Ball?" in 1949, celebrated individual players. Bruce Springsteen sang of a faded high school baseball star in "Glory Days." In 1985, John Fogerty created a modern baseball classic when he sang about the glories of playing "Center Field." Steve Goodman, afflicted with terminal cancer, memorably discussed baseball and life in "A Dying Cub Fan's Last Request."

◆ Bud Abbott and Lou Costello in a scene from their classic baseball routine "Who's on First."

Baseball also invaded all levels of American literature, used by our foremost writers to illustrate aspects of our national experience. Mark Twain, in *A Connecticut Yankee in King Arthur's Court* in 1889, had his protagonist, Hank Morgan, introduce the game, along with other elements of modern America, to the Knights of the Round Table. F. Scott Fitzgerald injected baseball subtly, but sharply, into *The Great Gatsby* in the 1920s, when he introduced gambler Meyer Wolfsheim as the man who fixed the 1919 World Series, evoking a sense of awe and wonder from narrator Nick Calloway. Ernest Hemingway invoked "the great DiMaggio" as an inspiration to an aging Cuban fisherman in *The Old Man and the Sea*.

The sport had become a common topic of American juvenile literature and short stories in the late 19th century. It arrived as the subject of a serious novel in 1916 when sportswriter and humorist Ring Lardner conjured up Jack Keefe, an aspiring, but not very talented pitcher for the Chicago White Sox in *You Know Me, Al.* Transplanted from small town to big city, the naive, overconfident Keefe sent hilarious letters describing his experiences to his hometown friend Al, creating a revealing portrait of life in pre-World War I America. Beginning in the 1950s, many of the nation's leading novelists, writers who included Bernard Malamud, Philip Roth, and Robert Coover, made baseball the centerpiece in their works, in books like *The Natural, The Great American Novel,* and *The Universal Baseball Association Inc., J. Henry Waugh, Prop.*

Malamud's *The Natural,* as much as any other novel, demonstrated the power of baseball as an American metaphor. Malamud merged elements of Arthurian legend and baseball folklore to create Roy Hobbs, a blend of Lancelot, Mighty Casey, Babe Ruth, and Joe Jackson. *The Natural,* written in 1952, in the aftermath of World War II and under the shadow of the nuclear age, was a dark, brooding exploration into the underside of the American Dream. Given the opportunity that was Casey's, Hobbs not only strikes out, he throws the game. Thirty years later, when filmmakers Barry Levinson and Robert Redford brought *The Natural* to the screen, the American psyche had changed. After decades of uncertainty created by battles over the Civil Rights movement, the Vietnam War, Watergate, and economic challenges, Americans in the age of Ronald Reagan craved a more optimistic, unifying vision. In the movie version of *The Natural,* Hobbs—played by Redford, the golden-haired American movie star—strikes the game-winning blow, accompanied by an inspirational, uplifting soundtrack. Remarkably, both the novel and the movie, so different in tone and outcome, stand on their own, classics of their respective genres.

The cinema version of *The Natural* also reawakened the American appetite for baseball movies. From the earliest days of the medium, baseball had attracted filmmakers. Biographies of ballplayers starred many of Hollywood's top actors. Gary Cooper portrayed a memorable Lou Gehrig in *The Pride of the Yankees.* Jimmy Stewart played Monty Stratton, a pitcher who lost his leg yet returned to compete on the diamond in *The Stratton Story.* Future president Ronald Reagan turned in one of his best performances as Grover Cleveland Alexander in *The Winning Team.* Baseball fantasies comprised a second popular variety of film. In *It Happens Every Spring* a college science professor played by Ray Milland fulfills his wildest dreams when an irreproducible chemical compound enables him to become a standout major league pitcher. The 1980s and 1990s, however, proved the golden age of baseball movies, with films like *The Natural, Field of Dreams, A League of Their Own,* and *Bull Durham* leading the way.

With the exception of perhaps the Western, it is hard to identify another distinctively American institution that has cut such a wide swath across popular culture over such an extended time span, as has baseball. American artists have built an impressive body of baseball-related works, and the American people have come, to enjoy, absorb, and reflect in their power and glory.

—Jules Tygiel

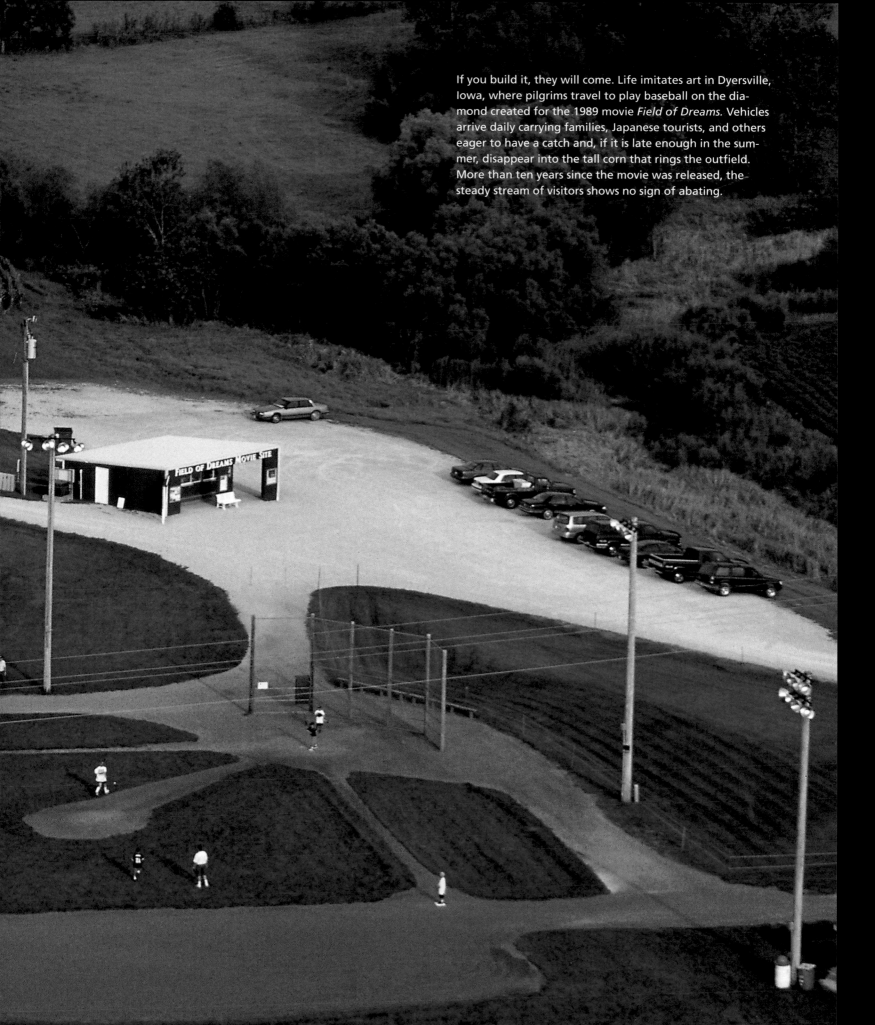

If you build it, they will come. Life imitates art in Dyersville, Iowa, where pilgrims travel to play baseball on the diamond created for the 1989 movie *Field of Dreams*. Vehicles arrive daily carrying families, Japanese tourists, and others eager to have a catch and, if it is late enough in the summer, disappear into the tall corn that rings the outfield. More than ten years since the movie was released, the steady stream of visitors shows no sign of abating.

Casey at the Bat

The outlook wasn't brilliant for the Mudville nine that day;
The score stood four to two with but one inning more to play.
And then when Cooney died at first, and Barrows did the same,
A sickly silence fell upon the patrons of the game.

A straggling few got up to go in deep despair. The rest
Clung to that hope which springs eternal in the human breast;
They thought if only Casey could but get a whack at that—
We'd put up even money now with Casey at the bat.

But Flynn preceded Casey, as did also Jimmy Blake,
And the former was a lulu and the latter was a cake;
So upon that stricken multitude grim melancholy sat,
For there seemed but little chance of Casey's getting to the bat.

But Flynn let drive a single, to the wonderment of all,
And Blake, the much despis-ed, tore the cover off the ball;
And when the dust had lifted, and the men saw what had occurred,
There was Johnnie safe at second and Flynn a-hugging third.

Then from 5,000 throats and more there rose a lusty yell;
It rumbled through the valley, it rattled in the dell;
It knocked upon the mountain and recoiled upon the flat,
For Casey, mighty Casey, was advancing to the bat.

There was ease in Casey's manner as he stepped into his place;
There was pride in Casey's bearing and a smile on Casey's face.
And when, responding to the cheers, he lightly doffed his hat,
No stranger in the crowd could doubt 'twas Casey at the bat.

Ten thousand eyes were on him as he rubbed his hands with dirt;
Five thousand tongues applauded when he wiped them on his shirt.

Then while the writhing pitcher ground the ball into his hip,
Defiance gleamed in Casey's eye, a sneer curled Casey's lip.

And now the leather-covered sphere came hurtling through the air,
And Casey stood a-watching it in haughty grandeur there.
Close by the sturdy batsman the ball unheeded sped—
"That ain't my style," said Casey. "Strike one," the umpire said.

From the benches, black with people, there went up a muffled roar,
Like the beating of the storm-waves on a stern and distant shore.
"Kill him! Kill the umpire!" shouted some one on the stand;
And it's likely they'd have killed him had not Casey raised his hand.

With a smile of Christian charity great Casey's visage shone;
He stilled the rising tumult; he bade the game go on;
He signaled to the pitcher, and once more the spheroid flew;
But Casey still ignored it, and the umpire said, "Strike two."

"Fraud!" cried the maddened thousands, and echo answered fraud;
But one scornful look from Casey and the audience was awed.
They saw his face grow stern and cold, they saw his muscles strain,
And they knew that Casey wouldn't let that ball go by again.

The sneer is gone from Casey's lip, his teeth are clenched in hate;
He pounds with cruel violence his bat upon the plate.
And now the pitcher holds the ball, and now he lets it go,
And now the air is shattered by the force of Casey's blow.

Oh, somewhere in this favored land the sun is shining bright;
The band is playing somewhere, and somewhere hearts are light,
And somewhere men are laughing, and somewhere children shout;
But there is no joy in Mudville—mighty Casey has struck out.

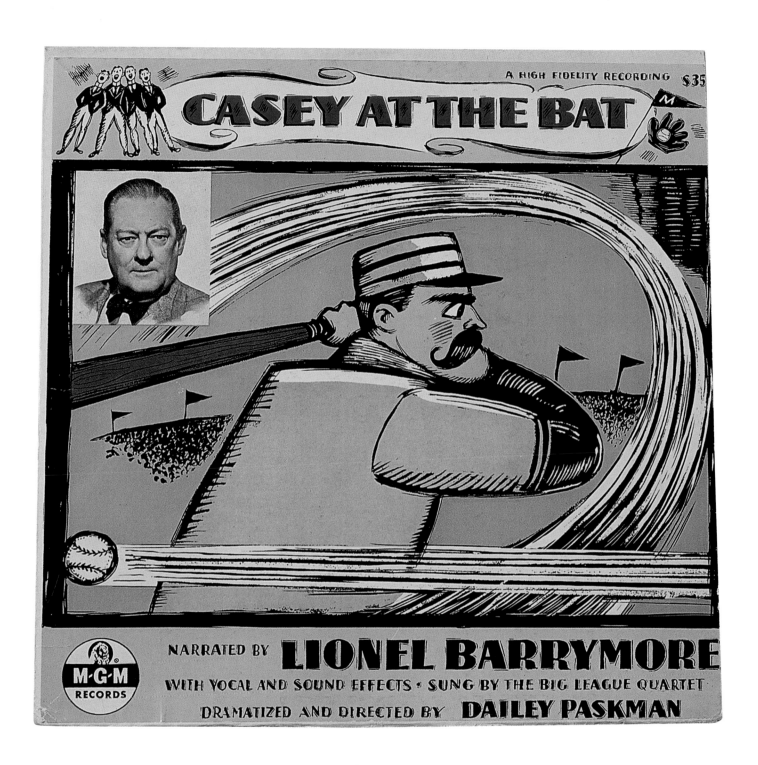

◆ From the Edison cylinder of the famous declamation of DeWolf Hopper, the rhythmic verses of "Casey at the Bat" have been recorded by many, including Lionel Barrymore, but also Vincent Price, Bob Costas, and Garrison Keillor.

Joshua Siegel

The Big Show on the Big Screen

FOR ALMOST AS LONG as people have been making movies, they've been making baseball movies. Back in 1899, the Edison Studio in New Jersey made a three-minute film consisting of one shot, in which a batter strikes out and argues with the umpire. The film was called *Casey at the Bat*. Since then, *Casey at the Bat* has been filmed six times. But, as Hal Erickson notes in his definitive guide *Baseball in the Movies*, Disney's wonderful 1946 cartoon version comes closest to the "satiric hyperbole" of Ernest Lawrence Thayer's ballad.

The pleasure of baseball movies lies less in their re-creations of the game's historic moments than in their embellishment of the legends that grew out of those moments. The biographical films that flourished in the late 1940s and 1950s followed the classic arc of the American success story, in which a kid from Tomkinsville (or some other "-ville") beats all odds to achieve glory. Gary Cooper's stoic performance as Lou Gehrig made *The Pride of the Yankees* (1942) the best of these, and others followed in quick succession, including *The Stratton Story* (1949), *The Winning Team* (1952), *The Pride of St. Louis* (1952), and *Fear Strikes Out* (1957). Baseball stars regularly portrayed themselves: In 1950, three years after he broke the color barrier, Jackie Robinson made *The Jackie Robinson Story*. Babe Ruth, unsurprisingly, still holds the record for cameo appearances.

Art makes the impossible possible, and baseball movies have taken this to fanciful extremes. A cat inherits a professional team (*Rhubarb,* 1951), a chemical formula makes a ball unhittable (*It Happens Every Spring,* 1949), and the hapless Pittsburgh Pirates are saved by divine intervention (*Angels in the Outfield,* 1951). Other inept, but likable teams, such as Walter Matthau's bumbling Bad News Bears and the Cleveland Indians in *Major League* (1989), are also blessed with miraculous comebacks.

In 1988, *Eight Men Out* tried to recount baseball's darkest hour, the 1919 Black Sox scandal, in painstaking detail—and it failed at the box office. A year later, *Field of Dreams* had Shoeless Joe Jackson assure filmgoers that it really wasn't so—and the movie was a commercial hit. Such rosy optimism was also true of films made in the years following the actual scandal; in *Trifling with Honor* (1923), *Life's Greatest Game* (1924), and *Elmer the Great* (1933), ballplayers are tempted to throw a World Series, but they do not.

Some recent films tell baseball stories that haven't been told before, from the Negro leagues in *The Bingo Long Traveling All-Stars & Motor Kings* (1976) to the professional women's league in *A League of Their Own* (1992). Foreign films testify to the popularity of baseball abroad. In Masahiro Shinoda's *MacArthur's Children* (1985), Japanese villagers are introduced to the game by American officers during the postwar occupation. In Arturo Ripstein's *The Ruination of Men* (2000), the heated passions of a Mexican ball game have fatal consequences. Baseball has expressed the democratic ideal in more than a few of these movies, but none has articulated this sentiment more movingly than Nagisa Oshima's *The Ceremony* (1971), in which America's pastime is assimilated into one Japanese family's daily ritual.

◆ *The Pride of the Yankees,* the poignant story of the tragic life of Lou Gehrig and his love for his wife Eleanor, starred Gary Cooper and Teresa Wright, with a cameo appearance by Babe Ruth. The film received 12 Oscar nominations in 1942.

Reflections on *The Natural*

BERNARD MALAMUD OBSERVED that "the whole history of baseball has the quality of mythology." In 1952, his first novel, *The Natural*, created the legend of Roy Hobbs, an aging New York Knights right fielder whose best years were ruined when he was shot and nearly killed by a Baseball Annie, but who still dreamed of becoming "the best there ever was." Malamud's dark fable became decidedly sunnier when Hollywood filmed it in 1984. As directed by Barry Levinson, the film *The Natural* ended not with Robert Redford's Roy Hobbs selling out to fixers, but instead with his hitting a colossal, pennant-winning homer. *The Natural* earned four Oscar nominations and grossed $40 million at the box office.

In the interview that follows, Mr. Levinson talks about his own contribution to the mythology of the game.

JS: You were twelve years old in 1954, the year the St. Louis Browns became the Baltimore Orioles. Is this when you fell in love with baseball?

BL: Actually, growing up in Baltimore, I followed the Orioles as a minor league team, when they played clubs like Rochester. We used to listen to them on the radio. Then, when major league ball came to Baltimore, to a young kid, that was huge, a celebration. We would sit in front of the television and do our own box score of the game. Of course, that first year we lost a hundred games. And yet there was great optimism, even though our leading home run hitter, Vern Stephens, had only eight homers!

JS: What drew you to *The Natural?*

BL: I've always loved the mythology of baseball, and what intrigued me about Malamud's novel was his making reference to all the baseball stories passed down through the ages, from the Chicago Black Sox scandal to "Casey at the Bat."

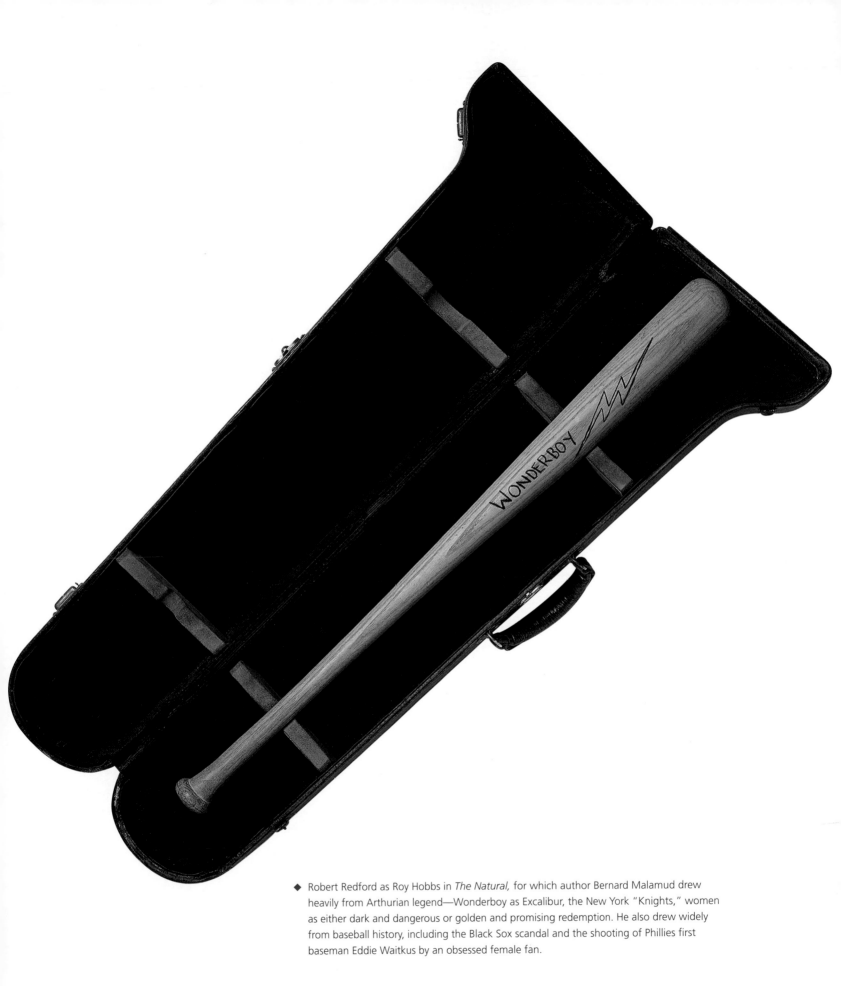

◆ Robert Redford as Roy Hobbs in *The Natural,* for which author Bernard Malamud drew heavily from Arthurian legend—Wonderboy as Excalibur, the New York "Knights," women as either dark and dangerous or golden and promising redemption. He also drew widely from baseball history, including the Black Sox scandal and the shooting of Phillies first baseman Eddie Waitkus by an obsessed female fan.

JS: In the movie, Harriet Bird tells Roy that, if Homer were alive today, his heroes would be baseball players. I think it's an interesting allusion—not only because epics, like baseball stories, are about men who aspire to greatness but also because Homer belonged to an oral tradition that is very much in keeping with the way that the folklore of baseball is passed down through the generations.

BL: Yes, *The Natural* is about the passing of stories and the elaboration of those stories, rather than simply about "the game." If you know the past of baseball, it makes the present that much more exciting. If you know the (history of the) matchup between the pitcher and the batter, it is far more fascinating than simply watching a game on television and seeing that pitcher, that hitter, that moment. Baseball does not exist just in the moment of now, but in the past that leads to that moment.

JS: Perhaps that's why baseball stories work in a way that no other sports stories do.

BL: I think it's partly because it's the only one-on-one team sport. At some point, it becomes a duel between a pitcher and a hitter and, although it's a team sport, it gets highlighted in that way. The mythology comes from this …"Casey at the Bat," Bobby Thomson's home run.

JS: Certainly Malamud draws from the entire history of baseball, moving freely between eras, from the 1920s to the '50s. His novel is full of allusions—to the Black Sox scandal, to Babe Ruth, Bob Feller, Ray Chapman, and Pete Reiser, to the 1949 shooting of Phillies first baseman Eddie Waitkus at a Chicago hotel by a woman he never knew. Did you have these references in mind when you were making the film?

BL: I definitely had some of these stories in the back of my mind, particularly the Eddie Waitkus shooting and the "Say It Ain't True, Roy" reference to Shoeless Joe Jackson. Malamud was incorporating all the mythologies and legends from the past until when the book was written, and the trick was to use some of that in the movie and yet be specific to a particular time and place—New York in 1939.

JS: Eddie Waitkus's son later said that his father got over losing four years of his career to World War II because everyone went, but he never got over the time lost because of the shooting. Sounds very much like Roy Hobbs.

BL: Yes, we tried to capture that in the movie. There's a measure of regret in the careers of many ballplayers. Mickey Mantle, at the end, spoke of the regret he had about never living up to his potential. Baseball players are endowed with a certain kind of extraordinary talent. Some ultimately abuse that talent or are injured, and then their youth is gone. But there's that one brief, precious window of time when an athlete has such remarkable physical ability, after which the talent can't be brought back. It can be a very dramatic story.

JS: Gary Cooper brought the traits of an archetypal Western hero—strong, aloof, just—to his performance as Lou Gehrig in *The Pride of the Yankees*. Malamud portrays Roy Hobbs in a similar manner. He's a man with a mission, a loner who tries to bury a secret from his past. Robert Redford has long been compared to Gary Cooper. Did you have the Western in mind when you made *The Natural*?

BL: Not consciously, no. The Western mythology of the loner applies, I guess, but the loner exists in other genres. I was thinking in many ways of Ted Williams, who was always a loner. Williams had extraordinary ability but was never embraced in his time, as great as he was. He never acknowledged the fans. On the day of his retirement, he went around the bases but never tipped his cap. He was bigger than life.

JS: Redford, who has said that he idolized Ted Williams, wears No. 9 on his uniform. Williams studied every aspect of the game to make himself a better hitter, but some have said that he was a self-serving ballplayer, more concerned with improving his batting average than helping his team. Similarly, Malamud wrote that Roy had no interest in learning how to bunt, that he was strictly a home run hitter. There's little camaraderie between him and his teammates. Do you think there's a kind of arrogance about him?

BL: No, because I think that the standoffishness has to do

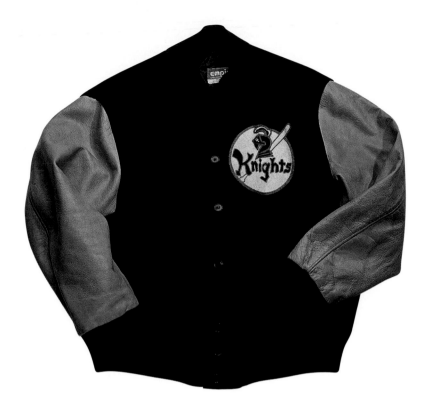

with the focus of certain ballplayers and why they're so misunderstood. They have a talent that is unexplainable, an ability that no one can ever understand. Williams had that ability. But that doesn't mean that they could be at ease with their teammates all the time, or be accessible to the journalists. Babe Ruth was one type, who could hit home runs and drink and party and act lovable. But the other type was like the gunslinger of the Westerns, who kept to himself, wasn't capable of being extroverted. There has been talk about whether Albert Belle should be in the Hall of Fame; some complain that he wasn't easy, didn't chat with the press. Is it that he was so angry or that he was so focused?

JS: For many immigrants—in Malamud's time they came from Italy and Eastern Europe; now they come from Latin America—baseball has held the promise of assimilation and inclusion. Why do you think that is?

BL: Immigrants embraced many things considered American as quickly as they could. Take Gershwin and Irving Berlin, whose music became the American music. Immigrants embraced baseball because they loved the game and because they wanted to be a part of the American scene.

JS: In the novel, Malamud wrote that, as a boy, Roy was shunted from one orphanage to the next but that during the summer, when his father wasn't working, he would toss a ball around with him. In the film, you elaborated on Roy's relationship with his father and gave him a son and a woman to whom to return home. Indeed, Roger Towne said that he had the configuration of the baseball diamond and of returning home in mind when he wrote the script.

BL: It's the introduction of the game and how it's passed on, which has always begun with the father to the son. The father can tell you about the past, the things that you didn't know, and that's part of the mythology. That's how the oral history is passed on. It's a story told seven times over, and it gets more vivid and exciting each time. That's where it all connects, from generation to generation and from father to son.

◆ Roy Hobbs's New York Knights jacket, worn by Robert Redford in *The Natural.*

A League of Our Own

"THERE'S NO CRYING IN BASEBALL."

Perhaps this bit of movie dialogue does not occupy the same lofty heights of universal recognition as "Play it again, Sam" or "I coulda been a contender," but these words from *A League of Their Own* carved out a pretty deep niche in the popular culture.

A League of Their Own started for us when we saw a documentary featuring interviews with many of the veterans of the All-American Girls Professional Baseball League. None of us nor anyone we consulted had any idea that such an organization had ever existed. The former players we met were very proud of what they had done and very happy with their memories, but they were also a little bit frustrated that they and their accomplishments had been so completely forgotten. We decided we would try to bring what they had done back to life. We wanted to make a comedy, but we were also determined not to ridicule or belittle what they had done. This was because, old as they were, many of them could still beat the living crap out of us.

In making the movie, we really had a sense of a journey to another place and time—with the old woolen uniforms, the old Midwestern, minor-league, brick ballparks. To a degree we felt as if we had gone off, as they had, to Rockford or Racine to be on a team and try to make good. It felt like a baseball season—complete with wins, losses, friendships, rivalries, injuries, heat exhaustion, and a particularly virulent strain of digestive flu, of which the less said, the better.

The popularity of the film probably rests to a great degree on the intensely American ideas and images to which a baseball movie lends itself: the small-town factory-league game; the big-city scout arriving at the family farm with an offer of fame and fortune; and the cross-country train trip to the big city and a new and more glamorous life. And added to it, there was the classic underdog or outsider story of a group of people (in this case, women) being told that some aspect of the American dream (in this case, baseball) is not for them, and then not accepting their exclusion.

What impressed us most about these women was not just that they had played or had played well, but that, in a time when most young girls were given a very narrow range of dreams from which to choose, these young girls overcame all manner of cultural oppression to follow their dream that a woman's place is at home—sliding, not cooking. Years after the movie's release, we read that the U.S. Olympic Women's Softball Team watched *A League of Their Own* before going out to play their gold-medal-winning game. This was, of course, flattering. But even more pleasing is the knowledge that, since the film came out, more fathers are playing catch with their daughters. For us, it balances out all those little Irish boys who are now practicing ballet.

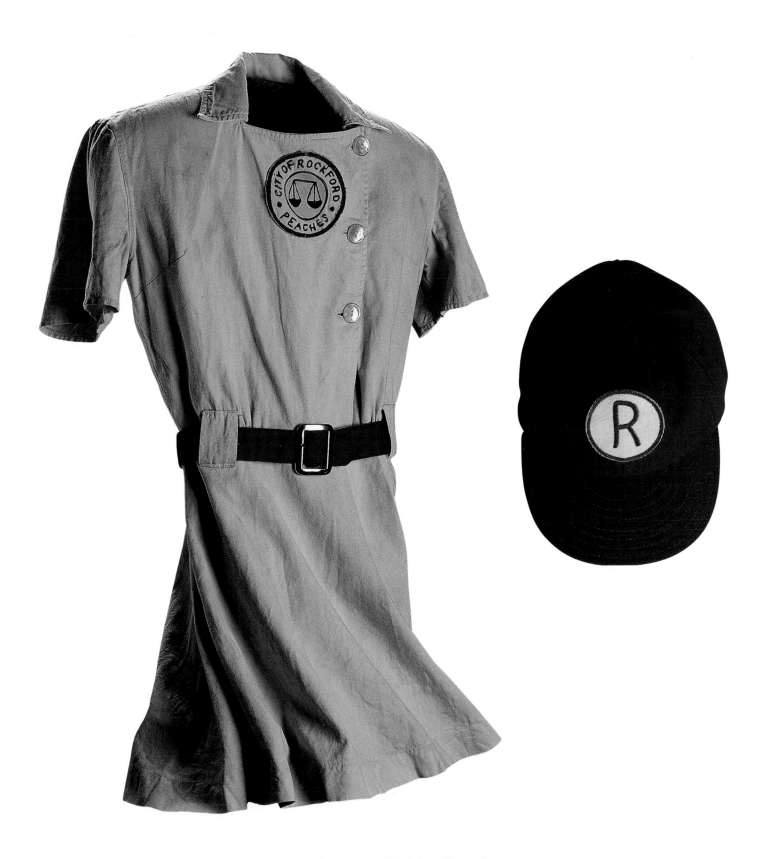

◆ Rockford Peaches cap and uniform worn by Geena Davis in *A League of Their Own*. The movie, written by Lowell Ganz and Babaloo Mandel and directed by Penny Marshall, brought the story of the AAGPBL to a large audience and remains popular a decade after its 1992 release.

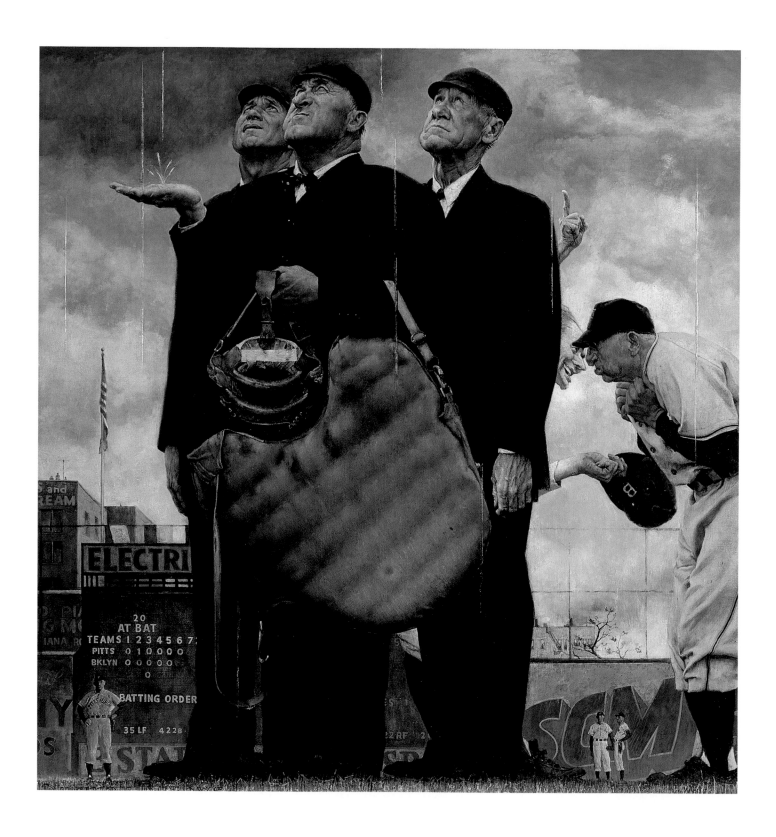

SHELLY MEHLMAN DINHOFER

Baseball as Art: The American Vernacular

BASEBALL, THE GREAT AMERICAN PASTIME, is a straightforward, lively game strenuously played in the warmth of the summer sun. It is a sandlot game in quiet town squares and a gritty game of stickball on the hard pavements of urban streets. It is a hard-fought minor league contest and a World Series in vast, high-tech stadiums. It is a visual extravaganza.

From its inception, baseball provided artists and illustrators with provocative themes and icons that reflected a unique American experience. It captured their imagination with its outdoor setting, numerous figures, varied palette, and spontaneous action. They were intrigued by the game's dramatic confrontations and colorful atmosphere, by its moments of humor and frustration, and by the hordes of spectators—sometimes raucous and quarrelsome, but more often simply content to be out in the summer sun, expressing fidelity to their team. Artists were not simply viewers, however. Some were participants and others proved to be among the game's foremost fans and most acute observers.

On a bright June afternoon in 1846, at the Elysian Fields in Hoboken, New Jersey, the Knickerbockers played against the New York Base Ball Club in the first officially documented game. The players, newly uniformed, were ready for action. The gentry was in attendance. Men in top hats and boaters watched from the sidelines. Families in formal finery crowded together at the field's perimeters, and fancy carriages lined the roadway as far as the eye could see. Twenty years later, in 1866, a carefree image was widely disseminated by the publishing firm of Currier and

Ives in a full-color lithograph, "The American National Game of Base Ball." Although the Knickerbockers lost ignominiously, on that momentous day the game of baseball left the rarefied atmosphere of the rich and entered the popular culture.

Quickly read and understood, baseball's imagery was a handy political weapon for those directly involved in the power plays and civil chaos of the 1860s. In response to the vitriolic dialogues and debates, Currier and Ives produced an inexpensive print for mass distribution, "The National Game ... Three Outs and One Run ... Abraham Winning the Ball" (1860). It depicted the presidential candidates, Abraham Lincoln, John Bell, Stephen Douglas, and John C. Breckenridge as baseball players espousing the usual election year rhetoric. As a media hype, it was the 30-second television spot of its day, but without the soft money incentive.

The art of illustration developed dramatically during the years of the Civil War. Illustrators visited the scattered war fronts, creating sometimes poignant and sometimes horrific images of death and destruction for distribution to an insatiable public. On occasion, an artist would attempt a "leitmotif" to offset the war's despair. Otto Boetticher (1816-1864) chose baseball as the theme for "Union Prisoners at Salisbury, N.C." (1863). The game is spirited and engrossing. Some spectators are watching intently; others are just lounging about. The barracks are in a semicircle, neatly drawn and positioned amid foliage, with only

◆ Norman Rockwell created several baseball paintings, including the classic "Game Called Because of Rain, Tough Call," 1949. With the Pittsburgh Pirates leading 1-0, Brooklyn Dodger coach Clyde Sukeforth points optimistically at the sky, as Pirates manager Billy Meyer hopes for a cancellation by umpires (l-r) Larry Goetz, Beans Reardon, and Lou Jorda. Pittsburgh outfielder Dixie Walker waits at bottom left.

a picket fence separating the players from the peaceful village just beyond. It is a civilized scene and an excellent propaganda ploy for the confederacy. Actually, Boetticher made the drawing while incarcerated in the Confederate prison. It was later adapted as a lithograph.

Perhaps the strongest, most representative figure of the late 19th century neoclassic style is Douglas Tilden's bronze sculpture "The Baseball Player" (1888-89). An avid sports fan and college athlete, Tilden (1860-1935) clearly understood the importance of the game to the American psyche. The player stands clear-eyed and intent, his shirt moving with unexpected grace as he prepares to throw the ball in the designated underhand motion. His stance—left arm bent across the chest, upper torso thrust forward—accentuates the illusion of immediate action. In keeping with Tilden's sense of reality, the face is a carefully modeled self-portrait. Though based on the classical canons of balance and weight, "The Baseball Player" epitomizes the idealized hero so relevant to his times.

In the mid-20th century, illustrators were still in great demand. The scores of large-circulation pictorial magazines devoted to all aspects of American life had not yet succumbed to television's blandishments. And Norman Rockwell (1894-1978), perhaps the most sought-after illustrator of his generation, parlayed baseball's humorous exchanges into many of his *Saturday Evening Post* covers, spreading the game's largesse virtually everywhere.

Ebbets Field made the cover on April 23, 1949, with an illustration that has become a classic comic reflection on the game. In his "Game Called Because of Rain, Tough

Call" (1949), Rockwell groups three umpires in the foreground of the playing field, one with his palm held straight out to catch a trickle of rainwater and all gazing solemnly upward at a single cloud in an otherwise blue sky. They are sternly and judiciously assessing the raindrop index. Although not exactly based on scientific data, their judgment will ultimately prevail. Continuation of the game between the Brooklyn Dodgers and the Pittsburgh Pirates appears imminent. In the background, a Dodger coach (Clyde Sukeforth) is gleeful. Obviously, if the game had been called, Brooklyn would have lost.

If the marketplace was the art palace of Pop Art, Andy Warhol (1928-1987) was its entrepreneur. How well he understood the public's passion for commonplace material objects and titillating images. He reproduced Brillo boxes, Campbell's soup cans, and pictures of catastrophes. He said every human being is entitled to 15 minutes of fame, and yet he presented image after image of celebrity icons, isolated in time—Jackie Kennedy, Mao Tse Tung, Marilyn Monroe. He was a baseball fan, and one of his heroes was the great pitcher who took the miracle New York Mets to World Series victory in 1969. His silk-screen portrait of "Tom Seaver" (1985) surrounded by a halo of primary colors, staring purposefully at the viewer and at the catcher, in thoughtful, timeless imprint, evokes much more than 15 minutes of fame.

In art as in baseball, illusion, myth, and reality coexist in grand style and personal introspection. Art and baseball remain the most exciting playgrounds of the American imagination.

◆ Douglas Tilden's bronze sculpture "The Baseball Player," 1888-1889. Though overhand deliveries were legalized in the mid-1880s, Tilden presumably drew on his childhood memories for the pitcher's dynamic pose.

◆ Andy Warhol's *Tom Seaver* was painted in 1985, the year before Seaver's retirement. In a 20-year Hall of Fame career, Seaver won 311 games for the New York Mets, Cincinnati Reds, Chicago White Sox, and Boston Red Sox.

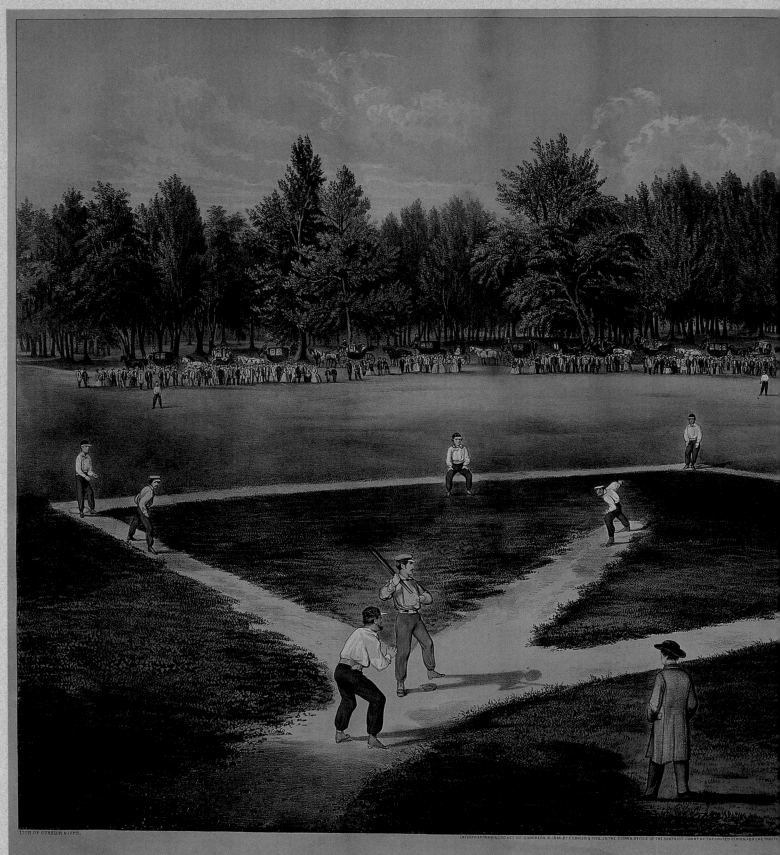

ENTERED ACCORDING TO ACT OF CONGRESS AD 1866, BY CURRIER & IVES, IN THE CLERKS OFFICE OF THE DISTRICT COURT OF THE UNITED STATES FOR THE SOUTHERN

THE AMERICAN NATIONAL GAME O

GRAND MATCH FOR THE CHAMPIONSHIP AT THE ELYSIAN FIELDS, HOBOKEN

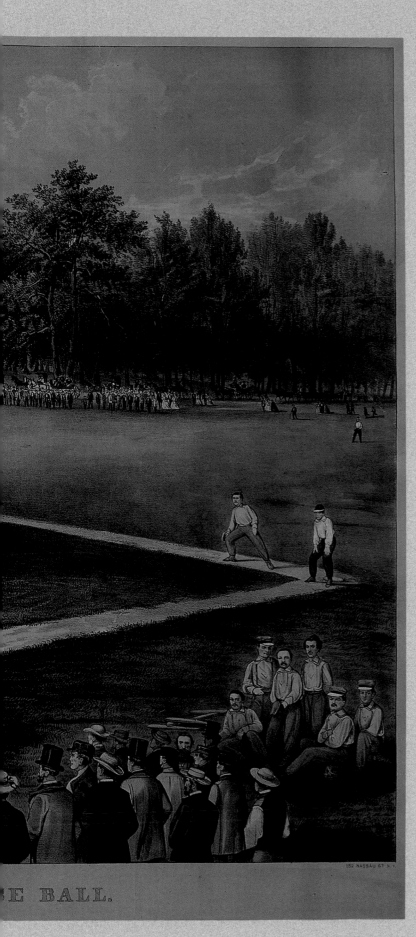

E BALL.

How Early Is Early?

◆ Historians disagree about what is depicted in *The American National Game of Base Ball,* one of the sport's earliest lithographs. New research challenges the traditional view that the print shows a June 1846 game, the first played by baseball's seminal organization, the Knickerbockers of New York City.

On August 3, 1865, the Brooklyn Atlantics beat the New York Mutuals 13-12 in what the *New York Clipper* called "The Grand Match for the Championship," also the subtitle of the lithograph. Some of the Atlantics pictured in the foreground are identifiable by face, pose, and uniform from photographs in the Hall of Fame collection. The diamond's well-worn base paths show a field in use for some time, not the virginal green of a new sport. The game was national news and confirmed the Atlantics as America's best team.

The significance of the lithograph is undeniable. For its many 19th-century purchasers it captured the excitement of the day's greatest game, but more than that, it moved baseball into the realm of popular culture.

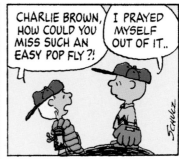

JOHN ODELL

Charlie Brown: American Baseball Icon

A BEAGLE AT SHORTSTOP, a piano-playing catcher, and the worst pitcher in baseball history could only describe one team—Charles Schulz's lovably incompetent *Peanuts* gang. Always losing but never quitting, Charlie Brown's All-Stars were Schulz's model for any neighborhood team: boys and girls playing together, dogs starring, and birds cheering. Within this world, Schulz created a microcosm of America on the baseball diamond, using his comic strip to comment on the way things were and the way they ought to be.

Two decades before they were permitted to play in Little League, girls starred on the *Peanuts* team. Franklin, the strip's sole African American, played outfield for Peppermint Patty and was just one of the guys. Snoopy collected corporate endorsements. Lucy was traded for a pizza. Schulz took the topics that Americans discussed at the dinner table and put them on a sandlot. The result was 50 years of magic.

Approximately 10 percent of Schulz's strips related to the national pastime; no other sport or theme came close. With more than 350 million readers worldwide, Schulz made Charlie Brown baseball's greatest ambassador. Nevertheless, it was not Schulz's love for the game that made baseball a great comic-strip motif. Timing and pacing are at the core of both humor and baseball, and sports have long been used as metaphors for life. Schulz combined these elements and added heaping doses of anxiety and a fear of failure to create his unique brand of humor.

Failure made *Peanuts* the perfect fit for baseball. The game mercilessly documents failure—at the plate and in the field—and "every kid" Charlie Brown failed better than anyone. Whether striking out or serving up the game-losing home run, Charlie Brown lived what every child feared, and he returned to do it again and again.

Schulz said that winning was great, but it was not funny. For every winner, he saw the hundred losers who used humor to console themselves. Those hundreds, multiplied by millions, were his audience, and baseball was the perfect vehicle to apply the salve of laughter. "Baseball is ideal, because little kids do play it at that age, and they aren't very good," he noted. "But they do suffer at it."

How many losses did the *Peanuts* gang suffer? By 1966, the team's record was already 0-999, and it lost untold more games over the next 34 seasons. Despite the seeming hopelessness of their prospects, Charlie Brown cheerfully entered every game determined to win. His spirit would have made his heroes—the legendary Willie Mays and the mythical Joe Shlabotnik—proud. Every spring Charlie Brown climbed the mound with the optimism that characterizes baseball fans, and each fall he descended again with the unending hope of the old Brooklyn Dodgers: "Wait Till Next Year."

Ultimately, Schulz's baseball strips were more than about just the game; they were about life, relationships, and trying one's best. His favorite thing about the baseball strips was that he could "have these long discussions on the pitcher's mound and the topic doesn't necessarily have to be about baseball." Schulz used baseball as his window into America, and his observations and humor made us all winners.

◆ Of the approximately 18,000 *Peanuts* strips drawn by Charles Schulz between 1950 and 1999, about 10 percent featured a baseball theme. Because the strip appeared in 2,600 newspapers worldwide, in 25 languages, to an estimated total audience of 355 million people daily, Schulz ranks as one of baseball's greatest ambassadors.

On the Air

IN THE 1950S AND EARLY '60S, through sheer accident of birth, I was extraordinarily lucky to be able to listen to a remarkable generation of broadcasters gifted at bringing major league baseball to life over the airwaves, with words evoking images of game action from distant places, like Fenway Park, the Polo Grounds, Yankee Stadium, and Crosley Field.

For decades, radio and television have ferried baseball to distant homes and small shops and gentle backyards. The broadcasters who provided the game's signature voices became members of our extended families, turning us to baseball like a heliotrope turns toward the sun.

It is said that, with the possible exception of the Equator, everything begins somewhere. Baseball broadcasts began on August 5, 1921, over radio station KDKA, from Forbes Field in Pittsburgh. In 1939, the first TV game emanated from Brooklyn's Ebbets Field.

"Millions come to the park each year," noted NBC broadcaster Bob Costas recently. "Others can't. To them, TV and radio became the game's eyes and ears."

In 1925, only 10 percent of Americans had a radio; 63 percent had one by 1933. By World War II, all 16 major league teams of the time used the wireless. Each broadcaster became a Rubik's Cube of actor, writer, director, and producer. Many of these legendary voices became synonymous with their teams.

In Brooklyn, Red Barber mixed Faulkner with the fielder's choice. At Yankee Stadium, Mel Allen made listeners swear that a florist must have decorated his voice. In Cincinnati, Waite Hoyt broadcast in the past tense. At Shibe Park, the voice of the Phillies offered malapropisms like "Hello, Byrum Saam, this is everybody speaking." Their stories rounded out the scenes on the field.

"Other sports permit only play-by-play," observed a broadcaster from a later generation, ABC's Al Michaels. "Baseball's pace is slow enough to show your personality and humanity."

Ernie Harwell, the Tigers' voice for 40-plus years, said the way that baseball and radio fit together made them the Bogart and Bacall of sport. "They're wed because baseball is a linear game," said Harwell. "In your mind's eye, you imagine it all."

Radio made the game accessible and crucial to the shut-in, the housewife, and the sandlot kid. For millions, broadcasts were their link with the outside. Then, in 1955, network television began the "Game of the Week." Its niche: sport's first weekly series. Its star: a bodacious mix of Ma Kettle, Billy Sunday, and Tennessee Ernie Ford named Jay Hanna Jerome Dean, better known as "Dizzy."

Dean fractured the English language like no one else has before or after him. Batters "swang." Runners "slud" into bases. A slugger stood "confidentially" at the plate. Once Diz ate a watermelon while working a game. He refused to do a beer commercial because it was Mother's Day. Homespun and direct from the heartland, Dean apotheosized mid-America: To Mayberry, he evoked almost

existential pleasure. "Ol' Diz was really the first to show that baseball could work on TV," observed Lindsey Nelson, a longtime voice of the Mets.

As television's popularity swelled, other voices emerged as widely recognized. The Falstaffian Harry Caray sold beer, sacked pomp, and seemed deliciously truant. Curt Gowdy became a network paradigm. Joe Garagiola grew into a Bob Hope of the rosin bag. The lyrical Vin Scully became the sport's Laurence Olivier. "It was so hot today," Scully once noted, "the moon got sunburned."

Costas, among the current group, offers a sensibility that can be described as David Letterman-esque by way of Tom Lasorda. Fox's Tim McCarver is able to reach eggheads and laborers alike. ESPN's Jon Miller lends elegance to his craft. Each treats boredom like "a side dish he declined to order," in the words of Ring Lardner.

"Baseball means company," mused Miller. "It comforts you and you enjoy it." It is comforting to know, thanks to the seamless web of baseball on the air, you can drive down a street, window open, and not miss a pitch during the season. Listen and you can almost see the blur of caps and socks and emblems on those billowy woolen uniforms; the sunlight, the shadows and the smoke, and the timeless tableau of fielder crouched, batter cocked, and pitcher poised to release.

Shakespeare wrote in *Love's Labour's Lost* of "the heavenly rhetoric of thine eye." For 80 years, baseball's radio and television rhetoric has been heavenly—funny, humane, and human.

◆ The microphone used by Red Barber while cutting his teeth as a broadcaster at the University of Florida, ca 1932. Barber would go on to become the beloved broadcaster of the Cincinnati Reds, New York Yankees, and Brooklyn Dodgers. In 1978, he and Mel Allen were the first recipients of the Ford C. Frick Award, given to broadcasters by the Baseball Hall of Fame for "major contributions to the game of baseball."

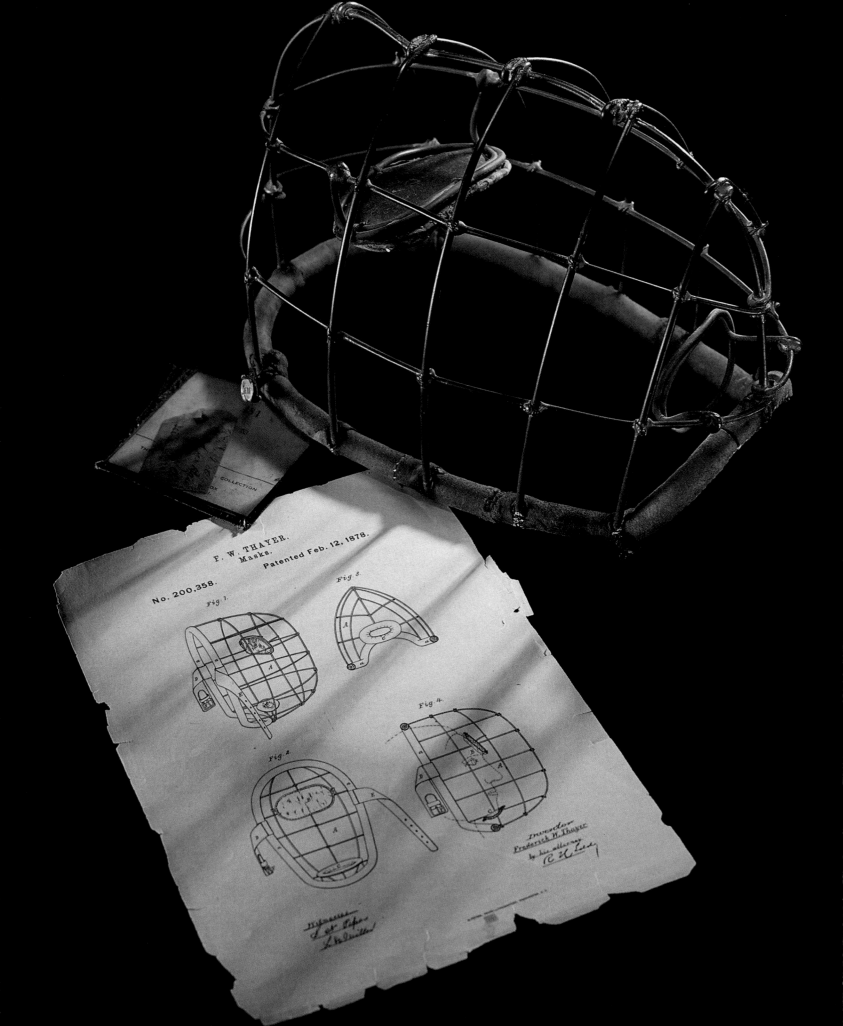

Ingenuity, not necessity, is the true mother of invention. It is a seldom recognized truism that the things that one takes for granted, that seem natural by virtue of their familiarity, had to be conceived and implemented by some individual or group of individuals, at some point in our history. At times, a tool or behavior is the product of evolution; at others they spark from calculated inspiration. Within short order, these

INVENTION AND INGENUITY

varied elements become engrained in the expected rhythms of our lives. ◆ Baseball— the way the game is played, the ballpark experience, and the transmission of these wonders to the broader national audience—is the accumulation of thousands of inventions and innovations, large and small. ◆ The game itself evolved from earlier bat-and-ball contests like rounders, town ball, and cricket played for generations in England and the American colonies as well as in the early days of this nation. In the 1840s and 1850s, members of the Knickerbocker Base Ball Club and other pioneer ball teams adapted the varied elements of these pastimes to create a modern sport, suited to the temper of an urban, industrial society. They limited play to nine men on a side, set the length of the game to nine innings, established three outs as the duration of a half-inning, and laid out a diamond with bases set 90 feet apart and foul lines angling into the outfield. Unlike other ball games, play was largely confined to a "fair territory," which both offered a greater rationality and accommodated spectators who wished to be close to the action. Other elements of the sport—the definition of balls and strikes, the distance between the pitcher and home plate, whether a ball should be caught on a bounce or a fly for a putout—remained to be resolved. But the basic configuration of baseball was largely in place by the late 1850s. ◆ Over the decades, players added a

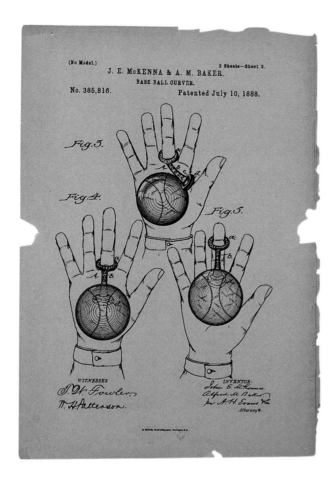

each possible play for easy recording. Thus a "K" came to stand for a strikeout. Chadwick constructed and distributed scoring forms to facilitate this practice. These innovations allowed people to transfer a contest from the field onto paper, creating a historical record of each game.

To summarize the myriad details entered on a scorecard, Chadwick created the box score. Working from earlier box scores used in cricket, Chadwick compressed the more complex information required for baseball into an artful miniature. Over the years, Chadwick's box score, expanded and adapted to include an ever growing compilation of data, has become a fixture in the nation's newspapers, offering both an instant summary for current fans and a record for posterity. The box score, wrote Branch Rickey is, "the mortar of which baseball is held together."

Chadwick also grew determined to develop statistics to distinguish the more productive "modest, but efficient workers" from the "dashing, general players" who caught the eye of the fans but contributed less to a team's sustained success. In the late 1860s and early 1870s, Chadwick and others experimented with averages as a measure of batting prowess, first calculating hits per game, then later dividing hits by at-bats to create the modern batting average. The batting average failed to take into account the efficacy of walks and extra-base hits in creating runs. (Chadwick, himself, always had an almost irrational distaste for home runs.) Nonetheless, the batting average became the dominant standard for offensive performance. Chadwick also developed the concept of earned runs and other statistical categories still used today.

As baseball's popularity spread, inventors throughout the land created equipment and contraptions designed to enhance the game. Many caught on quickly; others faded into oblivion.

In Philadelphia, Ben Shibe, a former streetcar driver, developed machinery to tightly wind the yarn inside baseballs and to punch uniform holes for stitching in two-piece covers. This facilitated the mass production of a standard baseball. In 1884, John A. Hillerich of Louisville, Kentucky,

variety of new tactics to the game, including the stolen base, the slide, the bunt, and the curveball. Although historians argue about who first applied these new tools, it is clear that they all contributed to the development of the game as we know it today.

Some of the most enduring innovations of this era occurred, however, not on the field but in the fertile mind of sportswriter Henry Chadwick. From the late 1850s until his death in 1908, the British-born Chadwick reigned as baseball's foremost innovator and popularizer. Chadwick firmly believed that if baseball were truly to become America's "national game," it needed to adopt uniform standards, rules, scoring, and statistical measures. Chadwick developed a scoring system to document all plays on offense and defense, a form akin to the double-entry bookkeeping commonplace in business at the time. He assigned a letter to

◆ PAGE 244: The original catcher's mask (and patent drawings) first used by James Tyng of the Harvard baseball team in 1877. The team captain, Fred Thayer, designed the mask—modeled on masks used by the fencing team—after Tyng refused his request to play catcher because of the high risk of disfigurement. Although initially criticized as unmanly, the mask allowed a catcher to play closer to the hitter and was standard by the 1880s.

246 BASEBALL AS AMERICA

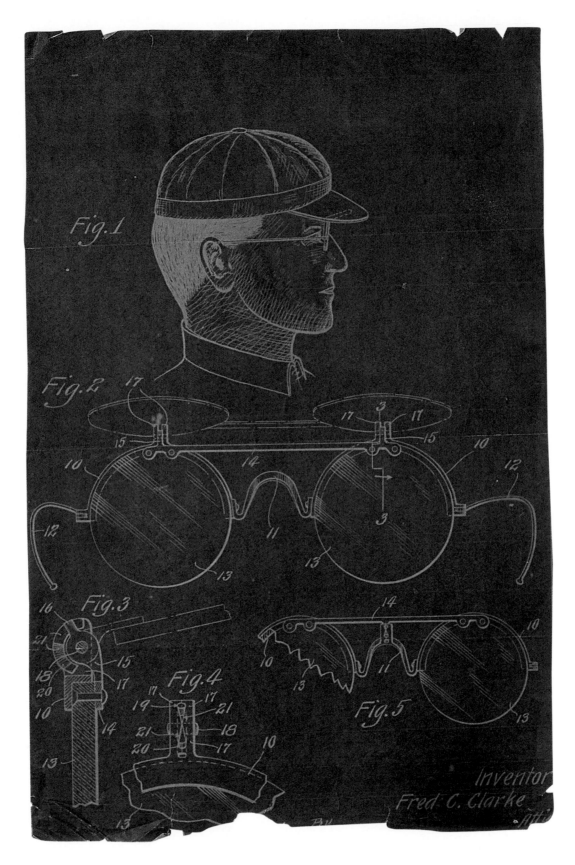

Fig.1

Fig.2

Fig.3

Fig.4

Fig.5

Inventor
Fred. C. Clarke

◆ OPPOSITE: An 1888 patent for a ringlike device that teaches how to throw a curveball.
ABOVE: 21-year-old future Hall of Fame outfielder Fred Clarke patented these flip-down sunglasses in 1915.

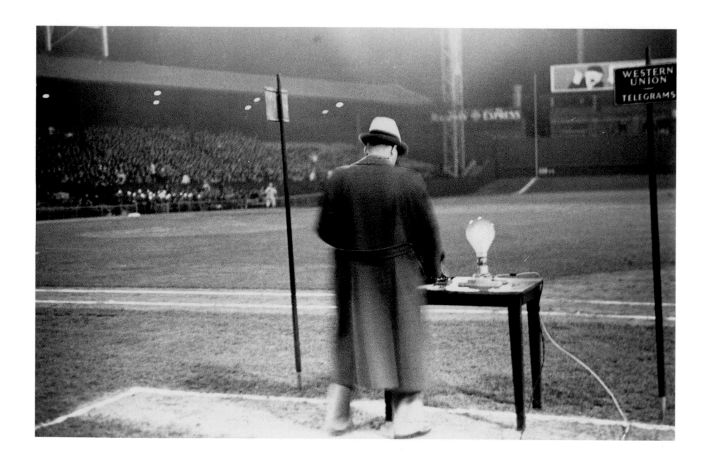

age 17, turned a bat made of white ash in his father's wood-working shop for local star Pete Browning. Using Hillerich's bats, Browning won renown as the "Louisville Slugger." In 1894, Hillerich began producing Louisville Sluggers for major leaguers and sandlot players as well.

In 1878, Fred Thayer, captain of the Harvard University Base Ball Club, patented the first catcher's mask, which bears a marked resemblance to the modern model, though the original was a bit more fragile and less padded. Seven years later, catchers and umpires began wearing chest protectors to protect themselves from foul balls. Shin guards, on the other hand, were allegedly developed by African-American second basemen Bud Fowler and Frank Grant to protect them from the hostile spikes of sliding white players.

Not all inventions proved as useful or enduring as these. Would-be baseball Thomas Edisons devised straps and other devices to make balls curve, bats of varying shapes to improve hitting, and improved bases, including one with a hidden bell that would ring to announce the arrival of the baserunner. Hundreds of baseball-related contrivances flooded the U.S. patent office in the latter half of the 19th century, most of them destined for obscurity.

On the field, players continued to formulate strategies that both adhered to and stretched the rules. In the 1890s, the Boston Beaneaters, led by Tommy McCarthy, began using hand signs to coordinate communications between hitter and baserunner, leading to the development of the "hit-and-run" play. "The batsman gets a signal from the man on first that [he] is going to steal on a certain pitched ball," described John Montgomery Ward in 1893. "The moment he starts for second the batsman just pushes the ball for the place occupied only a moment before by the infielder who

◆ Let there be light! On May 24, 1935, President Franklin Delano Roosevelt flipped a switch at the White House, which illuminated the large table-top lightbulb shown above. Cincinnati Reds general manager Larry MacPhail, pictured, then threw a switch that illuminated Crosley Field for the first major league night game, and a new era was born.

has gone to cover second base." John McGraw's Baltimore Orioles used the play to great effect later in the decade.

Catcher Connie Mack would surreptitiously tip players' bats, interfering with their swings, and insert frozen baseballs into the game to weaken his opponents' hitting.

In the early 20th century, St. Louis Browns manager Branch Rickey devised new training techniques designed to improve player performance. Baseball, Rickey believed, could be reduced to a science through research and experimentation. "He is a Professor of Baseball," observed a sportswriter in 1914. "His efficiency courses in sliding, baserunning, and batting mark a new departure in the game." Rickey became the foremost innovator in the game's history, creating the farm system for developing players for the major leagues and a preseason "Baseball College," for the teaching of fundamentals of the game. He encouraged the use of sliding pits, batting tees, and batting helmets.

In the 1940s at Brooklyn, Rickey employed Allen Roth to undertake a detailed pitch-by-pitch analysis of Dodger hitters and pitchers and how they performed in given situations. Beyond these impressive contributions, Rickey also had the foresight to sign Jackie Robinson and end baseball's Jim Crow era.

Technological developments unrelated to baseball also triggered innovation. The development of the radio required the creation of the sportscaster. When Grantland Rice first broadcast the World Series in 1921, he had no concept of what to do. He simply described the plays with no analysis or commentary. "The broadcast officials wanted me to keep talking. But I didn't know what to say," confessed Rice. At the following year's World Series, Graham McNamee, a former concert singer, invented the role of the radio sports reporter. "You must make each of your

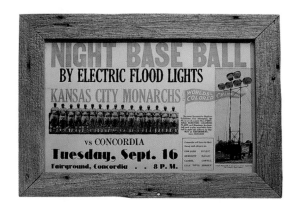

listeners, though miles from the spot, feel that he or she, too, is there with you in that press stand, watching the movements of the game, the color, and the flags," explained McNamee. "He painted word pictures that other minds could feast upon," noted a sportswriter.

Through the 1920s, professional baseball had always been played during daylight hours. In 1929, however, Kansas City Monarchs owner J. L. Wilkinson asked an Omaha, Nebraska, company to design a portable lighting system that would allow the Negro league club to play night games. The Monarchs transported the equipment, which included a 250-horsepower motor, a generator, and collapsing poles that extended to 50 feet in height, on the team bus. The novelty made the Monarchs the most popular traveling team in the land. One year later, the minor league Des Moines Demons installed permanent floodlights in their stadium, ushering in a new age of night games in organized baseball.

The influx of baseball innovations continues unabated. In the early 1960s, Yankee catcher Elston Howard introduced the weighted donut to fit over bats allowing hitters to warm up more efficiently. After a broken bat nearly severed his throat as he waited in the on-deck circle, catcher Steve Yeager helped to design a throat protector for catcher's masks. Instant replay, the ability to re-create video footage on the spot, has transformed the fan experience both on television and in the ballpark. Aluminum bats now dominate play in most venues, though they cannot be used in the majors or minors. JUGS guns to measure the velocity of pitches via radar have greatly influenced pitching strategies and training.

Like the creations of earlier eras, these innovations have become expected and commonplace, an ongoing testimony to the limitless potential of American ingenuity.

—Jules Tygiel

◆ "What talkies are to movies, lights will be to baseball," said J.L. Wilkinson, visionary owner of the Kansas City Monarchs of the Negro National League. This poster is probably from the 1930 season, the first year lights were used in official Negro and minor league action. The Monarchs would bring portable light standards with them, towing them behind the team bus and other vehicles.

The baseball glove, standard equipment today, was still an innovation in the 1880s. After nine years in the game, Cincinnati Reds second baseman John "Bid" McPhee derided the newfangled apparatus. Seven years later, McPhee relented ... and broke the fielding record for a second baseman by a whopping 19 points.

Bid McPhee **1890**

About Second Basemen

NO, I NEVER USE A GLOVE on either hand in a game. I have never seen the necessity of wearing one; and, besides, I cannot hold a thrown ball if there is anything on my hands. The glove business has gone a little too far. It is all wrong to suppose that your hands will get battered out of shape if you don't use them. True, hot-hit balls do sting a little at the opening of the season, but after you get used to it there is no trouble on that score.

◆ One day in 1888, catcher Joe Gunson of the Western League's Kansas City Blues, pressed in service to catch both games of a doubleheader due to an injury to the other catcher, was forced to improvise. Gunson, whose hand was already suffering, fashioned a catcher's mitt by adding felt scraps, sheepskin, and buckskin to a fielder's glove. Thus, wrote Gunson, "the suffering and punishment we endured ... was all over." One of his mitts appears at top. RIGHT: A fielder's glove, ca 1920s. OPPOSITE: A fielder's glove, ca 1880s; worn on both hands, these gloves were more of a protective device than a fielder's aid, as we have come to think of gloves today.

ROBERT K. ADAIR

Pitching and Hitting Curveballs

AS TENNIS PLAYERS HAVE KNOWN for 400 years and base-ball players have known since Candy Cummings and others threw curveballs in the 1860s, spinning balls curve. But why?

When he was only 23 years old, Isaac Newton explained that the spinning balls used in the court tennis contests of his era—which resembled small baseballs—curved because the side of the ball that moved fastest through the air met more resistance than the side that moved more slowly. This simple—and simplistic—description of a complicated process that no one has ever been able to calculate from first principles still suffices

As seen from above, curveballs like the wide-breaking, 70-mile-per-hour versions thrown by the right-handed curve-ballers Tommy Bridges (in the 1930s and '40s) and Bert Blyleven (in the '70s and '80s) rotate approximately 13 times counterclockwise during the 550 milliseconds (thousandths of a second) that they take to travel to home plate. Thus the side of the ball toward third base moves faster through the air (approximately 80 mph) than the side toward first base (approximately 60 mph). As Newton recognized, the air-resistance force on the third-base side of the ball is greater than on the side facing first, so the ball is pushed—or curves—toward first.

The nearly constant force toward first base, typically about one-fifth of the ball's weight, moves the ball in a smooth arc that can be accurately fitted to a circle. The "break" of the curve is generally understood to be the distance between where the ball crosses the plate and where it would have crossed the plate without the curve. Though the ball moves in a smooth arc, simple geometry tells us approximately half of that break takes place during the last 15 feet of the ball's journey to the plate—the "sharp break" that the batter sees. The total break for a typical big league curveball might be 10 inches, more than half the width of the plate, but the ball will only deviate from a straight line drawn from the pitcher's release point to where it crosses the plate by a "sagitta" of about one-fourth of the break, or 2.5 inches—less than the 2 7/8-inch diameter of the ball. It is the confusion between the small "sagitta" and the much greater "break" that has led to old claims based on photographs that a baseball doesn't curve.

The big league curveball is as much of a drop as a curve; in fact, Christy Mathewson called the great curve-ball he threw before World War I his "out drop." So, the ball from the right-handed pitcher that curves out 10 inches from the right-handed batter also drops about 10 inches below where it would fall under gravity alone. Hence, the batter might see a curveball that appears to be headed right at his ear drop and swerve out across the plate for a strike.

If the batter is to hit the curveball, he must see the ball sailing toward him, then send signals from the eye to the brain describing the eye's picture. The brain must process the information in the picture, make a decision on the basis of that information, and send a set of precisely timed signals to the muscles that power the swing. The eye-brain processing takes about 200 milliseconds, and it takes

♦ When asked in 1950 if a curveball really curves, Philadelphia Phillies manager Eddie Sawyer replied that if it doesn't, "it would be well to notify a lot of players who were forced to quit the game they love because of this pitch and may now be reached at numerous gas stations, river docks, and mental institutions." Edward J. Brindle's book (opposite) on the subject was published in 1888.

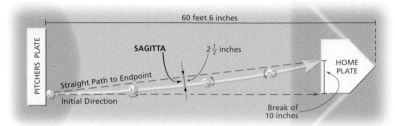

60 feet 6 inches

PITCHERS PLATE

SAGITTA

2½ inches

HOME PLATE

Straight Path to Endpoint

Initial Direction

Break of 10 inches

another 150 milliseconds to swing a bat. Thus, the batter must make most of the decisions as to whether and how to swing the bat from the information he gathers during the first half of the ball's flight toward the plate. At that halfway point, the ball will have curved only about 2.5 inches toward the center of the plate and dropped about 2.5 inches more than the 14 inches it would have dropped from gravity alone. If the batter misjudges the amount of the curve and the drop by an inch at that decision time, that error will translate to four inches off when the pitch arrives at the plate—the difference between a line drive and a swing-and-a-miss.

The rising fastball is a curveball also, though the curve is upward. Because the ball is typically thrown overhand by a tall man pitching from a ten-inch mound downward to the strike zone, which is centered close to the waist of the batter, the ball is always traveling down. But the rising fastball, thrown with a lot of backspin, will cross the plate perhaps three inches higher than the ordinary fastball, which has less backspin. The batter must act on his view of this rising fastball after it has traveled only about one-third of the distance to the plate, when the added rise is only about a quarter inch. Hence, he can't really see the extent of the rise, and if he doesn't guess right, the ball will hop over his swing.

It's no wonder that curving up, down, or sideways, the crooked pitch is tough to hit.

◆ Hall of Fame pitching great Christy Mathewson, photographed by Charles Conlon, ca 1915. From 1903 to 1914, Mathewson won a minimum of 22 games per year, finishing with 373 victories, still good enough to tie him with Grover Cleveland Alexander for third on the all-time list. Mathewson was known for his "fadeaway" or "outdrop" pitch, which dropped dramatically across the outside corner on right-handed hitters.

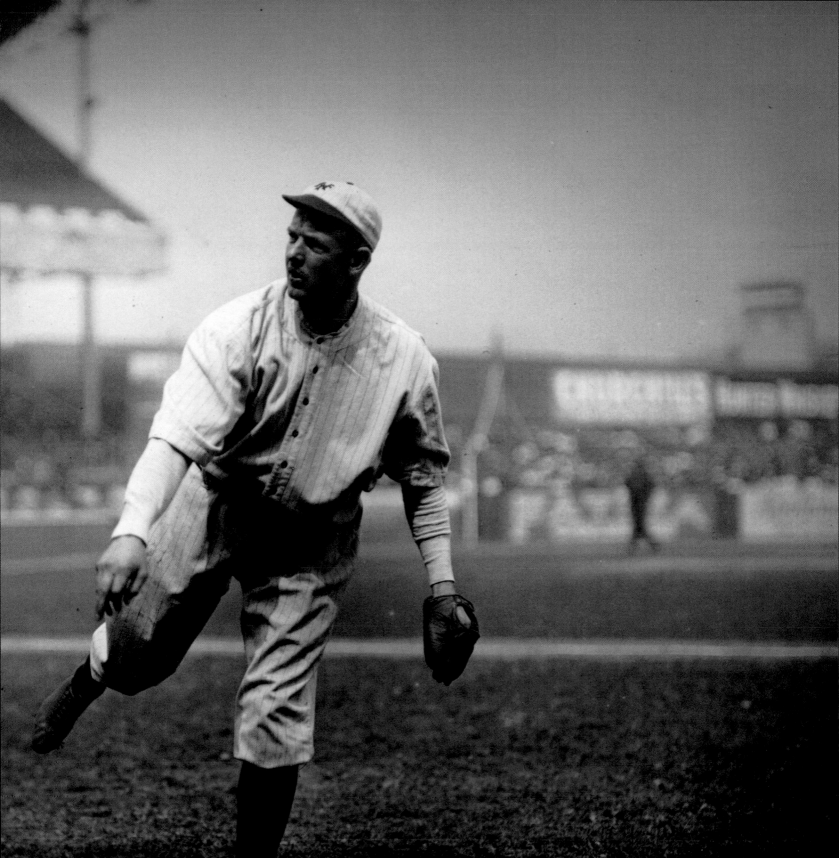

The Home Run

THE HOME RUN, of course, is a defining instant in baseball, and some in the game's long history enjoy huge significance—long remembered and cherished, except, it should be mentioned, by the pitcher who in all likelihood made a very bad mistake at a pivotal moment.

Not long ago I took the opportunity to canvass a number of sportswriters, most of them members of the Baseball Writers Association of America to ask how they would rank historic, dramatic home runs.

Bobby Thomson's so-called "Shot Heard 'Round the World" led the voting by a substantial margin over Bill Mazeroski's series-winning home run in 1960 (101 points to 77). Thomson, a career .270 hitter, hit it in the ninth inning of the third and final game of the National League playoff series between the New York Giants and the Brooklyn Dodgers. Two men were on base at the time, the Giants trailing 4-2. Thomson swung at a pitch and drove it over the left-field wall of the Polo Grounds.

I remember the instant though I was thousands of miles away, indeed playing an evening game of bridge with fellow classmates at Cambridge University. A Giants fan, I had an Armed Service radio broadcast murmuring in a corner, and when Thomson hit the home run and Russ Hodges, the announcer, began shouting, "The Giants win the pennant! The Giants win the pennant!" I fell backward in my chair with a loud cry, and one foot went up and hit up under the bridge table, sending the cards flying. It scared my partner who thought I was being violently critical of his play.

Mazeroski's aforementioned home run in 1960 was, according to a few of my correspondents, far more important then Thomson's because it settled a World Series, not a playoff. Moreover, it was hit in the bottom of the ninth, the score tied 9-9. Coming down the third base line, Mazeroski was greeted by such an exuberant crowd of celebrants that it was doubted he ever touched home plate. Still, the Thomson home run led the voting by a large margin.

I once had the opportunity to talk to Ralph Branca, who was the pitcher for the Dodgers when Thomson came to the plate. At the time, he was an insurance salesman in Binghamton, New York, and I was able to reach him by phone. He didn't seem to mind talking about what happened.

He told me that Thomson had hit a fastball thrown high and inside—what he intended as a waste pitch—hitting it with overspin, topping the ball slightly, and he kept crying inwardly, "Sink! Sink! Sink!" as he watched the ball head for the seats. The newsreels show him picking up the rosin bag behind the mound and throwing it down in disgust. Branca doesn't remember this. He remembers a long walk to the clubhouse steps in deep center field, hardly aware of the huge crowd noise around him as his inner voice blared in horror at what he had done.

"I kept wondering why it happened to me. 'Why me?' I was a gung-ho all-American boy then. I lived the best life I could. I didn't mess around. So I sat there and said to myself that there was no justice in life."

He remembers getting dressed, the last player in the

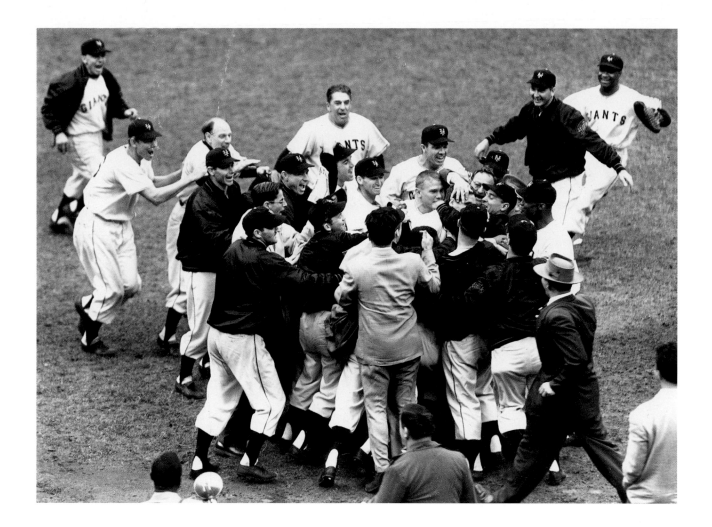

locker room, and walking out to the parking lot where his fiancée was waiting in the car with Father Pat Rawley, who was a dean at Fordham University.

"My fiancée saw me coming and burst into tears. I got into the car and I said, 'Why me?' Why did it have to happen to me?' I really was frantic to know. Father Rawley leaned over the back seat and reminded me what Christ had realized from God: that He had been given the cross because He had a strong enough faith to bear it."

Branca went on to say that obviously the whole experience had a lasting effect. "It was an albatross for a long time," he told me. "But on the other hand I'm recognized. Why if I walked down the street with Bobby Thomson I think more people would recognize me."

I asked him why.

"Well, I think they're more interested in me," he said. "They look at me and wonder if I'm all right. What did it do to me? It's not that they appreciate a loser. But they're curious about how a man's difficulties affect him. It's awfully close to their own lives, and it makes them feel better to see that someone can go through that and walk around and smile and function."

I remember thinking afterward that while games like baseball don't do much to tell us about many aspects of life such as marriage, running a household, personal finances, and so on, certainly Ralph Branca, and the rest of us by inference, had learned a very important lesson out of the trauma of that long-ago afternoon in the Polo Grounds.

◆ Often considered the most dramatic moment in baseball history, Bobby Thomson's home run in the ninth inning of the deciding game of the 1951 National League playoff series gave the come-from-behind New York Giants the pennant over the Brooklyn Dodgers. Known as "The Shot Heard 'Round the World," the home run so epitomizes American culture that the U.S. Postal Service issued a "celebrate the century" stamp commemorating it in 1999.

Ever since Babe Ruth became "Sultan of Swat,"
Americans have worshipped home runs—and the
batters who deliver them. The five bats shown here
represent a hitter's hit parade. Babe Ruth used the
bat in the foreground to hit his record-setting 60th
homer in 1927. "Let's see some son-of-a-gun try to
beat that," Ruth reportedly said upon returning to
the dugout. No one did until Roger Maris notched
his 61st home run on the final day of the 1961 sea-
son using the bat second from the top. Maris's
record stood for 37 seasons until eclipsed by Mark
McGwire and Sammy Sosa in the magical home run
chase of 1998. Using the bat at center, Sosa hit
home runs 64-66, giving him the single season home
run record...for 45 minutes. Then McGwire passed
66 on his way to an unbelievable 70 homers, swing-
ing the bat pictured here. Mickey Mantle borrowed
Loren Babe's bat in the top corner to hit a mon-
strous 565-foot home run at Griffith Stadium in
Washington, D.C., in 1953.

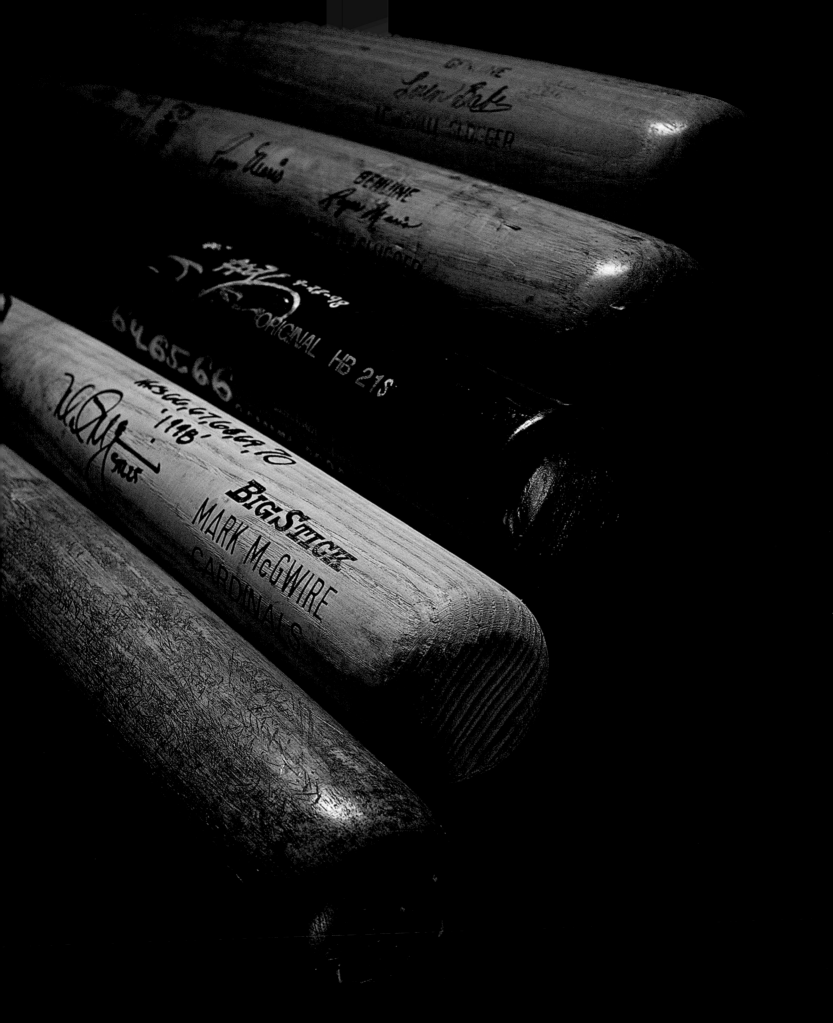

CRAIG M. VOGEL

What Wood You Rather Use?

THE ALUMINUM BAT HAS NOT MADE IT to the major leagues and will probably not for the foreseeable future. The battle over wood and aluminum is not just a decision between two materials, it is instead an argument between progress and tradition. And no other game in the United States stands or rests on its traditions more than baseball.

When the Astrodome and later multiuse stadiums built in the 1970s started to use AstroTurf and other forms of artificial turf as a replacement for grass, it heralded the beginning of a new era of technological change in all sports. It seemed that the adoption of the aluminum bat would be a natural technological improvement to complement a synthetic surface. Both products were more durable and cost effective.

However, as a result of high superball-like turf bounces, turf-related injuries, and turf-aggravated ailments, the recent shift has been back to turn-of-the-century-style stadiums and a return to grass playing fields. The familiar sight of groundskeepers raking the dirt from first base to third base during the seventh-inning stretch is connected to a baseball aesthetic of images, sounds, and experiences that include the wood grain of bats turned on lathes and the sound of wood connecting with a leather ball bouncing on green grass.

The first aluminum bats, designed in the 1930s, could be used only for softball. Aluminum bats were eventually chosen for use in Little League, high school, and college games because they performed more consistently and were more cost effective than easily broken wooden bats. But several decades passed before aluminum bats became serious competition for wood. The long-standing tradition of wood and the prejudice against aluminum made it difficult for athletes and coaches to see the value of an aluminum bat.

During the past few years, competition among aluminum bat manufacturers has resulted in bats that impart a powerful trampoline effect on the ball and are far more forgiving than wood. Aluminum bats have become so effective that they figure to upset the desired balance between hitting and pitching and threaten to cross the fine line between enhancing the natural performance of an athlete and transforming it through technology. Shouldn't technology be capped to allow human capacity to remain the primary determinant of athletic success?

Aluminum bats help batters swing faster, contain a larger sweet spot, and have greater flex in their handles. These qualities increase the likelihood that there will be solid contact made with the ball. The added distance traveled by balls coming off aluminum bats has shifted the approach to hitting and pitching from Little League through college, with the emphasis on power hitting and pitching. Hitters are not developing bat control, and pitchers are no longer developing the precise location that would allow them to claim the inside portion of the plate.

Young hitters are not learning to hit for average or to develop the discipline necessary to hit to all fields; they are

learning to swing for the fences. There are also fewer weak spots in the strike zone that pitchers can exploit. The inside pitch that would break a wooden bat and result in a feeble grounder is turned into a hit when it is met by an aluminum bat. In fact, with aluminum bats offering such an advantage to hitters on the lower levels of the game, a case can be made that fewer of the best young players are gravitating toward becoming pitchers.

And there is another consideration: The inevitable inflation of offensive statistics with the advent of aluminum bats would tend to devalue achievements of past sluggers. Babe Ruth, Lou Gehrig, Joe DiMaggio, and Hank Aaron all established batting records using wooden bats, but their numbers would be dwarfed if today's professionals were allowed to use aluminum bats. If Mark McGwire and Sammy Sosa had been using aluminum bats in 1998, they might have hit more than 100 home runs apiece. While Barry Bonds had special bats turned for him in 2001, he still broke Mac's record using a woden bat.

Ultimately, the reluctance to allow aluminum bats in the major leagues goes beyond issues of how the change would impact the balance between hitters and pitchers and beyond the impact on existing records. The key issue is how they would change the ritual experience of the game and begs a question: Should technological advances always displace traditional ways of doing things?

The production of wooden bats is tied to the human history of woodworking, carrying with it centuries of tradition. Every wooden bat is unique and makes a distinct cracking sound upon impact with the ball. A knowledgeable fan hears this sound and can tell how well the ball was hit, but every aluminum bat makes one sound no matter how solid the contact—a technological ping.

We have decided to preserve buildings and parks and species. It is also important to think about preserving traditions. A player with a turned piece of wood in his hand facing a player throwing a leather sphere makes for a classic confrontation. As Ted Williams said, hitting a pitched ball is the hardest thing to do in sports. Keeping wooden bats maintains the essence of the pitcher-hitter confrontation. It is a tradition worth preserving and celebrating every summer in cities and small towns around the country.

◆ Bursting on the scene in 1970, the aluminum bat was approved for Little League play in 1971 and for NCAA collegiate play in 1974. By 1975, sales of aluminum bats surpassed those of wood. Cost-conscious schools and municipalities would not have to replace aluminum bats nearly as often as the more fragile wood bats. Professional baseball, however, remains a wood-only environment.

NEIL HARRIS

Communicating Baseball

BEFORE THE 1920S, Americans depended on the press far more than they do today, although newspaper strikes reveal the continuing power of newspaper-reading rituals even after the arrival of television and the Internet. Newspapers were read daily by a majority of the adult population and, in this country, read in many languages besides English. Commuting urbanites scanned newspapers on trains and streetcars, going to and from work. Newsstands made them available almost everywhere. Morning and evening papers created a community of readers, and this was never more demonstrable than with sports fans. The rise of the daily newspaper and the flourishing of institutionalized sports—among Americans, that meant a growing appetite for professional baseball—had intimate links.

By the 1880s or early '90s, sports journalists were playing a central role in newspaper circulation. Their work helped create the newspaper "fan" or "crank," the reader who rarely attended a game but was absorbed by box scores, statistics, and the rich prose (and occasional poetry) provided by reporters covering the sport. Such absorption, insisted one newspaper fan in 1908, was "the best cement democracy knows." As an instance, he proffered an Italian immigrant with whom he shared the same train each day. They both read the same paper. "One day, at the sixth inning, he stopped, thick forefinger against the page." The spot marked the description of how a local favorite had struck out for the second time. We "exchanged speaking glances, shook our heads, and read on," the writer continued. "Thereafter we

fought sympathetic battles ..." The social cohesiveness of this newspaper community seemed reassuring.

Colorful side stories, profiles of individual players, and cartoons complemented the game summaries. Some journalists, at least, professed bewilderment about why professional mercenaries, few of them natives or even residents of their sponsoring cities, could evoke such loyalty. The *Chicago Tribune* mused on "the singular capacity of nine men to envelop a large and growing community in gloom by the misadventure of their hopes." However "irrational," it was quite real.

Communications strategies were sharpest at World Series times, because most games occurred on weekday afternoons when most fans were occupied with making a living. Before radio coverage began in the 1920s, Series results spread rapidly by word of mouth in the workplace, gathered from window bulletins in newspaper and telegraph offices, from electric scoreboards placed in parks or displayed to paying audiences in theaters and auditoriums, or from newspapers rushed to outlying areas by special trains. It was not easy to learn about these games in progress. People attempted brief escapes from work, gathering in streets and city squares to watch scoreboards, oblivious to traffic. Newspaper fans, devouring the stories day after day, read not only about the games, but about the efforts other fans made to learn the details.

By the 1920s, radio had begun to make the fan's life easier and more fulfilling. Soon Graham McNamee, Ted

◆ In this 1950s painting by Thornton Utz, all eyes—and ears—are riveted to the World Series on television, over the radio, at the newsstand, and of course in the barbershop and cigar store.

Husing, Lowell Thomas, and Major Andrew White were names as familiar as those of writers Grantland Rice, Heywood Broun, Hugh Fullerton, and Irvin Cobb. Their dramatic narratives—and reenactments in some cases—constituted a separate art form and earned them affectionate monikers of their own.

Yet, even radio's arrival did not destroy the established fan practices of gathering in front of temporary scoreboards, phoning newspaper offices for the latest scores, and devouring the printed stories. Some radios were brought into the office and factory and played sporadically, but in time stolen from work. The principle of invaded time thus perpetuated itself, and the ritual resisted, at least for a time, the new electronic medium.

In 1926, the *New York Times* commented that scoreboard crowds seemed smaller because so many were listening to radios at home. But the following year, 10,000 jammed City Hall Park to follow scoreboards during the Yankees-Pirates Series. Although a national network enabled 100 million people to tune in to the games simultaneously, the *Times* still printed its annual front-page request: "Please do not phone to this office for World Series results." With continuous broadcasting and loudspeakers on every corner, why did the calls continue? The *Times's* self-serving conclusion was that the newspaper remained authoritative and that radio was too evanescent a "message" and "not a record." Fans listened at radio's convenience, not their own, and they did so intermittently. Newspapers, on the other hand, could make the game pleasurable even on the following day. Compared with their young, more immediate rival, newspapers were things to savor and linger over.

Radio had its own magic, however, even if its exclusive broadcasting hold lasted only little more than a generation. That was a long-enough era for broadcasters Red

Barber and Rosey Rowswell and Ty Tyson to become the voices of their respective teams, personalizing the contests beyond "cold newsprint." Colorful phrases like Mel Allen's "Going ... going ... gone!" home run call and Barber's rural metaphors entered the national vernacular.

In 1939, television introduced still a third phase of baseball communications, although it was not until the 1950s that a national audience could watch a game simultaneously. But, along with newspapers, radio continued to play a vital role, and some of the great announcers made the transition easily to another medium. Although the games were televised, Bobby Thomson's pennant-winning home run in the third and final game of the 1951 Giants-Dodgers playoff is still known as the Shot *Heard* 'Round the World. The radio call of Giants announcer Russ Hodges exclaiming, "The Giants win the pennant! The Giants win the pennant! The Giants win the pennant!" preserves the essential moment for fans.

Television's impact, however—with its insistent breaks for ads, encouragement of night games, and titanic team revenue levels—ultimately would be transformative. And its own distinctive broadcasters, many of whom were equally at home on radio, became celebrities and even legends. Today's fans have access to additional and fast-changing media forms.

Web sites and Internet media offer more information than a newspaper, do it more quickly than a televised report, and are linkable to data for endless comparison and juxtaposition. Every fan can become his or her own commentator, announcer, and color specialist in one, interacting with other fans across the Web. This virtual community is just the latest enclave of baseball enthusiasts created by the communications revolution. Only a foolhardy prophet would assert it is the last.

◆ Broadcaster Russ Hodges's call of Bobby Thomson's dramatic, pennant-winning 1951 homer was so famous that it not only was the subject of this 1952 record album but also was referred to in the headline of Hodges's 1971 *New York Times* obituary.

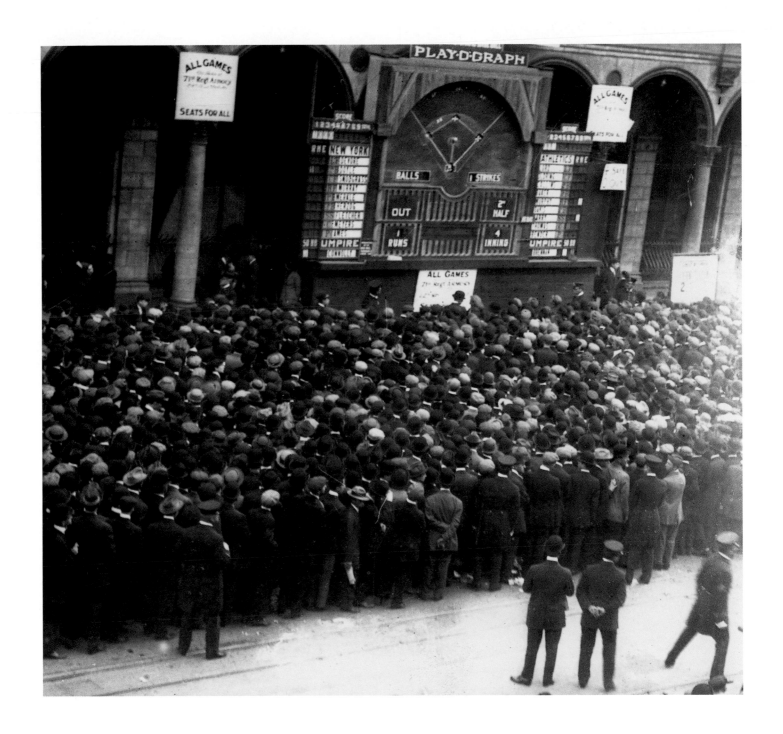

◆ A large crowd watches an electric scoreboard relaying play-by-play of the 1911 World Series between the New York Giants and the Philadelphia Athletics. Telegraph operators would wire the action, pitch-by-pitch, from the ballpark to the scoreboard locations, usually in large public areas. Fans would follow the action visually, cheering or booing as their team's fortunes required. Often admission of 25 to 50 cents was charged to view these boards.

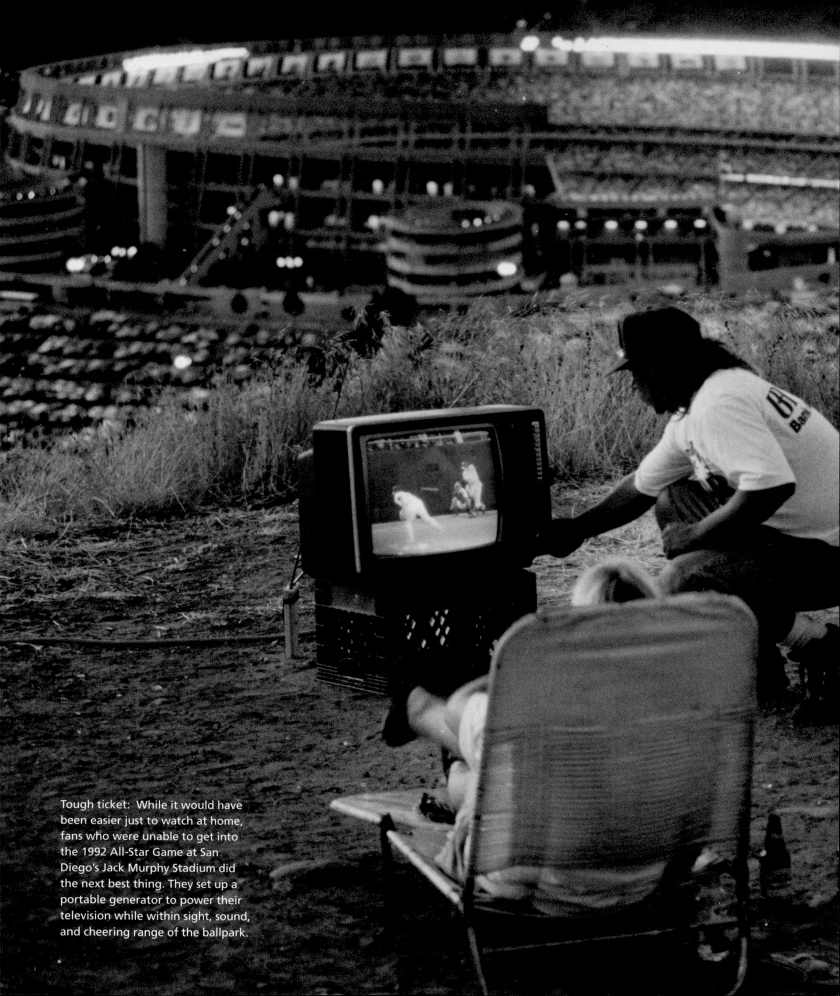

Tough ticket: While it would have been easier just to watch at home, fans who were unable to get into the 1992 All-Star Game at San Diego's Jack Murphy Stadium did the next best thing. They set up a portable generator to power their television while within sight, sound, and cheering range of the ballpark.

CHAPTER
7

Baseball mythology begins with James Creighton, the game's first superstar. ♦ Creighton exploded on the baseball scene in 1859 as an 18-year-old pitcher with the Brooklyn Niagaras. Pitching underhand, he hurled the ball with remarkable speed and spin, generating a rising fastball that proved difficult to hit. He frequently interspersed this pitch with tantalizing off-speed deliveries that further confused a batter's timing.

WEAVING MYTHS

Creighton also possessed extraordinary talent as a batter; one 1862 home-run blast awed even the game's sportswriter ♦ Teams in Brooklyn competed for Creighton's services. The Excelsiors probably paid him to perform in 1860, making him the first truly professional player. But Creighton's star burned briefly. He died in October 1862, at age 21. The circumstances of his death remain shrouded in controversy. Some accounts attribute his demise to a ruptured bladder, suffered while hitting a home run. Others say the injury occurred in a cricket match. ♦ His teammates constructed a shrine for him in Brooklyn's Greenwood Cemetery, a large gravestone engraved with crossed bats, a baseball cap, a base, and a scorebook. Atop the granite obelisk sat a large baseball. His monument, observed the *Brooklyn Eagle,* "would never be mistaken for anything else than the grave of a ballplayer." For many years visiting teams would make pilgrimages to Creighton's grave to honor baseball's first sainted martyr. ♦ Creighton remains, however, a little-remembered ancient god. The deity of Babe Ruth towers over the modern game. Ruth is, as historian Marshall Smelser observes, "our Hercules, our Samson, Beowulf, Siegfried." Ruth traveled the path of many a mythic superhero. Cast out as a child, abandoned to an orphanage, he emerged with powers beyond those of ordinary mortals. He hit home runs harder, farther, and more frequently than anyone

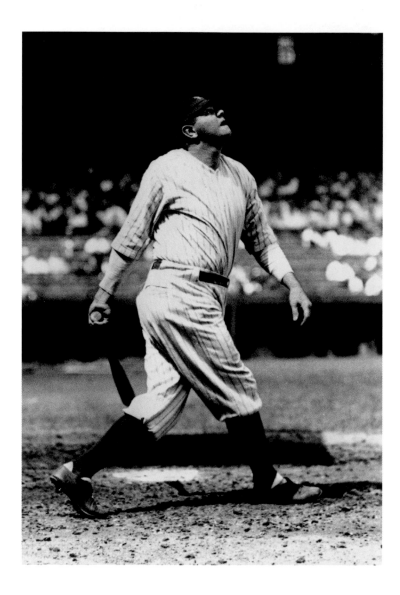

Satchel Paige was Ruth's Negro league counterpart. Black baseball was simultaneously more hidden and more visible than the major league variety. The mass media largely ignored the Negro leagues, but the itinerant reality of teams like Paige's Kansas City Monarchs gave black athletes an exposure throughout small-town America. Paige, a natural showman with a blazing fastball, who could call his fielders in and guarantee to strike out the side, won renown in black and white communities alike. That he emerged as a Cleveland Indian, at an indeterminate age after the race barrier had fallen, and triumphed over his American League rivals, enhanced Paige's legend.

That baseball is enshrouded in myth stems in part from its peculiar configuration in the late 19th and early 20th centuries. Baseball was the national pastime, played throughout the land, but surprisingly few Americans actually attended major league games. The elite players, like Ruth, Christy Mathewson, or Ty Cobb, played on teams confined to a narrow band of the North American continent.

From 1903 to 1953, there were only 16 major league teams. They played in only ten cities—three in New York City, two each in Boston, Chicago, Philadelphia, and St. Louis, and one in Cincinnati, Cleveland, Detroit, Pittsburgh, and Washington. Negro league teams covered a wider circuit but played relatively few games in any one locale. Most Americans, even those who avidly followed baseball in newspapers, never saw their heroes perform. They might travel long distances to witness a game in the big city or catch a glimpse of major league and Negro league stars on the postseason barnstorming circuit. But accounts of these sightings, passed along largely by word of mouth, took on a mythic quality where tales of prodigious 700-foot homers and miraculous fielding abound.

With the advent of newsreels in the 1920s, fans could more accurately envision baseball. People could see Babe Ruth's mighty swing or glimpse the grace of Joe DiMaggio. Radio gave them instant access to the games. Nonetheless, until television arrived in the 1940s and 1950s, offering an unimpeachable document of a game's progress,

conceived possible. He cured the sick, promising and then striking a blow that raised an invalid from his hospital bed. Off the field, he led a Dionysian existence, succumbing to excesses that at times threatened his baseball skills, only to rise again in greater glory.

"With Ruth, they often loved him for his naughtiness," explained sportswriter Fred Lieb. "He would go off the reservation and then try to regain favor by knocking a few more over fences which had never been cleared. And the regaining was never difficult."

◆ PAGE 268: Eight is enough: Baseball ironman Cal Ripken, Jr., says farewell to baseball at his final game, October 6, 2001. In addition to breaking Lou Gehrig's "unbreakable" record of 2,130 consecutive games and setting a new mark of 2,632, Ripken was a 19-time All-Star and helped lead the Baltimore Orioles to the 1983 World Championship.

baseball remained an exercise in imagination, breeding a rich folklore. That few people saw the slashing, often malignant brilliance of Ty Cobb in his prime, added to his allure. Christy Mathewson's fadeaway and Walter Johnson's fastball conjured up fantasies of infallibility. When Babe Ruth allegedly pointed to the bleachers in Chicago in the 1932 World Series and called his shot, there was no instant replay to confirm or deny his feat. Thus, it became the topic of debate, conjecture, and legend.

The ballparks themselves, the final destination of many a prolonged pilgrimage, became the holy relics of a golden age. The bandbox dimensions of Ebbets Field, the irregular eccentricities of the Polo Grounds, the neoclassic motifs of Comiskey Park and Shibe Park speak to us of a time when life seemed simpler and true giants seemed to walk the Earth.

Modern writers reach back into this mythic past to illuminate our present. Bernard Malamud plumbed the depths of baseball folklore to create the world of Roy Hobbs in *The Natural*. Paul Simon famously wondered where Joe DiMaggio had gone and turned the nation's lonely eyes to the Yankee icon of the 1930s and 1940s with his lyrics in "Mrs. Robinson." Characters in W. P. Kinsella's *Shoeless Joe* summon the disgraced Chicago White Sox of 1919.

Players of today, like Mark McGwire, Barry Bonds, or Pedro Martinez are no less talented and oversized than those of earlier eras, their feats no less miraculous. One might wonder, however, with their every triumph and failure meticulously recorded and chronicled, if they can achieve the same legendary status of their forebears.

Mythology, after all, derives from imagination. The less we know of our gods, the more we can mold them to fit our needs. Yet one senses that the process, though changed, has not vanished. The stars of today will join their predecessors in Cooperstown, and people will recount tales, often exaggerated, of their prowess. And a nation just might, in some distant decade, turn its lonely eyes to them.

—*Jules Tygiel*

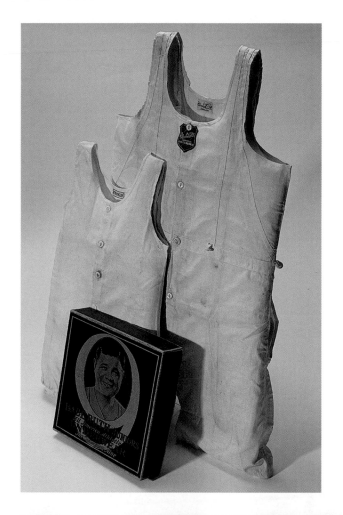

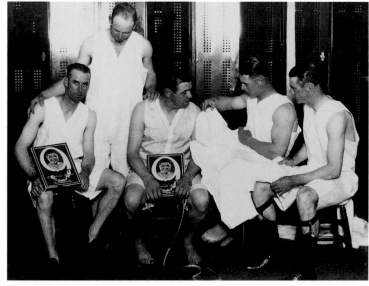

◆ OPPOSITE: Babe Ruth, ca 1927. ABOVE: Babe Ruth, center; Lou Gehrig, second from right; and other Yankees try on "Babe Ruth Underwear," marketed in the 1920s. TOP: Ruth was in heavy demand for product endorsements, and he shilled for everything from cereal to laxative chewing gum.

Author W. P. Kinsella, whose novel *Shoeless Joe* became the film *Field of Dreams*, paints a loving portrait of baseball on a summer night. Kinsella evokes the sense that there is no better symbol of what it means to be American, and no better place to be on a warm August eve.

W. P. Kinsella 1982

Shoeless Joe

They'll walk out to the bleacher and sit in shirtsleeves in the perfect evening, or they'll find they have reserved seats somewhere in the grandstand or along one of the baselines—wherever they sat when they were children and cheered their heroes, in whatever park it was, whatever leaf-shaded town in Maine, or Ohio, or California. They'll watch the game, and it will be as if they have knelt in front of a faith healer, or dipped themselves in magic waters where a saint once rose like a serpent and cast benedictions to the wind like peach petals.

The memories will be so thick that the outfielders will have to brush them away from their faces: squarish cars parked around a frame schoolhouse, blankets covering the engine blocks; Christmas carols drifting like tinseled birds toward the golden wash of the Northern Lights; women shelling peas in linoleum-floored kitchens, cradling the unshelled pods in brindled aprons, tearing open corn husks and waiting for the thrill of the cool sweet scent; apple cheeked children and collie dogs; the coffee-and-oil smell of a general store; people gliding over the snow in an open cutter; the dazzling smell of horsehide blankets teasing the senses.

I don't have to tell you that the one constant through all the years has been baseball. America has been erased like a blackboard, only to be rebuilt and then erased again. But baseball has marked time while America has rolled by like a procession of steamrollers. It is the same game that Moonlight Graham played in 1905. It is a living part of history, like calico dresses, stone crockery, and threshing crews eating at outdoor tables. It continually reminds us of what once was, like an Indian-head penny in a handful of new coins.

Midwest League baseball at John O'Donnell Stadium in Davenport, Iowa. With the Mississippi River rolling on beyond the outfield fence, the Quad City Angels defeat the Waterloo (Iowa) Diamonds, 2-0. The classic brick stadium, built in 1931, suffers frequent flooding due to its riverside location.

GERALD EARLY

American Diamonds

ON APRIL 12, 1965, baseball changed the world of stadium architecture by opening the Harris County Domed Stadium in Houston, to become better known to the world as the Houston Astrodome. It was the world's first enclosed, air-conditioned stadium for baseball. It was built for the Houston Colt .45s, who had been playing outdoors in Colt Stadium, in the mosquito-filled humidity and heat of the typical Houston summer, since their birth as a National League expansion team in 1962. If a domed stadium had not been built, major league baseball may not have survived in Houston, because neither players nor patrons could have been expected to endure the miserably uncomfortable weather.

As a result of a threatened lawsuit by a malt liquor company that called its product "Colt 45"—one wonders why the Colt Gun Company didn't threaten similar action against the malt liquor manufacturers for a similar infringement—the team promptly changed its name to the Astros. In any case, this seemed a fitting change for a franchise that would be playing in this new stadium, dubbed "The Eighth Wonder of the World" by the club's first owner, Judge Roy Hofheinz. A Western-theme name was hardly appropriate for a team in a stadium that seemed futuristic and surreal, and with the adoption of Astros as a club name, baseball entered the space age.

Houston was a command center for spaceflights, which were nationally televised and launched with great regularity as part of the Cold War struggle with the Soviets, America's only rivals in space exploration. We were a

mere four years away from what was, arguably, the greatest technological feat in human history: the manned moon mission—the first time human beings left this planet, landed on another surface, and returned safely. Baseball officially left behind the 19th-century industrial age, when it had become the American pastime and a cornerstone of American pop culture, to enter this new era of technology, leisure, and information. The Astrodome—with its large, numerous sky boxes, its huge, exploding scoreboard and loud music, its padded seats (which, I must admit, I enjoyed when I visited the stadium, despite the garish orange color)—was really the first postmodernist sports facility, which is to say the stadium itself was as much a source of entertainment as the game on the field.

Baseball was admitting for the first time that the game may not be quite enough and that the fan must be made self-conscious about his comfort and awed by a technological spectacle. I suppose it was all right for the Houston Astrodome to be a spectacle; after all, so is Yankee Stadium, with its grand history as the House that Ruth Built and its center-field monuments that seem like a cemetery. Indeed, most baseball stadiums are something like grand green cathedrals, secular sites of pilgrimage and prayer, of homage and honor, for the fans. Almost everyone who first walks into a major league ballpark and sees the green expanse of manicured field, the huge scoreboard, the sea of seats, and the banks of lights is stunned and impressed. But there was no escaping the fact that, for 35 years, the

◆ The immense scoreboard and carefully manicured grass of the Colorado Rockies' Coors Field are emblematic of today's baseball-only ballparks. Multipurpose stadiums like the Houston Astrodome, sometimes with roofs and usually with artificial turf, have fallen by the wayside as teams and cities build new parks that embrace the varied configurations of the game's historical venues.

Houston Astrodome was a lousy place to play baseball.

The Astrodome not only ushered in the domed sports stadium, with the cities of Montreal, New Orleans, Minneapolis, Seattle, St. Louis, Toronto, and Phoenix building such facilities for professional baseball teams, for pro football teams, or for both to share; it also ushered in a new field surface that changed the nature (and some argued, the quality) of playing baseball: the artificial grass playing surface or, as the Houston version was called, AstroTurf.

The Houston Astrodome originally had grass but was forced to abandon it when, as a result of painting the dome to make it easier for fielders to see fly balls, the grass died. In 1966, Monsanto's AstroTurf became a part of baseball. It was a green rubber surface over padding that covered concrete—an unforgiving, unyielding surface that, in open-air stadiums, tended to heat up to the point where players risked seriously burning their feet through their shoes. Batted balls bounced higher and skidded faster on this surface, like souped-up ping-pong balls. Infielders and outfielders had to play defense differently.

In St. Louis the second Busch Stadium, built in 1966, adopted an artificial surface in 1970, and Whitey Herzog, who became manager and general manager of the Cardinals in 1980, assembled a team completely suited to a park with deep outfield alleys covered in AstroTurf. His speedsters hit few home runs, batted the ball into the ground or sliced it into the alleys, ran like jackrabbits, and stole bases with impunity. Herzog's Cards also won three pennants and one World Series between 1982 and 1987, when AstroTurf was the rage.

The hope was that such a surface, because it was as smooth and as even as a pool table except for its seams, would prevent injuries such as the one Mickey Mantle sustained when he ripped up his knee tripping over a drain in the outfield of Yankee Stadium. The artificial surface wound up wrecking more knees than it saved, wrecking more knees than an uneven grass surface would have. The Houston Astrodome did not replace Yankee Stadium as the most storied, most universally well-known ballpark in America

(although director Robert Altman did feature the Astrodome in his oddball, 1970 film *Brewster McCloud*). The Astrodome is no longer used for major league baseball, having been replaced by Enron Field in the year 2000, and Yankee Stadium hasn't gone anywhere.

But the differences in major league ballparks—which have always varied in configuration, not only in being domed or open air and in featuring an artificial surface or grass—has affected and particularized the nature of the game played in them. A football field is always the same, whether it is a high school game or any National Football League game. The configuration of a major league baseball field however, is a combination of mandate and innovation.

The infield of a baseball diamond is set by the rules: The pitcher's mound is 60 feet, 6 inches from the plate; the bases are 90 feet apart; the bases are made of canvas and are 15 inches square. But the outfield can differ dramatically from ballpark to ballpark. The outfield fences must be a minimum of 250 feet from home plate. But especially in old ballparks, the maximum distances could vary. The Polo Grounds, which the New York Giants called home, had a center-field dimension of close to 500 feet. Boston's Fenway Park, on the other hand, was slightly under 400 feet to center by 1934.

In fact, outfield fences have been moved back and forth over the years, and it is common practice. The rules only specify that a team cannot change the distances during the season or between games. But teams regularly change distances between seasons. Suddenly, a pitchers' park is altered to become more friendly to home run hitters when the home team acquires a productive slugger, or a hitters' park is made more pitcher-friendly when the home team acquires an ace pitcher. The right-field fence in Fenway, for instance, was shortened after World War II so Ted Williams, a left-handed pull hitter, could hit more home runs. And the right-field fence in Yankee Stadium has always been short, enabling a left-handed pull hitter like Roger Maris to break Babe Ruth's single-season home run record and helping the left-handed-hitting Ruth to set the record

in the first place. During the 18 years I have lived in St. Louis, the Cardinal management has changed the outfield dimensions probably a half dozen times.

Natural and man-made elements affect play as well: The way the wind blows across the lake has lots to do with whether the score of a game at Chicago's Wrigley Field will be 11-10 or 3-2. The air-conditioning at the Astrodome made it very difficult to hit home runs. The atmospheric conditions at Atlanta's Fulton County Stadium—the predecessor to Turner Field, also known as the "The Launching Pad"— made home runs commonplace, thereby aiding longtime Atlanta Brave Hank Aaron's quest to break Ruth's lifetime home run record. And the windy, cold conditions of Candlestick Park in San Francisco thwarted Willie Mays's chance to do so.

This is the fun of baseball: No two ballparks are exactly the same in their dimensions and conditions, and the differences are important in how the game is played at each. And, of course, these differences do affect statistics and the illusion that the numbers tell the story. Not only are the numbers not strictly comparable between eras in baseball, they are skewed—some inflated, some deflated—when players post them playing their home schedules in significantly different stadiums. That helps explain why a player who has a great offensive year for the Colorado Rockies (playing half his games at Coors Field in Denver, where the air is light and the ball travels far) can take a back seat in the Most Valuable Player voting despite boasting superior statistics to those of another offensive standout who played his home games in a far less hitter-friendly ballpark.

Of course, none of this stops the baseball fan from ignoring the notion that the numbers don't mean the same thing when achieved in different places. Such is the desire that baseball be a sort of universal, unalterable truth, a perfect meritocracy, a complete realization of the American dream of fairness and justice.

◆ The covered roof, luxury boxes, padded seats, and exploding scoreboard all added to the Houston Astrodome's entertainment value, making it an attraction in its own right. The stadium changed the history of pro sports in 1966 by installing AstroTurf, the first artificial sports surface. In 1977, more than 40,000 fans packed into the Astrodome for this game against the Cincinnati Reds.

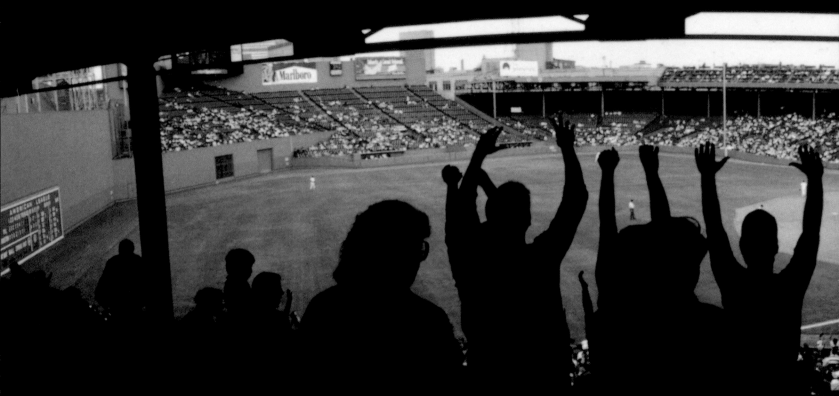

A game of travel, paced by a metaphorical journey away from home, and then back again, the mythopoetics of baseball are remarkably in sync with those of America, and the sites that have emerged as meccas among the legion of baseball aficionados— from Cooperstown to Fenway Park ... embody these qualities."

—CHARLES F. SPRINGWOOD

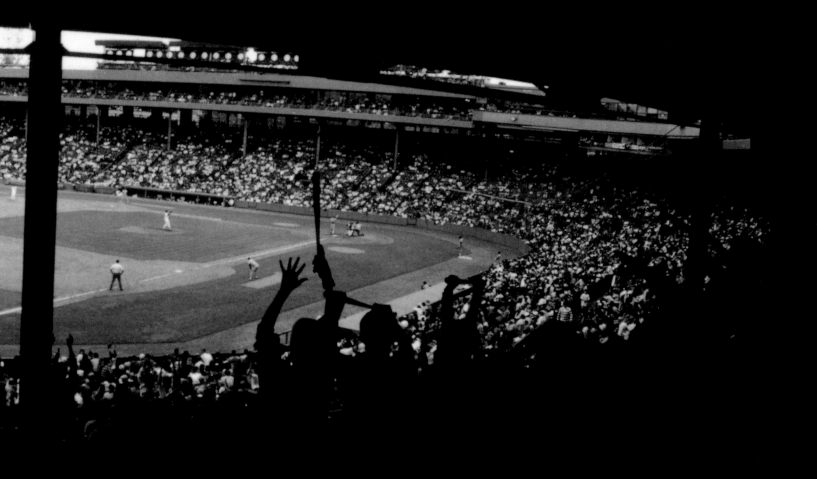

The smallest and oldest ballpark in the major leagues, Fenway Park opened in 1912. This picture is taken from what many consider to be the worst seats in the house, the extreme left-field corner seats. In intimate Fenway Park, though, the worst seats in the house offer closer sight lines than some of the best seats in larger stadiums.

Farewell

THE POLO GROUNDS WENT UNDER last week, and I had no wish to journey up and watch the first fierce blows of ball and hammer. The newspaper and television obituaries were properly melancholy but almost entirely journalistic, being devoted to the celebrated names and happenings attached to the old ball field: John McGraw, Christy Mathewson, Mel Ott, Carl Hubbell's five strikeouts, Bobby Thomson's homer, Willie Mays's catch, Casey Stengel's sad torment.

Curiously, these historic recollections played little part in my own feeling of sadness and loss, for they had to do with events, and events on a sporting field are so brief that they belong almost instantly to the past. Today's fielding gem, last week's shutout, last season's winning streak have their true existence in record books and in memory, and even the youngest and brightest rookie of the new season is hurrying at almost inconceivable speed toward his plaque at Cooperstown and his faded, dated photograph behind a hundred bars.

Mel Ott's cow-tailed swing, Sal Maglie's scowl, Leo Durocher's pacings in the third-base coach's box are portraits that have long been fixed in my own interior permanent collection, and the fall of the Polo Grounds will barely joggle them. What does depress me about the decease of the bony, misshapen old playground is the attendant irrevocable deprivation of habit—the amputation of so many private, repeated, and easily renewable small familiarities.

The things I liked best about the Polo Grounds were sights and emotions so inconsequential that they will surely slide out of my recollection. A flight of pigeons flashing out of the barn-shadow of the upper stands, wheeling past the right-field foul pole, and disappearing above the inert, heat-heavy flags on the roof. The steepness of the ramp descending from the Speedway toward the upper-stand gates, which pushed your toes into your shoe tips as you approached the park, tasting sweet anticipation and getting out your change to buy a program. The unmistakable, final "plock!" of a line drive hitting the green wooden barrier above the stands in deep left field. The gentle, rockerlike swing of the loop of rusty chain you rested your arm upon in a box seat, and the heat of the sun-warmed iron coming through your shirtsleeve under your elbow. At a night game, the moon rising out of the scoreboard like a spongy, day-old orange balloon and then whitening over the waves of noise and the slow, shifting clouds of floodlit cigarette smoke.

All these I mourn, for their loss constitutes the death of still another neighborhood—a small landscape of distinctive and reassuring familiarity. Demolition and alteration are a painful city commonplace, but as our surroundings become more undistinguished and indistinguishable, we sense, at last, that we may not possess the scorecards and record books to help us remember who we are and what we have seen and loved.

◆ Turnstile from the Polo Grounds, home of the New York Giants from 1911 to 1957, the New York Yankees, 1913 to 1922, and the New York Mets, 1962 to 1963. How many fans passed through this turnstile in its day?

Ebbets Field, the Polo Grounds, and other beloved ballparks may vanish from American cities, but they live on in American hearts. Frank Sinatra, in his 1973 album *Ol' Blue Eyes Is Back*, immortalized songwriter Joe Raposo's lament for the lost arenas that still mean so much to so many.

Joe Raposo 1973

There Used to Be a Ballpark

And there used to be a ballpark
where the field was warm and green,
and the people played their crazy game
with a joy I'd never seen.
And the air was such a wonder
from the hot dogs and the beer,
yes, there used to be a ballpark right here.

And there used to be rock candy
and a big Fourth of July
with the fireworks exploding
all across the summer sky.
And the people watched in wonder;
how they'd laugh and how they'd cheer,
and there used to be a ballpark right here.

Now the children try to find it
and they can't believe their eyes,
'cause the old team isn't playing
and the new team hardly tries.
And the sky has got so cloudy
when it used to be so clear,
and the summer went so quickly this year.

Yes, there used to be a ballpark right here.

◆ Demolition of the Polo Grounds began on April 10, 1964, using the same wrecking ball that brought down Ebbets Field in 1960. Willie Mays made his great catch and throw just about at the exact center of this photograph, in center field, during the 1954 World Series.

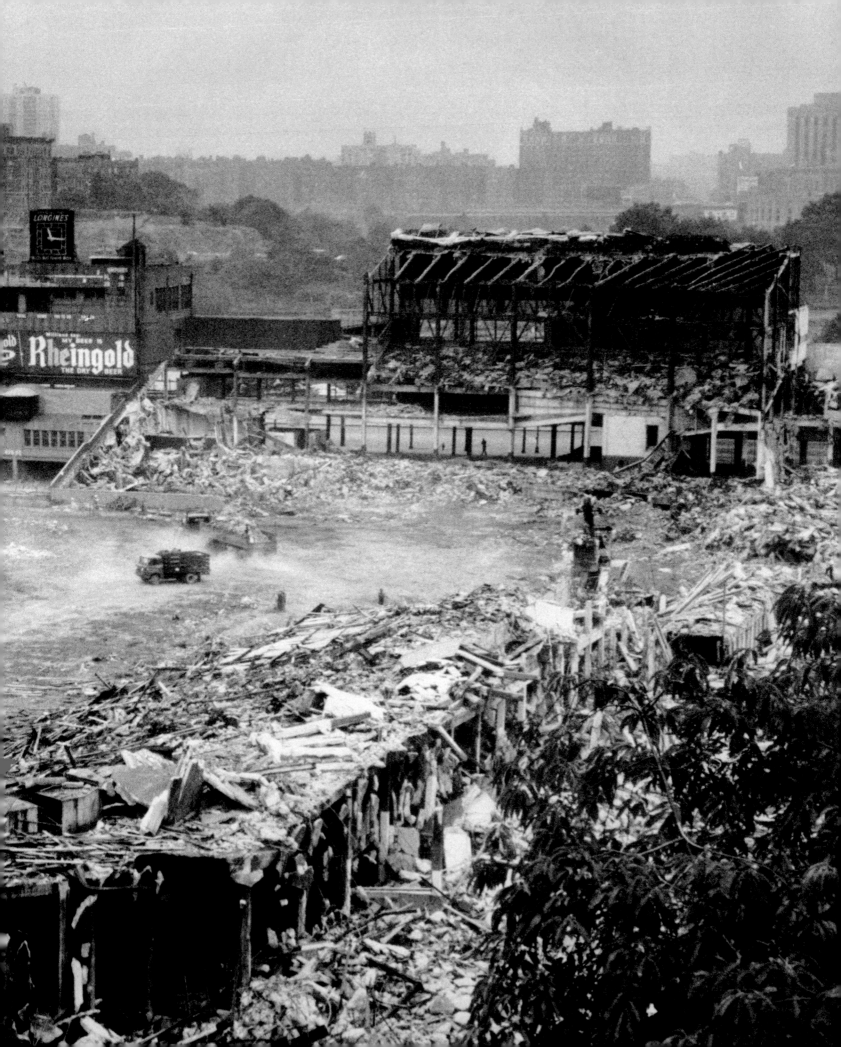

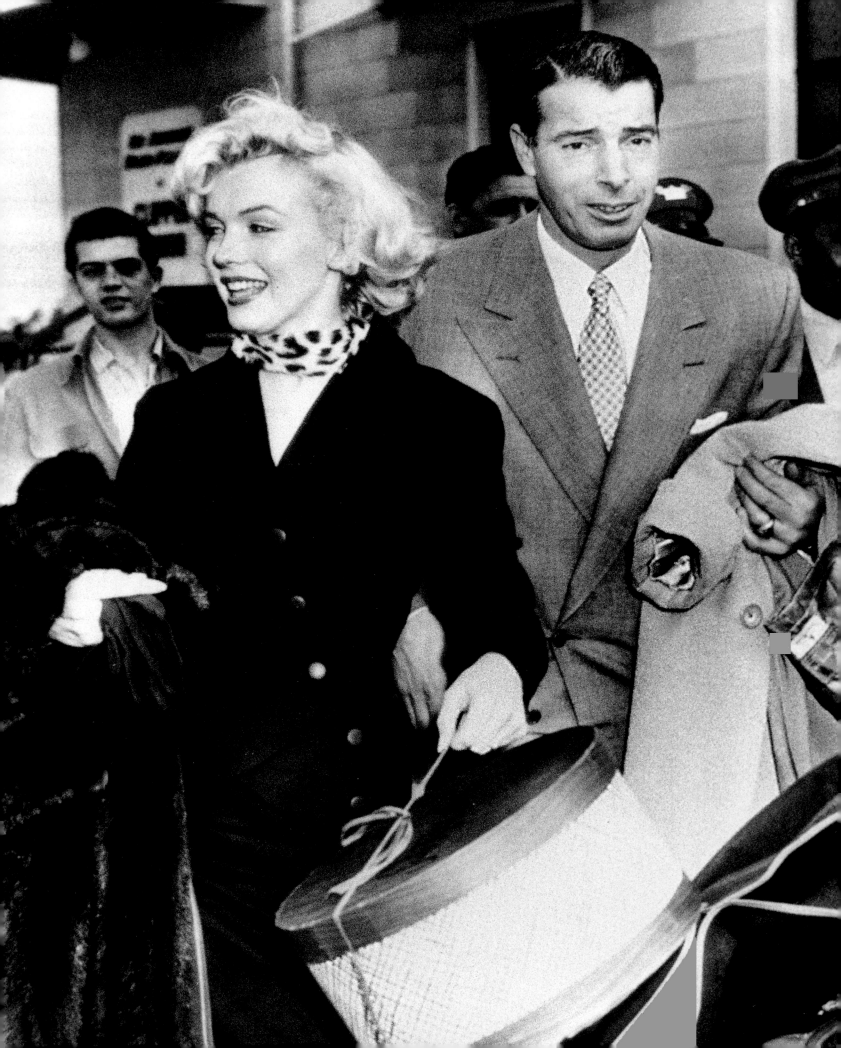

The Silent Superstar

MY OPINIONS REGARDING the baseball legend Joe DiMaggio would be of no particular interest to the general public were it not for the fact that 30 years ago I wrote the song "Mrs. Robinson," whose lyric "Where have you gone, Joe DiMaggio? A nation turns its lonely eyes to you" alluded to and in turn probably enhanced DiMaggio's stature in the American iconographic landscape.

A few years after "Mrs. Robinson" rose to No. 1 on the pop charts, I found myself dining at an Italian restaurant where DiMaggio was seated with a party of friends. I'd heard a rumor that he was upset with the song and had considered a lawsuit, so it was with some trepidation that I walked over and introduced myself as its composer. I needn't have worried: He was perfectly cordial and invited me to sit down, whereupon we immediately fell into conversation about the only subject we had in common.

"What I don't understand," he said, "is why you ask where I've gone. I just did a Mr. Coffee commercial, I'm a spokesman for the Bowery Savings Bank and I haven't gone anywhere." I said that I didn't mean the lines literally, that I thought of him as an American hero and that genuine heroes were in short supply. He accepted the explanation and thanked me. We shook hands and said good night.

Now, in the shadow of his passing, I find myself wondering about that explanation. Yes, he was a cultural icon, a hero if you will, but not of my generation. He belonged to my father's youth: He was a World War II guy whose career began in the days of Babe Ruth and Lou Gehrig and ended with the arrival of the youthful Mickey Mantle (who was, in truth, my favorite ballplayer).

In the '50s and '60s, it was fashionable to refer to baseball as a metaphor for America, and DiMaggio represented the values of that America: excellence and fulfillment of duty (he often played in pain), combined with a grace that implied a purity of spirit, an off-the-field dignity and a jealously guarded private life. It was said that he still grieved for his former wife, Marilyn Monroe, and sent fresh flowers to her grave every week. Yet as a man who married one of America's most famous and famously neurotic women, he never spoke of her in public or in print. He understood the power of silence.

He was the antithesis of the iconoclastic, mind-expanding, authority-defying '60s, which is why I think he suspected a hidden meaning in my lyrics. The fact that the lines were sincere and that they've been embraced over the years as a yearning for heroes and heroism speaks to the subconscious desires of the culture. We need heroes, and we search for candidates to be anointed.

Why do we do this even as we know the attribution of heroic characteristics is almost always a distortion? Deconstructed and scrutinized, the hero turns out to be as petty and ego-driven as you and I. We know, but still we anoint. We deify, though we know the deification often kills, as in the cases of Elvis Presley, Princess Diana and John Lennon. Even when the recipient's life is spared, the

◆ Just two weeks after their marriage, Joe DiMaggio and Marilyn Monroe arrived in Japan for their honeymoon. Marilyn would quickly take off on an impromptu tour of American bases in Korea, visiting 100,000 troops in four days. "Joe, you never heard such cheering," she said upon returning to DiMaggio. "Yes, I have," he replied.

◆ Joe DiMaggio presented his 1951 New York Yankees jersey to the Baseball Hall of Fame. During DiMaggio's 13-year career, the graceful and reserved superstar made 13 All-Star teams, batted .325, and led the Yankees to nine World Series championships.

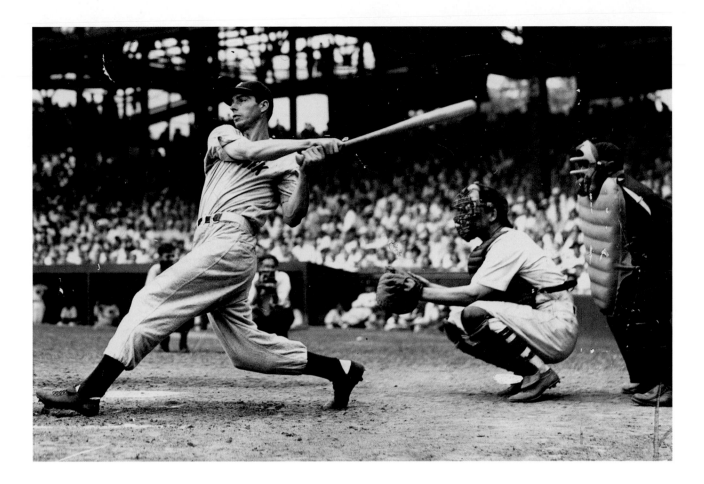

fame and idolatry poison and injure. There is no doubt in my mind that DiMaggio suffered for being DiMaggio.

We inflict this damage without malice because we are enthralled by myths, stories and allegories. The son of Italian immigrants, the father a fisherman, grows up poor in San Francisco and becomes the greatest baseball player of his day, marries an American goddess and never in word or deed befouls his legend and greatness. He is "Yankee Clipper," as proud and masculine as a battleship.

When the hero becomes larger than life, life itself is magnified, and we read with a new clarity our moral compass. The hero allows us to measure ourselves on the goodness scale: O.K., I'm not Mother Teresa, but hey, I'm no Jeffrey Dahmer. Better keep trying in the eyes of God.

What is the larger significance of DiMaggio's death? Is he a real hero? Let me quote the complete verse

from "Mrs. Robinson":

> *Sitting on a sofa on a Sunday afternoon*
> *Going to the candidates' debate*
> *Laugh about it, shout about it*
> *When you've got to choose*
> *Every way you look at it you lose.*
> *Where have you gone, Joe DiMaggio?*
> *A nation turns its lonely eyes to you*
> *What's that you say Mrs. Robinson*
> *Joltin' Joe has left and gone away.*

In these days of presidential transgressions and apologies and prime-time interviews about private sexual matters, we grieve for Joe DiMaggio and mourn the loss of his grace and dignity, his fierce sense of privacy, his fidelity to the memory of his wife and the power of his silence.

◆ Joe DiMaggio's 56-game hitting streak in 1941 is often mentioned as a baseball feat that will never be duplicated. Amazingly, DiMaggio himself topped the streak in the minor leagues, hitting in 61 straight games as an 18-year-old for the San Francisco Seals in 1933. This photograph shows DiMaggio in the 42nd game of the streak.

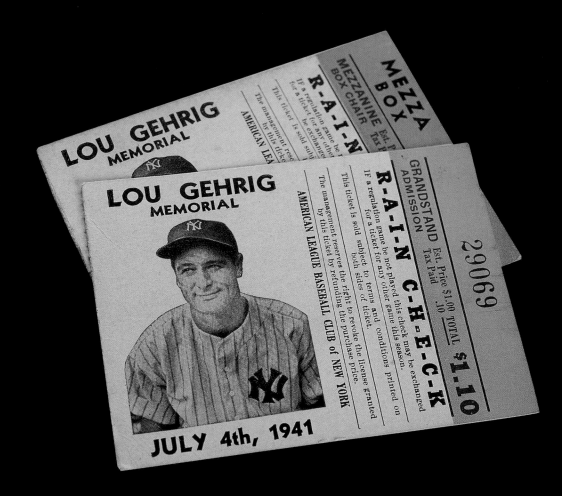

MEZZA
BOX

MEZZANINE
BOX CHAIR

LOU GEHRIG
MEMORIAL

R-A-I-N

AMERICAN LEA

LOU GEHRIG
MEMORIAL

R-A-I-N C-H-E-C-K

GRANDSTAND
ADMISSION Est. Price $1.00 TOTAL $1.10
Tax Paid .10

29069

IF a regulation game be not played this check may be exchanged
for a ticket for any other game this season.
This ticket is sold subject to terms and conditions printed on
both sides of ticket.
The management reserves the right to revoke the license granted
by this ticket by refunding the purchase price.
AMERICAN LEAGUE BASEBALL CLUB of NEW YORK

JULY 4th, 1941

Lou Gehrig

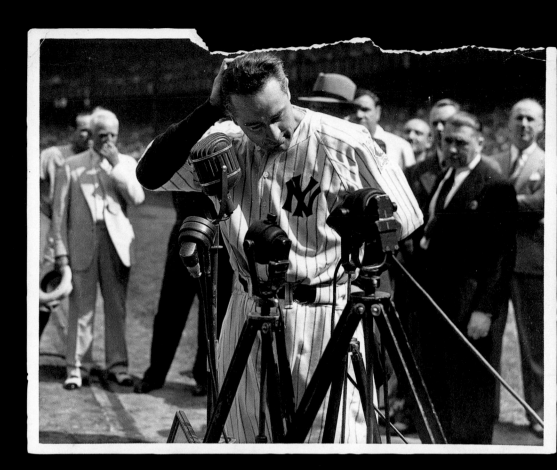

◆ The New York Yankees' Lou Gehrig played in 2,130 consecutive
games, hit .340, cracked 493 home runs, and in 1931 drove in
184 runs batting behind Babe Ruth! One of the greatest players
in history, Gehrig was tragically stricken with amyotrophic lateral
sclerosis and was forced to end his career abruptly in 1939.
Clockwise from above: Gehrig at the microphones on Lou
Gehrig Day, July 4th, 1939 (when he told the crowd, "Today I
consider myself the luckiest man on the face of the Earth"); the
trophy given to Gehrig by his Yankee teammates; a bracelet
Gehrig fashioned for his wife, Eleanor, from World Series and
All-Star pins; and tickets to the Memorial Service for Gehrig at
Yankee Stadium, approximately one month after his death on
June 2, 1941, at age 37.

Baseball's often eccentric rules and traditions may be familiar to most Americans, but can you imagine what a newcomer might make of them? Comedian Bob Newhart can.

Bob Newhart 1960

Nobody Will Ever Play Baseball

I GOT THINKING ABOUT BASEBALL, and how games are marketed today…? You know, you go to a game manufacturer, and they figure everything out, and decide whether the game is right for the public or not, and then they market it. And it got me to thinking: Supposing Abner Doubleday had called one of the game manufacturers with this new invention of his called baseball. Now I think a phone conversation would have taken place something like this:

Hello, Olympic Games. What can I do for you, Mr. Doubleday? You've got a game? How many couples? Eight-eighteen people? That's a lot of people! Well, the ideal game is ah, I mean ah, two-three couples, you know, ah, come over to the house, get a little smashed and, you know….

You can't play it in the house either? See, you got two things right there against you. All right, all right, tell me about it. You got nine guys on each side. Yeah. And you got a pitcher and a catcher, and they throw this ball back and forth. And that's all there is to it? All right. A guy from the other side stands between them…. With a bat!… I see. And he just watches them? Oh, I see. He swings at it…. He may or may not swing at it. Depending on what? If it looked like it were a ball. Ah, what's a ball, Mr. Doubleday? You've got this plate … Uh-huh … And as long as it's above the knees, but below the shoulders … No, go ahead, I'm listening … it's a strike. Three strikes and you're out, and three balls…? No, not three balls. Four balls. Why four balls, Mr. Doubleday? Nobody's ever asked you before.

Or, he may hit it. If he hits it, what happens? He runs as far as he can before somebody catches it…. As long as it stays what? As long as it stays fair. And what's … what's fair, Mr. Doubleday?

You've got these two white lines…?

Is this a rib? Is this one of the guys in the office? Who is this?… Mr. Doubleday, that's the most complicated game I've ever heard in my life. Forget it! Right. Mr. Doubleday, listen though. You come up with anything … two-three couples, you be sure and let us know, huh? All right, Mr. Doubleday. I'll be talking with you. Bye.

◆ The beautiful "Parlor Base Ball" game, one of many games dependent upon a spinner to provide the action, 1878. Of the hundreds of table-top versions of the national pastime, not one has really come close to capturing the beauty and strategy of our national game.

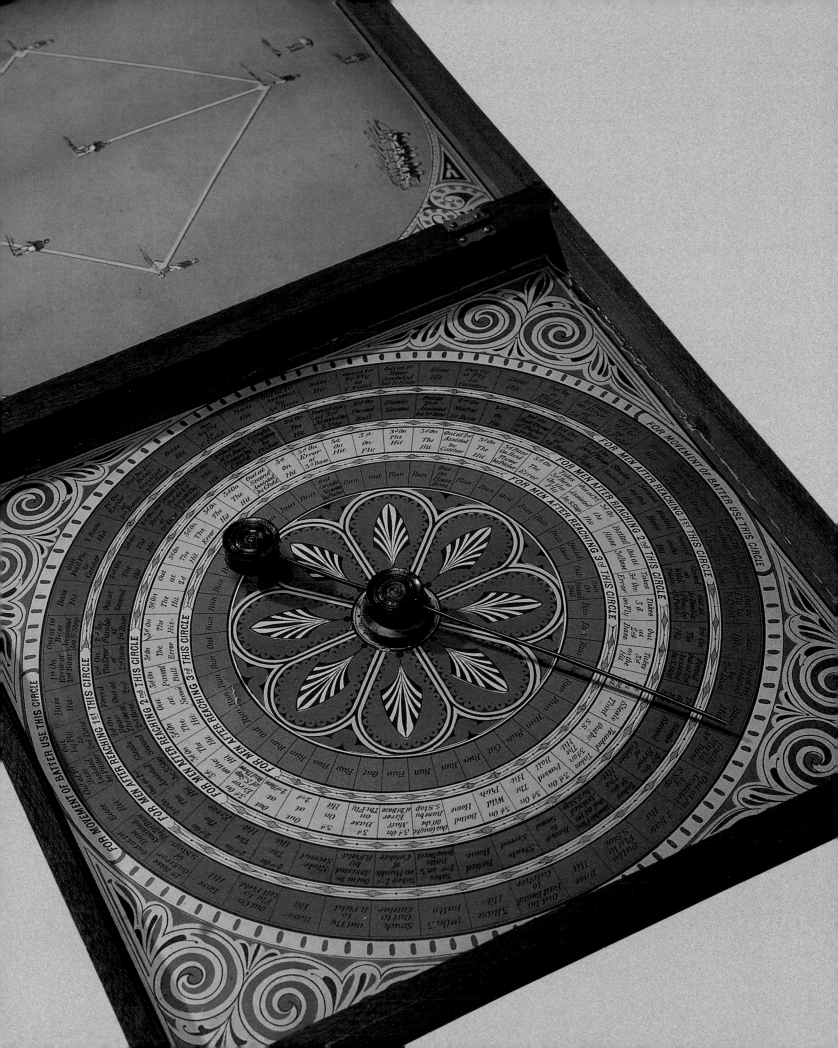

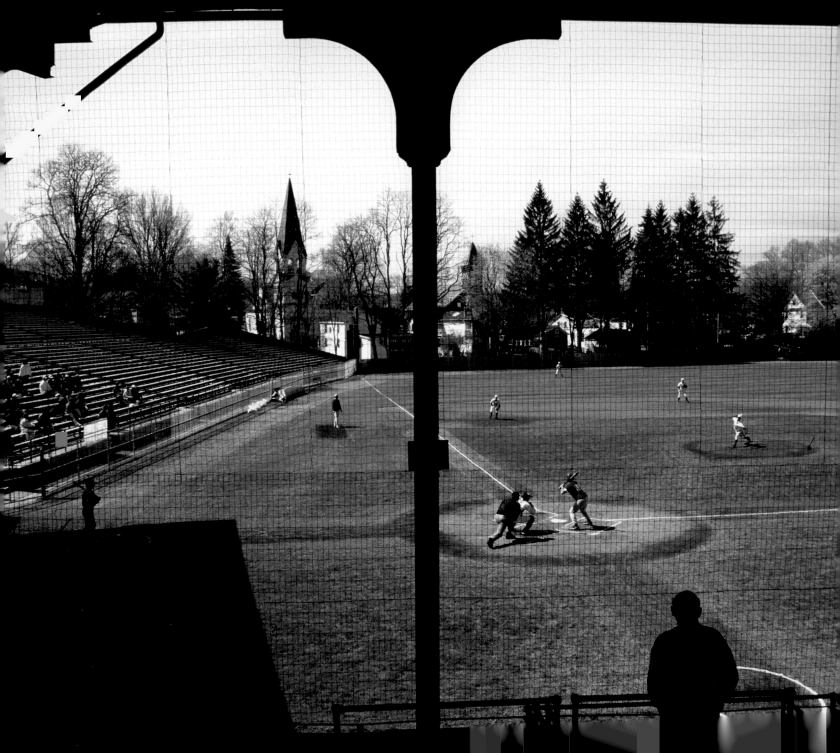

CHARLES F. SPRINGWOOD

The Mythopoetics of Place and Memory

I WAS RAISED BY MEMBERS OF MY FAMILY to love–indeed, to need–baseball and to cherish the Chicago Cubs. While I have suffered in particular from the latter indoctrination, I am most grateful for the former. My remarks here, then, are framed by a genuine affection for the game of baseball, but as a scholar, I have dedicated much effort to better understand how cultural memory and geographical space are commingled to produce magical places (in academic parlance, "site sacralization"), especially in the context of baseball. People, it seems, have always inscribed space with memory, mythos, and emotion in the creation of transcendent places. But why, in particular, is baseball–more than any other game–commonly at the center of mythopoetic place?

Many writers have longingly remarked, in hyperbole poetic and sublime, on the pastoral essence of baseball, a game that they argue is best suited for grassy diamonds in rural hamlets and best played by strapping farm boys. Indeed, the mythos of Cooperstown–the acknowledged "birthplace" of baseball–was literally choreographed in terms of this fascination with the bucolic. Yet, other historians are quick to note that baseball likely owes its origins to decidedly more urban spaces–Hoboken, New Jersey, to be precise–and that it is somehow a game more at home on city streets and in cozy stadiums nestled in populated downtown city blocks.

Importantly, the landscape of American history has always been punctuated by urban and rural episodes, and I might even argue that a rigid distinction between that which is urban and that which is rural is often inappropriate. But in the making of America, in the process of the American people defining who they have been and who they are, pastoral allegory and rural symbolism have always been central to the national imagination. Fittingly, then, as the American pastime, baseball has always been linked in both real and imagined spaces as a manifestation of rural landscapes and bucolic dreams.

For those who truly love baseball, I would argue, the seasonal flow of the game is one factor that pulls at their hearts. Of all the major American sports, only the baseball season unfolds much as life does, emerging from sleepy winters to a springtime of new dreams and optimism. It persists through the summer months, offering a reliable companionship, before it leaves all too soon. As the one-time commissioner of baseball A. Bartlett Giamatti lamented, "It breaks your heart. It was designed to break your heart … just when the days are all twilight, when you need it the most, it stops."

A game of travel, paced by a metaphorical journey away from home, and then back again, the mythopoetics of baseball are remarkably in sync with those of America, and the sites that have emerged as meccas among the legion of baseball aficionados–from Cooperstown to Wrigley Field to Fenway Park to the *Field of Dreams* movie site in Dyersville, Iowa–embody these qualities.

It seems to be important, in some way, that in order to arrive in Cooperstown, one must traverse state roads,

◆ A baseball game at Cooperstown's Doubleday Field, built on the site where, according to legend, Abner Doubleday invented the game in 1839. The field is used by all manner of teams throughout the spring, summer, and fall, including high school, college, American Legion, fantasy camps, over-30, and youth leagues.

journeying into the magical hills of upstate New York no faster than an automobile will go. For America, the automobile and the open highway comprise a narrative in their own right—in which the vehicle is a stylus, assertively etching the national landscape with the ideals of freedom and movement. When Red Sox great Bobby Doerr traveled to Cooperstown in 1986 for his induction into the Hall of Fame, perhaps he was influenced by this narrative. Refusing the invitation to fly into New York and be delivered via a limousine, Doerr instead loaded his family (including his 93-year-old mother) into a van and drove to the ceremony all the way from his Oregon farm.

Likewise, it is important, I think, that a single road, U.S. Route 20, connects Cooperstown with what is perhaps the Baseball Hall of Fame's "spatial-temporal soul mate," the corn-laced diamond where the movie filled with baseball ghosts and bucolic magic was filmed. After the actors and cameras left, this Dyersville ball field remained, poised to fulfill Terence Mann's claim at the end of the movie that, indeed, "people will come." Well, they have come, for over a decade now, to merge with this simple landscape, to commingle their memories with others they have only just met, and often, to throw a baseball on the outfield grass.

Baseball is animated by a unique relationship to space and time, and I think this explains its romantic attachment to place. For example, we all know well that the game eludes the constraints of time, unfolding at its own pace, theoretically without end, given the possibility of extra innings. Space, too, is uniquely configured, with each park and stadium enlivened by its own, often idiosyncratic set of features and dimensions.

Diversity is the common theme, from Fenway's 37-foot Green Monster to the gatelike fence down the line at Chavez Ravine, barely a few feet high; from the cavernous center field of the now vanished Polo Grounds to the ivy-covered "wells" down the lines at Wrigley. What other sport has inspired coffee-table books that memorialize stadiums?

Only baseball could have produced perhaps my all-time favorite moment: On April 14, 1976, Dave Kingman, swinging for the Mets, launched a gargantuan drive that cleared the left-field bleachers, sailed past Waveland Avenue, and landed in the yard of the third home on perpendicular Kenmore Street, bouncing up against the house itself. Yes, the wind was blowing out that day. In part, it is moments such as this one that map meaning and memory onto the physical landscapes of baseball, from its shrines to its tourist sites to its ballparks.

Baseball needs a home. Over the decades, Cooperstown has been transformed into its quintessential home, painstakingly transformed by those for whom this beautifully complicated game has offered endless joy and chronic disappointment. At the moment in 1939 when the Hall of Fame opened its doors, celebrating four years' worth of inductees, including Babe Ruth, Ty Cobb, Honus Wagner, Walter Johnson, and Christy Mathewson, the national pastime's creation myth was transformed from mere narrative into material reality.

To mark the opening of baseball's new shrine as well as its ostensibly mythical centennial anniversary, the Cooperstown post office sold official commemorative stamps that featured a scene in which several boys are gathered to play baseball on a dusty plot of land. A landscape consisting of trees, barns, a church, and a schoolhouse surrounds them, and an American flag flies in the distance. Bucolic allegory and rural innocence define the context of baseball's origins.

But, Cooperstown, New York, as baseball's birthplace? Why? How?

With the national popularity of the game largely consolidated by the late 1800s, a need to clarify its history emerged. Although some argued that the game clearly was connected to earlier, British variants, such as rounders, others—including one-time baseball great and powerful National League executive Albert Spalding—were motivated by a desire to identify an inscrutably American setting for baseball's conception. Spalding established the Mills Commission in 1905 to prove the indigenous origin of his beloved sport. That year, Spalding received a letter from former Cooperstown resident Abner Graves, claiming that he knew how, when, and by

whom baseball was invented. Graves reported that his boyhood friend, Abner Doubleday—later a U.S. Army general and Civil War Union hero—interrupted a marbles game in front of the tailor's shop one spring afternoon to scrawl the diagram of his new game in the dirt. Graves even identified various locations around the town, including a cow pasture, where games were commonly played.

A narrative of baseball's conception, with the village of Cooperstown at its center, was refined over the years. The village was ideal in a number of respects, including its pastoral setting, its colonial aura, and its renown as the home of American literary figure James Fenimore Cooper. Perhaps most important to its future as the site of baseball's Hall of Fame was that it was already a place where people enjoyed spending summer vacations, and it was home to a number of wealthy citizens who took an interest in memorializing the pastime with a local shrine.

One of these benefactors, local Stephen Clark, was able to locate what would ultimately be accepted as baseball's original ball. A collector of ephemera and antiques, in the 1930s Clark purchased a crude, cloth-stuffed ball that was uncovered in an abandoned trunk found in an attic in

nearby Fly Creek. The trunk was "determined" to have been that of Abner Graves, and the local newspaper proudly concluded that, indeed, the "Doubleday Baseball" had been located. This baseball, the prevailing icon of Cooperstown's prominence in the mythology of baseball's beginnings, is among the very first items encountered by a visitor to the Hall of Fame.

Visitors to Cooperstown must surely engage, at an emotional level, the significant amalgam of space and time, and of people and memory, that defines baseball. Baseball fans have continually consecrated and re-consecrated a variety of baseball landscapes and images—from Fenway's yellow left-field foul pole, imbued against a canvas of dark green, to the ornate façade that adorns Yankee Stadium's upper boundary to the Hollywood-generated field of Ray Kinsella's dreams. Importantly, in Cooperstown at the Baseball Hall of Fame, this nuanced sacralization of space and time assumes the significance of both rite and pilgrimage. Only in Cooperstown can someone experience elements of the Abner Doubleday creation myth and, at the same time, come to appreciate the historical importance to baseball of Hoboken, New Jersey, and Alexander Cartwright.

◆ The living members of the Baseball Hall of Fame assemble at the first induction ceremony and grand opening of the Hall of Fame, June 12, 1939. Standing, left to right: Honus Wagner, Grover Cleveland Alexander, Tris Speaker, Napoleon Lajoie, George Sisler, and Walter Johnson. Seated, left to right: Eddie Collins, Babe Ruth, Connie Mack, and Cy Young. Ty Cobb missed the photo by just a few moments because his train arrived late.

W. P. Kinsella 1982

Shoeless Joe

IT IS A GHOSTLY FEELING, standing chest-deep in
history here at the Baseball Hall of Fame. We tour
the museum until our ankles swell. Salinger has never
been here before. I have. I guide him back over the
years as if he were a time traveler. We are both
red-eyed and unkempt. My eyebrow is swollen and
unsightly, the skin around it saw-blade blue.

 Among the larger relics present is a turnstile
from the Polo Grounds in New York—one of the same
ones that counted the 2,000 fans who watched Moon-
light Graham's brief appearance that June day in 1905.
It is with reverence that I touch its pocked silver sur-
face, as if I were in a basilica reaching out tentatively
to finger the face of a holy statue.

Local fans and tourists jam Main Street in Cooperstown
at the grand opening of the Baseball Hall of Fame, June
12, 1939. Major League Baseball shut down for two
days that summer so that players and officials could
travel to Cooperstown to celebrate the occasion.

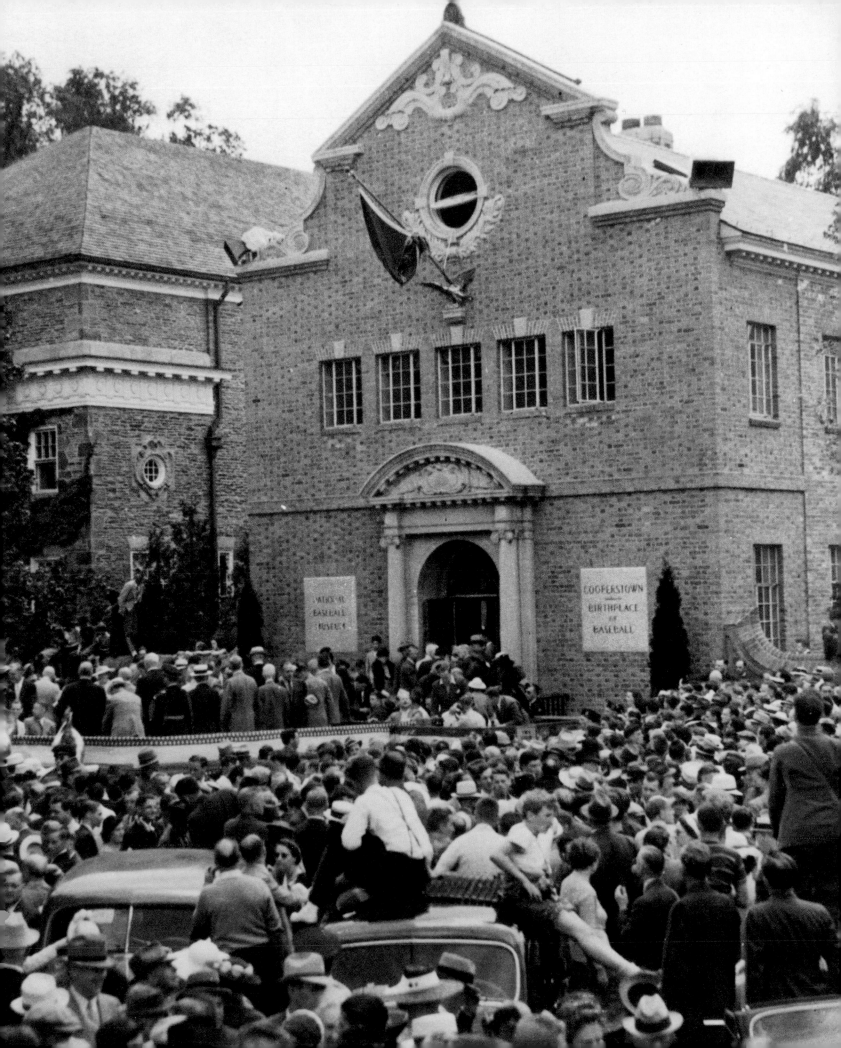

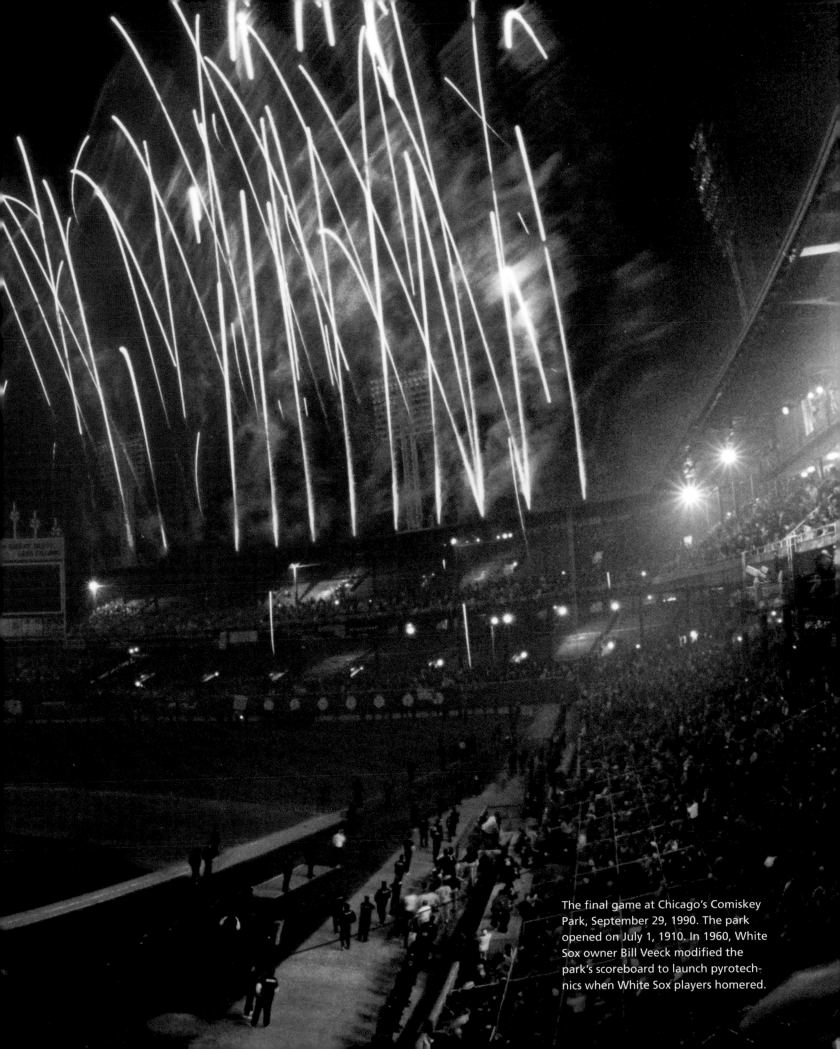

The final game at Chicago's Comiskey Park, September 29, 1990. The park opened on July 1, 1910. In 1960, White Sox owner Bill Veeck modified the park's scoreboard to launch pyrotechnics when White Sox players homered.

CONTRIBUTORS

Robert K. Adair is the Sterling Professor Emeritus of Physics at Yale University. In addition to numerous positions, publications, and honors, he held the position of Physicist to the National League and is the author of *The Physics of Baseball*, New York, 1990.

Roger Angell is an editor and writer with *The New Yorker*. His baseball books include *The Summer Game, Five Seasons, Late Innings,* and *A Pitcher's Story: Innings with David Cone*.

Eliot Asinof was born and raised in New York City and graduated from Swarthmore with a major in history. He played minor league baseball in the Philadelphia Phillies farm system. The author of *Eight Men Out*, he currently lives in Amcramdale, N.Y., in a house he built with his son.

Dave Barry is a humor columnist for the *Miami Herald*. In 1988 he won the Pulitzer Prize for Commentary. Many people are still trying to figure out how this happened. He has written a total of 23 books. Dave lives in Miami, Florida, with his wife, Michelle, a sportswriter.

Jacques Barzun, University Professor Emeritus at Columbia University, is a noted historian and cultural critic. His wide-ranging researches have resulted in many publications and brought him many honors. His most recent book is *From Dawn to Decadence: 500 Years of Western Cultural Life*.

Gary S. Becker is Professor of Economics and Sociology at the University of Chicago. Among his extensive achievements and honors, he has received the Nobel Prize in Economics.

Tom Brokaw is the anchor and managing editor of the top-rated and award-winning *NBC Nightly News*. He is also an author, writing three best-selling books about World War II: *The Greatest Generation, The Greatest Generation Speaks,* and *An Album of Memories*.

Charles Camp teaches Art History at the Maryland Institute, College of Art, and has also taught on baseball and American life at Johns Hopkins University. Widely published on American culture, particularly American foodways, he is currently completing a book entitled, *The Modern Orioles: Baseball Life in Baltimore 1954-1994*.

Michael Chabon recently won the Pulitzer Prize for *The Amazing Adventures of Kavalier and Clay*. His two earlier critically acclaimed novels are *The Mysteries of Pittsburgh* and *Wonder Boys,* which was made into a film starring Michael Douglas. One of his favorite nonfiction writers is Roger Angell.

Shelly Mehlman Dinhofer is an unregenerate Brooklyn Dodger fan who has devoted her career to the visual arts. As Director and Curator of the Museum of the Borough of Brooklyn, she organized "The Grand Game of Baseball and the Brooklyn Dodgers." She is the author of *The Art of Baseball* as well as numerous articles on art, travel, and food.

Gerald Early is the Merle Kling Professor of Modern Letters in the English Department at Washington University. He has written and edited several books, including *The Culture of Bruising: Essays on Prizefighting, Literature, and Modern American Culture,* which won the 1994 National Book Critics Circle Award for criticism. He also served as a consultant for two documentaries by Ken Burns: *Baseball* and *Jazz*.

Curt Flood, All-Star outfielder for the St. Louis Cardinals (captain 1965-69), won seven gold gloves and two World Series and three National League rings, set the record for consecutive errorless games and innings in 1966, and batted .300 or better in six seasons (a high of .335). He unsuccessfully challenged the reserve clause before the Supreme Court. The case changed the game's relationship between labor and management and culminated in today's free agency.

Lowell Ganz and **Babaloo Mandel** have written 16 feature films, including *Splash, Parenthood, City Slickers,* and *A League of Their Own*.

Larry R. Gerlach is Professor of Sport History at is the University of Utah and the author of *The Men in Blue: Conversations with Umpires* (1980; rev. ed. 1994).

Annie Glidden attended Vassar College in 1866, where she played on either the Laurel or the Abenakis baseball club. As an 1876 photograph of the Resolutes team attests, young women played the game on the Vassar campus for more than a decade, with as many as seven teams participating. Interest eventually ebbed, however, and by 1880 all of the clubs had folded.

Warren Goldstein, Chair of the Department of History at the University of Hartford, is the author of *Playing for Keeps: A History of Early Baseball* and, with Elliott Gorn, of *A Brief History of American Sports*. His essays and reviews on a wide range of topics have appeared in numerous magazines and newspapers.

Barbara Gregorich's works include the award-winning nonfiction book, *Women at Play: The Story of Women in Baseball,* published by Harcourt; *She's on First,* a well-received mainstream novel about a woman major leaguer; and *Reading Baseball,* an activity book for grades 5-8, which she co-authored with Christopher Jennison.

John Grisham is one of America's best-selling authors, and his books include *The Firm, The Pelican Brief, The Rainmaker,* and *The Chamber*. A lawyer and master of the legal thriller, Grisham once dreamed of being a professional baseball player. He is the local Little League commissioner, and the six ball fields he built on his property play host to 26 Little League teams.

Neil Harris is the Preston and Sterling Morton Professor of History at the University of Chicago. His interests center on the evolution of American culture, and his books include *Humbug: The Art of P. T. Barnum* and *Cultural Excursions: Marketing Appetites and Cultural Taste in Modern America*. He still loves the Brooklyn Dodgers.

Shirley Jackson is best known for *The Lottery*, first published in *The New Yorker* in 1948 and anthologized many times. *Raising Demons* (1957) melds individual stories into a continuous narrative of family life. Her novels include *The Haunting of Hill House* (1959) and *We Have Always Lived in the Castle* (1962).

Milton Jamail is the author of *Full Count: Inside Cuban Baseball*, published in 2000 by Southern Illinois University Press. He is a regular contributor to *Baseball America* and covers baseball throughout the Caribbean. He lives in Austin, Texas, where he is a lecturer at the University of Texas.

Bill James is the author of many baseball books, including *The New Bill James Historical Baseball Abstract* (2001), from Simon and Schuster. He lives with wife and family in Lawrence, Kansas.

Harry "Steamboat" Johnson umpired from 1911 to 1947, primarily in the minor leagues. *Standing the Gaff*, his colorful 1935 memoir, was recently reissued.

Roger Kahn's most recent baseball book is *The Head Game: Baseball Seen from the Pitcher's Mound*. He is a five-time winner of the Dutton Award for best sports magazine article and the author of the American classic *The Boys of Summer*. In the *New York Review of Books* Stephen Jay Gould called him "the best baseball writer in the business."

William W. Kelly is Professor of Anthropology and Sumitomo Professor of Japanese Studies at Yale University. He is presently completing a book-length case study of a Japanese professional baseball team, the Hanshin Tigers, based on several years of fieldwork and interviews in Osaka.

W. P. Kinsella is the author of 22 books. In addition to *Shoeless Joe*, which was filmed as *Field of Dreams*, his baseball fiction includes *The Thrill of the Grass, The Iowa Baseball Confederacy, the Dixon Cornbelt League, Go the Distance*, and *If Wishes Were Horses*. His most recent works are *Japanese Baseball*, a collection of stories, and *Magic Time*, a novel.

Bowie Kuhn was probably the last commissioner of baseball to reign in the Kenesaw Landis tradition. Serving from 1969 to 1984, Kuhn oversaw international expansion, nighttime postseason games, and the rise of free agency, all of which he detailed in his book, *Hardball: The Education of a Baseball Commissioner*.

Fiorello H. LaGuardia served as the mayor of New York City between 1934 and 1945, years of economic emergency and wartime conflict. His colorful personality, energy, and passionate attachment to his city contributed to his unusual popularity.

David Lamb, a longtime *Los Angeles Times* foreign correspondent, is part owner of the Yakima Bears in the short-season Northwest League and author of *Stolen Season: A Journey Through America and Baseball's Minor Leagues*.

Barry Levinson is an acclaimed director, screenwriter, and producer, and a winner of the Academy Award, Emmy Award, and Peabody Award. Among his numerous achievements are the films *Rain Man, Tin Men, Bugsy*, and *The Natural*, starring Robert Redford.

Ed Linn, a noted sports writer, was the author of 17 books, including *Hitter: The Life and Times of Ted William, Nice Guys Finish Last*, and *Where the Money Is*.

Bernard Malamud, winner of the National Book Award and Pulitzer Prize, was one of America's most distinguished novelists. His first novel, *The Natural* (1952), a baseball story, established his classic theme of the innocent outsider and a hostile society.

Bruce Markusen is manager of Program Presentations at the National Baseball Hall of Fame and Museum. He has written three books on baseball: *Baseball's Last Dynasty: Charlie Finley's Oakland A's; Roberto Clemente: The Great One;* and *The Orlando Cepeda Story*. He and his wife Sue reside in Cooperstown, New York.

Karal Ann Marling is Professor of Art History and American Studies at the University of Minnesota. Curator and author of more than a dozen books on American art, popular art, and culture, she is a rabid Twins fan.

Penny Marshall is a noted director, producer, and actress. Among her achievements as a director are *Big*, which brought Tom Hanks his first Academy Award nomination and made Marshall the first female director to pass the $100 million mark. She directed *A League of Their Own* and recently directed *Riding in Cars with Boys*.

John "Bid" McPhee played second base for the Cincinnati Reds from 1882 to 1899. Although he was the last second baseman to adopt the then-new invention of the glove, he nevertheless regularly led the league in defense playing without a glove. He was posthumously elected to the Baseball Hall of Fame in 2000.

Richard Merkin is a painter and writer and regular contributor to *The New Yorker* (illustrations). He is firmly convinced that the most wonderful baseball game he ever saw was between the waiters and counselors of Stissing Lake Camp and the Pine Plains, New York Fire Department in the long ago summer of 1949.

Bob Newhart is perhaps the only man in the world who can talk to himself on the phone without people looking strangely at him. His first album, "The Button-Down Mind of Bob Newhart" was the first comedy album to go No. 1 on the charts. He has gone on to be a star of television, film, video, and, of course, live performance.

John Odell is Curator of History and Research at the National Baseball Hall of Fame and Museum. His exhibit "You're in the Hall of Fame, Charlie Brown!" explored baseball in the works of *Peanuts* cartoonist Charles Schulz. He is also the author of *Between the Eyes: Thomas Nast and the U.S. Senate,* and *U.S. Senate Graphic Arts Collection, Vol. I.*

Daniel Okrent is the author of the baseball classic *Nine Innings* (1985) and co-author of *The Ultimate Baseball Book* (1979) and *Baseball Anecdotes* (1989), not one of which has ever been out of print. He has spent the bulk of his career as a magazine editor, most recently as editor-at-large at Time, Inc.

Buck O'Neil played and managed in the Negro leagues from 1937 through 1955, almost exclusively with the Kansas City Monarchs. He became the first black coach in the major leagues with the Chicago Cubs in 1962. O'Neil is the chairman of the board of the Negro Leagues Museum in Kansas City, Missouri.

Molly O'Neill, whose work appears in the *The New Yorker* magazine, was a columnist for the *New York Times Magazine* for ten years and is the author of *The New York Cookbook, A Well-Seasoned Appetite,* and *The Pleasure of Your Company.* Her memoir about growing up with baseball will be published in 2002.

George Plimpton is the author of many books and anthologies, perhaps the best-known *(Paper Lion, Out of My League, Shadow Box, The Bogey Man)* written from the perspective of a participatory journalist. In addition, he is both the editor of the international literary quarterly *The Paris Review* and the Honorary Commissioner of Fireworks of New York City.

Shirley Povich served as a sports columnist for the *Washington Post* for nearly 75 years. He began in 1924, when Lou Gehrig was still warming the bench behind Wally Pipp, and was still writing when Cal Ripken, Jr., broke Gehrig's consecutive-games-played streak in 1995. In between, many credit the popularity of Povich's daily column with keeping the *Post* afloat during lean times, and he was a leader in opposing segregated sports in Washington and the nation.

Joe Raposo is probably best known for his Grammy-winning songs for *Sesame Street,* including the classic, "Bein' Green." But in addition to Kermit the Frog, Raposo's music and lyrics were made popular hits by such stars as the Carpenters and Frank Sinatra, who surely sang the definitive styling of "There Used to Be a Ballpark."

Albert Deane Richardson, a Civil War correspondent for the *New York Daily Tribune,* was captured near Vicksburg, Mississippi, and spent 18 months in Confederate prisons.

Steven A. Riess is Professor of History at Northeastern Illinois University. The former editor of the *Journal of Sport History,* he has written and edited several books, including *Touching Base: Professional Baseball and American Culture in the Progressive Era* and *City Games: The Evolution of American Urban Society and the Rise of Sports.*

Lawrence S. Ritter is the author of the classic *The Glory of Their Times* (1966), in addition to numerous other works on the sport, including *Lost Ballparks* (1992) and, for teenagers, *The Story of Baseball* (1999). In his spare time, he teaches finance and economics at New York University.

Jackie Robinson broke professional baseball's color barrier when he signed with the Brooklyn Dodgers in 1946. He won the first Rookie of the Year Award and was a six-time All-Star. Both during and after his extraordinary ten-year baseball career, Hall-of-Famer Robinson was an outspoken leader for integration in all areas of American life.

David Rockwell began his career as an assistant to a lighting designer. Trading the thrills of a single show for a broad-based architectural practice with theatrically inspired projects, David has steered Rockwell Group into one of Manhattan's prominent architecture firms, specializing in restaurants, hotels, casinos, and stadiums.

Franklin Delano Roosevelt was the 32nd president of the United States, from 1933 to 1945. He led the nation during two of its greatest crises: the Great Depression and World War II.

Philip Roth is a master of prose, many of whose writings have become classics. Beginning with the National Book Award in 1960 for *Goodbye, Columbus,* Roth has been recognized with numerous prizes, including a second National Book Award, the National Book Critics Circle Award twice, the Pen/Faulkner Award, and the Pulitzer Prize.

Allan H. "Bud" Selig was named Commissioner of Major League Baseball by a unanimous vote in 1998. As commissioner, he has shaped the historic revenue-sharing agreement, interleague play, and the wild-card playoff format. He has had a lifelong involvement with baseball; he has also received many

awards for his community and national service with many organizations.

Dan Shaughnessy is a columnist for the *Boston Globe* and appears regularly on radio and television. He is also the best-selling author of *The Curse of the Bambino, At Fenway,* and *Fenway: A Biography in Words and Pictures.*

Tom Shieber is Webmaster and Curator of New Media at the National Baseball Hall of Fame and Museum. A former board member of the Society for American Baseball Research, his research interests include the history of antebellum baseball and early baseball images.

Joshua Siegel, Assistant Curator in the Department of Film and Video at the Museum of Modern Art, has been the organizer or co-organizer of more than 30 exhibitions, including the theatrical premiere of Ken Burns's *Baseball* series, which Robert Merrill inaugurated with a rousing rendition of the national anthem.

Paul Simon, preeminent singer/songwriter, has received 12 Grammy awards for albums whose music ranges from folk to jazz, rock, reggae, and Latin. He is the recipient of a number of other honors, including the Frederick D. Patterson Award from the United Negro College Fund. His lyrics to "Mrs. Robinson" became the touchstone of an age.

Curt Smith is a best-selling author, award-winning radio commentator, and former presidential speechwriter who teaches at the University of Rochester. His *Voices of the Game* is the definitive book on baseball broadcasting.

Ted Spencer is Vice President and Chief Curator of the National Baseball Hall of Fame and Museum. A Boston Red Sox fan, and named after Ted Williams, he was born in Quincy, Mass. He graduated from Massachusetts College of Art in 1969. He joined the Hall of Fame in 1982 as Curator of Exhibits.

C. C. Johnson Spink was a Coast Guard veteran, an amateur photographer, a philanthropist, and publisher of the *Sporting News* from 1962 to 1982. He was named for his grandfather, Charles Claude Spink, who also ran the publishing enterprise, and for Ban Johnson, founder of the American League. He died in 1992.

Charles Fruehling Springwood, Associate Professor of Anthropology at Illinois Wesleyan University, is the author of *Cooperstown to Dyersville: A Geography of Baseball Nostalgia,* as well as numerous essays on baseball and culture.

Ernest Lawrence Thayer, a Harvard graduate, published "Casey at the Bat" in the *San Francisco Examiner* on June 3, 1888, over the pseudonym "Phin." Thayer remained puzzled by the popularity of the verse and, once his authorship became known, refused to discuss payments for its reprinting, once saying, "All I ask is never to be reminded of it again."

Jules Tygiel is Professor of History at San Francisco State University and the author of *Baseball's Great Experiment: Jackie Robinson and his Legacy* (1983) and *Past Time: Baseball as History* (2000). He also co-founded the Pacific Ghost League. Born a Brooklyn Dodgers fan and raised a New York Mets fan, he now lives in San Francisco and avidly roots for the Giants.

Bill Veeck, son of the first general manager and the president of the Chicago Cubs, was one of the most innovative owners in the history of baseball. Owner of the Cleveland Indians, the St. Louis Browns, and the Chicago White Sox (twice), Veeck was inducted into the National Baseball Hall of Fame in 1991.

Craig M. Vogel, FIDSA, is Professor of Design in the College of Fine Arts at Carnegie Mellon University. He is co-author of *Great Products: Succeeding through Style, Technology and Value.* Raised in Brooklyn as a devoted Yankees fan, he is glad the Pirates have a stadium that re-creates a classic early 20th-century ballpark with natural grass.

Sol White was an early professional African-American ballplayer who played on a number of integrated teams until the color barrier became insurmountable in 1895. Over the course of the next 30 years, he played on or managed a number of black ball clubs, and in 1907 he wrote the *History of Colored Baseball,* the only history of the early African-American game.

Walt Whitman has been called America's Homer and America's Dante. His poetry, published primarily in the 1850s and '60s, confronted the great themes of democratic life and popular ideals and is indissolubly linked with dreams of freedom and fulfillment.

Tim Wiles is Director of Research at the National Baseball Hall of Fame Library. He is the co-editor of *Line Drives: 100 Contemporary Baseball Poems* (Southern Illinois University Press, 2002). His subjective writings on baseball's literary, cultural, and historical facets can be viewed at www.baseball1.com.

Ted Williams achieved some of baseball's best offensive statistics despite losing nearly six years of his career to military service and injuries. Williams tallied 521 home runs and two Triple Crowns, and he became the last man in the 20th century to bat .400, when he hit .406 in 1941. When he was inducted into the Baseball Hall of Fame in 1966, he called for the inclusion of Negro league stars into the Hall.

Andrew Zimbalist is the Robert A. Woods Professor of Economics at Smith College. A specialist in the economics of sports, he is well known as an author, consultant, and commentator on the subject. His writings include his acclaimed *Baseball and Billions: A Probing Look Inside the Big Business of our National Pastime,* New York, 1992.

Selections from the Collection of the National Baseball Hall of Fame and Museum, and the Baseball As America Exhibition

Baseballs

19th century "Doubleday Ball," purported to have been used by Major General Abner Doubleday to "invent" the game of baseball

1857 Ball with wool yarn wound around a core of palm leaves

1858 Ball from first game in which admission was charged

1858 "Junior League" early lemon-peel style ball with box

1871 Trophy ball, Troy Haymakers vs. New York Mutuals

ca 1882 Early National League ball

1889 From game played at the Pyramids as part of the 1888-1889 World Tour, Egypt

1903 First ball used in Game One of the first modern World Series

1910 First "Presidential First-Pitch Baseball," thrown by President William Taft to Senators pitcher Walter Johnson

1910s Ball signed by ten U.S. presidents: Taft, Harding, Coolidge, Hoover, F. Roosevelt, Truman, Eisenhower, Kennedy, L. Johnson, and Nixon

1910s Handmade ball made by Babe Ruth at school

1940 Autographed first-pitch baseball thrown by President Franklin D. Roosevelt on Opening Day

ca 1942 Foul ball returned by fan at the Polo Grounds for donation to military teams

1949 Ball from the Chicago Colleens and Springfield Sallies barnstorming tour, All-American Girls Professional Baseball League

1956 Ball used by Yankees pitcher Don Larsen in the only perfect game in World Series history

1957 Autographed first-pitch baseball thrown by President Dwight D. Eisenhower on Opening Day

1960 Signed by then-Vice President Richard M. Nixon and Mayor George Christopher at the dedication of Candlestick Park, San Francisco, CA

1964 Autographed first-pitch baseball thrown by President Lyndon B. Johnson on Opening Day

1972 Orange baseball, designed for better visibility

ca 1976 Oversize Pioneer Audio "beep" ball that emits a tone for the sight impaired

1978 First ball thrown in 1978 World Series, by Dodgers pitcher Tommy John

1979 Ball signed by President Jimmy Carter at Game Seven of the 1979 World Series

1986 Ball used by Roger Clemens vs. Seattle when he set the record for most strikeouts in a nine-inning game with 20

1998 Ball hit by Sammy Sosa for home run #62 of the season

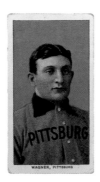

Baseball Cards

ca 1909 Honus Wagner, Pittsburgh Pirates, T-206 American Tobacco Company

ca 1910 Charles "Chief" Bender, Philadelphia Athletics, American Caramel Company

1910 John "Chief" Meyers, New York Giants, attributed to C. A. Briggs Company

1941 Robert "Indian Bob" Johnson, Philadelphia Athletics, Play Ball

1949 Larry Doby, Cleveland Indians, Bowman

1950 Henry Thompson, New York Giants, Bowman

1951 Monte Irvin, New York Giants, Bowman

1952 Orestes "Minnie" Miñoso, Chicago White Sox, Topps

1952 Mickey Mantle, New York Yankees, Topps

1955 Carlos Paula, Washington Senators, Topps

1956 Elston Howard, New York Yankees, Topps

1959 Ozzie Virgil, Detroit Tigers, Topps

1960 Pumpsie Green, Boston Red Sox, Topps

1961 Bob Clemente, Pittsburgh Pirates, Topps

1966 Bob Clemente, Pittsburgh Pirates, Topps

1973 Roberto Clemente, Pittsburgh Pirates, Topps

Bats

1888-89 Heavy "Wagon Tongue" bat used by Charles Comiskey, St. Louis Browns (American Association)

ca 1905 Bat used by outfielder Willie Keeler of the New York American League club (later, Yankees)

ca 1912 Louisville Slugger decal bat endorsed by Boston Red Sox outfielder Tris Speaker

ca 1917 Bottle-style bat used by Heinie Groh of the Cincinnati Reds

ca 1919 "Black Betsy," bat used by Chicago White Sox outfielder Joe Jackson

1920s Bat weighing 56 oz. used by Babe Ruth in exhibitions at spring training

1927 Bat used by New York Yankees outfielder Babe Ruth to hit his 60th home run of season

1928 Bat used by Babe Ruth to hit 28 of 54 home runs, one notch carved for each home run

1942 Bat carved from a tree limb, used by American Embassy officials and reporters detained in Nazi Germany

1951 Bat used by New York Giants outfielder Bobby Thomson to hit the "Shot Heard 'Round the World"

1953 Loren Babe bat used by Mickey Mantle to hit an estimated 565' home run

1961 Bat used by New York Yankees outfielder Roger Maris to hit his 61st home run of season

1969 Bat used by San Francisco Giants center fielder Willie Mays to hit his 600th career home run

1974 Bat used by Hank Aaron to hit his 714th career home run, tying Babe Ruth

1978 Aluminum fungo bat

1980-81 Cupped end bat used by Cincinnati Reds catcher Johnny Bench

*** 1983** Bat used by Kansas City Royals third baseman George Brett in "Pine Tar" incident

1984 "Wonderboy" bat used by Robert Redford as Roy Hobbs in the movie *The Natural*

1984 Aluminum bat used by future major leaguer Will Clark on the U.S. Olympic team

1993 Bat used by Toronto Blue Jays outfielder Joe Carter to hit World Series-winning home run

1998 Bat used by St. Louis Cardinals first baseman Mark McGwire to hit home runs 66 through 70

1998 Bat used by Chicago Cubs outfielder

* Items on loan to the Baseball As America exhibition

Sammy Sosa to hit his 66th home run of the season

1999 Maple bat used by San Francisco Giants outfielder Barry Bonds

Books, Booklets, and Periodicals

1856 Bylaws and Rules for the Mercantile Club, New York

1875 *DeWitt's Base Ball Umpire's Guide,* Henry Chadwick, editor

1877 *The Constitution & Playing Rules of the National League*

1885 Alphabet primer, *Base Ball ABC*

1888 *The Reach Art of Curve Pitching,* Edward J. Prindle

1906 *Baseball Jokes, Stories and Poems,* James Sullivan

1907 *History of Colored Baseball,* Sol White

1911 *The Young Pitcher,* Zane Grey

1912 *Casey at the Bat,* Ernest Thayer

1915 *Catcher Craig,* Christy Mathewson and James Wheeler

1933 Booklet, "Baseball's Pot of Gold"

1937 *Radio Guide* magazine

ca 1943 Booklet, "A Guide for All-American Girls" deportment manual

1948 *Pitchin' Man: 'Satchel' Paige's Own Story,* Leroy "Satchel" Paige and Hal Leibovitz

* **1950** *Life* magazine featuring cover photograph of Jackie Robinson

1950 Comic book, "Roy Campanella Baseball Hero"

1954 *NOW* magazine, Joe DiMaggio and Marilyn Monroe on cover

1957 Booklet, "Dizzy Dean Baseball Guide"

1958 *70 Nights in a Ball Park*

1959 Comic book, "Mutt & Jeff"

1961 *Life* magazine with cover of Mickey Mantle and Roger Maris

1971 *The Science of Hitting,* Ted Williams

1979 *Breaking Balls,* Marty Bell

2000 *Official Baseball Rules*

Broadsides, Handbills, and Posters

1869 Handbill for New York Mutuals vs. Cincinnati Red Stockings

1888 Advertising poster promoting insert cards available in packs of Old Judge Cigarettes

1889 Advertisement featuring Buck Ewing of the New York Giants and Cap Anson of the Chicago White Stockings, E & J Burke Beer Co.

1908 Handbill, Senator Athletic Club vs. Belmont Colored Giants

1924 Broadside, Kansas City Monarchs, first "World's Colored Champions"

1937 Broadside, Homestead Grays vs. Pittsburgh Crawfords

1949 Movie poster for *It Happens Every Spring*

1953 Handbill urging integration of the New York Yankees

1998 Placard supporting San Diego Padres pitcher Trevor Hoffman

1998 Poster promoting the construction of a new ballpark in San Diego

1999 Poster advertising exhibition game played between the Cuban National Team and Baltimore Orioles in Havana, Cuba

*

Caps

1931 Edd Roush, Cincinnati Reds, cap with attached sunglasses

1952 Satchel Paige, St. Louis Browns

1969 Seattle Pilots

ca 1971 Roberto Clemente, Pittsburgh Pirates

1973 Phil Niekro, Atlanta Braves, no-hitter cap

2001 Hideo Nomo, Boston Red Sox, no-hitter cap

Cartoons

1867 From early cartoon book *Base Ball As Viewed by a Muffin,* S. Van Campen

ca 1930 "Is Babe Ruth Worth It?" Gene Mack

1955 "The Stars in His Eyes," Willard Mullin

1968 "It Happens Every Spring," George Desko

Communications Equipment

1920s Western Union ticker tape machine

1930 Typewriter of *New York Times* sportswriter John Kieran

ca 1932 Microphone used by Red Barber in his first job as a broadcaster, at the University of Florida

* **1996** "Sports Trax" sports pager by Motorola

Decorative Art

ca 1860s "American Sports" Staffordshire plate

1873 Clock, American Clock Company, with decorative baseball figures

Ephemera

1868 Trade card, Peck & Snyder Base Ball Players' Supplies

ca 1880s "Something Must Be Done" trade card for Merchant's Gargling Oil Liniment

1881-1908 Business card for Henry Chadwick

1882 Trade card, Marshall & Ball Clothiers, Newark, NJ

1887 Advertising "currency" coupon featuring the National League champion Detroit Wolverines

ca 1888 Trade card with Maher & Grosh baseball scene advertising Thea-Nectar

ca 1905 Combination paper fan and baseball scoring device

1913 Lithograph advertising "Mooney's 'Giants' The Famous Elephant Base-Ball Team"

1914 Page from Royal Tailors merchant's catalogue and sample book featuring Christy Mathewson

ca 1922 Babe Ruth Baseball Scorer

ca 1935 Store placard featuring Babe Ruth for Quaker Puffed Wheat

1942 Advertisement for Alpen Brau Beer with St. Louis Cardinals mascot and caricature of Adolf Hitler

1950 Theater lobby card for *The Jackie Robinson Story*

1959 Drawing showing how to light a minor league park

1971 Brochure advertising "Super Box" luxury boxes at Veterans Stadium, Philadelphia, PA

2001 Advertisement for the Ichi Roll sushi, Safeco Field, Seattle, WA

*

Fan Art and Fine Art

1882 *A Foul Tip*, published by Currier and Ives, color lithograph

ca 1889 *The Baseball Player*, Douglas Tilden, bronze statuette

1912 "The Base Ball World of 1912," Scrapbook created by Alan Jackman and his brother

ca 1914 Blanket created from felt cigarette premiums

ca 1945 Mini-bat decorated by fan for Vivian Kellogg of the Ft. Wayne Daisies, All-American Girls Professional Baseball League

1963 Ball decorated with painted images and statistics of Detroit's Charlie Gehringer by George Sosnak

ca 1972 Baseball pitcher, batter, and catcher made of bolts, Guido Ottavine

* 1979 *Night Game (Practice Time)* by Ralph Fasanella, oil on canvas

1985 *Tom Seaver,* Andy Warhol, acrylic/screenprint on canvas

1996 *Big Mouth Woodhead, Manager of the Tinkerville Tomcats*, Lavern Kelley, basswood

Games and Toys

1878 Parlor Base Ball board game

1888 "Darktown Battery" cast iron mechanical bank

ca 1920s Spinner from Walter Johnson Baseball Game

1948 Magic Baseball Fortune Teller Paper Weight and box

* 1953 View-Master viewer and View-Master Major League Baseball Stars picture reels

ca 1962 Tabletop gumball machine

ca 1963 "Play Ball" Ken doll produced by Mattel

1968 Major League Baseball Players Association combination lunch box and baseball game

1978 Mattel Electronics handheld baseball game

1983 Strat-O-Matic Baseball Game

Gloves and Mitts

ca 1886 Fingerless fielder's glove

1888 First padded catcher's mitt, worn and invented by Joe Gunson

1912-1953 Oversize gag glove worn by Nick Altrock, baseball clown

1927 Glove used by Washington Senators pitcher Walter Johnson

ca 1940s Glove used by Negro leagues veteran Art "Superman" Pennington

ca 1951 Glove used by Joe DiMaggio

ca 1955 Trapper model first baseman's mitt

1956 "Presidential model" glove used by President Eisenhower to throw out Opening Day pitch

1956 Mitt used by New York Yankees catcher Yogi Berra in perfect World Series game

1960 Big Bertha oversize catcher's mitt

1970 Glove used by Baltimore Orioles third baseman Brooks Robinson in World Series

ca 1978 Hinged catcher's mitt with fluorescent target

1987-93 Mitt used by Julie Croteau, who played first base on the St. Mary's College of Maryland Seahawks men's baseball team

1990 Glove used by Chicago Cubs second baseman Ryne Sandberg

1995 Glove used by Atlanta Braves pitcher Greg Maddux in the World Series

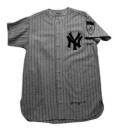

Jerseys and Uniforms

1906 New York Giants jersey

1917 Chicago White Sox World Series jersey

1920s "Bustin' Babes" barnstorming uniform jersey worn by Babe Ruth

* ca 1922 Philadelphia Bobbies jersey worn by ten-year-old shortstop Edith Houghton

1933 National League jersey from first All-Star Game, worn by Frankie Frisch

1938 Pittsburgh Crawfords jersey

* 1943-45 San Fernando Aces jersey worn by first baseman Tak Takahashi while interned at Manzanar Relocation Center, California

1948 Boston Braves satin uniform designed for night games

* 1951 St. Louis Browns jersey worn by 3'7" pinch-hitter Eddie Gaedel

1952-53 Patch from the Chicago Colleens of the All-American Girls Professional Baseball League

1954 Kalamazoo Lassies tunic of the All-American Girls Professional Baseball League

1956 Brooklyn Dodgers jersey worn by Jackie Robinson

ca 1968 Atlanta Braves team logo patch

1973 Patch featuring Roberto Clemente's uniform number 21, worn by the Pittsburgh Pirates after his death

1974 Atlanta Braves jersey worn by Hank Aaron when hitting his 715th home run

1975 Cleveland Indians jersey worn by Frank Robinson, first black major league manager

* 1976 Chicago White Sox Bermuda shorts

1976 Bears jersey worn by George Gonzales as Miguel Agilar in the movie *The Bad News Bears*

ca 1979 The San Diego Chicken costume

1984 New York Knights jersey and warm-up jacket worn by Robert Redford as Roy Hobbs in the movie *The Natural*

1990 Texas Rangers jersey worn by Nolan Ryan when he pitched his sixth career no-hitter

*** 1992** Rockford Peaches movie prop tunic worn by Geena Davis as Dottie Hinson in the movie *A League of Their Own*

2001 New York Mets jersey, worn by shortstop Rey Ordoñez

Jewelry

1871 Boston Red Stockings pin

1897 Beanpot pin worn by the Boston Rooters fan club

1908 "The Big Stick" baseball bat campaign pin supporting William H. Taft for president

1913 World Series press pin

ca 1939 Charm bracelet made from championship jewelry, given by Lou Gehrig to his wife

1945 Chicago Cubs World Series press pin

1993 Expansion draft press pin, Colorado Rockies & Florida Marlins

Letters and Documents

1877 Patent drawings of catcher's mask invented by Fred Thayer

1888 Patent drawing of baseball curver device

1905 Letter from Abner Graves to Albert Spalding, stating that General Abner Doubleday devised the structure of the game of baseball in Cooperstown, NY in 1839

1905 Share of stock, Brooklyn Base Ball Club

1908 Handwritten manuscript, "Take Me Out to the Ball Game," by Jack Norworth

ca 1915 Patent drawing of flip-up sunglasses invented by major league outfielder/manager Fred Clarke

1919 Transfer agreement sending Babe Ruth from the Boston Red Sox to the New York Yankees

*** 1932** Handwritten letter from Babe Ruth to polio patient Freddie Clark

1935 Membership card for the Boston Braves Knot Hole Gang

1940 Newark Bears Knot Hole Gang membership packet with tickets

1942 "Green Light" letter from President Franklin D. Roosevelt to Baseball Commissioner Kenesaw Mountain Landis

1944 Office of Strategic Services identification card issued to Moe Berg, former major league catcher

1960 Letter from Senator John F. Kennedy to Jackie Robinson

1964 All-Star ballot filled out by Casey Stengel

ca 1971 Membership card, New York chapter of the Roberto Clemente Fan Club

2001 Membership card, Houston Astros Buddies Club

Medical-Related Items

*** early 1960s** Trainer's medical bag

1966 Modified rubber inner tube used by Dodgers pitcher Sandy Koufax for ice baths

*** 1985** Ankle brace used by Baltimore Orioles shortstop Cal Ripken, Jr.

2001 Medical instruments of the type used in "Tommy John" surgery

2001 Ethyl chloride numbing spray

Merchandise

ca 1894 Box for New York Champions Chocolates

1920s Babe Ruth underwear and box

ca 1930s Trophy Official League Ball radio

ca 1940s Crate label for Safe Hit vegetables

1941 Gillette promotional "World Series Special" blades and shaving cream

ca 1943 Sportsman's Chocolate Bracer candy bar

1947 Red Rock's Players strawberry soda bottle

ca 1950s McCrory's Home Run Milk Chocolate Nut Roll candy bar

ca 1950s Little Sport Brand corn can

ca 1950s Big League Rub rubbing alcohol

ca 1950s Batter Up shaving lotion

ca 1950s Batter Up talcum powder

*** ca 1951** Jackie Robinson doll

ca 1952 Safe Hit Texas vegetables bag

ca 1960s Ted Williams brand fishing line

ca 1963 Ted Williams brand fishing bobber

1963 Favorite brand chewing tobacco endorsed by Nellie Fox and other major league stars

ca 1964 Home Run Cigarettes package

1970 Meadow Gold milk carton, the "Official Milk of the Pros"

1974 Pittsburgh Pirates transistor radio

1978 Base Brau Appleton Foxes Beer can

ca 1978 Broca Pop soft drink can featuring Lou Brock

1980 Reggie Bar wrapper

1985 "Slugger" baseball phone

1987 Wheaties box featuring World Champion Minnesota Twins

1989 Ken Griffey, Jr. Bar wrapper

1993 Roberto Clemente Commemorative Corn Flakes

1993 Kellogg's Corn Flakes box picturing Nolan Ryan

1994 Iron City Light Beer can commemorating Roberto Clemente

1995 Cecil Fielder Bar wrapper

1998 Maple Frosted Wheaties box with Toronto Blue Jays pitcher Roger Clemens

1998 Willie's Gourmet Chocolate Chip Cookies box, promoted by former Cardinals outfielder Willie McGee

1998 Omar Vizquel Salsa jar, with label artwork by Vizquel

1999 Slammin' Sammies cereal box picturing Sammy Sosa

2001 Big League Chew shredded bubble gum, invented by former major leaguer Jim Bouton in 1977

Miscellaneous Equipment

1887 Umpire's counter

1877 Catcher's mask invented by Harvard baseball team captain Fred Thayer

1905 Reach Pneumatic head protector

1905-1911 Umpire's indicator used by Amanda Clement

ca 1905 Inflatable catcher's chest protector

ca 1930 Catcher's shin guards made of canvas-covered wooden reeds with plastic knee protectors

1934 Warm-up jacket worn by catcher Moe

Berg during the U.S. baseball tour of Japan

* **ca1943** Protective goggles used by Cleveland Indians pitcher Bob Feller while operating gun-in-placement aboard the battleship U.S.S. Alabama

ca1952 Prototype of Pittsburgh Pirates fiberglass batting helmet

ca1955 Cowbell used by famed Brooklyn Dodgers supporter Hilda Chester

1968 Metal "doughnuts" used by players loosening up before batting

1974 Prototype JUGS Speed Gun

1975 Ballpoint pen used by Catfish Hunter to sign free agency contract

1977 Catcher's mask with handmade protective throat flap invented by Los Angeles Dodgers catcher Steve Yeager

1985 Batting gloves worn by Rod Carew to secure his 3,000th career hit

1985 Batting helmet worn by Pete Rose in the game he broke Ty Cobb's career hits record

1991 Knee Saver prototype used by catchers

1998 Instep guard worn by Mark McGwire

2000 Modern batting helmet with protective ear-flap worn by Derek Jeter during the World Series

* **2001** "Catcher Cam" catcher's mask camera, developed by AVS-Aerial Video Systems, Burbank, CA

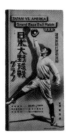

Programs and Scorecards

1888 Menu from banquet honoring members of world tour, Sydney, Australia

1893 Scorecard from Brooklyn vs. Chicago

1899 Scorecard with space for advertisements, Brooklyn Base Ball Club

1907 Program for banquet to honor the Chicago Cubs, winners of the 1906 World Series

1913 Program promoting the world tour of the Chicago White Sox and New York Giants

1924 Program for first Colored World Series

1931 Program from the U.S. baseball tour of Japan featuring Yankees first baseman Lou Gehrig

1943 World Series program

1953 Souvenir program, "Welcome Braves Rally"

1954 Program highlighting female ballplayers Toni Stone, Mamie "Peanut" Johnson, and Connie Morgan, who played on Negro leagues men's teams

1954 Signed scorecard kept by President Eisenhower on Opening Day

1974 Program for the minor league Syracuse Chiefs

1997 Scorecard with detailed commentary, St. Louis Cardinals vs. Chicago Cubs

Sheet Music and Records

1867 Sheet music of "Base Ball Polka"

ca1906 Record disc, "Casey at the Bat," recited by DeWolf Hopper

1908 Edison wax cylinder record "Take Me Out to the Ball Game"

ca1908 "Take Me Out to the Ball Game" magic lantern slide

1908 Sheet music of "Take Your Girl to the Ball Game"

1913 Sheet music of "They All Know Cobb"

ca1914 Sheet music of "The Feds Are Here To Stay"

1923 Sheet music of "Babe Ruth He Is a Home Run Guy"

1949 Sheet music of "Take Me Out to the Ball Game," with cover image of Frank Sinatra

1950 Record sleeve of "Take Me Out to the Ball Game," performed by Yankees and Dodgers

1952 Album cover of "The Giants Win the Pennant," by Russ Hodges

1954 Sheet music of "Say Hey, Willie"

1968 Sheet music of "(Love is Like a) Baseball Game," recorded by the Intruders

1973 Sheet music of "There Used to Be a Ballpark," by Joe Raposo

1973 Record sleeve single celebrating Atlanta Braves outfielder Hank Aaron's pursuit of Babe Ruth's career home run record

1973 Roberto Clemente tribute album

1981 Record sleeve of "Ole Fernando!"

1981 Record sleeve of "Talkin' Baseball: Willie, Mickey and the Duke," by Terry Cashman

1983 Sheet music of "Karma Chameleon," recorded by Culture Club

Shoes

ca1910s Shoes worn by Ty Cobb, outfielder for the Detroit Tigers

1919 Shoes worn by Chicago White Sox outfielder "Shoeless" Joe Jackson

ca1922-46 Shoes worn by Negro leagues veteran James "Cool Papa" Bell

ca1928-43 Shoes worn by New York Giants pitcher Carl Hubbell, with toe plate

1999 Shoes worn by New York Mets outfielder Rickey Henderson

1999 Shoes worn by San Diego Padres outfielder Tony Gwynn in getting his 3,000th career hit

Souvenirs

1887 Silk give-away from Ladies' Day promotion, Opening Day at Sportsman's Park, St. Louis

1895 Glass souvenir of the Baltimore Base Ball Club

1909 Plaster statuette, Honus Wagner, Pittsburgh Pirates

ca1910 Pennant, Philadelphia Athletics

ca1911 Mini-bat, Frank "Home Run" Baker, Philadelphia Athletics

1934-35 Newark Bears Knot Hole Gang pin

ca1940s Pennant, New York Black Yankees

1948 Cleveland Indians souvenir pencil with Larry Doby pocket clip

ca1950-62 Louisville Slugger mini souvenir bat with Richie Ashburn facsimile signature

ca1953-58 Mini pennant, Cincinnati Redlegs

ca1953-58 Pin-back button, Cincinnati Redlegs

ca1957 Price board from Polo Grounds souvenir stand

ca1959-67 Cincinnati Reds vinyl seat cushion

ca1960 Pennant, Kansas City A's

1961 Button, I'm for Maris—60 in '61

ca 1963 Ladies straw hat featuring felt appliques of Los Angeles Dodgers

ca 1963 Silver plate "spangle" bracelet, Milwaukee Braves

1964 "The Amazin' Mets" child's plastic wallet

ca 1965 Bobbing head doll, Cleveland Indians

ca 1966-71 Bobbing head doll, Minnesota Twins

ca 1968 Los Angeles Dodgers "Official" baseball sunglasses

ca 1973 Pennant, Oakland A's

1974 Certificate given to fans when Hank Aaron broke Babe Ruth's career home run record

* **ca 1979** Combination cardboard popcorn holder and megaphone from Busch Memorial Stadium, St. Louis

1995 Pin honoring baseball clown Max Patkin on his retirement

1995 Pin-back button celebrating Los Angeles Dodgers pitcher Hideo Nomo

* **1997** Foam tomahawk souvenir, Atlanta Braves

1998 Beanie Baby promotional give-away

1999 Key chain, Colorado Rockies

2001 Plastic "clapper" souvenir from minor league Sioux Falls Canaries

2001 Plastic rattle, Sioux Falls Canaries

Stadium Equipment/Artifacts

Ticket window from old Comiskey Park, Chicago

Turnstile from the Polo Grounds, New York, home of the Giants from 1911-1957 and the Mets in 1962-63

1903 Gate-revenue receipt from the first modern World Series, Boston vs. Pittsburgh

ca 1910 Hot dog vending bucket

1925-27 Outside scoreboard from the balcony of the Blair Hotel in Waynesburg, PA

* **ca 1940s** Hot dog vendor's basket, Harry M. Stevens Company

* **1943** Wooden home plate made by internees for Zenimura Field, Gila River Relocation Center, Arizona

1950s Presidential box seat from Griffith Stadium, Washington, D.C.

ca 1950s Seats from the original Busch Stadium (Sportsman's Park), St. Louis

ca 1950s Cash and ticket bag from Fenway Park, Boston

1967 Harmon Killebrew home run sign from bleachers of Minnesota's Metropolitan Stadium

1969 Half of home plate from Shea Stadium following the New York Mets' pennant-clinching victory

1984-86 Original "K" from Shea Stadium, honoring strikeouts by New York Mets pitcher Dwight Gooden

1990s Esskay Franks hot dog vending box used at Memorial Stadium, Baltimore

2000 Artificial turf from Three Rivers Stadium, Pittsburgh

2001 Official Opening Day batting order card, Texas Rangers

2001 Chopsticks from concession stand, Safeco Field, Seattle

Tickets and Season Passes

1871 Season pass, Philadelphia Athletics

1896 Ticket, Cincinnati Red Stockings

1902 Silver season pass, Cincinnati Reds

1914 Silver season pass and pencil, New York Giants

1915 Ticket to Union College baseball game

1924 Silver season pass, New York Giants

1938 Lightbulb shaped night game ticket, Brooklyn Dodgers

1939 Ticket to Lou Gehrig Day

1942 Ticket to benefit doubleheader held at Chicago's Comiskey Park for the Army and Navy Relief funds

1943 Ticket to charity game between the Navy "Cloudbusters" and the "Yanklands," a combined team of New York Yankees and Cleveland Indians

ca 1953 "Colored entrance" tickets for Eastman, GA Dodgers

1955 Sample ticket for the first Global World Series, an eight-team international baseball tournament, Milwaukee

1962 Ticket to the grand opening of Dodger Stadium, Los Angeles

1962 Ticket from first major league game for Houston franchise, Colt .45s vs. Cubs, Colt Stadium

1969 Ticket to inaugural game, Montreal Expos

1972 Ticket stub to Roberto Clemente's last game

1993 Ticket to expansion draft, Colorado Rockies and Florida Marlins

1999 Ticket from game in which Tampa Bay Devil Rays third baseman Wade Boggs collected his 3,000th career hit

Trophies and Awards

1887 Medal to Detroit Wolverines players for winning the National League championship

1887 Champion Base Running medal given to Michael "King" Kelly, Boston Red Stockings (NL)

1889 Watch fob presented to Roger Connor, New York Giants

1894-97 Temple Cup, awarded to the champion of the National League

1914 Silver bat presented to Edward "Dutch" Zwilling, Chicago Federal League team

1916-24 Silver trophy presented to Cleveland pitcher Stan Coveleski by the Polish Boys of Cleveland

1926 World Series ring of St. Louis Cardinals pitcher Grover Cleveland "Pete" Alexander

1929 Bat presented to the New York Giants and manager John McGraw by the Loyal Giants Rooters fan club

1936 Berlin Olympic participation medal for U.S. exhibition baseball team

1939 Trophy presented to Lou Gehrig by his Yankee teammates on Lou Gehrig Day

1946 Championship bracelet of Racine Belles outfielder Betty Russell

1965 Cy Young Award given to Sandy Koufax

1967 *Sporting News* Player of the Year Award presented to Orlando Cepeda of the St. Louis Cardinals

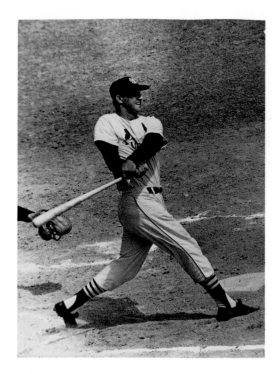

BASEBALL AS AMERICA EXHIBITION
SPONSOR STATEMENT

At Ernst & Young, we are excited to sponsor the *Baseball As America* exhibition because, quite simply, baseball *is* America. Since its earliest days, baseball has been a source of American ingenuity and inspiration. It has served as a symbol of our country's egalitarian ideals, a catalyst for positive social change, and a shining example of how America really is a land of opportunity.

As the sponsor, Ernst & Young is the first business ever to take part in a public partnership with the National Baseball Hall of Fame and Museum. We are privileged to help bring the treasures of the Hall of Fame to Americans all across the country—most of whom have not been fortunate enough to experience the treasures in person in Cooperstown, New York.

We believe this is a fitting collaboration because our firm shares so many of baseball's values, especially leadership, teamwork, diversity, innovation, opportunity, and performance excellence. Our people perform like baseball players, who may step up to the bat alone, but must rely on an entire team in order to win the game. In sponsoring the Hall of Fame's *Baseball As America* exhibition, Ernst & Young is helping to ensure that these values—along with the remarkable artifacts that represent them—will be celebrated and cherished as never before.

James S. Turley
Chairman, Ernst & Young

◆ Modesty. Consistency. A gentleman. Stan Musial embodies many attributes that baseball—and Americans—hold dear. Of Musial's 3,630 hits during his 22-year career with the St. Louis Cardinals, exactly half came at home, the other half on the road. He also hit .331 against left-handers and .331 against right-handers. A measure of the respect for him within the game: His famous nickname, "The Man," came from Brooklyn Dodgers fans.

ACKNOWLEDGMENTS

First and foremost we wish to thank all of our colleagues at the National Baseball Hall of Fame and Museum. This project was so far reaching that every single person on the staff contributed in some material way. We are grateful for their unfailing support. We would like to mention every one by name but space does not permit this. Particular mention must be made of Jane Forbes Clark, Dale Petroskey, Bill Haase, Jeff Idelson, Ted Spencer, Jeff Arnett, Becky Ashe, Mary Bellew, Dan Bennett, Bruce Brodersen, W. C. Burdick, Peter Clark, Kristian Connolly, Erin Crissman, Mike Fink, Bill Francis, Jim Gates, Shirley Gohde, Darci Harrington, Jeremy Jones, Pat Kelly, Sue MacKay, Bruce Markusen, Jane McCone, Anne McFarland, Amy Miles, Scot Mondore, Nate Owens, Rob Pendell, Barbara Shinn, Milo Stewart, Helen Stiles, Rebecca Torres, Tim Wiles, Katie Willers, and Russell Wolinsky.

We want to thank all of the authors of the book. Their knowledge and talents are the core of this volume. We are grateful not only for their contributions but for the way all of our requests were met with intelligence, speed, and good humor. Special mention must be made of Jules Tygiel. His contribution to this project goes beyond the eloquent and erudite introductions to this book. His astute and always forthcoming advice added immeasurably to this project. Larry Gerlach also gave us valuable assistance on many aspects of this undertaking. We also want to thank all those who generously granted the rights to use their works in this volume.

Resnicow Schroeder Associates was essential in realizing this project. We wish particularly to thank David Resnicow for his advice and expertise on a myriad of subjects. Sascha Freudenheim, Sophie Henderson, Jaime Feiner, Neal Appleman, Christine Beidel, and Teni Apelian were invaluable to this undertaking.

Gallagher and Associates designed the exhibition, which this publication complements. Patrick Gallagher led this process with unfailing invention and diplomacy. Kevin Kearns steered the complicated actualization with precision. The extraordinary talents of Terry Healy, Cybelle Lewis-Jones, Maureen Nugent, Yanitza Tavarez, and Rodrigo Vera have given life to our vision of baseball and American culture.

With wit, energy, and unending imagination, Paul Rosenthal translated our ideas into words. He, too, added immeasurably to the creative process.

To the countless people at the National Geographic Society who made this book a success, we offer our thanks, especially to Nina Hoffman and Kevin Mulroy for their enthusiasm and professionalism. We wish we could name everyone but we want to mention Bill Marr for his elegant design and his attention to the story of baseball, Sadie Quarrier for her energetic and far-reaching picture research, Mark Thiessen for his beautiful photographs, and Agnes Tabah for her legal expertise.

Despite the richness of the collections of the Hall of Fame certain key loans were vital to the success of our vision. We wish to thank President George W. Bush, Jane Forbes Clark, Hank and Billye Aaron, the African American Museum in Philadelphia, AVS-Aerial Video Systems, Bette A. Beaumont, the John Bennett Family, the Brett Family, William O. DeWitt, Jr., Eric Enders, Bob Feller, William Gladstone, the Midori Hall Family, Edith Houghton, Mas Inoshita, the Japanese American Citizens League, the Little League Museum, the Gus Mauch Family, Vin Mavaro, the Newseum, the Ripken Museum, Sportsrobe, the Harry M. Stevens Family Foundation, and Mits Takahashi.

Of paramount importance are the many people who will visit this exhibition. All of our colleagues at all of the venues are critical to the realization of the project. We extend our profound thanks for everything that the staffs of these museums will do to present our ideas and objects. We wish that we could thank each individual, but we would mention

Ellen Futter, President and Craig Morris, Dean of Science, American Museum of Natural History; Douglass W. McDonald, President and C.E.O. and Sandra Shipley, Head of Exhibitions, Cincinnati Museum Center; John McCarter, President, Cathleen Costello, Vice President Museum Affairs, and Sophia Siskel, Head of Exhibitions, Field Museum of Natural History; W. Richard Johnston, President and C.E.O. and Kathy Oathout, Vice President of Operations and Development, Florida International Museum; Dr. Robert R. Archibald, C.E.O. and President and Myron Freedman, Director of Exhibitions, Missouri Historical Society; Dennis O'Connor, Under Secretary for Science, Smithsonian Institution and Acting Director, Robert Sullivan, Associate Director, Joe Madeira, Head of Exhibitions, National Museum of Natural History; and Dr. Jane Pisano, President and Director and Dan Danzig, Manager of Special Exhibits, Natural History Museum of Los Angeles.

Stephanie Glaser and William Gaske of Patterson, Belknap, Webb, and Tyler LLP offered their sound counsel, as did several staff members of The Clark Estates.

The exhibition would not be standing without the expertise of Maltbie Associates. We thank Chuck Maltbie, George Mayer, and Steve Philpott. Joan Stanley of JG Stanley Associates allowed us to share the joy of baseball through her merchandising of the exhibition. The shipping talents of Dietle International Services, Inc. have enabled this tour to travel throughout the country. Special thanks to Fritz Dietle, Tom MacDonald, and Dierdre O'Connell.

There were countless details connected with the research, writing, publishing, and realization of this exhibition and book in which we were generously helped by a great many people. We extend our profound thanks to all of them for their myriad acts of generosity. We fear that many people who provided vital information or assistance might not have their names mentioned here. This does not lessen our gratitude to you. Our thanks to: Linda Allen, Paul Anbinder, Victoria Bond, Brian Boucher, Carl Brandt, Curt Brett, Mariner Brito, Kenneth Cobb, Lucy Coccia, Jean and John Comaroff, Mary Corliss, Paul Cunningham, Sachi Cunningham, Juanita DeSilva, Mary Evans, Judy Flood, Victoria Fox, Amanda Freymann, Dixon Gaines, Steve Gietschier, Tom Gilbert, Barbara Kirschenblatt Gimblett, Nicholas Graham, Marc Hacker, Neil Harris, Bill Hunt, Ronald Hussey, Russell James, Karina Kabigting, Lawrence Kardish, Dave Kelly, Treva Kelly, Hildy Linn, Chris Morris, Alan Newman, Brian Niiya, Kerry Nakagawa, Kateri Noone, Erin O'Connor, Arthur Price, Betsey Quick, Brian Riley, Rachel Robinson, Susan Rossen, Jim Rubinstein, Alyssa Sachar, Michael Seitz, Joseph Serene, Eddie Simon, Judi Smith, Gretchen Sullivan Sorin, Catherine Sprinkel, Carolyn Swayze, Raymond Teichman, Fred Toulsch, Mary Frances Veeck, David Wilbourne, John Henry Williams, Katherine Winingham, and Leo Ziffren.

Teri Edelstein was an invaluable part of the team from Day One. Her expert guidance and unflagging enthusiasm were essential to the success of both this volume and the exhibition.

Profound thanks to our families who gave moral and intellectual support and were infinitely understanding of all the time and effort that this worthy project consumed.

Finally, to all of those who have made baseball The National Pastime—the players, the clubs, the commentators but, above all, the fans—we dedicate this book to you.

CURATORIAL COMMITTEE FOR BASEBALL AS AMERICA
Kristen Mueller, Lead Curator
Kathleen Gallagher, John Odell, Mary Quinn,
Tom Shieber, Erik Strohl

Selected Bibliography and Suggested Readings

For those interested by the prospect of viewing America through the game of baseball, we offer a selection of works used in developing *Baseball As America*. This list, by no means exhaustive, offers a core of information and thought that may guide the reader to a new understanding of the role our National Pastime has played in our culture. Selections marked with an asterisk have been reprinted or excerpted in this volume.

BOOKS

Adair, Robert. *The Physics of Baseball*. New York: Harper Perennial, 1994.

*Angell, Roger. *The Summer Game*. New York: Viking Press, 1972.

Asinof, Eliot. *Eight Men Out: The Black Sox and the 1919 World Series*. New York: Holt, Rinehart and Winston, 1963.

*Barzun, Jacques. *God's Country and Mine: A Declaration of Love Spiced with a Few Harsh Words*. New York: Vintage Books, 1954.

Clark, Dick and Larry Lester, eds. *The Negro Leagues Book*. Cleveland, OH: Society for American Baseball Research, 1994.

Dinhofer, Shelly. *The Art of Baseball*. New York: Harmony Books, 1990.

Gerlach, Larry. *Men in Blue: Conversations with Umpires*. Lincoln: University of Nebraska Press, 1994.

Goldstein, Warren. *Playing For Keeps: A History Of Early Baseball*. Ithaca: Cornell University Press, 1989.

Gregorich, Barbara. *Women At Play: The Story Of Women In Baseball*. San Diego, CA: Harcourt Brace, 1993.

*Jackson, Shirley. *Raising Demons*. Farrar, Straus and Giroux, Inc., 1953,54,56,57.

Jamail, Milton. *Full Count: Inside Cuban Baseball*. Carbondale: Southern Illinois University Press, 2000.

James, Bill. *The New Bill James Historical Baseball Abstract*. New York: Free Press, 2001.

*Johnson, Harry "Steamboat." *Standing the Gaff*. Nashville: Parthenon Press, 1935.

Kahn, Roger. *The Boys Of Summer*. New York: Harper & Row, 1972.

*Kinsella, W.P. *Shoeless Joe*. Boston: Houghton Mifflin Co., 1982.

*Kuhn, Bowie. *Hardball: Education of a Baseball Commissioner*. New York: Times Books, 1997.

Lamb, David. *Stolen Season: A Journey Through America And Baseball's Minor Leagues*. New York: Random House, 1991.

Light, Jonathan Fraser. *The Cultural Encyclopedia of Baseball*. Jefferson, NC: McFarland, 1997.

*Malamud, Bernard. *The Natural*. New York: Farrar Strauss Giroux, 1952.

O'Neil, Buck with Steve Wulf and David Conrads. *I Was Right on Time*. New York: Simon & Schuster, 1996.

Plimpton, George, ed. *Home Runs*. New York: Harcourt, 2001.

Riess, Steven A. *Touching Base: Professional Baseball And American Culture In The Progressive Era*. Westport, CT: Greenwood Press, 1980.

Ritter, Lawrence S. *The Glory Of Their Times: The Story Of The Early Days Of Baseball Told By The Men Who Played It*. New York: Quill, William Morrow, 1992.

Robinson, Jackie with Alfred Duckett. *I Never Had It Made*. Hopewell, NJ: Ecco Press, 1995.

Smith, Curt. *Voices Of The Game: The First Full-Scale Overview Of Baseball Broadcasting, 1921 To The Present*. South Bend, IN: Diamond Communications, 1987.

Springwood, Charles F. *Cooperstown to Dyersville: A Geography Of Baseball Nostalgia*. Boulder, CO: Westview Press, 1996.

Thorn, John. *Treasures Of The Baseball Hall Of Fame: The Official Companion To The Collection At Cooperstown*. New York: Villard, 1998.

Tygiel, Jules. *Past Time: Baseball As History*. New York: Oxford University Press, 2000.

Tygiel, Jules. *Baseball's Great Experiment: Jackie Robinson And His Legacy*. New York: Oxford University Press, 1997.

*Veeck, Bill and Edward Linn. *Veeck as in Wreck*. New York: GP Putnam Sons, 1962.

Voigt, David Q. *America Through Baseball*. Chicago, IL: Nelson-Hall, 1976.

Walker, Donald E. and B. Lee Cooper. *Baseball And American Culture: A Thematic Bibliography Of Over 4,500 Works*. Jefferson, NC: McFarland, 1995.

Wallace, Joseph E., Neil Hamilton and Marty Appel. *Baseball: 100 classic moments in the history of the game*. New York: Dorling Kindersly, 2000.

Ward, Geoffrey C. and Ken Burns. *Baseball: An Illustrated History*. New York: Knopf, 1994.

*White, Sol. *History of Colored Base Ball*. Philadelphia: Walter Schlichter, 1907.

Zimbalist, Andrew, *Baseball And Billions: A Probing Look Inside The Big Business Of Our National Pastime*. New York: BasicBooks, 1992.

PAMPHLETS AND PROGRAMS

Touring the World: New York Giants and Chicago White Sox 1913-1914. 1913.

Report of the Mayor's Commission on Baseball to Mayor LaGuardia. October 31, 1945.

LETTERS

*Curt Flood to Bowie Kuhn, December 24, 1969. Copy in National Baseball Hall of Fame Library files.

*Annie Glidden to her brother, April 20, 1866. Copy in National Baseball Hall of Fame Library files.

*Albert D. Richardson to his sister, 2/12/1864. Massachusetts Historical Society.

*Franklin Delano Roosevelt to Kenesaw M. Landis, January 15, 1942. Original in the National Baseball Hall of Fame Library.

NEWSPAPER AND MAGAZINE ARTICLES

*Barry, Dave. "Our National Pastime," *Miami Herald*. March 31, 1996.

*Chabon, Michael. "A Gift." *New York Times Magazine*, 1991.

*"Communication." *National Advocate* (New York). April 25, 1823. Courtesy the Newseum.

Gould, Stephen Jay. "Creation Myths of Cooperstown." *Natural History Magazine*, November 1989.

*McPhee, Bid. *Sporting Life*. April 12, 1890.

*Obituary of Elizabeth Dooley. *Boston Globe*. June 20, 2000.

* Povich, Shirley. "This Morning with Shirley Povich." *Washington Post* April 7, 1939.

*Roth, Philip. "My Baseball Years." *New York Times*, April 2, 1973.

*Simon, Paul. "The Silent Superstar." *New York Times*. March 9, 1999.

*Spink, C.C. Johnson. Diamonds for Girls. *The Sporting News*, April 27, 1974.

*Thayer, Ernest L. "Casey at the Bat." *San Francisco Daily Examiner*, 1888.

RECORDINGS

*Newhart, Bob. "Nobody Will Ever Play Baseball," *The Button Down Mind of Bob Newhart*, Warner Brothers, 1960.

*Raposo, Joe. "There Used to Be a Ballpark." Sergeant Music Co. and Jonico Music, Inc., 1973.

*Robinson, Jackie. Pregame ceremony, World Series Game Two, Cincinnati, Ohio, October 15, 1972.

*Williams, Ted. National Baseball Hall of Fame Induction speech, 1966.

CREDITS

INDEX

NATIONAL
★ ★ ★ ★ ★
BASEBALL

HALL OF FAME

Founded in 1939 in Cooperstown, New York, the National Baseball Hall of Fame and Museum is a not-for-profit educational institution dedicated to fostering an appreciation of the historical development of the game and its impact on our culture by collecting, preserving, exhibiting, and interpreting its collections for a global audience, as well as honoring those who have made outstanding contributions to our national pastime.

NATIONAL BASEBALL HALL OF FAME AND MUSEUM

Jane Forbes Clark *Chairman of the Board*
Dale Petroskey *President*
Bill Haase *Senior Vice President*
Ted Spencer *Vice President and Chief Curator*
Jeff Idelson *Vice President of Communications and Education*

BASEBALL AS AMERICA

John Odell *Editor, Baseball As America*

CURATORIAL COMMITTEE FOR BASEBALL AS AMERICA

Kristen Mueller *Lead Curator*
Kathleen Gallagher
John Odell
Mary Quinn
Tom Shieber
Erik Strohl

SELECT STAFF FOR THE EXHIBITION AND BOOK

Fran Althiser *Controller*
Peter Clark *Curator of Collections*
Jim Gates *Librarian*
Becky Ashe *Administrative Assistant*
Bruce Brodersen *Director of Multi-Media Services*
Bill Francis *Researcher*
Shirley Gohde *Exhibits Technician*
Pat Kelly *Director of Photograph Collection*
Sue MacKay *Registrar*
Anne McFarland *Director of Technical Services*
Rob Pendell *Multi-Media Producer*
Milo Stewart, Jr. *Photographer*
Tim Wiles *Director of Research*

Teri J. Edelstein *Consultant*
Paul Rosenthal *Exhibition Writer*

Exhibition design by Gallagher and Associates, Washington, D.C.